PAINTINGS AND SCULPTURE AT HATFIELD HOUSE

Paintings and Sculpture at Hatfield House

A Catalogue compiled by
Erna Auerbach and C. Kingsley Adams

Constable & Co. Limited

Designed and produced by
George Rainbird Limited
Marble Arch House, 44 Edgware Road, London W2
for
Constable and Co. Limited
10 Orange Street, London WC2

Editor: Mary Anne Norbury
Design: George Sharp

First published 1971

The text, colour plates, monochrome illustrations and
jacket were printed by
Balding and Mansell Limited, Wisbech, Cambridgeshire
The colour plates were originated by
Supreme Litho Limited, Stockwell
The book was bound by
Bemrose and Sons Limited, Derby

ISBN 0 09 457640 8

CONTENTS

A COMPLETE LIST OF PAINTINGS AND SCULPTURE CATALOGUED

Part One – up to 1632

BY ERNA AUERBACH

PREFACE

My greatest debt is due to Lord Salisbury, who asked me to write this part of the Catalogue and generously gave me the benefit of his unique knowledge of the family Collection. His enthusiasm stimulated my work and gave me much encouragement and support. I am also grateful to Lord Cranborne for furthering and promoting the publication of this book.

Throughout my studies the Librarian and Archivist at Hatfield House, Miss Clare Talbot, was untiringly helpful in answering questions relating to documents in her care, in producing the relevant manuscripts and giving me information about the various art treasures at Hatfield.

My thanks are due to Miss Carolyn Merion for undertaking the painstaking and often unrewarding task of checking references and for enlightening me on many interesting problems connected with her special field of research into sixteenth-century English history.

Again, I enjoyed the privilege of having access to the records of the National Portrait Gallery, first under the Directorship of Mr David Piper, now Director of the Fitzwilliam Museum, and later under the present Director, Dr Roy Strong.

It is difficult to mention all the colleagues and friends who assisted me in many ways. First of all, my most sincere gratitude is due to the late Mr C. Kingsley Adams, my co-author, who was always ready to help me in every possible way. I received valuable advice from the following: M. Jean Adhémar, Directeur of the Cabinet des Estampes, Bibliothèque Nationale; Mr H. M. G. Baillie of the Royal Commission on Historical Manuscripts; Mme Sylvie Béguin, Conservateur au Départment des Peintures, Musée du Louvre; Mr Noel Blakiston, of the Public Record Office; Professor Sir Anthony Blunt, Director of the Courtauld Institute of Art; M. and Mme Boissinot (for information concerning the portrait of ?Sir Walter Cope, Cat. No. 74. The inscription resembles *Aeneid*, III, line 490); Miss Ida Darlington, formerly Head Archivist of the Greater London Council; Mr Robert Elmore, Miss Jean Morris, Dr John Shearman, of the Courtauld Institute of Art; Dr Pamela Tudor-Craig, who paved the way for some of the entries; and many others.

Finally, I am deeply grateful to Miss Mary Anne Norbury of George Rainbird Limited for helping me to prepare the manuscript for the printer with so much understanding and unfailing patience. I should also like to thank her for many useful suggestions.

London, 1970 E.A.

ABBREVIATIONS

QUESTION MARKS

If a question mark appears before the name of an artist or sitter the author is tentatively suggesting authorship or personality depicted. If the question mark appears in brackets after the artist or sitter this denotes that although the author has no documentary evidence to prove the fact she is practically certain of the attribution.

ORIGINAL DOCUMENTS

B.M.	British Museum Manuscripts
P.R.O.	Public Record Office
S.P.	State Papers
L. & P.	*Letters and Papers, Foreign and Domestic of the Reign of Henry VIII*, 21 vols, London, 1862–1932

MANUSCRIPTS BELONGING TO LORD SALISBURY

Cecil Papers	The main series of original MSS. at Hatfield House are known as the Cecil Papers, and these, with a less numerous series known as Petitions, have been calendared up to 1608 by the Historical Manuscripts Commission under the title:
Cal.	*Calendar of the Manuscripts of the Most Hon. the Marquess of Salisbury at Hatfield House*, 19 vols, 1883–1966. The other relevant manuscripts in Lord Salisbury's collection have not yet been calendared by the Historical Manuscripts Commission. As a whole they are referred to as 'Cecil Family and Estate Papers' and include the following:
Accounts	Mainly household and estate accounts
Bills	Bills and other financial papers
Boxes A to U	Mainly inventories
General; Legal	Various financial and legal documents

PRINTED BOOKS AND OTHER RELATED WORKS

Auerbach, *Tudor Artists*	Auerbach, Erna, *Tudor Artists*, London, 1954
—— , *Hilliard*	Auerbach, Erna, *Nicholas Hilliard*, London, 1961
Burl. Mag.	*The Burlington Magazine*
Cat. British Portraits 1956/7	*Catalogue of the Exhibition of British Portraits at the Royal Academy, 1956/7*, London, 1956
Cat. Burghley House	Exeter, Marchioness of, *Catalogue of Pictures at Burghley House*, 1954
Cat. Holbein 1950/1	*Catalogue of the Exhibition of Works by Holbein and Other Masters of the 16th and 17th Centuries at the Royal Academy, 1950/1*, London, 1950
Cat. Liverpool 1953	*Catalogue of the Exhibition, Kings and Queens of England*, at the Walker Art Gallery, Liverpool, 1953
Cat. Portraits 1866	*Catalogue of the First Special Exhibition of National Portraits ending with the Reign of James II on loan to the South Kensington Museum*, London, 1866
Cat. R.A. 1953	*Catalogue of the Exhibition of Kings and Queens, 1653–1953, at the Diploma Gallery, Royal Academy*, London, 1953
Cat. Tudor 1890	*Catalogue of the Exhibition of the Royal House of Tudor, New Gallery*, London, 1890
Cooper	Cooper, C. H., *Memoire of Margaret, Countess of Richmond and Derby*, 1874
Cust	Cust, Sir Lionel, 'The Painter HE (Hans Eworth)', *Walpole Society Publications*, II (1913)
Goodison	Goodison, J. W., *Catalogue of Cambridge Portraits*, vol. 1, Cambridge, 1955
Gunton	Transcripts of various documents made by Mr R. T. Gunton, Archivist and Secretary to the 3rd Marquess of Salisbury

Hind	Hind, Arthur M., *Engraving in England in the 16th and 17th Centuries*, 2 vols, London, 1952–1955
Holland	Holland, L. G., *A Descriptive and Historical Catalogue of the Collection of Pictures at Hatfield House and 20 Arlington Street*, privately printed, 1891
Lodge	Lodge, Edmond, *Portraits of Illustrious Personages of Great Britain*, 4 vols, London, 1821–34
MSS.	Manuscripts
Mercer	Mercer, Eric, *English Art, 1553–1625*, Oxford, 1962
Millar	Millar, Oliver, *Tudor, Stuart, and Early Georgian Pictures in the Collection of Her Majesty the Queen*, London, 1963
Musgrave	Musgrave, Sir William, *Catalogue of Portraits at Hatfield House*, June 28, 1769, B.M. Add. MSS. 6391, ff. 79–80
N.P.G.	The National Portrait Gallery
Pennant	Pennant, Thomas, *The Journey from Chester to London*, London, 1782
Piper, *De Critz*	Piper, David, 'Some Portraits by Marcus Gheeraerts II and John de Critz Reconsidered', *Huguenot Society Proceedings* (1960), vol. XLIV, No. II, London, 1960, pp. 210–29
— , *Essex*	Piper, David, 'The 1590 Lumley Inventory: Hilliard, Segar and the Earl of Essex', I and II, *Burlington Magazine*, XCIX (1957), pp. 224–31 and 299–303
Read, *Cecil*	Read, Conyers, *Mr. Secretary Cecil and Queen Elizabeth*, London, 1955
— , *Burghley*	Read, Conyers, *Lord Burghley and Queen Elizabeth*, London, 1960, paperback edition, 1965
Reynolds	Reynolds, Graham, *Nicholas Hilliard and Isaac Oliver, Catalogue of an Exhibition at the Victoria and Albert Museum*, London, 1947
Robinson	Robinson, P. F., *Vitruvius Britannicus, History of Hatfield House*, London, 1833
S.S.B.	Scharf, Sir George, Trustees' Sketch Books in the Archives of the National Portrait Gallery
Stone	Stone, Lawrence, 'The Building of Hatfield House', *Archaeological Journal*, CXII (1956)
Strong, *Cat. N.P.G.*	Strong, Roy C., *Catalogue of Elizabethan and Jacobean Portraits at the National Portrait Gallery*, 2 vols, London, 1969
—— , *Elizabeth*	Strong, Roy C., *Portraits of Queen Elizabeth I*, Oxford, 1963
—— , *English Icon*	Strong, Roy C., *The English Icon; Elizabethan and Jacobean Portraiture*, London, 1969
V. & A.	The Victoria and Albert Museum
Vertue	Vertue, George, *Notebooks*, 6 vols and index vol., *Walpole Society Publications*, XVIII (1930), XX (1932), XXII (1934), XXIV (1936), XXVI (1938), XXIX (1947), XXX (1955)
Walpole	Walpole, Horace, *Anecdotes of Painting in England*, ed. J. Dallaway and R. N. Wornum, 3 vols, London, 1888
Waterhouse	Waterhouse, Ellis K., *Painting in Britain 1530 to 1790*, London, 1953
Whinney	Whinney, Margaret, *Sculpture in Britain 1530–1830*, London, 1964
Whinney and Millar	Whinney, Margaret, and Millar, Oliver, *English Art 1625–1714*, London, 1957

Part One

INTRODUCTION

The period surveyed in Part I of this catalogue extends from the early Tudors to the year 1632, when Van Dyck came to England. All the works of art originating before 1632 in the collection of the Marquess of Salisbury at Hatfield House are therefore included. The growth and development of this fine collection consisting of pictures, miniatures and pieces of sculpture is due to the foresight, imagination, and taste of three great members of the Cecil family: William, Lord Burghley (1520–1598); Robert, 1st Earl of Salisbury (1563–1612); and William, 2nd Earl of Salisbury (1591–1668). Their patronage of the visual arts is still manifest in this collection, although many additions have been made to their earlier choices.

The bulk of the collection comprises family portraits, likenesses of friends and statesmen, as well as portraits of royalty both, native and foreign. They constitute records of immense importance and provide lively images of the courtiers and other contemporaries in this country and abroad. Apart from these portraits there are also examples of Italian and Flemish religious and allegorical paintings, which appear to have been collected during the Elizabethan and Jacobean periods.

For a fuller understanding and historical evaluation of the works of art thus assembled at Hatfield House, it is necessary to examine thoroughly the wealth of surviving manuscripts which relate to the period. These comprise an unusually large number of inventories, bills, accounts, letters and other documents. Some of them are calendared by the Historical Manuscripts Commission, at least up to 1608, but unfortunately there is no complete catalogue available. Although every care has been taken, it may be that in the course of time references will come to light which might make necessary the reconsideration of some individual items. The original documents are kept in the Muniment Room at Hatfield House. Also consulted have been the microfilms of some of the original documents taken for the Folger Shakespeare Library which are now deposited in the Department of Manuscripts at the British Museum.

The inventories start in 1611, the year when Hatfield House was completed, and they clearly show that the greater part of the collection had been assembled from works of art that had been kept at Salisbury House in London, Quickswood, Theobalds and other houses owned by the Cecils. There are, in particular, inventories of the collection at Salisbury House covering the period from 1629 to 1692

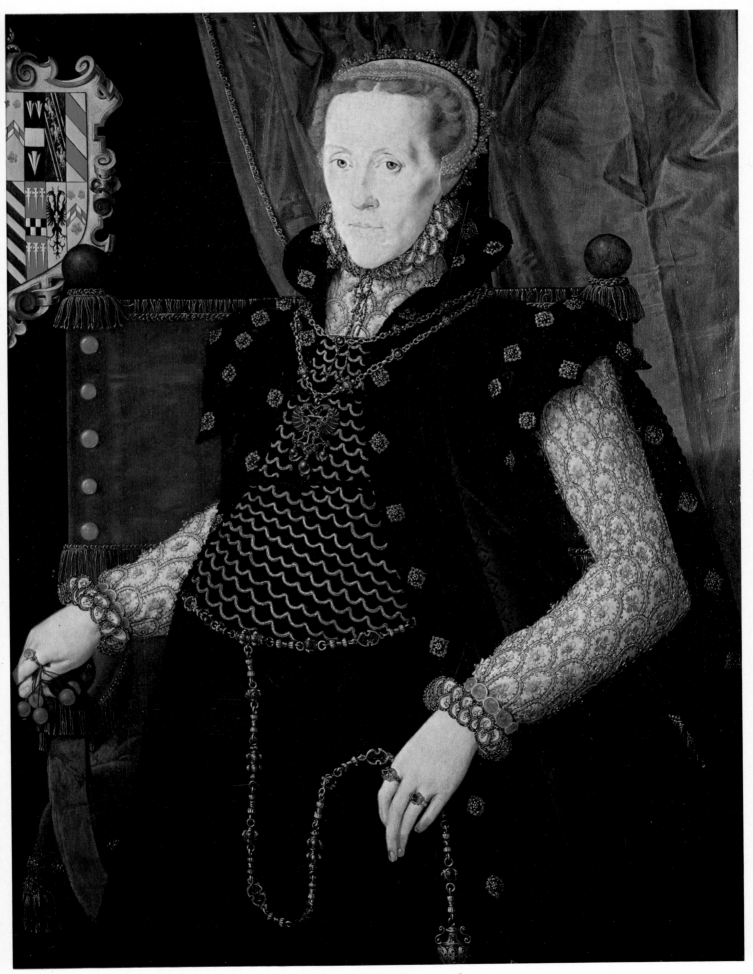

COLOUR PLATE I, **Mildred, Lady Burghley,** *c.*1563, by Hans Eworth(?) (Cat. No. 35, p. 46)

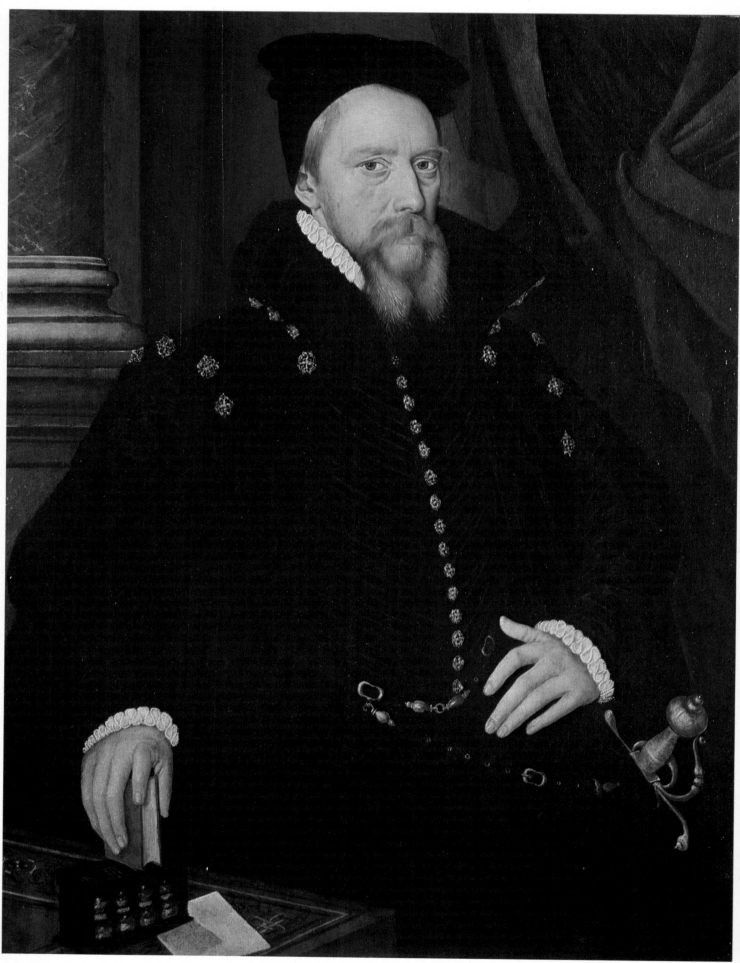

COLOUR PLATE II. **William Cecil, 1st Baron Burghley,** *c.*1565, by ?Hans Eworth (Cat. No. 36, p. 46)

which warrant the greatest interest. They shed light on the art treasures which at that particular time formed part of the collection, and in some cases indicate the date of their transfer to Hatfield. Additionally, much interesting information about the character of interior decoration of that period can be gleaned.

The earliest surviving inventory of the contents of Salisbury House is that dated June 20, 1629 and signed by John Glase (Box C.8), mentioning only three pictures in the Hall: those of a fool, of a jester, and of 'Garragantua head'. Another three pictures are listed as being in each of the three following rooms: the 2nd Earl of Salisbury's dining chamber, the withdrawing room adjoining, and the Earl's dressing room. There was one picture each, in the parlour, in the Earl's bedroom, and in the room next to Sir Anthony Forrest's. In the withdrawing chamber next to the gallery there stood '1 high chaire 1 longe cushion – of satten richlie imbroydered with imagrie with the late Queenes picture on them'. Thirty-five paintings decorated the Gallery.

As to the subject matter of these pictures, a great variety can be noted. There were eight religious and ten allegorical themes, ten portraits, and four landscapes and genre pictures. Maps were frequently used for decoration, and in the lobby between the great chamber and the gallery hung '1 picture of England at large, in a frame'. Among the seven paintings in the great chamber three may be singled out: '1 picture of the Lord Darneley and his brother with a curtaine of purple taffata fringed with gold; 1 faire picture of the Queene Mother of Scotland; 1 faire picture of the late Queene Elizabeth'. The six pictures in the great withdrawing chamber included a portrait of King James and one of Queen Anne. One picture of 'the betrayinge of Christ by night' was hanging in Lord Percy's dressing room, and in his lodging chamber the portrait of the Countess of Oxford with a taffeta curtain was noted. A 'Large Pedigree of all the Princes of England in a frame of wallnut tree inlaid' decorated the lobby next to the upper chapel. In the wardrobe there were four portraits and two pieces of sculpture: '1 picture of Aristotle in white marble' and '1 old picture of a woman in wax with a mantle of callico searsnet and a stool to stand on'. Also in the wardrobe were four pedigrees of Lord Cobham. In the left margin of the inventory the shifting is noted of the full-length portraits of the children of the 2nd Earl from the gallery to the wardrobe. A later addition also mentions '1 picture of my lord and lady Northumberland' and '1 other halfedrawn'. At the end of this inventory there is an interesting summary of the items as follows: 69 pictures, 5 maps, 6 pedigrees and 15 'Modelles' (pieces of sculpture).

By comparing this inventory with later ones of Salisbury House, London, it can be seen that the art treasures were moved about frequently. In 1639/40 (Box C.9), for example, the portrait of the Countess of Oxford was hanging in Lord Cranborne's bed chamber instead of in Lord Percy's lodging chamber. Four full-length portraits of the 2nd Earl's children were in the Armoury by 1640, having been moved from the wardrobe. Five years later (Box C.4 and 5, March 9, 1645/6) '1 picture of the Erle of Totnes' appears in the dining room below stairs. The portrait of Lord and Lady Northumberland had been moved to the gallery from the wardrobe. The portrait of Lady Oxford was moved from Lord Cranborne's chamber to the great chamber above stairs. The pictures which were hanging in the great withdrawing chamber in 1629 are now placed in Lady Lisle's bedchamber. But the most important change in 1646 is the disappearance of the picture of Lord Darnley and his brother from the great

chamber above stairs and indeed, from the whole inventory. As this double-portrait, which we know in two versions, is not mentioned in any other inventory, and is no longer in the collection, we may assume that it was either given away or lost between 1640 and 1646. It is quite possible that it can be identified with the life-size painting in Holyrood House in the Royal Collection, which was acquired by King Charles I, Darnley's grandson, for the Bear Gallery at Whitehall some time between 1640 and 1649. It is also feasible that originally in 1590 it was in Lumley Castle, and was bequeathed to Robert Cecil by Lord Lumley at the beginning of the seventeenth century.[1]

In the next inventory (Box C.6, June 1647 with a few additions to 1663) the movements of goods to Hatfield are noted. The picture of 'my lord's father', the 1st Earl, which had been listed in 1629 as hanging in the 2nd Earl's bedchamber, is now mentioned as being at Hatfield. There were apparently at this time no pictures in the wardrobe at Salisbury House.

A more concrete reference to the transfer of pictures can be found in: 'A breefe note of the stuff sent to Hatfield since the year 1612'. (Box C.29). Here two pictures are listed:

An° 1617 1: Picktore of moziake worke of the late Lo: thresorare my Lo: his father.

An° 1619 1: Picktore of the Lo: Burghley my Lo:s grandfather.

The first can be identified with the mosaic by an Italian artist based on the portrait of Robert Cecil by John de Critz the Elder, now hanging in the Library at Hatfield House. The second is probably one of the many portraits of Lord Burghley surviving at Hatfield House, but it is difficult to establish which one is meant.

There were, however, on April 3, 1685, still eleven pictures in the Hall of Salisbury House (Box C.7), and among them such paintings as one picture of King James I, two of Queen Elizabeth, one of Lady Mildred Burghley and one piece of Adam and Eve. The portrait of the Earl of Northumberland with his wife and child was now hanging in the Parlour. There were also pictures of religious subjects and landscapes. The last inventory of Salisbury House is dated August 30, 1692 (Box C.12). In the same year the move to Hatfield started, to which the following note refers: 'Helping to load the waggon when the pictures were sent to Hatfield, 1s'. London charges: 'going to your house for my Lord's picture and carrying it to Mr Dayles, loading wagons at Salisbury House'. (Bills 347 and 348).

By 1694 everything seems to have been taken to Hatfield House, for on December 5, 1694, we read (Bill No. 363): 'Calling over the inventory of all goods belonging to my Lord. In Gerrard Street packing the goods. Packing all the tapestry. Fitting up the cases that came from Hatfield for the goods and pictures. Paid porters with the pictures from Salisbury House and loading a wagon. New deal case for the spinet. Packing the spinet and harpsical. For mending the picture of the naked woman.'

As early as September 1654 two cases were packed for the removal of pictures to Hatfield (Box M.4). Two years earlier various pictures, amongst them a portrait of Sir Anthony Cooke and a picture of Adam and Eve were renewed and repaired at Salisbury House (Bills 254). One can imagine the lively activities involved in shifting the pictures from one place to another when one reads a report about Hatfield in 1697 (Bills 375), which describes the 'Putting pictures into frames and putting them up:

[1] Millar, Oliver, *Tudor, Stuart, and Early Georgian Pictures in the Collection of Her Majesty the Queen*, London, 1963. Cat. No. 57.

fetching the pictures from the house and putting them up in the dining room over the kitchen, taking down all the pictures in the Gallery and putting them up in the lobby, and putting up all the great pictures in the Gallery again; taking pictures out of cases and putting them up and taking others down in the dining room. 3 straining frames for "Limner" and 5 more. Putting frames to all the pictures in the Chapel. Making cases to carry pictures to London. (The traffic went apparently also in the other direction) . . . Taking all the pictures down in the great dining room over the kitchen and putting them up in the great dining room belowstairs . . . etc'. The task of a cataloguer at that time would have been extremely trying!

The earliest inventories, however, concern Robert Cecil's house in Enfield (Box D.41). There are actually two inventories in the same book, of which the first is the later in date. Part I is dated September, 1606. In the great chamber there are 'five frames with divinitie and other pictures'. The frames 'with divinitie' may be tapestries. In the next room 'called Pawleyvycynes (Palavicini's) chamber' there are 'the pictures of the vertues', which must have been hangings. In 'my Maisters Chamber' only a map is listed, whereas in 'the next chamber adioyninge for those that wayte in my masters chamber' there was 'A Picture of the Lorde of Shrewsburie'. The date of this inventory is earlier than the building of Hatfield House.

Part II is still earlier: 'The Inventory of the household stuffe of the right honourable my Lo. of Salisburie which was taken the 27th of May, 1597.' As Robert Cecil did not become Lord Salisbury before 1605, this is probably a copy of the original document. The location of the 'stuffe' in the house is not given. Two portraits are mentioned: 'A picture of Meistris Wentworthe' and 'A picture of Sir Horatio Paulenvycine'. The first can perhaps be identified with No. 60 [56] of the catalogue, if that portrait does not represent Robert Cecil's wife. The second cannot be traced any more. The above-mentioned picture of Lord Shrewsbury cannot plausibly be identified at the present moment.

In the Enfield Inventory of December 10, 1612 (Box D.40), no pictures are mentioned, nor are any listed on October 23, 1620 (Box C.32 and 34), but at the end of the latter inventory of 'such hangings and other things as are now att Quicswood', a note indicates the moving of some things to Hatfield. In the Quickswood Inventory of June 11, 1629 (Box C.35), three pictures are listed, two unnamed ones in the great chamber and 'one picture of my Lo: with a curtaine of taffata' in 'My Lo:s bedd chamber'. That was, of course, the 2nd Earl's portrait.

The next Quickswood Inventory of December 12, 1651, (Box C.33 and 37) is worthy of note. Apart from many maps, amongst them one of London, there were '1 picture of my Lord Burghley' and '1 picture of my Lord Burghley's Mother' in the great chamber. 'in my Lds Closet (it has to be inferred from the context that this was Lord Cranborne's room) 1 picture of my Lady Burghley' is listed. So Quickswood has to be added to the list of places where the many likenesses of Lord Burghley now at Hatfield, the one of his mother, and the two of his wife, were originally hanging.

The inventories of Salisbury House, London, Enfield, and Quickswood show clearly that pictures and other 'Stuffe' were moved to Hatfield House. Although no inventory of Theobalds has survived, there is at least one reference of 1635 among the Estate Papers (Accounts 32/1), which gives the charges for 'going to Theobalds for the picture that hangs in the Hall . . .'. This is enough to show that paintings were also moved to Hatfield from Theobalds, even after Theobalds had become a royal palace.

The earliest Hatfield House inventory is dated September 30, 1611 (Box A.1) and is arranged according to rooms. There were no pictures in the Hall or in the great parlour. Four paintings were hanging in the Antechamber, three of them portraits: one of Lord Leicester, one of Mistress Wentworth, which had presumably been sent from Enfield, one of a Dutch woman and 'one other picture of a banquete'. Robert Cecil had in his own private rooms only one picture of his father and one of his mother. On the second floor, on the east side near the King's rooms, in the Lobby between the great chamber and the Gallery, there were five pictures and amongst them Caterina Cornaro, Albert, Archduke of Austria and Isabella Clara Eugenia, which are still in the house and will be discussed in the relevant numbers of the catalogue. In the gallery adjoining there is listed only 'one fair great picture of the passion of Christ', with a curtain of purple taffeta with a gold fringe. Another religious painting, Isaac and Jacob, was hanging on the north side, in the withdrawing chamber. Still on the second floor in the passage on the west side, was 'one Picture of Nascendo morimur' which we can still see almost in the same place. In the lobby between the Gallery and the Chapel there were seven pictures of the Kings of England and two of the Queens. In the Chapel on the first floor six framed 'great pieces of paintings' are listed, representing the birth and story of Christ, which have still survived. But most of the pictures were housed in the Wardrobe on the upper floor in 1611, and not in the Hall or the Gallery as one would have expected. The list also includes maps and probably tapestries, and altogether amounts to forty-four items. Amongst them are nineteen portraits, including one of Queen Elizabeth, four religious paintings, eleven allegorical and genre pictures. There is one pedigree with verses, four 'old maps of divers countries', two architectural pictures of the Royal Exchange, one frame of wood carved with Robert Cecil's arms, one other map without a frame and one fair picture of a ship.

On June 9, 1629, another inventory of Hatfield House (Box A.6) was drawn up by James Hodgkinson. It has additions in a different and probably later hand. It starts with the Lobby between the Gallery and the King's great chamber on the first floor where '1 picture of Mercury and Paris' and two portraits of Edward IV and Richard III were hanging. By this date the Gallery seems to have become more important and twenty portraits are listed here, among them Edward VI, Lord Burghley, the mosaic of Robert Cecil, Lord Leicester, Mistress Wentworth, Queen Elizabeth and, a new addition to the collection, King Charles I. Incidentally, the name of Queen Elizabeth has later been struck out, and in the margin is written the note: 'in the wardrobe is pict(ure) of Qu(een) Eliz(abeth)'. Seven portraits of the 2nd Earl and his children are also crossed out and three names substituted in a later hand: '1 of the Countesse of Richmond and Derby, 1 of my Lord of Devonshire and 1 of my lady of Devonshire'; the two latter are 'in length in gilt frames'.

In the lobby at the end of the gallery by the Chapel there were three portraits of Kings, '1 picture of Nascendo Morimur, (which hung there before), a painting of a ship called 'the Beare' and (added in a later hand) '1 picture of a Banquett'. Three portraits appeared in the great chamber of the Queen's side: Henry VII, Elizabeth of York and the Countess of Richmond. All three are still at Hatfield House today. The eight religious paintings in the lower Chapel were, according to a later marginal note, to be inventoried in the wardrobe. On the great stairs on the King's side, there were, apart from '1 faire picture of Adam and Eve' two other religious paintings, '1 large picture of a shipp in a storme', one allegorical and one heraldic subject. The eight 'pictures of Hercules' labours', probably tapestries, were

added later to the Hall, having previously adorned the 2nd Earl's dressing chamber. Again, in the Hall, was a fair picture of a horse which hangs now on the great staircase. In the great parlour, which was called the 'dining room below stairs', and in the dining room next to it (which became the withdrawing room), only a few pictures and a map of the world were hanging. In the second withdrawing room there were five portraits, viz. of Lady Burghley, Edward IV, Henry VI and Lord and Lady Northumberland, while in the 2nd Earl's dressing room there was '1 large landskipp of a bridall sett in a frame of wallnut tree', which can probably be identified with Hoefnagels's picture still at Hatfield. One portrait of Lord Burghley was added here later. In the Countess of Salisbury's bedroom a portrait of the Earl of Pembroke was to be found. In the steward's room five portraits were listed, one architectural painting and two tablets with Latin and Dutch inscriptions. More interesting are the later additions of the pictures of Queen Elizabeth, 'Lucretia' and Sir Francis Drake to the wardrobe. Altogether portraits have increased in number. The summing up at the end of this list mentions ninety-one or ninety-two pictures of all sorts, quite a considerable collection.

The next inventory of September 23, 1638 (Box A.7) conforms in general to that of 1629, though a few changes have been made between the rooms, and the portrait of Sir Francis Drake is not mentioned, although it reappears in 1646 and again in 1679/80. Thereafter it vanishes from the inventories and cannot be traced further. At the end a 'numerary of particulars' gives one roll of heraldry and ninety-six pictures of all sorts in the new inventory, compared with ninety-one in the old one.

Inventories of Hatfield House in 1646, 1679/80 and 1702 follow. Then there is a break in the records, and no inventories survive for the period between 1702 and 1823, but in printed and other outside works (Pennant, Vertue) reference is made to the location of some of the paintings. Three large and quite detailed inventories were made in the nineteenth century, in 1823, 1868 and 1891. (The 1868 inventory is the fullest version of a list originally made in 1845 which was also published as a limited edition in 1865.) The last was drawn up by L. G. Holland, then a member of the staff of the National Portrait Gallery, and was printed privately for the 3rd Marquess of Salisbury. Although Holland's catalogue was conscientiously prepared, modern developments in research into the history of English sixteenth- and seventeenth-century art and a fuller knowledge of available documents have made it possible to approach the subject afresh and prepare a catalogue less dependent on traditional identifications and attributions. Under the entries for the individual works of art, attention will be paid to each painting when mentioned in the various inventories.

Reverting to William Cecil, Lord Burghley, the founder of this splendid collection, what do we know about his appreciation of the fine arts and his patronage of craftsmen and artists? This subject is not discussed in the biography by the late Professor Conyers Read, nor does the word 'patronage' appear in the index of his two-volume study. However, something may be gleaned from the Hatfield documents and from considering the individual works of art Cecil commissioned.

So far no-one has yet attempted to compile an account of the books in Lord Burghley's vast library, however, we do know that he was a man of great learning, deeply interested in reading history, theology, and other scholarly books.[2] It may also be inferred that he had gained an excellent

[2] Read, Conyers, *Mr Secretary Cecil and Queen Elizabeth*, London, 1955, pp. 30 and 114 of paperback edition, 1960: Robert Smallwood, *Lord Burghley as a Patron of Religious Books*, Univ. of Birmingham, M.A. thesis, 1963.

knowledge of architecture and was able to draw. His interest is reflected by the presence in his collection of a drawing showing the Escorial in the process of being built. Already during the reign of Edward VI, young William Cecil, together with Sir John Thynne, the Duke of Somerset and his associates, had shown much interest in building. In 1550 the Duke of Northumberland sent John Shute to Italy to view ancient buildings and to confer with Roman architects. During Mary's reign, Sir Thomas Smyth (1513–1577), who was ambassador in Paris from 1562 to 1566, joined Thynne and Cecil in their efforts to start building their own houses. Thynne was the architect of Longleat; Sir Thomas Smyth built himself a house near Eton, and Cecil began to rebuild Burghley near Stamford in Lincolnshire in 1556. All three had books on architecture in their libraries. From a letter from Cecil's mason, Roger Warde, to his master, we learn that Cecil was asked to supply a drawing of a dormer window and a gable for his workmen engaged in building Burghley. About ten years later he employed a Flemish mason, otherwise engaged on Gresham's Royal Exchange, for the erection of a gallery, but gave him a pattern drawn by himself. It may therefore be significant that 'two architectural pictures of the royal exchange' were listed in the Wardrobe in the earliest inventory of 1611 of Hatfield House (Box A.1). During this time architecture was greatly influenced by the Flemish style, but the later buildings at Burghley showed Cecil's knowledge of French architecture, such as Philibert de l'Orme's work at Anet, and indeed we know that he sent to Paris for de l'Orme's book, *Nouvelles Inventions*, which was published in 1561.[3] From about 1566 Cecil became increasingly wealthy. He bought the estate of Theobalds in Hertfordshire and began to build there the magnificent mansion intended for his son Robert.[4]

There is no doubt that the Queen's progresses through the land stimulated the erection of ever larger houses, as more accommodation and more spacious lodgings were needed for Her Majesty and the expanding Court. Although Cecil was very much aware of the enormous expenses this involved, he was anxious to do everything that would help to endear him to the Queen. In July, 1564, for instance, he invited her to make a brief stay at Theobalds, although his new buildings there were hardly begun. In 1566 he fully intended to entertain the Queen at Burghley, when suddenly, on August 3, his daughter Anne became ill.[5]

So Cecil reports in his diary (Murdin, 761)[6]:

The Queen's Majesty was at my House in Stamford at the Grey Friars, because my Daughter Anne Cecile was sodenly fallen sick of the smallpox.

Queen Elizabeth paid another visit to the rising house at Theobalds in September 1571. By July 1572 the grand Middle Court there was ready to receive her[7] and in 1573 the Inner or Fountain Court was reshaped. The new plans for that Court were provided by Henry Hawthorn and may have been based on a construction by Serlio for a house in Naples. In any case, Burghley was always the director and final supervisor of the building programme. At times thereafter, as in the year 1583, the Queen stayed

3 Summerson, Sir John, *Architecture in Britain 1530 to 1830*, Pelican, 1953, pp. 17–18, 23.
 Read, *Cecil*, p. 352.
5 Read, *Cecil*, p. 353.
6 Murdin, William, *A Collection of Statepapers, 1571–1596*, London, 1759, p. 761.
7 Read, Conyers, *Lord Burghley and Queen Elizabeth*, London, 1960, pp. 122–23 of paperback edition, 1965.

at Theobalds for a whole week. Whenever there was a family celebration, the Queen honoured the Cecils with her presence. In 1564 she visited Cecil House, near Charing Cross in London, for the christening of Elizabeth Cecil. In December 1571 she attended the marriage of the elder sister Anne to the Earl of Oxford at Westminster Abbey, after which a great banquet was ready for the wedding guests at Cecil House, or as it was now known, Burghley House. If we jump ahead twenty years to July 1591, we find Queen Elizabeth again in residence at Burghley House, London, this time for a martial display by the Earl of Essex of the cavalry due to embark for Normandy to aid Henry IV – a different occasion indeed for a royal visit from the earlier purely social events, but like them an indication of the necessity which had prompted Burghley to build so lavishly.

Lord Burghley's appreciation of painting may be gathered from the style of his own portraits and those of his second wife, Mildred Cooke, of the early 1560's, which testify to a definitely Flemish bias. His own portrait (No. 36 [33]) comes near to the style of Hans Eworth, the best known representative of Italo-Flemish Mannerism in this country, and the portraits of his wife are attributed to the same artist. Another painter from whom he may have commissioned his likeness is Arnold van Brounckhurst, whose picture representing Cecil is signed and dated 1573. He too was a Flemish painter working in this country. A friend of Nicholas Hilliard, he became Court Painter to the Scottish King in the 1580's. In the Hall in Hatfield House there is also the painting of 'Diana', formerly believed to represent Queen Elizabeth I, an allegorical painting of c.1560 now attributed to Frans Floris, one of the most important Flemish painters of that period. Again, we see Italo-Flemish Mannerism very well represented by this beautiful painting, which is mentioned in the earliest inventories of Salisbury House. It may also not have been a sheer coincidence that it was Lord Burghley who, in 1563, drafted a proclamation to safeguard the quality of the Queen's portraits and was waiting for 'some speciall conning payntor' to produce the accepted royal image from a 'natural representation' of her 'person or visage'.[8] This proclamation apparently remained a draft, and we do not know whether a specially skilful painter arrived, or, if he did, who he was. It may be assumed that, apart from Queen Elizabeth herself, her Minister of State was interested in the style and standard of royal portraiture.

It is quite well known that by the 1580's Lord Burghley had become a loyal supporter of Nicholas Hilliard. Petitions by the latter to the Cecils have survived, such as the undated letter to Lord Burghley or Sir Robert Cecil – the addressee is not mentioned – in which he asked his patron to intercede on his behalf as he was in danger of being arrested for debt.[9] When in immediate danger, Hilliard always appealed to the Cecils for help.

In his letter of July 1587 addressed to an Exchequer Official, Cecil offers himself as second guarantor against Hilliard's inability to produce two sureties to expedite a new lease. Lord Burghley therefore helped his protegé and confessed to being Hilliard's patron.

Four years later, on December 7, 1591, an entry in Burghley's Diary confirms the friendship between the Lord Treasurer and the ever-needy painter: 'A forfeiture of 400 *l.* granted to Nicolas Hilliard'. This diary contains records of an intimate nature, family events, Leicester's death and an account of various entertainments of the Queen at Theobalds, and the note of this grant, which was officially enrolled

8 Auerbach, Erna, *Tudor Artists*, London, 1954, p. 103.
9 Auerbach, Erna, *Nicholas Hilliard*, London, 1961, p. 21. Petition 782, *c.*1588–90.

on December 11,[10] is therefore, most important even if one assumes Burghley had written it down in his official capacity.

Apart from the early portraits of the Cecil family at Hatfield House which show a marked Flemish style, there is one important work, hanging in the Hall, which clearly reveals Hilliard's manner. It is the 'Ermine Portrait' of Elizabeth I, dated 1585; we may assume that this beautiful portrait was commissioned by Lord Burghley, perhaps for an entertainment of the Queen, and it thus shows the outcome of the close association between the mighty Minister of State and the famous Court Painter.

William Cecil's second son Robert, 1st Earl of Salisbury, followed in his father's footsteps. He too was very much interested in architecture and was mainly responsible for the building of Hatfield House, though he did not live to reside there. In April 1607, he chose personally the site of the new house to the south-east of the old palace. The building of a new house at Hatfield had become an urgent task for Robert Cecil after King James I had surrendered the Royal Palace at Hatfield to him in exchange for Cecil's residence at Theobalds. The Earl examined closely all the designs submitted to him and co-ordinated them according to his own liking. There were, therefore, four men in co-operation: the designer and clerk of the works Robert Liming; the professional adviser, Surveyor of the King's Works, Simon Basil, who was also concerned about the Earl of Salisbury's buildings in London – 'The New Exchange' south of the Strand and 'Britain's Burse' – built by him in 1608 and 1609; and Cecil's financial administrator Thomas Wilson, also exercised an influence on the designs. Finally, it was the patron himself, Robert Cecil, who examined everything and made the final decisions.[11]

The north front of this early Jacobean house developed the Elizabethan style in more moderation and with a fuller symmetry. The south front was redesigned in 1609/10, and it is quite possible that Inigo Jones had a hand in the erection of this part of the building, in view of the 'classic order' applied to the centre part. On February 28, 1609/10, he was paid 10 *l.* as a reward for the drawing of some architecture. (Accounts 160/1). On April 17 in the same year he was paid for 'making of the show – 9 *l.* 12s.' and on April 26 an additional 13 *l.* 6s. 8d., in reward. The occasion for this 'show' was a masque to honour the King and Queen and Prince Henry who came with other nobles to 'Britain's Burse' on April 14, 1609. On October 30, 1610, Thomas Wilson was ordered to provide Inigo Jones with a horse from the Earl's stables to ride down to Hatfield House with him (State Papers Dom. James I, 57/82). In May 1611 the south porch was finished. The clear fact emerges that Robert Cecil made use of the most progressive architect among official court artists at an early stage in his career, and this speaks for Cecil's modern views in the field of architecture.

Robert Cecil's appreciation of painting continues along the lines started by his father, and he follows up the close contact with the Queen's favourite painter, Nicholas Hilliard, which Lord Burghley had established so successfully. A number of petitions have survived among the Cecil Papers which confirm this view and clearly testify to the great respect the powerful statesman and the struggling artist had for each other. On March 16, 1593/4 Hilliard petitioned Sir Robert to intervene in favour of a craftsman who in his view had been wrongly prosecuted, whom he had known for five years and who had worked and engraved in his workshop. A second letter of May 17, 1594, by Richard Martyn, the

[10] Auerbach, *Hilliard*, p. 24.
[11] Lawrence Stone, 'The Building of Hatfield House', *Archaeological Journal*, CXII, 1956, pp. 105–6.

Master of the Mint, also addressed to his patron, supports the worthiness of Hilliard's plea (Cecil Papers, Vol. 22 f. 74, Cal. IV, 490; Vol. 26 f. 96, Cal. IV, 537).[12] Other petitions were received in 1593 and 1594 from two painter-stainers desiring a monopoly for heraldic work, to be shared with Hilliard, who is 'to your Honors so well knowne for his sufficiencie and care in his works' and therefore, they hope, for Hilliard's sake, they will be granted the favour to them the more speedily (Cecil Papers, *170*. 50, Cal. V, 63).[13]

When at last on August 17, 1599 Hilliard was awarded an annuity of 40 *l.* a year, it was again his faithful patron who had obtained the grant for him. We learn this fact from the letter of July 28, 1601 written by the miniaturist to Sir Robert Cecil in which the former emphasized that 'lately her Ma^tie of her most gracious goodnes the rather for your honors sake, granted me an Annuity of 40 *l.* per Año, which will be a good stay and comfort to me . . . ' (Cecil Papers, *87*. 25, Cal. XI, 306).[14] Now, however, in 1601, his debts had increased and for fear of being pursued, he strongly wishes to go abroad, and he implores Cecil to secure the Queen's permission for him to spend one or two years outside this country. He will return later, he insists, better equipped to work for her Majesty. In the meantime he hopes Sir Robert will remember his earlier promise and take his son Laurence into his service as a secretary. Laurence speaks Spanish well and can write and draw. Hilliard again mentions his son in a letter of May 6, 1606, in which he asks his patron to let Laurence wait on his lordship in his livery at the feast of St George. He emphasizes that Cecil had asked him to keep Laurence longer in his workshop to give him a better training to become perfect in 'lymned pictures and in the Medals of golde'. (Cecil Papers, *115*. 130, Cal. XVIII, 130).[15] Nicholas seems indeed to have been quite at ease in writing to his patron whenever need arose and about whatever weighed heavily on his mind, always hoping for an open ear and a kind appreciative response. Sometimes he even mentioned artistic matters connected with the craft of the goldsmith, such as his ability to mould in sand and clay or to decorate and gild a monument of stone. In one of these letters he called the 1st Earl of Salisbury 'a great beautifier of his City' and thus showed the deep admiration he had for his patron's abilities in the field of the visual arts (S.P. 14/188/57 and Cecil Papers, *119*. 8, Cal. XVIII, 409).[16] In another letter (Cecil Papers, *115*. 30, Cal. XVIII, 130, May 6, 1606) Hilliard notes a conversation he had with Salisbury 'about five years ago when I drew your Lordship's picture', so we know that a miniature of this nobleman drawn from life must have once existed, though unfortunately, it can no longer be traced. The only specific payments to Hilliard occur in the Agent's Accounts 1608–11, 160/1 under 1610, September 30: 'To Hilliard the painter upon a bill for Christall sett upon twoe pictures in a Georg for your honour 20 *l.*'; and 1611, June 15: 'To Mr. Hilliard the painter for 3 limned pictures which were maid for my lady Clifford 10 *l*'. These payments refer, of course, to miniatures.

When it came to the pattern for his own portrait in oils Robert Cecil called on an official artist who must have been well known to him, the Serjeant Painter John de Critz the Elder, to create his likeness. The authorship of this refugee artist from the Netherlands is first documented by a bill, dated October 16, 1607 (Box U. 74/81) which is quoted under catalogue entry No. 66 [60.] We also learn from letters addressed to the Earl by Sir Henry Wotton from Venice that an Italian artist worked

[12] Auerbach, *Hillaird*, pp. 26–7. [13] Auerbach, *Hilliard*, p. 27. [14] Auerbach, *Hilliard*, p. 31. [15] Auerbach, *Hilliard*, p. 38.
[16] Auerbach, *Hilliard*, pp. 36–7.

the Earl's portrait in mosaic from a likeness painted by the Serjeant Painter. (See under No. 67 [61.]) It would appear, therefore, that the efficient and matter-of-fact manner of an artist with the Flemish touch appealed to Robert's taste; and the surviving portraits all based on that pattern, show the precise features of the statesman, plain and without much ornament and trimmings. A Flemish approach can also be traced in his tomb, a most imposing monument in Hatfield Church, carried out by the King's sculptor, Maximilian Colt, again a refugee, but this time from France; and though the tomb was only erected after the Earl's death, under the direction of his son, Robert had seen the patterns and approved of them. Thus, a very novel and impressive sculpture originated under the sponsorship of the 1st Earl.

It is interesting to observe how eclectic Robert Cecil was in his patronage, commissioning native English and refugee Flemish and French artists to paint the family portraits and at the same time carrying on an active correspondence with Sir Henry Wotton, the English Ambassador in Venice, urging him to buy Italian pictures in the most modern style to enrich the collections at Salisbury House and at Hatfield. The pictures from Italy were mostly on religious or allegorical topics and if we go by the titles of paintings in early inventories, many fascinating subjects which were brought to England for Cecil have now been lost. However, some of the following pictures, such as Nos 108 [218] and 109 [219] by Bassano or Nos 106 [220] and 107 [221] by Bordone, may have been included originally in the shipments arranged by Sir Henry Wotton. There are also 'Cupid Scourging a Satyr', No. 94 [202] and the Mannerist painting of 'Mercury, Argos and Io', No. 93, which have recently turned up and have now been cleaned, and somehow fill a gap in a collection which at one time must have been richer in paintings of a general character than one would realize today.

Robert Cecil's great interest in Italian paintings, if they were available at a reasonable price, is also indicated in a letter from Sir Walter Cope on January 26, 1610/11 (S.P. 14, Vol. 61, No. 33) to Sir Dudley Carleton at Venice, in which Cope suggests that Carleton 'cannot send a thinge more gracious' to Prince Henry or to Cecil than 'any auncient Master peeces of paintinge'. (See pp. 78–80 below.)

There was yet another painter of versatile abilities who was closely connected with the building activities at Hatfield House: Rowland Bucket, a member of the Painter-Stainers' Company. He was employed in designing and decorating the Chapel, and he was also engaged in carrying out numerous and various kinds of decoration. His religious paintings are of a high artistic standard, as can be seen, for instance, in his beautiful 'Annunciation' (No. 110 [198]), the style of which recalls Venetian art during the Mannerist period at the beginning of the seventeenth century.

Robert Cecil's son, William Cecil, 2nd Earl of Salisbury (1591–1668), was the first inhabitant of Hatfield House. Unlike his father and grandfather he never held any very important position in national politics and so has been rather neglected by historians. But in the field of the visual arts he followed the family tradition of active patronage, commissioning portraits and collecting paintings abroad. Already as Lord Cranborne he had been friendly with Sir Henry Wotton, and there are many letters addressed to him by the Ambassador from Venice. An early task awaited him in the carrying out of his father's tomb; for that purpose he was in close touch with the sculptor Maximilian Colt.

His interest was focused on foreign artists, and it may be useful in this connection to point out that immediately after his marriage, December 1608, to Catherine Howard, daughter of Thomas Earl of Suffolk of Audley End, he went abroad.

He was in Paris in December 1609, in Venice in January 1610/11, and in the Low Countries in March 1610/11. As a youth he was closely associated in riding and hunting with young Prince Henry, a generous patron of the arts, and with Robert Devereux, 3rd Earl of Essex. His friendship with these young men must have made him acquainted, apart from his travels on the Continent, with the progressive views of the younger generation at Court.

During the Civil War he joined Parliament, together with his son Charles (1619–1660), against the King. He sat as M.P. for King's Lynn from 1649 to 1653 and for Hertfordshire from 1654 to 1655, and from 1656 to 1658 and was a Councillor of State for the Commonwealth from 1649 to 1651 and from 1652 to 1653. Nevertheless, he was able to make his peace with Charles II at the Restoration.

There are two charming full-length portraits hanging on the Grand Stairs which represent the 2nd Earl and his wife Catherine. They are painted by George Geldorp, native of Cologne, who went to the Netherlands and became a member of the Antwerp Painters' Guild in 1610. He came to England about 1623 and in addition to various important private commissions was for a time in the royal employ. Both portraits (Nos 82 [86] and 84 [83]) are of an extremely good quality.

Various extracts from the Accounts (see under No. 82 [86]) link the name of the artist firmly with these magnificient paintings. Apart from these two, portraits of the children of the 2nd Earl are noted also in the Accounts. The style of these family portraits is Flemish. They represent the grand European style of the first quarter of the seventeenth century, and it is perhaps fitting that the Earl in his portrait stands before a wide landscape background that includes the full view of Hatfield House.

Both Paul van Somer (c.1577/8–1622) and Daniel Mytens (c.1590–before 1648) are represented by large life-size paintings at Hatfield. They came to this country from the Netherlands in the second decade of the seventeenth century and were soon to be overshadowed by the great superiority of Van Dyck. Van Somer's name is connected with two portraits of James I (Nos 79 [70] and 80 [71]). Mytens is credited, according to an account of 1629 (Box F.3), with '4 pictures drawn for my Lord', which we are told were taken from London to Hatfield. Thus they were specifically painted for the 2nd Earl. One of them may be No. 86 [75], the portrait of Philip Herbert, Earl of Pembroke and Montgomery, a painting which turns out to be most colourful and impressive after its recent cleaning.

Although it is outside the scope of this part of the catalogue, we have to mention that William, 2nd Earl of Salisbury, was probably responsible for commissioning the extremely fine portrait group No. 126 [88], attributed to the Van Dyck studio, which will be discussed in Part II of this book. In 1632 Van Dyck became painter to Charles I and was to introduce the Baroque style into English portraiture.

Part One

CATALOGUE

The numbers in square brackets refer to L. G. Holland's catalogue of 1891

I ill. 1, p. 113

Henry V (1387?–1422)

King of England

Painter unknown

Panel 21 × 16 in. (53·4 × 42 cm.)

Inscribed in Roman letters, top left, 'HENRICUS'

Bust portrait, shown in profile to the left against a plain background. Both hands are visible in the lower left corner, the left hand is slightly raised, and there are three rings on the fingers. The King wears an ornamented gold chain and on his head a black cap.

This much repainted portrait gives the standard type of Henry V. The best version is to be found in the Windsor Castle collection, No. 6. There are, however, differences between this picture and the one at Windsor: the plain background here as contrasted with the patterned background in the Windsor picture, also details of the dress and jewellery, and especially the features of the face and the movement of the fingers of the raised left hand. In spite of the frequent repainting and the poor preservation of this picture, some traces of old gold-leaf paint are visible.

Other versions of the same standard portrait type are in the collections of Eton College, Stanford Park, Queen's College, Oxford, the Society of Antiquaries, the National Portrait Gallery (No. 545), and Sir G. Bellew.

Collection: A portrait of Henry V is recorded at Hatfield from 1611 to 1646, as follows:
(1) 1611, in the West range, second storey, there were 'Seaven picktures of the Kinge[s] of England', probably including Henry V (Box A.1).
(2) July 1612, among a list of pictures, whereabouts not given, 'A picture of Henry the 5th' (Box B.5, confirmed by Box D.1).
(3) June 1629, a portrait of Henry V is listed as hanging in 'the Lobbie Roome att the end of the gallerie by the Chapple' (Box A.6).
(4) September 1638, the entry repeated (Box A.7).
(5) July 1646, the entry repeated (Box A.8 and 9).
After 1646 the picture disappears from the inventories and is not included in Holland's catalogue. The present Lord Salisbury believes that this picture was bought back by his grandfather.

Literature: Millar, Nos 6 and 7; Pl. No. 2.

2 [1] ills 2 and 3, p. 114

Jacqueline of Bavaria (Jacoba van Beiren) (1401–1436), c.1430

Jacqueline of Bavaria, in her own right the Countess of Holland, Zealand, Friesland and Hainault, was the first wife of Humphrey, Duke of Gloucester, and godmother of Henry VI

After Jan van Eyck (working 1422–1441)

Panel 17 × 11¼ in. (43·2 × 28·6 cm.)

Inscription in large Roman letters running horizontally above the head of the sitter:

VROVWE IACOBA VAN
BEIEREN GRAVINNE
VAN HOLLANT STARF
A° 1436

A nineteenth century label on the back confuses the sitter with Jacquetta of Luxembourg.

Bust portrait turned three-quarters to the right. A stern face with a rather wooden expression. She wears on her yellow hair a gold net veil as a head-dress, which is ornamented with the lions of Hainault and Holland. Similar lions are shown on the lozenge-shaped shield in the background to the right above her head. Holland interprets the shield as follows: 'Quarterly 1 and 4. Paly bendy Argent and Azure (*Bavaria*), 2 and 3. Quarterly 1 and 4. Or, a lion rampant Sable (*Hènault*), 2 and 3. Or, a lion rampant Gules (*Holland*)'. The portrait has perhaps been cut down a little on the left hand side.

Jacqueline was the only child and heiress of William IV, Count of Hainault, Holland and Zealand, and Lord of Friesland (d. 1417). Her mother was Margaret of Burgundy. During her lifetime political considerations involved Jacqueline in a series of marriages and dynastic broils. In 1421 she fled to the English court, where she married Duke Humphrey and acted as a sponsor at the baptism of the infant King Henry

VI. A few years afterwards Humphrey accompanied her on her return to the Netherlands in an effort to restore her to her kingdoms. Later they parted, and this marriage, which had been Jacqueline's third and Humphrey's first, was dissolved by the Pope in 1428.

This is an impressive picture in the linear style, probably early Flemish or German.

Collection: This portrait may have been included among pictures described as '14 little peeces without frames of the princes of diuers Countries', in one Hatfield inventory of about 1612 (Box D.1), or of 'duch countries' in others of 1612 or after (Box D.1) and July 1612 (Box B.5). Later, that is in 1629 (Box A.6), it may be referred to in the category '20 small pictures of Emperors, Popes, and other princes' which were hanging in the dining room next to the Great Parlour. Similar entries are found in 1638 (Box A.7) and 1646 (Box A.8 and 9). It was identified by Musgrave in 1769 but not until 1823 do we find a precise description: 'Head of Jacqueline of Bavaria and Hainault, Countess of Holland, Wife of the Duke of Gloucester, Uncle of King Henry VI', which was then in the Breakfast Parlour. In 1868 the same picture, as by 'Mostert of Haerlem', was listed under No. 79 as hanging in the Winter Dining Room, South Side.

Exhibition: The National Portrait Exhibition, 1866, No. 10.

Literature: Holland, No. 1, as after Jan Mostaert. Here Holland mentions erroneously portraits of Jacqueline and her fourth husband, François de Borsèle, by Jan Mostaert in the Museum at Antwerp (Nos 263 and 264), which were engraved by F. Folkema in 1753. It has now been established that these portraits neither represent this couple nor were they painted by Mostaert.

A portrait by Mostaert in Copenhagen, No. 105, represents the same sitter as at Hatfield but is a later picture. This may possibly be the painting by Mostaert which van Mander saw in the studio

of Mostaert's grandson. It is now usually assumed to be a copy from a lost painting by Jan van Eyck, since seventeenth century engravings of the portrait state that the original was by Van Eyck. (Scriverius, *Principes Hollandiae et Westfrisiae*, 1650, Pl. 29). Likeness also confirmed by drawings in Frankfurt (No. 15), Arras, and Brussels. Two prints of Jacqueline and her mother can be found in Bernard de Montfaucon's *Les Monuments de la Monarchie Françoise*, Paris, 1729–1733, III, p. 186. Cf. S.S.B., 81, p. 55 and 85, p. 37; H. Walpole, *Anecdotes*, I, p. 33; Gustav Glück, *Beiträge zur Kunstgeschichte*, Wien, 1903, pp. 68 ff; Max. J. Friedländer, *Die altniederländische Malerei*, Berlin, 1932, X, pp. 9, 15 ff.

3 [2] ill. 4, p. 115

Henry VI (1421–1471), *c.*1500

King of England

Painter unknown

Panel 23 × 18½ in. (58·5 × 47 cm.)

Bust portrait, face turned three-quarters to the left, dark eyes turned in the same direction. The King wears an ermine-lined black robe, with some gold on the sleeve just visible at the lower right-hand corner. Round his shoulders he has a heavy gold chain of the Lancastrian order of SS, decorated with rubies, from which a jewelled cross is suspended. The clasped hands extend slightly to the left above the lower edge of the frame. Red damask background with a gold framework on the upper corners of the picture, leaving the middle free. In the gold spandrels in each corner appear the painted arms of France and England.

This picture, which was cleaned in 1962, is of a very fine quality and well preserved. The face is lightly modelled. It belongs to a series of portraits of Henry VI which survive in various collections. Type and quality are nearest to the

painting at Windsor, and it cannot be stated which is the original version. Both seem to date from *c.*1500 and must be assumed to be the earliest of Henry VI's images now surviving. The painter was probably of English origin.

Collection: The following entries in the Hatfield House inventories refer to Nos 3 [2] and 4 [3], both of which have been at Hatfield at least since 1611–1612:

(1) 1611, presumably among the seven pictures of Kings of England in the West Range, second second storey (Box A.1).
(2) 1612, two pictures of Henry VI (Box B.5, confirmed by Box D.1).
(3) 1629, one picture of Henry VI in the Lobby room at the end of the Gallery by the Chapel and another in the 'withdrawinge Chamber to the dyninge roome'. (Box A.6).
(4) 1638, the former in the same place as before and the latter in 'Mr. Matthews Chamber' (Box A.7).
(5) 1646 and 1679/80, similar entries (Box A.8, 9 and 10).

Musgrave in 1769 and Pennant in 1780 saw a picture of Henry VI in the Lumber Room. In 1823 two portraits are recorded, a small one in the Drawing Room and one in Lord Salisbury's Sitting Room. They are at this time described as by Mabuse. In 1868 the two portraits were hanging in the Winter Drawing Room and listed as Nos 75 and 83.

Literature: Vertue, *Notebooks*, I, 58, IV, 65; Walpole, I, 34: Pennant, 411; Robinson, 28; S.S.B., 81, 55; Holland, Nos 2 and 3; Waterhouse, *Painting in Britain*, p. 2, Pl. 1 (from National Portrait Gallery, No. 2457); Millar, No. 8, Pl. 4; Strong, *Cat. N.P.G.*, pp. 146–48, Pls 283–84.

Apart from the Windsor Castle portrait there are other versions at Albury, Sudeley Castle, King's College, Cambridge, and the National Portrait Gallery, No. 546. Variants in the National Portrait Gallery, No. 2457 (reproduced by Water-

house, see above) and in the Society of Antiquaries are slightly different and may have been painted a little later. The portrait at Eton College giving the image of its founder is more ostentatious but also seems to be based on the Windsor pattern.

4 [3]

Henry VI (1421–1471)

King of England

Another version of No. 3 [2]

Painter unknown

Panel 16¾ × 12¾ in. (42·6 × 32·4 cm.)

Inscription: HENRICVS VI

Type similar to No. 3 [2]. Quality less good and damaged in parts. Harder lines and darker shades in modelling. Ornamentation quite good. A plain background, lacking the damask pattern and gold framework.

Entries in inventories mentioned under No. 3 [2].

5 [4] ill. 5, p. 116

Richard III (1452–1485)

King of England

Painter unknown

Panel with canvas backing 22½ × 18¼ in. (57·2 × 46·3 cm.)

Half-length. Face three-quarters to the right. Hazel eyes are to the same direction. The sitter wears a dark fur-lined coat over a shirt of striped gold. His dark cap is decorated with a large gold jewel. He wears a jewelled gold chain round his shoulders and he is slipping a ring on to the little finger of one hand with the other. Two more rings decorate his right hand, and the thumb is slightly overlapped by the gold chain. The background is of red damask, patterned with pomegranates in quatre-foils. In the gold spandrels within the top frame appear miniature busts in profile of a woman and a man with a crown, perhaps meant to resemble antique busts.

The canvas backing is of recent date. Holland still mentions a panel. Although the background together with the top gold frame are partly repaired, the painting is quite well preserved and of an imposing quality. The modelling of the face is even. Image and composition come nearest to the portrait of Richard III at Windsor Castle. It may belong to the same workshop as the Henry VI above (No. 3 [2]). It appears to be slightly later than the Windsor portrait of Richard. The measurements are larger, and the greater width especially points to the beginning of the sixteenth century when Renaissance ideas were being introduced into English art. The pattern in the background is clearer than that of the Windsor portrait. The painter was probably of English origin.

Collection: Always at Hatfield since 1611/12, it was probably among the seven Kings mentioned in 1611 (Box A.1). Inventory 1612 (Boxes B.5 and D.1) 'One picture of Richard the 3rd'. Inventory 1629 (Box A.6): 'In the Lobbie betwixt the gallerie and the great chamber on the Kinges side – 1 picture of Richard 3rd'. A repeat of this entry appears in the inventories of 1638 (Box A.7) and 1646 (Box A.8 and 9). In the inventory of 1679/80 (Box A.10) the portrait is listed as hanging in the Gallery. It was in the same place in 1769 and in 1780 when Musgrave and Pennant visited Hatfield. In the inventory of 1823 'King Richard the 3rd (small) [by] Mabuse' was found in the Drawing Room. In May 1868, No. 82, 'King Richard 3rd [by] Mabuse', was mentioned as in the Winter Dining Room, South Side. A few years ago it was hanging in the Marble Hall.

Exhibition: 'Art Treasures 1857' (Label on back, referring to the exhibition held at Manchester).

Literature: Vertue, I, p. 58: IV, p. 65; Walpole, I, p. 46, note 2, p. 47, reference to the portrait in 1761: 'same as at Kensington'; Pennant, p. 408; Holland, No. 4, as by 'Painter Unknown'; G. Harriss, *The Mystery of Richard III*, Hatfield House Booklet, No. 3; Millar, No. 14. Other versions are in the National Portrait Gallery, No. 148, Welbeck Abbey, No. 336, Albury, Anglesey Abbey, Swynnerton, Capesthorne, formerly in the collections of the Duke of Leeds and Commander Dunn, and at Bramshill (sold at Sotheby's July 16, 1952, Lot 25). Only the versions at Windsor and Hatfield have the gold moulding.

6 [5] ill. 6, p. 116

?Caterina Cornaro (1454–1510), formerly called 'A Persian Queen'

Queen of Cyprus

Painter unknown, perhaps a copy of Titian (*c.*1487/90–1576) or Paris Bordone (1500–1570)

Brass 20¾ × 16½ in. (52·7 × 41·9 cm.)

Caterina Cornaro, a Venetian aristocrat, was married in 1472 to Jacques de Lusignan, King of Cyprus, and after his death in 1473 continued to rule Cyprus under the protection of the Republic of Venice until 1489 when she abdicated and retired to Asolo.

Bust portrait with flowing hair and jewelled headdress. The face has been well modelled, although it is damaged in places. The identity is doubted by Holland, who claims it to be 'an ideal representation of some Eastern Queen'. It is true that it was called 'A Persian Queen' in the seventeenth century inventories, but since it does not appear until 1629, we may well presume that its identity had by then been lost. There is a close likeness between this picture and No. 7 [6], which has always been called Queen of

Cyprus in the inventories. Also it closely resembles Titian's version of a half-length portrait, formerly in the Holford Collection and sold at Christie's on July 15, 1927 (photo in *Bazaar*, June 25, 1927).

Collection: Inventory of Salisbury House, London, June 20, 1629, 'In the Gallerie: – 1 picture of a Persian Queene in a table of brasse' (Box C.8). Same entry Salisbury House 1639/40 (Box C.9). By 1679 it had been taken to Hatfield, for it appears there in an inventory of March 3, 1679: 'In the Wardrobe, 1 Picture of a Persian Queen on a brasse plate' (Box A.10). Hatfield inventory, 1823: 'Head of Catherine de Cornaro, Queen of Cyprus, painted on copper', in the Breakfast Parlour. In the 1868 inventory two pictures of Catherine are mentioned as Nos 46 and 136.

Further comments under No. 7 [6].

7 [6]

Caterina Cornaro (1454–1510)

Queen of Cyprus

After Titian (*c.*1487/90–1576) or Paris Bordone (1500–1570)

Canvas 44 × 34 in. (111·9 × 86·5 cm.)

Inscription in Roman letters:

> CATHERINA CORNARA
> REGINA DI CIPRI

A three-quarter length figure standing, both hands visible. Rich curtain on the left, plain wall on the right. Black dress, blue shawl thrown over her shoulder. Décolletée. White veil gathered by a spiked crown. Large pearls. Venetian style. Her portrait was widely circulated during Titian's lifetime and many versions exist. This picture is badly preserved.

Collection: Hatfield inventory, 1611 (Box A.1) –

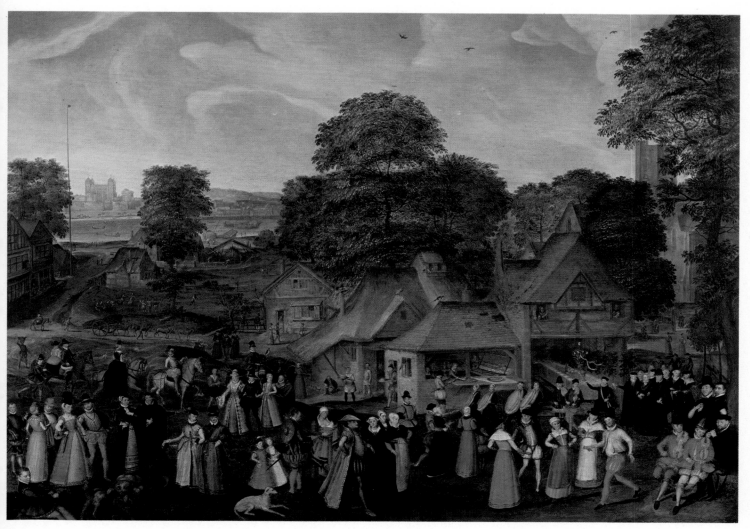

COLOUR PLATE III. *A Fête at Bermondsey*, *c.*1570, by Joris Hoefnagel (Cat. No. 49, p. 53) See also ills 27–32, pp. 128–31

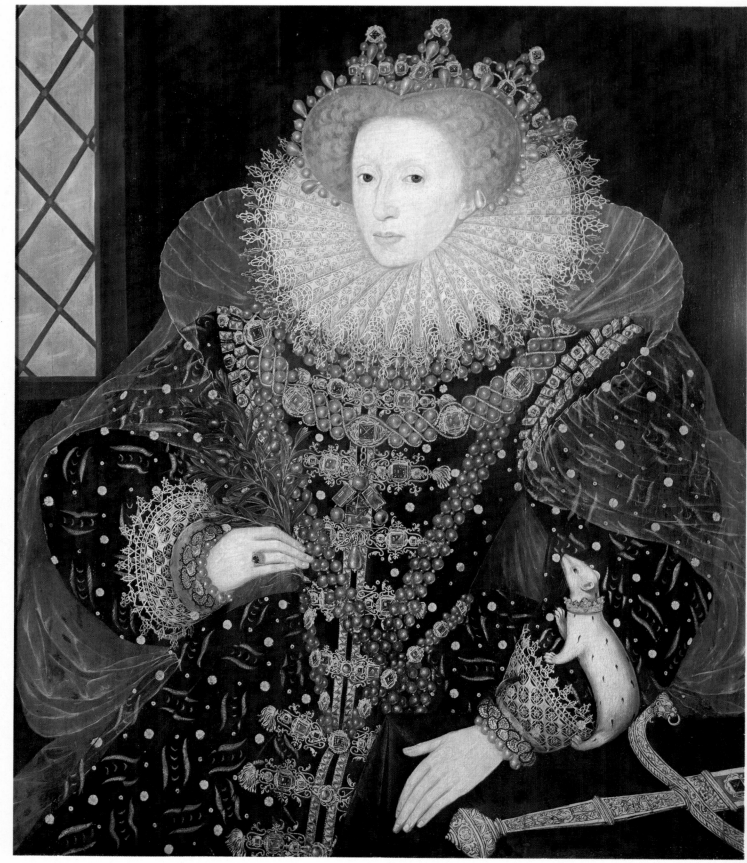

COLOUR PLATE IV. **Queen Elizabeth I,** 'The Ermine Portrait', 1585, by Nicholas Hilliard (?) (Cat. No. 50, p. 55)
See also ill. 33, p. 132

'In the Lobbie between the great Chamber and the Gallery: One picture of the Queen of Cyprus'. Again, 1612 (Boxes D.1 and B.5), the same entry, as in 1629, 1638, and 1646 (Box A.6, 7 and 9). In 1679, March 3 (Box A.10), two pictures referring to Nos 6 [5] and 7 [6] are mentioned. The first records: 'Picture of a Persian Queen on a brasse plate', the second: 'Picture of the Queen of Cyprus'. Both were in the Wardrobe. This clearly distinguishes No. 7 [6] as the picture which had been at Hatfield since 1611 and No. 6 [5] as the painting on brass which had been transferred from Salisbury House, London. Musgrave in 1769 and Pennant in 1780 saw it in the Lumber Room. In 1823 only the portrait on brass was registered as in the Breakfast Parlour. In the inventory of 1868 both pictures are again recorded as Nos 46 and 136.

8 [9] ill. 7, p. 117

Margaret Beaufort, Countess of Richmond and Derby (1443–1509), c.1509

Margaret Beaufort was the mother of Henry VII. She was the founder of St John's and Christ's Colleges, Cambridge, and was well-known for her interest in scholarship and the arts

Maynard Waynwyk (working from 1509–1523)

Panel 15¾ × 12½ in. (40 × 31·7 cm.)

Inscribed in large Roman letters:

'Obiit anno *1509 3 Kal: IVLII*'

Head and shoulders, almost half-length, holding in her hands an open book. She wears a triangular high hood and the widow's dress, with the 'barbe' or white muffler under the chin. The background is of a dark colour. The features are precise and clear, the hands are good and the white lines of the muffler effective. In parts the picture appears to be slightly retouched.

Lady Margaret resided at the Old Palace at Hatfield and she kept twelve poor men and women there (*Archaeologia*, LXVI, p. 37), for whom she made provision in her will of February 15, 1509 (Cooper, p. 129). An inventory of her possessions at Hatfield of August 8, 1509 is now kept in St John's College, Cambridge.

In Executors' Accounts of 1509 (Cooper, p. 185), payment is mentioned to a painter for making two pictures of 'My ladys personage' and later 'Wolff the paynter' received 66s. 8d. for 'all hys warkemanshipp'. For John Wolf (Wolff) who was mainly known as a heraldic painter see Auerbach, *Tudor Artists*, p. 193.

Another important fact is that according to Christ's College Accounts for January 1511/12 to June 1512, a portrait of Margaret was painted by 'Maynarde Payntor' and given to the College. The Hatfield portrait conforms in style with the one in Cambridge. Not much is known about this painter. One 'Maynard Waynwyk' appears in accounts between 1509 and 1511. In November 1511 he is also referred to as 'the Frenchman' and in 1523 he resided in All Hallows, London. (Auerbach, *Tudor Artists*, p. 191).

Collection: Unless included among two pictures of the Queens of England mentioned in the Hatfield inventory of 1611 (Box A.1), this portrait is first listed in the inventories of 1612 (Boxes B.5 and D.1): 'A picture of the Countesse of Richmond – Kinge Henry the 7th mother'. In the inventory of 1629 (Box A.6) it is mentioned as hanging in 'the great chamber on the Queenes side'. An identical entry appears for 1638 (Box A.7). In 1679/80 (Box A.10) it was in the Wardrobe, but in 1769 Musgrave and in 1780 Pennant (pp. 407–8) saw it in the gallery. In 1823: 'Breakfast Parlour – Portrait of Margaret, Countess of Richmond – small'. In 1868, under No. 74: 'Winter Dining Room, East End. Margaret Countess of Richmond, Mother to Henry 7 – van Eyck'.

This portrait is therefore recorded as having

been continuously at Hatfield House from the time when the house was built. It is one of the best versions of this type. There are similar portraits at St John's College, Cambridge; Windsor Castle; National Portrait Gallery; Swynnerton; Capesthorne; and in the collection of Mr G. Baron Ash. Full-length versions in St John's and Christ's Colleges, Cambridge. The likeness is very close to Torrigiano's bronze effigy in Westminster Abbey.

Literature: C. H. Cooper, *Memoir of Margaret, Countess of Richmond and Derby,* 1874; *Archaeologia,* LXVI, 1915, p. 37; Auerbach, *Tudor Artists,* pp. 191 and 193; J. Goodison, *Catalogue of Cambridge Portraits,* Vol. I, The University Collection, 1955, pp. 2–3; *Connoisseur,* 1957, pp. 139, and 213–18; Millar, No. 15.

9 [8] ill. 8, p. 118

Henry VII (1457–1509), *c.*1500

King of England. Founder of the Tudor Dynasty in 1485

Painter unknown

Panel 18 × 13¾ in. (45·8 × 34·9 cm.)

Companion to No. 10 [7] though turning to the same side, eyes in the opposite direction. The King is clad in a gold brocade doublet under a red fur-lined garment, and he wears a cap with a jewel attached (probably a Yorkist badge) and a jewelled chain. Hands placed on parapet, slightly left of centre, holding red rose, three rings visible. Treatment and modelling good. Green brocade background. The picture is quite well preserved, but there are two horizontal cracks in the panel. It was recently cleaned. This portrait was probably painted in 1500 or shortly afterwards, during the sitter's lifetime.

Collection: Like No. 10 [7] this portrait has been at Hatfield since 1611/12. The inventory of 1611 (Box A.1) refers to seven pictures of the Kings of

England. Inventories of 1612 (Boxes D.1 and B.5:) 'A picture of Kinge Henry the 7th'. Inventories of 1629 (Box A.6) and 1638 (Box A.7) list one picture of Henry VII in 'the great chamber on the Queenes side'. Inventories 1646 (Box A.8 and 9) mention the portrait. In 1823: 'Drawing Room, King Henry the Seventh – Mabuse'. In 1868 under No. 73, 'King Henry 7th – Mabuse'.

Literature: Musgrave, f. 80; Robinson, p. 28; Holland, No. 8. This portrait is near in type to that formerly in the collection of Earl Brownlow, Tudor exhibition, the New Gallery (1890), Catalogue No. 22. It is now in the possession of Mr Irving T. Bush, New York. Another variant at Hinton Manor, belonging to Mr Nicholas Davenport. G. Glück, 'The Henry VII in the N.P.G.', *Burl. Mag.* lxiii, 1933, p. 100, ascribed this type to an 'English painter of before 1491'. Waterhouse, p. 2, thinks that the painter could be Flemish or English. See Auerbach, *Tudor Artists,* pp. 26 and 47. As to other versions see *Cat. R.A.1953,* Nos 62 and 63, referring to two versions at the Society of Antiquaries. *Cat. Liverpool 1953,* No. 1 (from Christ Church, Oxford), facing to the right. The same position in the version at Windsor Castle: Millar, No. 16. Similar versions at Albury, Nostell Priory, Tyrwhitt-Drake Collection, Anglesey Abbey.

As in No. 10 [7] the quality is very good and it is a contemporary portrait, probably English under Flemish influence, but 'after Mabuse' cannot be maintained any longer.

10 [7] ill. 9, p. 119

Elizabeth of York, Queen of Henry VII (1465–1503), *c.*1500

Elizabeth of York was the daughter of Edward IV and Elizabeth Woodville. She married Henry VII in 1486. Thus after the defeat of Richard III the War of the Roses ended and the Yorkist and Lancastrian lines were united

Painter unknown

Panel, cradled $18\frac{1}{2} \times 13\frac{3}{4}$ in. (47×34.9 cm.)

Bust with both hands visible on a kind of parapet in front. Her right hand lies horizontally on top of the other holding the white rose of York. Face is turned three-quarters to the left and the eyes follow this direction. A richly ornamented and studded gold hood rises up like a gable with a triangular point. Her elaborate gold necklace incorporates Tudor roses. The background is a patterned green damask. The light grey shading in the white rose the Queen holds harmonizes with the ermine-trimmed cuffs of her robe.

This portrait is of very good quality and was probably painted during the sitter's life-time, *c.*1500.

Compared with other versions the Hatfield one is larger in size, the position of the hands holding the flower is different and the portrait is more clearly conceived according to the Renaissance style. The painter was probably an Englishman, influenced by Flemish art of the period.

Collection: Hatfield inventory 1611 (Box A.1), 'two pictures of the Quene[s] of England', may include No. 10 [7]. In inventories of 1612 (Box B.5) '1 picture of Hen. the 7. Queene' is mentioned. In 1629 (Box A.6): 'In the great chamber on the Queenes side 1 picture of Elizabeth his [Henry VII] Queene'. Similar entries follow in 1638 and 1646 (Box A.7, 8 and 9). In 1702: 'In the Lady Margaret's chamber, 1 old picture of Henry 7th Queene'. In 1823: 'Drawing Room: Elizabeth of York – Mabuse'. In 1868: 'Winter Drawing Room, East End . . . Elizabeth of York, Queen of Henry 7 – Mabuse', No. 72. The picture was thus at Hatfield from the time when the house was built.

Literature: Musgrave, f. 80; Robinson, p. 28; Holland, No. 7; Henry Bone, Drawings Collection in N.P.G., Vol. 1, p. 46. For other versions of this standard portrait see: *Cat. Liverpool 1953,*

No. 2, repr. in illustrated souvenir, p. 6 (from Christ Church, Oxford); Millar, No. 17, Pl. 6 (at Windsor Castle). Other versions at Trinity College, Cambridge; N.P.G. No. 311; Dunham Massey; Anglesey Abbey; Nostell Priory; Tyrwhitt-Drake Collection; Brocket Collection, formerly at Bramshill, sold at Sotheby's July 16, 1952, No. 24. Another sold at Christie's December 10, 1954, Lot 52.

I I [10] ill. 10, p. 120

Johannes Froben (1460–1527), *c.*1640

One of the finest printers from Basle

After Hans Holbein the Younger (1497/8–1543)

Coloured chalk on paper $10 \times 7\frac{1}{4}$ in. (25.4×19.7 cm.)

Small bust, almost in profile, turned to the right. A sketchy chalk drawing with reddish hues in the face. Precise and clear. The paper shows a black marginal line and is similar to the companion sketch of Ravaillac No. 65 [58] below. The likeness is that of Froben or Frobein as painted by Holbein, *c.*1522/23, in the oil portrait now at Hampton Court Palace. The drawing, probably of *c.*1640, is based on the oil portrait. The latter, in the Royal collection, has now (after cleaning and x-ray) been established as an original by Holbein. The label reads: 'Holbein – John Frobein – Winter Exh. 230'.

Froben in Basle was the printer of Holbein's book designs and he was also a close friend of Erasmus who stayed with him and whose books he published.

Hans Holbein the Younger (1497/8–1543) was born in Augsburg, but his father, Hans Holbein the Elder, had already moved to Basle by 1515. He came to this country late in 1526 and stayed until the summer of 1528 when he returned to Basle. During his first stay in this country he enjoyed the patronage of Sir Thomas More and he may

also have carried out designs for the Revels. He returned to this country in 1532 and entered the royal service as one of the King's painters in 1536. He died in London of the plague in 1543.

Collection: Musgrave, f. 80; Pennant, p. 408, refers in 1780 to a head of Froben by Holbein in a black gown lined with fur in the Gallery. In the inventory of 1823, the 'Thirteen coloured Drawings, various' may have included No. 11 [10]. Robinson, p. 28. Inventory 1868, No. 25, mentions 'John Frobein the Learned Printer of Basle by H. Holbein in the Yew Room South Side', but this entry may refer to No. 32 [49], which was erroneously called a portrait of Frobein.

Exhibition: Tudor Exhibition, 1890, No. 230.

Literature: All the important literature on Holbein's *Froben* quoted by Millar, No. 27, Pl. 12.

12-19 [11-17a]

Portraits of Henry VIII and members of his family.

Although after the death of Bishop John Morton Henry VII and particularly Lady Margaret Beaufort resided at the Old Palace, Henry VIII became in 1538 (*Letters and Papers, Henry VIII*, Vol. XIII, 1893, Part II, 904, g. 1182 (19)) the first royal owner of the Manor of Hatfield. He had stayed there occasionally from 1514 onwards. Afterwards Catherine of Aragon, Princess Mary, and Princess Elizabeth lived at Hatfield at various times. It was, therefore, perhaps, appropriate that in 1841 the 2nd Marquess of Salisbury purchased a group of ten portraits, including Henry VIII, his six wives, his son Edward VI, and his daughter Elizabeth I (see No. 20 [53] below), together with 'the Emperor Charles V' (now missing: he is not represented on No. 29 [26] below). The ten paintings were included, as Lot No. 397, in the sale of the effects of Mr Thomas Baylis,

Pryor's Bank, Fulham, on May 3, 1841, and Lord Salisbury paid £140 for them. They were said to have belonged formerly to George Thicknesse-Touchet, Lord Audley (1758–1818) and then to Sir William Horne. These are obviously not sixteenth- or seventeenth-century pictures, and it is likely that they were painted in the late eighteenth century or the early nineteenth century – at a date, in fact, during the period when Lord Audley would have been forming his collection.

Collection: In the inventory of 1868 they are registered as follows: No. 118 (12) Henry VIII, 125 (13) Catherine of Aragon, 135 (14) Anne Boleign, 132 (15) Jane Seymour, 128 (16) Anne of Cleves, 121 (17) Catherine Howard, 139 (18) Catherine Parr, and finally 142 (19) Edward VI. They are mentioned in this inventory for the first time.

12 [11]

Henry VIII (1491-1547)

King of England

Painter unknown, after Hans Holbein the Younger (1497/8–1543)

Paper on panel 20¾ × 15¾ in. (52·7 × 40 cm.)

Bust portrait in a very bad state of preservation. The paint is peeling off. The iconographic type is originally based on Holbein's likeness, but is nearer still to Francis Delaram's engraving of Henry VIII (Hind, *Engravers in England*, II, Pl. 61 (c), from *Baziliwlogia*, 1618). This set may have belonged to Horace Walpole. The panel is backed with canvas.

This portrait has been x-rayed and partly cleaned and it has emerged that it was painted, in contrast to the other portraits of this set, on paper. A removal of the upper layers of the paint was not possible. There is a conspicuous

gold ground visible which even extends under the face. The date is probably not later than the end of the eighteenth or the beginning of the nineteenth century.

13 [12]

Catherine of Aragon (1485–1536)

Painter unknown, after a drawing by Hans Holbein the Younger (1497/8–1543)

Panel 19½ × 14¾ in. (49·5 × 37·5 cm.)

Bust portrait with a black cap and square-cut dress. Type is different from the usual one. Likeness is that of engraving by Geldar after Holbein, published by Cornish & Co. 1813 from an original 'In the Collection of the Hon. Horace Walpole'. The engraving is labelled 'Queen of Henry VIII: out of Granger'. Thick overpaint. The nineteenth-century label on the back reads: 'Catherine of Aragon, first wife of Henry the eighth'.

14 [13]

Anne Boleyn (1507–1536)

Painter unknown, after a drawing by Hans Holbein the Younger (1497/8–1543)

Panel 20 × 15½ in. (50·8 × 39·3 cm.)

This portrait of Anne Boleyn wearing a bonnet is based on a drawing by Holbein now in the possession of the Earl of Bradford. It also resembles Renold Elstrack's engraving (Hind, II, Pl. 62 (a)) of 1618. The likeness is very much modernized and sweetened. Thick overpaint which cannot be removed. The high-lights speak for copy later than the beginning of the seventeenth century. A nineteenth-century label on the back reads: 'Anne Boleyn, second wife of Henry the Eighth'.

15 [14]

Jane Seymour (1509–1537)

Painter unknown, vaguely based on the drawing by Hans Holbein the Younger (1497/8–1543)

Panel 18½ × 14½ in. (47 × 36·8 cm.)

Bust portrait, turned to the left. The likeness is not as clearly based on Holbein's drawings as Nos 12 [11], 13 [12] and 14 [13]. A nineteenth-century label on the back reads: 'Jane Seymour, 3rd wife of Henry the Eighth'.

16 [15]

Anne of Cleves (1515–1557)

Painter unknown, based on Hans Holbein the Younger's (1497/8–1543) oil painting in the Louvre

Panel 20¾ × 14½ in. (52·7 × 36·8 cm.)

Frontal bust portrait. Rough and very much overpainted with thick paint. A nineteenth-century label on the back reads: 'Anne of Cleves, Fourth wife of Henry the Eighth'.

17 [16]

Catherine Howard (d.1542)

Painter unknown

Panel 20¾ × 15 in. (52·7 × 38·1 cm.)

In the generally accepted portraits she wears a round cap and not this type of hood. Very bad preservation. Not based on Hans Holbein the Younger.

18 [17]

Catherine Parr (1512–1548)

Painter unknown

Panel 21 × 14½ in. (53·4 × 36·8 cm.)

Not an authentic likeness: very bad state of preservation. On American cloth: 'Catherine Parr'.

19 [17a]

Edward VI (1537–1553)

Painter unknown

Panel 20½ × 14½ in. (52·1 × 36·8 cm.)

It is definitely Edward VI with the open neck and collar in red coat, but may be copied from 18 [17] (cf. North Estates: Christie's, March 19, 1948, Lot (a) a similar set, English School, c.1800).

Scrotes's type of Edward VI. No label on back, but formerly labelled on the frame 'Queen Catherine Parr'.

20 [53]

Queen Elizabeth I (1533–1603) erroneously called Empress to Charles V by Holland

Painter unknown

Panel 21 × 15 in. (53·4 × 38·1 cm.)

Bust portrait, life-size, with crown and large open ruff. This portrait belongs to the series Nos 12–19 [11–17a]. Very bad preservation. Removing of surface paint shows underneath an older panel revealing gold letters standing upside down. They are painted in gold leaf on oil size. They are Roman letters, 4½ in. (11·4 cm.) high, 'R.E.R.S.' and the beginning of another letter. The panel has been cut down, but not at the top. The face is thinly painted, but the corners of the panel show a thicker paint.

21 [18] ill. 11, p. 120

Frederick II, called The Wise (1463–1525)

Frederick II was Elector of Saxony. He succeeded his Father Ernest in 1485. He was the founder of the University of Wittenberg

Painter unknown

Panel 15 × 10¾ in. (38·1 × 27·3 cm.)

Small full-length portrait, precisely and clearly drawn. Frederick wears the cap and red ermine robes of an Elector and carries the dishes which symbolise the office of the imperial Lord High Steward. On the right in the plain background appear the arms of Bavaria – Quarterly 1 and 4, Sable, a lion rampant, queue fourchée, Or; 2 and 3, paly bendy Argent and Azure. Underneath inscribed: 'Frederic per la grace de Dieu Conte Palatin du ryn' in italics. This painting was damaged by water, but was repaired in 1964.

The likeness does not seem to be based on Cranach's portrait. Cf. Schloss Ambrass Coll. of Ferdinand of Tirol.

Collection: This picture may be among 'seven pictures of the princes Electors' and '7 little pictures of the princes electors' mentioned in the Hatfield Inventories of 1611 and 1612 (Boxes A.1 & D.1). In 1629, 1638 and 1646 (Box A.6, 7, 8 & 9) '20 small pictures of Emperors, Popes and other princes' are listed as hanging in the Dining Room or in the Withdrawing Room next to the Dining Room. In 1679 (Box A.10) '1 Pict. of the Count of Palatine of Rhine' in the Wardrobe is recorded. Pennant, pp. 410–11, saw No. 21 [18] in 1780 in the Lumber Room. In 1823 an entry refers to 'A small Picture, whole Length, Frederic Count-Palatine Ryn (an ancient Painting damaged)' as in the Drawing Room. In the 1868 Inventory it is No. 211 among pictures not hung up. According to Holland it had been recently found in the carpenter's workshop at Hatfield.

22 [31] ill. 12, p. 120

Catherine de Medici (1519–1589)

Queen Regent of France

After François Clouet (d. 1572)

Canvas 20¼ × 16½ in. (51·4 × 41·9 cm.)

A bust portrait, turned three-quarters to the left. The expression on Catherine's face is more pinched and gloomy than usual. She wears a widow's cap which comes down in a point on her forehead almost to eye-level. On both sides of it her frizzy red hair appears. Her white open collar is decorated with an unusual lace-like edge. A nineteenth-century label on the back reads: 'Catherine de Medici. Sketch by Pourbus'. At the bottom there is an old number '69'.

Catherine, the daughter of Lorenzo de Medici, married Henry II in 1533, and after his death in 1559 remained much in charge of events during the successive reigns of her three sons. Her daughter Marguerite of Valois married Henry IV of Navarre.

A similar type in the Louvre is illustrated by David Harrison, *Tudor England*, 1953, Vol. II, p. 41. A drawing of the sitter in the Bibliothèque Nationale is attributed to François Clouet, *c.* 1560 (Na 22 rés.).

Collection: Probably always in the family. In the Salisbury House inventory of June 20, 1629 (Box C.8): 'In the Gallarie – 1 picture of the Queene mother of France'. The same in the inventories of 1645/46 (Box C.4 and 5) and in Musgrave, f. 80.

In the Hatfield House Inventory of 1868 it is listed: 'Winter Dining Room, West End, Catherine of Medicis F. Pourbus'.

23 [20] ill. 13, p. 121

François de Coligni, known as Dandelot (1521–1569)

A distinguished soldier under Henry II of France, brother of the Admiral Gaspard de Coligni and of Odet, Cardinal of Châtillon

French School, sixteenth century

Panel 24 × 17½ in. (61 × 44·4 cm.)

Inscribed on top:

> DE COLLIGNI
> François
> Seigneur DÃDELOT

Bust portrait in life-size, turning three-quarters to the left, eyes turning to the right. He wears a gold-embossed suit of armour. It is quite a well modelled portrait, better than other copies of pictures by Pourbus in this collection.

On an engraving by Marc du Val of 1579, representing the three brothers Coligni. Francis on the right-hand side of the engraving corresponds in features and likeness with No. 23 [20]. This engraving is based on a drawing in the Bibliothèque Nationale (Coll. Hennin, Qb 207. D. 766). A nineteenth-century label on the back read: 'Francois de Coligni painted by Pourbus'.

Collection: The provenance as having been in Hatfield House since it was built is shown by the entries in the first inventories of 1611 and 1612 (Boxes A.1 and D.1), which list a portrait of the Admiral of France and '1 picture of Francis Dundelott, a german, in the Wardrobe, upper storey'. In 1629 (Box A.6) an entry refers to '2 pictures, one of the admiral of France and the other monsieur d'Andelot [his] brother'. The inventory of 1638 (Box A.7) states that in the Great Parlour there was '1 picture of Mounsieur Dandalitt' and another of 'Monsieur Shettollian'. In 1646 (Box A.8 and 9) in the 'Dyning Roome, below staires: 1 picture of his brother Monseir

d'Andelot'. Also in 1679 (Box A.10). Musgrave in 1769 and Pennant, p. 409, noticed it in the Gallery in 1780. Inventory 1823: In the 'Breakfast Parlour: Head of Francois de Coligni, Seigneur de Dandelot in Armour; he was the youngest son of Gaspar de Coligni, and Co. General of the French Infantry'. Robinson, p. 28. 1868: No. 36 in the Yew Room, North Side: 'Francois de Chatillon, G. de Coligni – F. Pourbus'.

24 [20a] ill. 14, p. 121

?Charles IX (1550–1574)

King of France

French School, sixteenth century

Panel (old canvas backed by new panel) $21\frac{1}{4}$ × $16\frac{3}{4}$ in. (56·5 × 42·6 cm.)

A bust portrait, three-quarters to the left, badly preserved, blistered and hard lines. Not very good. Holland calls it 'Charles IX' until corrected by Henri d'Orleans, Duc d'Aumale in 1859. A nineteenth-century label reads 'Charles Duke of Guise painted by Pourbus' and an inscription on the frame reads 'Duke de Guise'.

Collection: The identity of this portrait seems to have been confused, at least by the eighteenth century, with that of a Duke of Guise; for both Musgrave and Pennant refer to three pictures of the Dukes of Guise in the Gallery at Hatfield House – presumably meaning Nos 24 [20a], 55 [27] below, Henri de Lorraine, Duc de Guise, and 56 [30] below, Henri III, King of France. According to Holland it was Henri d'Orleans, Duc d'Aumale, who in 1859 established the correct identities of Nos 24 [20a] and 56 [30].

25 [32]

A Lady of the Sixteenth Century, 1556, formerly called Queen Mary Tudor and Mary, Queen of Scots

Painter unknown

Panel 42 × $27\frac{1}{2}$ in. (106·7 × 69·9 cm.)

A standing three-quarter-length figure in frontal position, the face slightly turned to the left. She wears a square-cut black dress trimmed with gold braid over a white embroidered satin dress with standing ruff collar. The raised shoulders of the dress and the costume in general is Elizabethan. With her left hand she holds a chalice suspended from a chain with a skull in it and inscribed on the outside is 1556. Her right arm is hanging down and the hand rests on a book inscribed IHS. A crucifix stands on a table on the left-hand side in the background. She wears an embroidered cap in the style of Mary, Queen of Scots.

It is difficult to say what remains of the original painting as it is almost entirely retouched. The crucifix would be the symbol of religious feeling which could fit either Mary. It appears to be made up as the companion picture to No. 26 [48], called ?Philip II. Details of the sleeves and composition correspond. We might add that this painting is much less like either Mary Tudor or Mary Stuart than No. 26 [48] is like Philip II.

The costume of No. 25 [32] comes near in style to a small panel at Burghley House, erroneously called Mary Tudor, Queen of England, by Holbein. In this picture the lady holds a heart-shaped locket in both her hands. It was engraved in 1830 by T.A. Dean as Mary I of England and also appears as such in Lodge.

Collection: In the Hatfield Inventory of 1868 this portrait may have been mentioned as 'Mary Tudor Queen of England, by Sir Anthony Moore' in the Winter Dining Room, South Side.

A portrait of Mary Tudor is listed by Musgrave as in the Lumber Room. In earlier inventories it may perhaps be identified with '1 picture of a Dutch woman – in the ante-chamber' 1611 (Box A.1) or in the same inventory as 'one picture of a woman houlding a cupp – in the Lobbie between the great chamber and the Gallery'.

26 [48]

A Nobleman of the Sixteenth Century, ?Philip II of Spain (1527–1598)

Companion picture to No. 25 [32]

Painter unknown

Panel $41\frac{3}{4} \times 27$ in. (105·9 × 68·7 cm.)

A half-length standing figure turned to the left, wearing the Order of the Golden Fleece. Terribly over-painted. On the left his right hand touches a helmet. The shield of arms in the left-hand top corner is surmounted by a Crown inscribed, (according to Holland): 'Philip Second, Rex'.

Just as No. 25 [32] this painting may have been made up to resemble Philip II. It is actually more like Philip II than No. 25 [32] is like Mary Tudor, but here again very little of the original state has been preserved. Musgrave, cf. No. 25 [32], calls it Philip II. A nineteenth-century label on the back reads 'Phillip the Second of Spain'.

27 [46]

Philip II (1527–1597)

King of Spain

?after Titian (c.1487/90–1576)

Panel $27\frac{1}{2} \times 22$ in. (69·8 × 56 cm.)

A bust portrait, three-quarters to the left. He wears the collar of the Order of the Golden Fleece hanging over a white embroidered doublet. The likeness agrees with Titian's full-length

portrait of Philip II of c.1553, painted in Madrid, now at Naples, National Museum.

Collection: In the inventory of 1868 in 'the Winter Dining Room, South Side' we read under No. 77: 'Philip 2nd of Spain. Consort of Queen Mary – Sir Anthony Moore'.

Literature: Holland, No. 46, as a copy after Sir Antonio Mor.

28 [47]

Philip II (1527–1597)

King of Spain

Painter unknown

Panel 20 × 16 in. (50·8 × 42 cm.)

Listed by Holland as 'A small copy on paper after the picture by Titian in the Corsini Palace, Rome'.

29 [26]

Unknown Nobleman wearing the Order of the Golden Fleece, sixteenth century

Painter unknown

Panel 19 × 14 in. (48·3 × 35·6 cm.)

Life-size bust portrait. The sitter has short grey hair and an aquiline nose. He wears gold-embossed foreign armour, a small close ruff, and the collar of the Order of the Golden Fleece.

The sitter was identified by Holland, No. 26, as the Emperor Charles V and was supposed to have been included with the other pictures, bought at Mr Baylis's sale at Pryor's Bank, Fulham, May 3, 1841 (cf. Nos. 12–19 [11–17a] above). The features do not agree, however, with the known likeness of Charles V. Mr F.M. Kelly, F.R.Hist.S., suggested, according to marginal notes in the Librarian's copy of Holland's catalogue, that the sitter could be identified as either Philip de Montmorency, Count de Hornes, or Lamoral, Count Egmont.

Collection: The Hatfield House inventory of 1868 lists this picture under No. 86.

30 [19] ill. 15, p. 121

?Robert Dudley, Earl of Leicester (1532?–1588), *c.*1560

Painter unknown

Panel 33¼ × 24½ in. (84·5 × 62·2 cm.)

Three-quarter length, life-size standing figure in a frontal position. Head turned to the right, eyes to the left. He is wearing a grand yellow-white doublet studded with gold buttons. The sleeves of the coat are decorated with filigree gold and jewels. Close-fitting ruff and plumed, studded velvet cap frame a bearded face with a huge moustache. He wears the Garter chain and the George. The background is dark green. The portrait stresses the fact that the sitter is a man of substance, painted in the Anglo-Flemish manner.

Relying on nineteenth century inventories (see below), Holland identified the sitter as Henry Grey, Duke of Suffolk, and ascribed it to Joannus Corvus. But the dates for both sitter and painter would be much earlier than the Elizabethan period of this portrait. The iconographical likeness with Leicester's portrait in the Wallace Collection leads to the possible identification of the sitter with Leicester or his brother, the Earl of Warwick (1528?–1690). There is also a likeness in style.

Collection: In the inventory of 1679 (Box A.10) '1 Picture of Ambrose of Warwicke' is mentioned as 'in the Gallery'. It is, however, not quite certain if this entry can be identified with No. 30 [19]. Inventory 1823: 'In the Breakfast Parlour; Henry, Duke of Suffolk, a small ½ Length – Mr Gerard'. The inventory of 1868 records under No. 30: 'Yew Room South Side: Henry Grey, Duke of Suffolk, by Mark Garrard'. It seems that this portrait was in Hatfield House for a long time, although recorded under two different

titles. See No. 31 [24] for references to portraits of the Earl of Leicester in the early inventories.

Exhibition: Cat. Portraits 1866, No. 8. Another version is in the N.P.G., No 189.

Literature: Engraved in Lodge's *Illustrious Personages*, Vol. 2; Strong, *Cat. N.P.G.*, pp. 192–96.

31 [24] ill. 16, p. 122

Robert Dudley, Earl of Leicester (1532?–1588), *c.*1585

?William Segar (d. 1633)

Panel (cleaned 1963/4), heavily cradled 44 × 34 in. (111·8 × 86·4 cm.)

Inscribed at the bottom in right-hand corner in a later hand: 'Painted by Mark Garrard'

Three-quarter length figure standing in frontal position, the head turned three-quarters to the left, eyes in the opposite direction. He wears a white, gold-embroidered doublet, a dark cap with a jewelled ornament and a dark brown furred coat. The chain of the Garter with the George suspended hangs round his shoulders. He holds a white wand of office in his right hand. (He was Master of the Horse, 1559–87 and Lord Steward of the Household, 1587–88.) His left hand touches the handle of his sword. A nineteenth-century label on the back reads: 'Robert Dudley Earl of Leicester, Master of the Horse to Queen Elizabeth, painted by Mark Garrard'. The words 'Robert Dudley, Earl of Leicester' are written on the frame.

Robert Dudley, created Earl of Leicester in 1564, was the favourite of Queen Elizabeth. In 1586 he agreed to be Governor of the United Provinces. In 1575 he had entertained the Queen lavishly at Kenilworth. He was twice married, first to Amy Robsart and secondly in 1578, to Lettice Knollys, widow of Walter Devereux, Earl of Essex.

The imposing portrait is of good quality and quite well preserved, although some repainting can be seen in the background.

The portrait is of a type which exists in various versions in life-size and in miniature. The best is probably the full-length miniature at Drumlanrig Castle (Auerbach, *Hilliard*, Pl. 244, pp. 281 and 333, as by ?Segar). Much in the treatment and especially in the modelling of the face comes near in style to the miniature of Dean Colet on the Statute Book of St Paul's School, documented as by Segar. (Auerbach, *op. cit.*, Pl. 240.) The oil portrait at Hatfield House is smoother and softer in handling, though the type is similar. Other versions in oils are at Penshurst, Corpus Christi College, Cambridge, University College, Oxford, and Hampton Court Palace, No. 68.

Portraits of Leicester by Segar (Piper, *Essex*, II, p. 300, note 8) are listed in the Lumley Inventory, One answering the description of the Hatfield House painting was sold in 1807 (Sotheby's, Lot 43). But in any event, the 1st Earl of Salisbury inherited several paintings from Sir John Lumley in 1609 (cf. No. 52 [22]). Although there is a possibility that Segar is the painter of the Hatfield House portrait, it cannot be established without any doubt. Marcus Gheeraerts the Younger might be another possibility, but there again, from the stylistic point of view, nothing definitive can be said at the present state of our knowledge.

Collection: There has been a portrait of Leicester at Hatfield House from the time it was built. Hatfield Inventory 1611 (Box A.1) 'In the Ante Chamber – 1 Picture of my Lord of Leicester'. Inventory 1612, July (Box B.5) 'A faire lardge picture of my Lo: of Leicester'. A similar entry for 1612 (Box D.1). 1629 (Box A.6): Among 'Pictures in the Gallerie 1 of my Lo: of Lester'. Repeat in 1638 (Box A.7), and in 1646, July 25 (Box A.8 and 9) and in 1679, March 3 (Box A.10). Musgrave saw it in 1769. Inventory of 1823:

Breakfast Parlour: 'Robert Dudley, Earl of Leicester, Master of the Horse to Queen Elizabeth, Knight of the Garter, etc., half length on Panel – Mark Gerrard'. Inventory 1868: 'No. 34 Robert Dudley, Earl of Leicester, Master of the Horse to Queen Elizabeth – Mark Garrard'.

There was another portrait of Leicester at Salisbury House in London according to the, following inventories: June 20, 1629 (Box C.8), 'In the Dyninge Chamber for my Lo. – 1 picture of the Earl of Lester'. Again in 1639/40 (Box C.9), cf. No. 30 [19].

Exhibition: British Institution, Pall Mall, 1820, No. 153. Art Treasures, 1857. *Cat. Portraits 1866*, No. 251.

Literature: Pennant, p. 401, Holland, No. 24, as by Marcus Gheeraedts the Elder (the Elder is not a possible suggestion); engraved in Lodge; S.S.B. *81*, p. 60; Piper, *Essex*, II, p. 200, note 8; Millar, No. 68; Strong, *English Icon*, No. 176, p. 18.

32 [49] ill. 17, p. 123

'An Old Man', erroneously called 'John Frobein', *c.*1550

Painter unknown

Panel 36 × 28½ in. (91·5 × 72·4 cm.)

A three-quarter length figure standing in a room. The rather old man who seems to have been working hard wears a grey hat and black tunic. His beard and moustaches are of a light brown colour. In his left hand he holds an open letter, in his right a tightly rolled document and a pair of spectacles. On the table on the left there is a pewter tankard, perhaps of German make. From the man's belt hang tools which may be a shoemaker's, a printer's, or an engraver's. On the latticed window sill there are bread rolls and a large cheese.

The painting is of a good quality and the

features are precisely and clearly characterized. It almost looks like an early-Flemish genre painting. A nineteenth century handwritten inscription on the back reads 'John Frobein The learned Printer of Basle painted by Holbein'.

Collection: Only two late references to this painting appear in the Hatfield House inventories: 1823 – 'In the Marchioness' Summer Bed Room . . . Portrait of an old man, probably a Tavern Keeper – Mabuse'. 1868 under No. 25 'Yew Room, South End John Frobein, the Learned Printer of Basle – H. Holbein'. This picture does not seem to be mentioned before the nineteenth century.

33 [25] ill. 18, p. 123

Jane Heckington, Mrs Cecil (1500–1587)

Jane Heckington was the mother of William Cecil, 1st Baron Burghley

Painter unknown

Panel 20¼ × 16¼ in. (51·4 × 41·3 cm.)

Head and shoulders, frontally seated in an armchair, two brass knobs of which appear in the background. Her very old and lined face is turned three-quarters to the right, her eyes are closed (she is said to have been blind). She wears a black dress lined with brown fur, a white stiff ruff round the neck and a narrow one on the wrist of her left hand. She holds a silver knobbed staff. Her black widow's cap, from which a black veil falls down behind, is lined with white. The terracotta background stretches well above her head and on the left-hand side a blue triangle appears to bring out the shape of the sleeve.

The face is very carefully modelled with all the drawn lines to give the wrinkles of an old face. All the details including the fur are well brought out. There is a similar version at Burghley House.

Jane Heckington was the daughter and heiress of William Heckington, Esq., of Bourne, Lincolnshire, and she married Richard Cecil, Master of Horse to Henry VIII. The inscription on their joint tomb at St Martin's, Stamford, praises her good and pious deeds, tells us that she lived to be eighty-seven, was a widow for thirty-five years and the mother of William Cecil, Lord Burghley.

A nineteenth-century label on the back reads 'Jane Heckington the wife of Richard Cecyll and Mother to the great Lord Burleigh'. The inscription on the frame is 'The Lady Burleigh'.

Collection: In the Salisbury House inventory of 1629, June 20 (Box C.8) there is an entry 'In my Lords dressing chamber – 1 picture of his Lordship's great grandmother'. This is repeated in 1639/40 (Box C.9). In 1646 this entry has disappeared from the pictures listed in Salisbury's dressing room. The portrait may then have been taken to Hatfield House where it is listed in the Hatfield inventory of 1679 'The Lady Marys Chamber: – 1 Picture of Lord Burleigh's Mother'. The inventory of 1823 records 'Breakfast Parlour: Portrait of the mother of Lord Burleigh at the advanced aged of 114 years, on Panel', and in the inventory of 1868 it is 'No. 42 Jane Heckington, wife of Sir Richard Cecil and mother of Lord Burleigh'.

Exhibition: Cat. Portraits 1866, No. 2.

Literature: Musgrave, f. 79v.; Pennant, p. 409; Robinson, p. 27; Holland, No. 25; *Burghley House Catalogue* by the Marchioness of Exeter, 1954, No. 209, in the Great Hall, 19⅜ × 11⅜ in. (49·2 × 28·9 cm.) on panel.

34 [28] ills 19 and 20, pp. 124–5

Mildred, Lady Burghley (1526–1589), c.1562

Mildred, Lady Burghley was the eldest daughter of Sir Anthony Cooke, of Gidea Hall, Essex, and married William Cecil, 1st Baron Burghley in 1545, as his second wife

Hans Eworth (?) (working 1540–1573)

Panel 36½ × 28½ in. (82·7 × 72·4 cm.)

A three-quarter length life-size figure, turning three-quarters to the right, standing in front of a green curtain. Her pale grey eyes look to the left. She is wearing a light-grey patterned and studded dress with close-fitting frilled ruff around the neck. Her black robe, broadening the shoulder line, leaves the long sleeves and the centre part of the dress free. Her round jewelled cap is fashioned to match the dress and ruff. Her right hand holds a red rose and her left a scarf or a handkerchief. She wears a long chain and three big jewels, one of which, in the form of a vase, is suspended from the chain. In the right-hand top corner appears a coat of arms framed by a cartouche and surmounted by a female mask. The arms of the Cooke family are shown in the first quarter.

Mildred, Lady Burghley, was the mother of Robert Cecil, 1st Earl of Salisbury. Her sister Ann married Sir Nicholas Bacon, Lord Keeper. She was a woman of great ability, known for her learning. Roger Ascham, in praising her knowledge in 1550, went so far as to declare that her qualities matched those of her husband.

The attribution of this portrait to Hans Eworth is plausible on stylistic grounds. This Flemhis painter came to England *c*.1545 and many paintings signed HE are ascribed to him, though recently an attempt has been made to distinguish between two or more different hands. His style is based on clear lines and a precise treatment of materials, jewellery and background objects, and is typically Mannerist. The portrait is of a fine quality and the detailed rendering of the face also shows psychological penetration. The colouring is strong and pleasant, with many contrasts. It was cleaned some years ago and is in a very good state of preservation.

Collection: Probably always in the family. It is of interest that Lord Burghley, who had a profound admiration for his wife (Holland, p. 20), thought fit to have at least three portraits of her, perhaps in his lifetime, kept in his three principal houses: Burghley, Northamptonshire; Theobalds, Hertfordshire; and Burghley House, London. There are three portraits of Lady Burghley mentioned in the seventeenth century inventories, one at Hatfield, one at Salisbury House, London, and one at Quickswood, Hertfordshire. It is not certain which two of the three are the portraits now at Hatfield.

The following are the pertinent entries in the inventories:
Hatfield House Inventory, 1611 (Box A.1), 'In your Lo: bedchamber – 1 picture of your Lo: mother'. Similar entries in 1612 (Boxes B.5 and D.1). By 1629 (Box A.6, f.9) the picture has been transferred to the 'second [or with-] drawinge Chamber' to the Dining Room. Repeat in 1638 (Box A.7) and in 1646 (Box A.8 and 9). By 1679 (Box A.10), there is 'In the Lady Mary's Chamber: 1 Picture of Lady Mildred Burleigh'.

Salisbury House Inventory, 1629 (Box C.8), 'In my Lords dressinge Chamber . . . 1: of the La: burleigh with a taffe[ta] curtaine'. Repeat in inventory of 1639/40 (Box C.9) and of 1646 (Box C.4 and 5). Inventory, 1685 (Box C.7), 'In the Hall . . . 1 of Lady Mildred Burleigh'. Repeat in inventory, 1688/9 (Box C.1).

Quickswood Inventory, 1651 (Box C.33 and 37), 'In my Lords [i.e. Lord Cranborne's] Closet. 1 picture of my Lady Burley'.

If we now turn back to Hatfield, we find that in 1833 Robinson (p.29) saw two portraits there. In the 1868 inventory two portraits are listed again. No. 38, Yew Room North: 'Mildred, daughter of Sir Anthony Coke, wife of Sir William Cecil – F. Zucchero'. No. 59, Grand Stairs, West Side: 'Mildred Coke, Wife of Lord Burleigh – F. Zucchero'. Both are ascribed to Zucchero in error.

Exhibition: Cat. Portraits 1866, No. 254. Engraved in Drummond's *Noble Families*, wrongly called Mrs Wentworth. *Cat. Holbein 1950–51*, No. 37.

Literature: Holland, No. 28, as Lucas de Heere (the monogram H.E. has formerly been identified with that painter and many English pictures had been wrongly attributed to him and Zuccaro). Cust, pp. 40–1, Pl. xxxc; D. Piper, *Portrait of Mildred Cooke*, B.B.C., February Painting of the Month, 1964; Strong, *English Icon*, p. 116, No. 63.

For literature in general on H.E., see Auerbach, *Burl. Mag.*, XCIII (Feb. 1951) 'Holbein's Followers in England', p. 50. Waterhouse, p. 19, Pls 10 (B), 11, 12, 13, and 14. Mercer, pp. 166–68, Pls 49 and 51. *Hans Eworth Exhibition* Catalogue, ed. Roy Strong, 1965/6.

35 [29] Colour Plate I, opp. p. 16

Mildred, Lady Burghley (1526–1589), *c.*1563

Hans Eworth (?) (working 1540–1573)

Panel 41 × 31 in. (104·2 × 78·8 cm.)

A three-quarter length life-size figure, turning three-quarters to the left, standing in front of a velvet upholstered armchair and a light green curtain. The positions of her hands and face are similar, though in the opposite direction, to those of No. 34 [28]; so is the closely fitting ruff and the embroidered cap sitting firmly on the hair, which is parted in the middle. She wears a white dress with pansies under a black bodice covered with a network of curved golden lines. Three rings adorn her fingers and she wears an ornament in the form of a double-headed eagle with three black pearls suspended from a gold necklace. From a belt-like jewelled chain, which she touches with her left hand, hangs a vase-like pendant. Her right hand is resting on the arm of the chair and holds a bunch of cherries. In the left-hand corner near the top appears part of a shield of arms (to be continued perhaps on a com-

panion picture of her husband) similar to that on No. 34 [28]. There are, however, eight quarterings instead of the seven on No. 34 [28] and they are differently marshalled.

Though the flesh tints are lighter and the treatment of the modelling much softer than on No. 34 [28], the features, the composition and the likeness are so similar that the same painter can be suggested for both portraits. Lady Burghley appears here slightly older with a big stomach which may lead one to believe that this was painted when she was expecting Robert who was born in 1563. The slight indentations shown on her left temple and cheek, are individual features which strangely reappear on the face of her son. This portrait has also been cleaned recently and is of an excellent quality and well preserved.

Collection: Probably always in the family. Entries in inventories as given in No. 34 [28]

Exhibition: Cat. British Portraits 1956/7, No. 27.

Literature: Holland, No. 29; Cust, p. 41; Piper, *op. cit.*, pp. 25–8; Strong, *English Icon*, p. 116, No. 64.

36 [33] Colour Plate II, opp. p. 17

William Cecil, 1st Baron Burghley (1520–1598), *c.*1565, formerly called Ambrose Dudley, Earl of Warwick (*c.*1527–1590).

?Hans Eworth (working 1540–1573)

Panel 37 × 28 in. (94·1 × 71·2 cm.)

On the frame No. 34 is inscribed

There is no doubt that the portrait represents Lord Burghley. Sir William Cecil became Lord Burghley in 1571, Lord High Treasurer and Knight of the Garter in 1572, and it was painted before that time, possibly *c.*1565. It shows Lord Burghley standing three-quarters to the right.

His blue eyes look in the same direction and his double-forked beard is of a yellow-brown colour. He wears a black cap and a black bejewelled suit with a closely fitting ruff. His right hand holds a red book which rests on an open wooden case containing four hour glasses. The case stands on a letter lying on a table stretching forward towards the centre of the painting. His left hand on his hip extends towards his belt and underneath the handle of his sword is visible. The background is adorned by a column on the left hand side and a green curtain on the right.

The portrait, which has been recently cleaned, is of excellent quality and rich in colour contrasts. It also shows a fine modelling of the features and is near to Eworth's work in the general treatment. It cannot be considered as a companion to either paintings of Mildred, Lady Burghley, but it comes near in style to them. (The measurement is slightly smaller.) Another version, showing Burghley without the Garter, therefore prior to 1572, is No. 2184, N.P.G., but holding a staff of office.

Collection: This painting has probably always been in the family collection. There are entries about numerous portraits of Lord Burghley (or of Ambrose Dudley, Earl of Warwick, as this sitter was formerly called) in the inventories of Salisbury House, Quickswood and Hatfield House. In the following account these entries will be given in chronological order.

In the 1611 Hatfield House Inventory (Box A.1) we read 'In your ho: bokechamber, 1 olde picture of my lo: your honours father'. In the inventory of 1612 (Box B.5) and also in another Box D.1, which is not dated, we read '1 picture of your Lordshippes granfather'. No locations are mentioned.

A second picture came to Hatfield in 1619, as has already been noted in the Introduction (see p. 15). It was duly recorded in the inventory of August 20, 1621 (Box A.4), for in that inventory

we find one picture of Burghley in Salisbury's bedchamber and another in the wardrobe. It is interesting that the latter is called 'your Lo: grandfather with a curtain and 1 curtain rodd'. By 1629 the two pictures listed are in the Gallery and in Salisbury's 'Dressinge Chamber', and they are still in the same places in 1638 and 1646 (Box A.7, 8 and 9).

Turning to Salisbury House, we find two portraits of Burghley in the inventory for 1629 (Box C.8). The first, described as a 'picture of your Lordships grandfather . . . with taffeta Curtanes' is coupled with a picture of Sir Anthony Cooke (Lady Burghley's father), both hanging in the withdrawing room adjoining Lord Salisbury's dining chamber. Both these pictures appear again in the same room in the inventories for 1639/40 (Box C.9) and 1645/6 (Box C.4 and 5).

The second portrait of Burghley in the inventory of 1629, in 'my Lords dressinge Chamber', is called 'the lo: burleigh with a taffe(ta) curt-(aine)'. By 1639/40 it seems to have been moved to 'Mr. Mathe(w)s Chamber' (Box C.9). In 1645/6 (Box C.4 and 5) it is no longer mentioned.

After 1645/6 no portrait of Burghley is mentioned by name in the Salisbury House inventories: 1685 (Box C.7), 1686 (Box C.3), 1688/9 (Box C.1 and 2), 1692 (Box C.12).

Perhaps one should note here that in 1651 another picture of 'my Lord Burley' is listed at Quickswood (Box C.33 and 37).

Four or perhaps five portraits of Burghley were at Hatfield by March 3, 1679/80 (Box A.10), one in the 'Parlour' and then, in the Gallery, three of 'Wm. Lord Burleigh' and one of 'Ambrose Earl of Warwicke'.

A century later Pennant, p. 403, found portraits of Burghley and his son Salisbury, both in robes and with white staves in the 'common parlour', now the Summer Drawing Room (see under Nos 43 [36] and 66 [60] below).

The inventories of 1823 and 1868 are not quite explicit as to the identification of Burghley's

portraits. In the former we find the 'Head of Sir William Cecil, Lord Treasurer Burleigh (Copy from half length) . . . Zucchero'. This was hanging in the Hall, No. 45 [43] and in the Drawing Room we find: 'Lord Treasurer Burleigh . . . Zucchero' and finally, in the Marquiss's Sitting Room, 'Portrait, Sir William Cecil'. No. 12 in 1868 is: Sir William Cecil. Lord Burleigh – F. Zucchero in the Summer Dining Room, West End where it appears as the companion picture of 'Robert, 1st Earl of Salisbury by Zucchero'. Three portraits of Ambrose Dudley, Earl of Warwick, one 'by Holbein' and 'one copied by Holbein' are listed under Nos 35, 63 and 124 and may refer to the present Nos 36 [33], 37 [34] and 38 [34a]. The one of 'William Cecil, 1st Lord Burleigh, No. 39 by Zucchero in the Yew Room North side', cannot be definitely linked with any portrait now at Hatfield.

Exhibition: British Institution Exhibition 1820 (123); *Cat. Portraits 1866*, No. 302; both as the Earl of Warwick by Holbein. *Cat. British Portraits 1956–57*, No. 26 as William Cecil, 1st Baron Burghley. Historical Manuscripts Commission Centenary Exhibition at N.P.G., 1969.

Literature: Musgrave, ff. 79 and 79v; Holland No. 33 as the Earl of Warwick by an unknown painter; Cust, p. 42 as Warwick by Eworth; Goodison, No. 9; Strong, *Cat. N.P.G.*, I, p. 28.

37 [34] ill. 21, p. 125

William Cecil, 1st Baron Burghley (1520–1598), 1573; formerly called Ambrose Dudley, Earl of Warwick (*c.*1527/8–1590)

Arnold van Brounckhurst (working from *c.*1565–*c.*1598)

Panel $37\frac{1}{4} \times 28$in. ($94 \cdot 6 \times 71 \cdot 2$ cm.)

Signed and dated on base of marble pillar: '15 AB 73'

On the frame No. 33 is inscribed

Likeness and composition agree so much with No. 36 [33] that one can say this picture is based on the pattern of the former likeness. It is, however, painted about eight years later, as in 1572 Lord Burghley became a Knight of the Garter and Lord Treasurer and he is here wearing the Garter chain with the lesser George suspended and holds the staff of the Lord Treasurer. There is no table on the left hand side in front of the figure, and the book is replaced by a wand of office. Nevertheless there are great differences between these two portraits of Cecil, and I am now inclined to think that they were painted by two different painters and that No. 36 [33] comes nearer to Eworth's manner. The colouring of No. 37 [34] is softer and darker and the treatment of the marble pillar and the curtain although similar in form is more painterly and reveals the hand of a younger artist. The face (slightly damaged round the nose and beard), is painted with stronger contrasts and shading. In addition, we are here in the fortunate position as the signature can be identified with the personality of a painter whom we know from documents.

Arnold van Brounckhurst, a Flemish painter, resided in this country from *c.*1565 to 1580, when he was appointed 'Court painter to the Scottish Court'. He was a cousin of Cornelis Devosse, a friend of Nicholas Hilliard, and all three prospected for gold in Scotland in the late 1570's (cf. Auerbach, *Tudor Artists*, pp. 117 and 151–2). Only recently evidence has been found of his style and manner as a portraitist in the signed and dated bust portrait of Oliver, 1st Baron St John of Bletso, 1578, now in the possession of the Hon. Hugh de B. Lawson Johnston, which establishes him as a competent and sensitive Flemish artist (Auerbach, *Hilliard*, Pl. 235 (a) and (b); see also Auerbach, *Burl. Mag.*, XCIX, 1957, pp. 9–13, 'Some Tudor Portraits at the Royal Academy'). This signed and dated portrait of

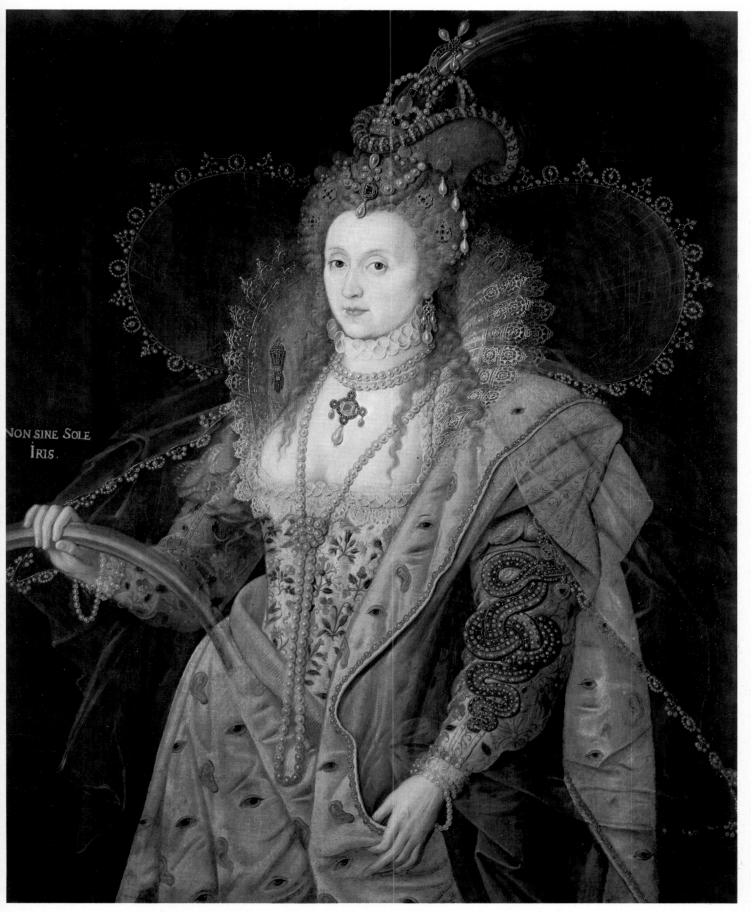

NON SINE SOLE
IRIS.

COLOUR PLATE V. **Queen Elizabeth I,** 'The Rainbow Portrait', *c.1600*, by ?Isaac Oliver (Cat. No. 51, p. 59)

COLOUR PLATE VI. **Catherine Howard, Countess of Salisbury,** 1626, by George Geldorp (Cat. No. 84, p. 86)

Lord Burghley (Auerbach, *Hilliard*. Pl. 236) can be linked to the above mentioned painting and appears to be near in style, even if we have no signature to prove the identity of the artist. That Lord Burghley commissioned this Flemish painter to execute his portrait is an interesting fact showing him again as a foremost patron of the visual arts. A slightly earlier version, mentioned under No. 36 [33] is N.P.G., No. 2184.

Collection: See notes relating to inventories under No. 36 [33]. Probably always in the family collection.

Exhibition: Cat. British Portraits, 1956/7, No. 26; *Elizabethan Image,* Tate Gallery, 1969/70, No. 49.

Literature: Auerbach, 'Some Tudor Portraits at the Royal Academy', *Burl. Mag.* XCIX, 1957, pp. 9–13; Auerbach, *Hilliard,* pp. 267–8, No. 271, Pl. 236; Strong, *English Icon,* pp. 11, 135–8, Pl. 90.

38 [34a]

William Cecil, 1st Baron Burghley (1520–1598)

By or copied from Arnold van Brounckhurst (working from *c.*1565–*c.*1598)

Canvas 38½ × 28 in. (97·8 × 71·2 cm.)

This is almost an exact copy of No. 37 [34], but smaller in size. It is likewise signed '15 AB 73'. The marble of the pillar is different; otherwise an exact replica in darker colouring.

39 [41] ill. 22, p. 126

William Cecil, 1st Baron Burghley (1520–1598), formerly called Thomas, Earl of Exeter

Painter unknown

Canvas 26 × 21 in. (66·1 × 53·2 cm.)

This is a well-drawn version, although appearing older, based on Nos 36 [33] and 37 [34], and it is probable that Nos 40 [38], 41 [39] and 42 [40] are replicas of this prototype. His right hand alone is visible enclosing the top of the white staff as in No. 40 [38]. The face is well preserved, slightly lengthened, the lids of the foreshortened eyes are well drawn; a light blue shading is visible round the temple; beard and ruff are well drawn. The lesser George is suspended from a gold chain, but in contrast to No. 40 [38] not cut off by the frame. The curtain behind the face is of a green and ochre shading. A brown pillar stands above the balustrade. Behind it are some brownish clouds and sunlight. A coat of arms fixed on a pillar, is standing on the right-hand side. Underneath on the base inscribed in gold, in a colour similar to that of the George: '*Cor vnum Via Vna*'.

Collection: See notes under No. 36 [33]. Probably always in the family.

Exhibition: Manchester, Whitworth Art Gallery *The Age of Shakespeare,* May 1964, No. 10.

Literature: Holland, No. 41 (listed as being painted on panel). Other versions of this type, but not of such good quality, are in Cambridge, Old Schools, and in Lord Beauchamp's collection.

40 [38]

William Cecil, 1st Baron Burghley (1520–1598)

Painter unknown

Panel 30 × 24½ in. (76·2 × 62·2 cm.)

A half-length figure, dressed in black, standing in front of plain balustrade. His left hand encloses the top of the white wand of office. From a gold chain hangs the lesser George, half cut off by the frame. Above the balustrade on the left hand side a brownish curtain appears to which a shield of

Cecil's arms is fixed. On the right the sky is seen, again in brownish colour.

An inscription on the back reads: 'William Cecil Lord Burleigh'. The likeness is based on Nos 36 [33] and 37 [34] but he looks older. For a similar, but better, version one should look at No. 39 [41]. In comparison with the latter, this is a much flatter and more linear variant.

Collection: See notes on inventories under No. 36 [33]. Probably always in the possession of the family.

Literature: Holland, No. 38.

4I [39]

William Cecil, 1st Baron Burghley (1520–1598)

Painter unknown

Panel 20 × 15 in. (50·9 × 38·2 cm.)

An indifferent version of No. 40 [38]. A shield of arms is fixed on the pillar to the right.

42 [36] ill. 23, p. 126

William Cecil, 1st Baron Burghley (1520–1598)

Painter unknown

Panel 20 × 15 in. (50·9 × 38·2 cm.)

Copy and repetition of No. 40 [38].

43 [36] ill. 23, p. 126

William Cecil, 1st Baron Burghley (1520–1598), *c.* 1590

Marcus Gheeraerts the Younger (?1561–1635/6) or John de Critz the Elder (working from 1568–1641)

Canvas (cleaned 1967) 43 × 31¾ in. (109·3 × 80·7 cm.)

A three-quarter length life-size figure in Garter robes, standing, turned to the right looking towards the viewer. He wears a black mantle over a purple robe and a crimson sash. The lesser George is suspended from the chain of the Garter. On his right shoulder there is a white plaited satin badge encircled with a crimson cord. He wears a close-fitting ruff and a black cap. His left hand touches his sword-hilt and in his right hand he holds the white wand of office. The features are softer than those of earlier pictures and more mellow. In the right hand corner are the Cecil arms encircled by the Garter. Underneath is a scroll bearing the words 'COR UNUM VIA UNA' and on the left hand side an inscription:

> 'Sir William Cecill knight, Baron of Burghley Lord high Treasurer of England, Knight of the most noble order of the Garter and Master of her Majstie Court of wardes and Lyueries.'

A nineteenth-century label on the back reads 'Sir William Cecil, the great Lord Burleigh principal and confidential Minister to Queen Elizabeth for forty years (until his death) born 1520 died 1598 painted by Zuccaro.'

The nineteenth-century attribution to Zuccaro was a mistake, often made in connection with Elizabethan pictures, which is now clearly recognized.

Similar portraits: Burrell Collection, Glasgow; Helmingham Hall, Lord Tollemache; Buckland Abbey (from Midgham Park, Newbury the former home of Lord Clarendon) and three at the N.P.G.

Collection: See notes on No. 36 [33]. Probably always in the possession of the family. This is the picture which Pennant saw in 1780 in the 'common parlour'.

Literature: In the version No. 362 at the N.P.G. see Strong, *Cat. N.P.G.*, I, pp. 29–30 and Strong, *English Icon*, p. 294, No. 295.

44 [42]

William Cecil, 1st Baron Burghley (1520–1598)

Painter unknown

Panel (cleaned 1963) 29¾ × 25 in. (75·6 × 63·5 cm.)

An impressive half-length portrait in fur-lined peer's robes. Plain background, on the right a shield of arms in vivid colours, encircled by the Garter. Underneath in Roman letters: 'COR VNVM VIA VNA'. He wears the Garter chain from which the George is suspended. Attitude of his right hand as on the preceding portraits. But here the left hand is also visible holding a brown glove. On his right side a piece of white paper or page of a letter appears partly covered by the coat. The face, well preserved, appears shorter and fuller, handled in a firmer way than in preceding portraits. It rather resembles No. 40 [38].

Collection: See notes under No. 36 [33]. Probably always in the possession of the family. Similar versions, half-length, holding wand of office and wearing great collar of Garter, are at Burghley House; Cardiff; Shrubland Park; Knole House; and in the N.P.G., No. 604.

45 [43]

William Cecil, 1st Baron Burghley (1520–1598)

Painter unknown

Panel 22¼ × 17¼ in. (56·5 × 43·8 cm.)

Life-size bust in Garter robes. Similar to No. 43 [36] but a replica, painted by an inferior artist – in left-hand corner: '1597'. A coat of arms in right-hand corner with motto underneath.

46 [44] ill. 24, p. 126

William Cecil, 1st Baron Burghley, riding his grey mule (1520–1598)

Painter unknown

Watercolour on paper 13 × 11¾ in. (33 × 29·8 cm.)

The small elderly figure of Lord Burghley, wearing his black cap and a fur coat, holding a pink flower in his hand, is shown riding side-saddle on a grey mule. Mule and rider are in a frontal position and take up the whole width of the picture. The background is an open landscape with trees and clouds. The Cecil arms are suspended from the branch on the left-hand side of the picture, and the George of the Garter is fastened to the mule's bridle.

This is a smaller copy of the oil painting in the Bodleian Library.

Lord Burghley used to ride on a little mule or donkey up and down the walks at Theobalds, and it seems that this kind of mild exercise suited him very well. A letter from Lady Mason to Burghley on July 16, 1578 (Cecil Papers, Vol. 202, f. 140; reference from Miss C. Talbot) indicates that he had written to ask her to send him an ass. Lady Mason apologized for not being able to send the animal at once, since it was in the care of her 'verie frind' Mr Burdet of Sonning, ten miles from her house, but promised that Burghley should have it by the next Thursday.

In October 1586 Burghley wrote to Stafford, the English ambassador at Paris, with the request that Stafford find him a replacement for his aged mule, which Mauvissière had sent him twelve years ago. (Seigneur de la Mauvissière was French ambassador to England from 1575 to 1585.) Stafford soon forwarded a 'little mulatt', described as young and tractable and apt for the Lord Treasurer's recreation. (Read, *Lord Burghley*, paperback ed, pp. 350 and 573.)

Collection: A firm of frame makers charged £1.11.6 on June 13, 1801 for a frame 'with Japand Glass, to a drawing of Ld. Burleigh on a white mule' (Bills 604).

Literature: Robinson, p. 12.

47 ill. 25, p. 126

William Cecil, 1st Baron Burghley (1520–1598)

? John de Critz the Elder (working from 1568–1641)

Panel 84½ × 51½ in. (2·15 × 1·23 m.)

Life size, full-length figure seated in a high arm-chair, in frontal position, holding a long wand of office in his left hand and a letter or document in his right. On the left-hand side there is a table covered with a green cloth, on which the chain and the Order of the Garter are displayed. The room in which the Lord Treasurer sits is further characterized by a carpet with red shades in its pattern and a green curtain. Lord Burghley looks old, and the features of his face are near to No. 43 [36]. He wears a tall black hat, closely fitting ruff, and a black fur-lined gown. It is a well-modelled portrait of good quality. The inscription is the same as appears in No. 43 [36]. Above the inscription Lord Burghley's arms are shown in the top left corner, within the Garter.

The companion picture to this one is the portrait of Burghley's son Robert, No. 72. Both portraits come from the Woburn Abbey collection and were presented to Lord Salisbury by Queen Elizabeth the Queen Mother in 1957.

Collection: Lord Burghley's wife Mildred had a sister Elizabeth who married into the family of the Russells, who were Earls of Bedford. This family relationship may explain how the portraits originally came to belong to the Woburn Abbey collection. They were sold in 1951 amongst other pictures from Woburn Abbey at Christie's, Lots Nos 97 and 99. They were described by George Scharf, *Catalogue of the Collection of Pictures at Woburn Abbey*, 1890, Nos 49 and 52, who suggested Gheeraerts II as the author.

48 [37] ill. 26, p. 127

Double portrait of William Cecil, 1st Baron Burghley (1520–1598) **and Robert Cecil, 1st Earl of Salisbury** (1563–1612), after 1606

Painter unknown

Panel 24 × 33½ in. (61·1 × 85·1 cm.)

Two separate portraits have been combined to make this double portrait. Against the pale grey background the two figures of father and son stand out. They are dressed in black and given in half-length, turning in a three-quarters direction towards each other. Lord Burghley rests his right hand on a wand of office. He wears his usual black hat, and his white beard overlaps a closely fitting ruff. The Earl of Salisbury grasps a white wand in his left hand. He wears no hat, and his dark beard contrasts with the wider and more radiating ruff of the later period. Both wear the blue ribbon of the Order of the Garter, but the badge is visible only in the portrait of Lord Burghley.

The double portrait must have been painted after Salisbury became a Knight of the Garter in 1606. The highlights shown on the facial features of the two sitters also indicate a date well after the death of Lord Burghley. The portrait types are close to the types represented in Nos 39 [41] and 68 [62] of this Catalogue .

Collection: The picture first appears in Musgrave's list of 1769, f. 79v in the Gallery. In the Hatfield House Inventory of 1823 it was hanging in the Library. In 1868 it is recorded under No. 99.

Exhibition: Cat. Portraits 1866, No. 246.

Literature: Robinson, p.27; Holland, No. 37.

49 [35] Colour Plate III, opp. p. 32; ills 27–32, pp. 128–31

A Fête at Bermondsey, *c.* 1570, formerly known as Marriage at Bermondsey

Joris Hoefnagel (1542–after 1600)

Panel 29 × 39 in. (73·8 × 99·2 cm.)

Signed and inscribed in the lower left-hand corner but only the artist's name is clearly legible.

This fascinating painting of Flemish origin depicts a crowded scene out-of-doors on the south bank of the Thames, opposite the Tower of London. On the left we have an open view towards the river, the Tower, and Wapping.

The details of the picture are so clear that one would at first imagine it to be very easy to identify the buildings at Bermondsey which the painter shows us in the foreground. But this is an illusion, for it is impossible to tell how much artistic licence Hoefnagel has used in giving the perspective, and this makes it difficult to gauge the distance from the river. The crux of the matter is, which is the church shown in the background on the right-hand side of the picture? It has sometimes been said to be part of the Hermitage which used to stand on the site of the present St John's Church, Horsleydown. If so, the scene of the festivities would be the High Beer House in or near Tooley Street which once belonged to Sir John Fastolfe. (G.R. Corner, *The History of Horsleydown,* London, 1858, p.18; William Rendle and Philip Norman, *The Inns of Old Southwark and their Associations,* London, 1888, pp. 32 ff.)

On the other hand, if the setting is meant to be a little further back from the river, the church is St Mary Magdalene, Bermondsey. It would then follow that the adjoining house, or part of a house, where all the festivities are taking place, may be the mansion built by Sir Thomas Pope in the grounds of the late Bermondsey Abbey

and occupied, at the time the painting was made, by Thomas Radcliffe, Earl of Sussex. Incidentally, it was here that Sussex entertained Queen Elizabeth at some time in 1564/5 and again, twice, in 1571. (Extracts from Lambeth Churchwardens' accounts in Daniel Lysons, *Environs of London,* 1792, Vol. 1, pp. 311 and 312.)

A maypole shown on the left of the picture at the edge of the road leading to the river indicates an open space for outdoor amusements. It is known that there was a maypole at Bermondsey which in 1617 was described as having been 'used for honest mirth and recreation' as long as anyone could remember. (William Rendle, *Old Southwark and Its People,* 1878, p. 288.)

The background of the painting is given in light colours to indicate the distance to the river and the houses on the other side, while the middle ground is taken up with extensive buildings shadowed by dark trees. In contrast, the foreground is filled by a gaily dressed crowd of people drawn in relatively small sizes and variegated colours. They are strolling and dancing along over a spacious area. The party on the right of the picture seem to be coming from the church. Preceding them are two men and two women carrying large round cakes wrapped in white handkerchiefs, two fiddlers, and a gentleman who bears a cup filled with bay or rosemary and flaunting coloured streamers. All the members of the party being honoured are dressed in black. First is an elegantly clad lady carrying gloves and wearing a sprig of rosemary and a gold chain. She is escorted by two aristocratic gentlemen accompanied by a group of young women. The whole party seems to be proceeding to a feast in the adjoining house, where great preparations are being made. In the foreground are five persons dancing a country village dance. The music for them is being played by some musicians who sit on the right. Standing behind the musicians or rather leaning up against a tree behind them we find the painter Hoefnagel him-

self. In the left foreground a number of small groups of people, most of them extremely well-dressed, appear to be approaching to take part in the festivities.

Hoefnagel was in England in 1571. It is difficult to establish whether he here intended to represent an actual gathering or festive occasion which he witnessed or whether he has created an imaginary scene in order to show as much of English social life as possible. By tradition, and according to Holland No. 35, the picture was called 'A Marriage Fête at Bermondsey'. This would agree with entries in the seventeenth-century inventories which point to 'the solemnity of a marriage', or '1 large landskipp of a bridal . . . '. which cannot be accounted for otherwise.

The reason for identifying it with a nuptial ceremonial, as Holland does, is based on contemporary evidence that a bridal procession might look very much like this one, as witnessed by the following extract:

> Then was there a faire Bride cup of silver and gilt carried before her, wherein was a goodly braunch of Rosemarie gilded very faire, hung about with silken Ribonds of all colours; next was there a noyse of Musitians that played all the way before her; after her came all the chiefest maydens of the Countrie, some bearing great Bride Cakes . . .
> (Thomas Deloney, *The Pleasant History of John Winchcomb*, 9th edition 1633, sig. D3. Probably first printed about 1597)

On the other hand, to identify the guest of honour, the lady in black on the right, as the bride, does not seem quite plausible and there is no other figure in the picture who seems likely to be a bride.

An alternative suggestion may therefore be ventured. There is some resemblance between the lady in black and Queen Elizabeth I as she appeared in paintings of the late 1560's. Perhaps her frequent visits to the house of the Earl of Sussex (probably portrayed in the background) occasioned the pictorial representation of special festivities in her honour. There may even be a combination of both: it is documented that Elizabeth during her visit to Kenilworth in 1575 attended a village wedding. Something similar may have happened in Bermondsey c.1570.

In addition to these two possibilities there is a certain atmosphere of genre recalling the manner of Brueghel to be found in the 'Fête at Bermondsey'. This may have to do with the origin of Joris Hoefnagel who, born in Antwerp in 1542, came to England in 1569 or 1570 and died in Vienna in 1600. The combination of the realistic topographical representation of the landscape with the lively crowding together of many different small figures is typical of this artist's work as it can be seen in his drawing of Nonesuch (for Braun and Hogenberg's *Civitates Orbis Terrarum*).

Hoefnagel belonged to a group of Flemish refugee artists who settled in England for a short time and lived on the South Bank. It is therefore of interest to state that Lucas de Heere used similar figures for his '*Theatre du tous les peuples et nations de la terre avec leurs habits et ornemens divers . . .*' (MS 2466. University Library, Ghent) in which he gives a vivid account in watercolour of various English people and their costumes. Some of these costume sketches have close similarities with Hoefnagel's figures in the 'Fete at Bermondsey', and it is interesting to compare them, though it is not quite clear whether de Heere or Hoefnagel designed them first. The '*Villaigeoise Angloise*' (No. 73 in de Heere's MS) with her short white cape, apron, and black hat, dances in Hoefnagel's group of five villagers in the foreground of the painting. Both '*une bourgeoise*' and '*une marchande Angl*'. (No. 72 in the MS) appear in the middle foreground of the picture in the group of women next to the gentleman with the elaborate swinging cloak. Again '*une bourgeoise*' is accompanied, further to the left, by a distinguished-looking man in a long black gown resembling '*Un de la livree du mestier*', a member of a city livery company

(No. 71). The two noblewomen, the *Dame et Damoiselle Angloises* (No. 69) and the *Gentils-hommes Anglois* (No. 70) appear frequently among the elegantly dressed assembly on the left side of the picture. Altogether a crowd including people of all classes of English society.

Collection: The first inventories we have of Hatfield and Salisbury House were taken about forty years after this picture was painted, when the officers of the Earl of Salisbury's household would perhaps be unaware of the origin of the picture and only have a dim idea of what it was meant to represent. In these circumstances one can only guess which entry refers to the picture. At Hatfield we can trace two pictures in the inventories, one called a marriage picture and the other called a banquet:

i) 'One picture of the solemnities of a marriage', 1611, in the wardrobe, upper story (Box A.1). The same, 'with a thick Frame of Wallnuttree', July 1612 (Box B.5). '1 large Landskipp of a bridall sett in a frame of wallnut tree in my Lord's Dressinge Chamber', 1629 (Box A.6). '1 picture of a marriage in Dutchland', 1638, in the withdrawing chamber (Box A.7).

ii) '1 . . . picture of a banquet', 1611, in the Antechamber (Box A.1). '1 duch picture of a Bancket', July 1612 (Box B.5). '1 picture of a banquet', 1629, in the Lobby, (Box A.6). '1 of a Dutch banquett', 1638, in the lobby at the end of the gallery (Box A.7).

With such a background in the earlier Hatfield inventories, and after another interval of forty years, the entries in the inventory of 1679/80 (Box A.10) are not very helpful:
'1 peice of Landskip' over the chimney in the withdrawing room.
'1 picture of a Dutch wedding, in my Lord and Ladys bedchamber'.

The inventories for Salisbury House in the same period are equally tantalizing, or even more so. There is a picture of a 'breakfast' in the Gallery in 1629 (Box C.8). There seem to be two pictures of breakfasts by 1645/6 (Box C.4 and 5). And by 1685 there are in the Hall' 1 Dutch peice of Eating' and '1 Landskipp with figures' (Box C.7).

In 1780 Pennant, pp. 405–6, saw this picture in the dressing room and interpreted it as 'a representation of some of the amusements of the Court of Henry VIII, who often relaxed his savage disposition in little progresses about the neighbourhood of the metropolis'. Following Hall's chronicle Pennant believed that this painting depicted the scene which took place in the spring of 1533 when Queen Anne Boleyn was pregnant, and he continued: 'We see Henry with his royal consort . . . at a country wedding, fair or wake, at some place in Surrey within sight of the Tower of London'. This idea was taken up in the nineteenth century and in the inventory of 1823 it was further assumed that this entertainment was given by Cardinal Wolsey for the King and his second Queen and that the picture was painted by Hans Holbein the Younger. A repeat of this statement appears in the inventory of 1868, No. 5.

Literature: Musgrave, f.79; Sir Lionel Cust, 'Notice of the Life and Works of Lucas D'Heere, Poet and Painter of Ghent', *Archaeologia*, LIV, 1894, part 1, pp. 59–79; Holland, No. 35; Philip Norman, 'On an Allegorical Painting in Miniature by Joris (George) Hoefnagel and on some other works by this artist', *Archaeologia*, LVII, 1901, part 2, pp. 321–30; Frances Yates, *The Valois Tapestries*, London, 1959; Waterhouse, p. 29; Mercer, p. 129; H. van Hall, *Portretten van Nederlandse Beeldende Kunstenaars, Repertorium*, 1963; Strong, *English Icon*, pp. 148–9.

50[50] Colour Plate IV, opp. p. 33; ill. 33, p. 132

Queen Elizabeth I (1533–1603), 'The Ermine Portrait', 1585

Queen Elizabeth I was the daughter of King Henry

VIII and Anne Boleyn and came to the throne in 1558

Nicholas Hilliard (?) (1547–1619)

Panel 41¾ × 35 in. (106 × 88·9 cm.)

Dated 1585 on the sword hilt

Life-size, three-quarter length, standing in frontal position, facing the spectator. A regal figure, wearing a black dress richly bejewelled and ornamented with little gold rosettes or daisies. The Queen wears strings of pearls, diamonds and rubies, a grey gauze veil and a radiating, close-fitting lace ruff and cuffs. A richly bejewelled diadem sits on her light yellowish hair. A little ermine is visible on her left arm and an elaborately decorated sword of state lies in front of her on a bronze-green covered table. The Queen holds a sprig of olive in her right hand. The uniformly grey background is intersected on the left by a narrow latticed window showing a dull blue sky.

From one of the necklaces hangs the famous jewel known as 'The Three Brothers' and belonging to the Royal Collection in 1587 when it was recorded. (B.M. Royal MS. Appendix 68, f.2. See Strong, *Portraits of Elizabeth I*, p. 82.) This jewel consists of three oblong diamonds set in a triangle round a pointed diamond and separated from each other by pearls. One large pearl is suspended below. The magnificent jewellery and the richly gem-embroidered gown stresses the majesty of the regal appearance. The ermine with its lovely white coat, symbolizes, according to Miss Yates, purity and virginity. The animal wears a collar of gold, shaped in the pattern of a crown. An ermine decorates the banner which was carried before Laura in Petrarch's *Triumph of Chastity*. The crowned ermine also has a connection with the Sword of State, both representing 'Justice', while the olive sprig symbolizes 'Peace'.

This outstanding portrait of Queen Elizabeth I known as the 'Ermine Portrait' has been attributed to Nicholas Hilliard by tradition.

Nicholas Hilliard (1547–1619), son of an Exeter goldsmith, was the Queen's limner, goldsmith and painter. His miniatures were of such superb quality that they changed the whole style of life-size painting during the Elizabethan period. Hilliard was the first English-born painter to gain status as a court artist. We know that he also painted life-size portraits, though an absolutely sure attribution of any painting to him could only be based on definite documentary evidence and such is lacking.

In 1585, the date of the 'Ermine Portrait', Hilliard was already in close touch with, and indeed patronized by, Lord Burghley.

In 1584 he was well established at the Court and in a draft patent for the monopoly of painting royal portraits in favour of the then Sergeant Painter, George Gower, his own name was included for the monopoly of making likenesses of the Queen 'in small compass in lymnynge only, and not otherwise'. In that year Hilliard was commissioned to make and engrave Elizabeth's second Great Seal, a task which suited him very well, as he could combine his skill as a goldsmith with that of a portraitist. His achievement was appreciated and as a reward Hilliard received on October 18, 1587 'for good service' a reversionary lease of various parcels of land to the value of £40 (C.66/1290, Auerbach, *Hilliard*. pp. 23–4). That his lease was granted mainly for his 'engraving of the great seale of England' emerges from a letter of November 8, 1586, which Walsingham wrote in Hilliard's favour to Sir Walter Mildmay, Chancellor of the Exchequer (E.310/41/15). It is, however, more significant for our purpose that Lord Burghley in July 1587 intervened in a letter to an Exchequer officially declaring himself willing to act as a surety for the ever needy painter. He suggested that the Chancellor could stand as the second guarantor and that the bond should be retained

privately. Lord Burghley, therefore, helped his protégé and confessed himself Hilliard's patron. And again, four years after the artist had worked on the Great Seal, between 1588 and 1590, Hilliard took heart to implore his patron, perhaps Lord Burghley or Sir Robert Cecil – the addressee is not mentioned – to intervene in his favour, when he was threatened with arrest (Petition 782, Auerbach, *Hilliard*, pp. 20–1), because he could not settle his obligations for lack of money. The close contact between the Queen's limner and Burghley, the Lord Treasurer, emerges again from an entry in the latter's diary (Cecil Papers, Vol. 229): December 7, 1591 – 'A forfeytuer of 400 *l*. granted to Nicholas Hyllyard': On December 11 of that year this grant was enrolled: for his good and faithful service 'to be taken unto him of our [the Queen's] free gift without any prest [tax] or other charge to be set upon him for the same or any part thereof'. (E.403/2559, f. 332: Auerbach, *Hilliard*, p. 24). Even if Burghley wrote this memo in his official position as Treasurer, it is still noteworthy. This diary mainly contains records of personal experiences, such as the birth and christening of his daughter Elizabeth, the sudden illness of his daughter Anne, the various entertainments of the Queen at Theobalds, Leicester's death, the death of his beloved daughter Anne and the funeral of his wife Mildred. From a number of later petitions and letters to Lord Burghley and his son, only one more piece of evidence will be given here, as it concerns the decisive period before 1600.

In 1593 two painter-stainers applied for a monopoly in heraldic decoration for funerals under Clarenceux and they addressed their petitions to Lord Burghley. One year later they appealed again to Robert Cecil and hoped for a more speedy grant, as 'Mr Nicholas Hillyard her Maties servant to your Honors so well knowne for his sufficiencie and care in his woorks' was determined to join them in their work. (Cecil Papers, Vol. 170, 50 and 51: Auerbach, *Hilliard*, p.

27, notes 2 and 3.) This remark establishes without doubt that at the beginning of the 1590's it was generally known that Hilliard was one of the favourites of the Cecils, father and son.

Apart from such indirect evidence the comparison of the 'Ermine Portrait' with Hilliard's miniatures clearly supports the traditional attribution. Miniatures of Elizabeth I of *c*.1585, such as those at Madresfield Court or The Hague, and even the later one in the collection of Mrs Doris Herschhorn (Auerbach, *Hilliard*, Pls 57, 59 and 85) show a similar three-quarter position of the face on the radiating ruff. The line of forehead and hair agrees and the general treatment of single features – the eyes, nose, mouth and the curls of the hair – is similar. In addition, the application of gold leaf to the sword, the necklaces, and the jewellery, and the precise imaginative rendering of the pearls and diamonds, which recall the prescriptions in Hilliard's *Treatise*, reveal the hand of the goldsmith. Moreover, those rich ornaments, the daisy-like rosettes, are scattered fully but not schematically over the black dress with a certain freedom. The sensitive life-like painting of the little ermine can only be paralleled by the imaginative treatment of the little dog, also looking up to his master, in the right-hand corner of Hilliard's *Sir Anthony Mildmay* of *c*.1595 (Auerbach, *Hilliard*, Pl. 93). The third point in favour of a likely attribution to Hilliard is the fact that this portrait was probably always in the family collection. The portrait is in a very good state of preservation and does not seem to have been shortened at any time.

Collection: All through the seventeenth century there seem to have been several pictures of Queen Elizabeth at Hatfield House. Lord Burghley, incidentally, had acquired a picture of the Queen which had formerly belonged to Thomas Wilson the Queen's Principal Secretary as early as 1582 (Legal 16/6: reference from Miss C. Talbot). The inventory of 1611 (Box A.1) mentions 'one

picture of the late Queen Elizabeth in the Wardrobe, Upper Storey'. The Officer of the Household at Hatfield who took the next inventory, in July 1612 (Box B.5) mentions three pictures of the Queen:

'A faire picture of Queene Elizabeth.
Another picture lesser of Queene Elizabeth.
A picture of Queene Elizabeth in her State, the Frame gilt'.

Their location in the house is not specified. Presumably the 'faire picture' could be either 'The Rainbow Portrait' (No. 51 [52] below) or this one. It is tempting to identify the 'picture of Queene Elizabeth in her State, the Frame gilt' with this picture; but comparison with another inventory of approximately the same date (Box D.1 not dated; from internal evidence 1612 or shortly thereafter) seems to rule out the possibility, since in it the third picture of Queen Elizabeth is given as '1 little picture of the Late Queene Elizabeth in her state, the frame gilt'. This picture could hardly be called little.

Four inventories of the goods at Hatfield dated 1620/1 (Box A.2, 3, 4 and 5) list '1 picture of the late queene' in Lord Salisbury's 'Booke chamber'. The other two pictures mentioned in 1612 may, in the meantime, have been transferred to Salisbury House, London, or they may simply have been stored somewhere out of sight at Hatfield House and forgotten by the clerk who took the inventory.

Further inventories list the following pictures of the Queen:
1629 (Box A.6) – one picture in the gallery and, perhaps, one in the wardrobe (the clerk may have intended to indicate that the one in the gallery has been moved to the wardrobe).
1638 (Box A.7) – one picture in Lord Salisbury's dressing chamber and one in the wardrobe.
1646 (Box A.8 and 9) – one picture in the gallery and one in the wardrobe.
1679 (Box C.10) – one picture in Lady Katherine's chamber and one in the wardrobe.

Meanwhile at Salisbury House there were also one or two portraits of Queen Elizabeth, as follows:
1629 (Box C.8) – '1 faire picture of the late Queene Elizabeth', in the Great Chamber.
1639/40 (Box C.9) – one picture of Queen Elizabeth in the Great Chamber.
1645/6 (Box C.4 and 5) – one picture of Queen Elizabeth in Lady Lisle's bedchamber.
1685 (Box C.7) and 1688/9 (Box C.1) – two pictures of Queen Elizabeth in the Hall.

It seems likely, therefore, that after the transfer of the contents of Salisbury House to Hatfield in the 1690's the Hatfield collection included four pictures of Queen Elizabeth, one of which was the 'Ermine Portrait'; but we do not have enough information to be sure where this portrait was at the various earlier dates. (The foregoing entries that refer to Queen Elizabeth cannot concern the 'Diana' portrait, for it appears in separate lists, which follow under No. 91 [51].)

On July 12, 1731, Vertue, IV, 16, gives the following report of the 'Ermine Portrait' at Hatfield: 'Queen Elizabeth on bord (half len.) a small creature an Ermine on her left arm in her right hand a branch of green flower. The sword lying on the Table'. Musgrave, in 1769 and Pennant in 1780, p. 411, saw the painting in the Chaplains' room. In 1804 (Bills 613) a workman at Hatfield presented a bill for an 'ornament to Queen Elizabeth's frame'.

In 1823 the Hatfield House Inventory includes: 'Breakfast Parlour – Queen Elizabeth in black highly ornamented, an Ermine on her arm, half length . . . N. Hilliard'. Again in May 1868 it appears under No. 92 in the Winter Dining Room, West End: 'Queen Elizabeth . . . Nicholas Hilliard'.

A portrait owned by Madame de Courcel, Château de Bois Hérault, Normandy, shows motifs from the 'Ermine' portrait. The full-length figure stands in an interior with a lattice window on the left. She holds an olive branch in

her right hand and an ermine appears on her left arm. The face resting on a similar ruff and crowned by a diadem recalling that of the 'Ermine Portrait' seems, however, to be heavily overpainted. The portrait is said to have been given to François de Civille by Queen Elizabeth I in 1589 and was always in the family (see Strong, *Elizabeth*, in Addenda, No. 5).

Exhibition: Cat. *Tudor, 1890*, 1410 A; Reynolds, 110; Historical Manuscripts Commission centenary exhibition at N.P.G., 1969.

Literature: Vertue, I, 58, IV 16; Musgrave, 1769, f. 79; Pennant, p. 411; Robinson, p. 28; F. M. O'Donoghue, *Descriptive and Classified Catalogue of Portraits of Queen Elizabeth*, London, 1894, Pictures, p. 25; S.S.B. *81*, ff. 58–9; Holland, No. 50; Auerbach, 'Portraits of Elizabeth I', *Burl. Mag.*, June 1953, p. 204, Pl. 40; *Tudor Artists*, p. 132; Piper, *Essex, II*, p. 300; Auerbach, *Hilliard*, pp. 62 and 278, Pl. 61, Cat. No. 183; Strong, *Elizabeth I*, p. 82, No. 86, 'attributed to William Segar'; Auerbach, *Burl. Mag.*, July 1964, p. 345; Frances Yates, *Allegorical Portraits of Queen Elizabeth I at Hatfield House*, Hatfield House Booklet, No. 1; Strong, *English Icon*, pp. 18 and 219, No. 177.

5 I [52] Colour Plate V, opp. p.48

Queen Elizabeth I (1533–1603) 'The Rainbow Portrait', *c.*1600

? Isaac Oliver (1565?–1617)

Canvas (cleaned 1959) $50\frac{1}{2} \times 40$ in. (128 × 101·6 cm.)

A life-size, three-quarter length figure, turned to the left with eyes looking towards the right. The Queen is clad in a flowered dress and cloak with an orange lining. She stands in front of a dark-brown archway holding a rainbow in her right hand, her left slightly touching the edge of her cloak, which is painted in gold leaf and richly ornamented with eyes and ears. On her left sleeve an elaborately twisted green serpent appears, with a head like a celestial sphere and a mouth from which a red heart-shaped jewel hangs. An open standing ruff, one earring, one brooch, three pearl necklaces and several bracelets, a transparent veil and a high and ostentatious head-dress complete the masque-like appearance of the Queen. The incription 'NON SINE SOLE IRIS' (No rainbow without a sun) in gold letters – although possibly of a slightly later date – gives some kind of explanation to the complex profusion of allegorical and allusive symbols.

The latter have been interpreted by Miss Frances A. Yates (*Allegorical Portraits of Queen Elizabeth I at Hatfield*) as follows. The eyes and ears indicate *Fame*, the design of the serpent with both a sphere and a heart stands for wisdom and prudence which prevail in things of *Intelligence* and the *Heart*. The English wild flowers embroidered on her dress present Elizabeth as *Astraea*, the Just Virgin of the Golden Age, and the ropes of pearls and the pearls in her head-dress combined with the Royal Crown symbolize *Virginity* and *Royalty*. The Rainbow is the symbol of *Peace* and was also the device of Catherine de Medici who used it with a motto in Greek (translated 'It brings light and serenity') alluding to the dawn of a new golden age. Queen Elizabeth, therefore, also personifies the 'Sun'. The literary sources on which Miss Yates based her conclusions were widely read in the late sixteenth century and include, amongst others, Ripa's *Iconologia* (1st ed. 1593) and G. Ruscelli, *Imprese Illustri* (Venice, 1580). The conception of the whole portrait takes us to the approach of the Court of James I, when the Elizabethan world of revels and pageantry found a new culmination in the performances of 'Masques' at the Royal Court. The jewel-like gauntlet attached to the inside of the ruff may point to a special tournament or tilt which was celebrated at that particular time.

Like many other late Elizabethan paintings, the 'Rainbow Portrait' was erroneously ascribed to Federico Zuccaro (working from 1542/3–1609), as scholars of the nineteenth century believed that the Italian artist was staying in this country for quite a long period. Researches in Italian documents have since shown that he came over to England at the end of 1574 and was back in Italy by the autumn of 1575. Only two drawings, one of Elizabeth, the other of Leicester, in the British Museum can be ascribed to him with certainty. The costume and style of the 'Rainbow' picture belonging to the period of *c*.1600 makes the attribution to Zuccaro impossible.

More recently scholars are inclined, on account of more research into the stylistic features of late Elizabethan portraiture, by general consent to ascribe this portrait to an Anglo-Flemish artist of *c*.1600. The Serjeant painter John de Critz the Elder (working from 1568–1641) has been tentatively suggested by Mr David Piper. In an article in Vol. 44, No. 2, of the *Huguenot Society's Proceedings*, 1960, pp. 210–29, 'Some Portraits by Marcus Gheeraerts II and John de Critz Reconsidered', Mr Piper refers to a bill of October 16, 1607, due to John de Critz for 'Worke don for the right hono: the Earle of Salisburie' (Box U.81) at Hatfield, of which one entry reads as follows: 'Item for altering of a pictor of Queen Elizabeth . . . 1 *l*'. (cf. the bill quoted under No. 66 [60] below); and he argues that such an alteration, which must have been, according to the price, quite a considerable one, may refer to the 'Rainbow Portrait', though as he admits, alterations are not now diagnosable. He then continues: 'I think, however, it is not too far-fetched to suggest that de Critz might be borne in mind as the possible original author as well as alterer of this fine piece.' (p. 224) But the 'Rainbow Portrait' shows no sign of having been altered, and it has certainly not been cut down, as is sometimes suggested. The only possible addition may have been the inscription in gold letters which could have been inscribed at a slightly later date.

Another name put forward by Dr Roy Strong, on grounds of style, is that of Marcus Gheeraerts II. Both painters, de Critz and Gheeraerts II, belonged to a circle of Franco-Flemish artists working in this country and probably sharing one studio.

I suggest still another member of that circle of Franco-Flemish refugee painters who, according to our knowledge, may have worked in the same studio. I am thinking of Isaac Oliver (who incidentally was married to Sara Gheeraerts); and I should like to adduce two points in support of this theory. The first is a stylistic one: the spirit of pageantry and masques which is so strongly expressed in the 'Rainbow Portrait' can often be seen in Oliver's miniatures and nowhere more than in his signed *Lady in Masque Costume* in the Victoria and Albert Museum (P.3–1942) reproduced in Winter, *Elizabethan Miniatures*, Pl. XIII b. Here is a similar treatment of the jewellery, the elaborate head-dress, the veil, the gown, the hair and the flesh tints. It is known that Oliver painted pictures 'in little' and 'in greate' (Auerbach, *Tudor Artists*, pp. 133, 179–80). Moreover, the face of the Queen is based on the pattern created by Hilliard, e.g. in his Ham House miniature, and Hilliard was Oliver's master. Again, assuming that Oliver was the author of the 'Rainbow Portrait', it would explain the rich use of gold leaf according to the typically English tradition, as was especially well known and frequently used by the miniaturists.

The second reason for the tentative attribution to Isaac Oliver is based on documents preserved at Hatfield House. It is known that in 1611 'Oliver the painter' was paid 6*l*. 'for a picture for my Lady Clifford' which, according to the price, was probably a miniature (Accounts 160/1). Further search amongst the Hatfield House manuscripts produced, however, evidence that

there was a closer connection between Oliver and the Earl of Salisbury. It appears that the latter owed the former the considerable sum of 200 *l*. In Box G.13 we read under 'Payments of Debts and for intereste' in November 21, 1611 to 'Isaacke Oliver the intereste of 200 *l*. for 6 moneths 18 November 1611: 10 *l*.' This debt and its final payment can be followed up from July 17, 1611 (Box U.39) to the Accounts following Michaelmas 1612 (Box U.3), when under 'Debts paid since my Lord Treasurer his deathe' an entry referring to 'Mr Oliver – 210 *l*.' appears. By April 18, 1613, Oliver's name has disappeared from the list of debts. The final payment is listed as 'upon Bonds, spetialties and for interest due upon the same' and on February 16, 1611/12 Robert Cecil had detailed what he owed in the following words: 'Theis debts herafter mencioned are my owne proper debtes wch I will to be paid by myne Executors'.

How this debt was incurred originally we do not know, nor do the manuscripts give us any clue as to its nature. It may have been a bond or a loan, but Oliver was not a goldsmith who would be likely to act as a money-lender. Would it be too much to assume that the £200 was due to him for work he had done for the 1st Earl of Salisbury?

Collection: The 'Rainbow' picture can certainly be identified with one or the other entry referring to the portraits of the Queen in the early inventories, both in Salisbury House and in Hatfield House. They are listed in general under No. 50 [50].

Pennant was struck by this picture when visiting Hatfield in 1780. He thought it 'extremely worth notice', 'not only the handsomest we have' of Queen Elizabeth, 'but as it points out her turn to allegory and apt devices'. In the nineteenth century this picture begins to be mentioned individually in the inventories. Inventory of Hatfield House 1823: In the Drawing Room: 'Portrait of Queen Elizabeth; perhaps the most

pleasing and genuine extant; – it is also (particularly in the colouring) one of the best specimens of this Master – Zucchero'. In 1868 it is mentioned under No. 29 as hanging in the Yew Room, South Side: 'Elizabeth Queen of England holding a rainbow with the motto 'non sine sole iris' – F. Zucchero'. In 1720 this portrait was already noted by Vertue when he visited Hatfield.

Exhibition: Art Treasures Exhibition, 1857 (672), label on back; *Cat. Portraits 1866*, 267, see label; *Cat. Tudor 1890*, No. 1410B; Elizabethan Exhibition, 1933 (206); Portraits of Queen Elizabeth, National Portrait Gallery, 1958.

Literature: Vertue, I, 58; Musgrave, f. 79; Add. MS, 5726 E.I, f. 10; Pennant p. 406; Robinson, p. 28; S.S.B. *76*, ff. 31–2; 81. f, 60; O'Donoghue, *op. cit.* No. 61; Holland, No. 52 erroneously as by Zuccaro; F. Yates, 'Queen Elizabeth as Astraea'. *Warburg Journal*, X, 1947, p. 61, note 3; and *Allegorical Portraits of Queen Elizabeth I at Hatfield*. Piper, *De Critz*, p. 224; Mercer, Pl. 56b, p. 179; Strong, *Elizabeth I*, Paintings, No. 100, pp. 21, 85–6. Strong, *English Icon*, p. 299, No. 304.

52 [22] ill. 34, p. 133

Mary, Queen of Scots (1542–1587)

Daughter of James V of Scotland and Mary of Guise, cousin of Elizabeth I. After the death of her husband Francis II, King of France, Mary Stuart, a Roman Catholic, returned to Scotland and in 1568 she fled to England, where she remained a prisoner until 1587 when she was beheaded

Painter unknown

Panel 77 × 41 in. (196 × 104·2 cm.)

A full-length life-size figure slightly turned to the left. She stands on a patterned carpet, and her right hand rests on a table covered with a red tablecloth; her left, hanging down, touches the

edge of her rosary. She stands against a wall and on the right-hand side is a green taffeta curtain which catches the light in vivid reflections. She wears a long back dress and a white cap, from which a light grey, transparent lace veils falls to the floor. The lace partlet opens into a standing ruff, open in front. A small crucifix and a larger cross with a rosary are suspended from gold chains. The goldsmith's work on these ornaments is of a good quality.

Inscription in yellow Roman letters at the top of the left hand side runs as follows:

'MARIA

D – G

PIISSIMA REGINA

FRANCIAE DOTARIA

ANNO

AETATIS REGNIQ

36

ANGLICAE CAPTIVIT

10

s . . . H (Salvationis Hominum)

1578'

In the left-hand corner on the carpet in modern white letters: 'Painted, By, Hilliard'.

Collection: From accounts and inventories the provenance of this portrait can be followed up from its earliest history to its present place in the Hatfield House collection. According to Account 160/1, July 4, 1609, payment was made under 'Rewards and Gifts': 'To my L: Lumleys man who brought your Honor Pictures wch was given your Lo: as a legacye – 4 *l.*'

Shortly afterwards, in the same Accounts on December 6, 1609, the following entry appears, again under the heading 'Rewards and Gifts paid': 'To my La: Lumleys man who brought your honor a picture of the Queene mother of Scotland – 40*s*'.

In the Lumley Inventory of 1598 (Walpole Society, VI, 1918) a portrait of Mary, Queen of Scots, is listed and it may be assumed that it was this painting which was bequeathed to Sir Robert Cecil, though no mention of this legacy can be found in Lord Lumley's will. In 1609, it must have been taken to London and delivered to Salisbury House, and indeed in 1629 (Salisbury House Inventory, Box C.8) we find a reference to '1 faire picture of the Queen Mother of Scotland' in the great Chamber. (Two small pictures of the Queen are also mentioned as being in the Wardrobe.) In 1639/40 (Box C.9), a similar entry appears, just as in the inventories of 1645/6 (Box C.4 and 5). Finally, in the inventory of 1685, April 3 (Box C.7) reference to this painting has disappeared. Instead, we now find it for the first time in the Hatfield House Inventory for 1679, March 3 (Box A.10): '1 Picture of Mary Queen of Scots' in the Gallery. It is also described by Pennant as in the Gallery in 1780. In the inventory of 1823 in the Winter Dining Room: 'Mary Queen of Scots after she had been 18 years in prison – N. Hilliard'. In May 1868, under No. 81 in the Winter Dining Room, South Side: 'Mary Queen of Scots painted a few days before her death – Nicholas Hillier 1573'. From these documents it becomes clear that this portrait came from the Lumley Collection to Salisbury House and thence to Hatfield House, where it remained.

The Hatfield House portrait comes nearest to No. 1073 in the National Portrait Gallery of Scotland and to that at Hardwick Hall, although the latter shows slight differences in the sleeves. A similar portrait, much restored, is No. 429 in the National Portrait Gallery. This type is called the 'Sheffield' portrait of 1578, alleged to have been painted by the imaginary Peter Oudry when the Queen was in Sheffield in captivity. The authentic likeness of this type is based on Hilliard's miniature, painted *ad vivum* in that year (Auerbach, *Hilliard*, pp. 76–7, 294). It may be this miniature, which was to be sent to Archbishop Beaton in France, to which a letter from Claude Nau, Mary's secretary, refers. Another version,

painted by Mytens at a slightly later date, is in Holyrood House.

There is no reason to assume that the Hardwick Hall portrait is the original from which the picture at Hatfield House was painted as a replica. It could easily be the other way round. Many replicas of portraits of Mary were distributed in her lifetime and afterwards, and many painters must have been commissioned to paint them. An example emerges from an Account book of William, Lord Cavendish, second son of Bess of Hardwick (Account Books, Vol. 29, 1608–13), in which Rowland Lockey, a pupil of Hilliard, was paid for work on portraits of the Scottish Queen (Auerbach, *Hilliard*, pp. 255–56).

Jan. 1609/10
To Mr. Lockeyes man for goinge with the Queene of Scotts Picture to my Lo: of Arundells and twoe porters to carry it 3s.
c. 21 June 1613
To Mr. Lockey's men that brought the Scotche queenes picture 2s.
To Mr. Lockey for the Scotche Queenes picture presented to my lord privy seale [Henry Howard, Earl of Northampton] nyne pounds 9l.
For frame and gulding it 10s.

Rowland Lockey was, therefore, one artist frequently engaged to paint Mary's portrait.

Exhibition: Cat. Portraits 1866, No. 305.

Literature: Vertue, I, 58, II, 37, IV, 16, VI, 90; Musgrave, f. 79v; Pennant, p. 409; Robinson, p. 28; Holland, No. 22 as 'Painted by P. Oudry, at Sheffield, in 1578'; Sir Lionel Cust, *Notes on the Authentic Portrait of Mary Queen of Scots*, 1903, pp. 77, 80–2; A. Lang, *Portraits and Jewels of Mary Stuart*, 1906, pp. 39ff.; Millar, pp. 78 and 85; Strong, *Cat. N.P.G.*, pp. 215 and 223, Pls 435 and 436.

53 [23] ill. 35, p. 133

?Mary, Queen of Scots aged 17 (1542–1587), perhaps a later copy of a sixteenth-century picture

Painter unknown

Panel under glass 35 × 25 in. (89 × 63·6 cm.)

A life-size, half-length figure, turning to the right, eyes facing the viewer. Mary is wrapped up in a large black veil, which glides over her hair and encircles the top part of her costume, falling in folds below her waist. Her right hand is seen holding the veil in front. This type of veil is called a 'heuck', and it was a Flemish sixteenth-century custom to wear it. She has a closely fitting ruff and an embroidered cap on her hair. Her dress is black, studded with triplets of pearls; the sleeves are white with black and yellow stripes.

The treatment of the painting and the modelling of the face are softer and smoother than would have been characteristic of a sixteenth-century work. Again, the expression is more sophisticated than in a contemporary rendering. It seems more likely to be by an eighteenth-century hand. The portrait type is based rather on Clouet's drawing done when Mary was very young, than on Hilliard's miniature of 1578.

Collection: This portrait seems to appear for the first time at Hatfield in 1769, when Musgrave saw it in the Gallery. It is listed in the inventory of 1823 as in the Drawing Room, under the heading: 'Mary Queen of Scots, when very Young, painted on Pannel . . . ½ Length . . , Zucchero. N.B. See a similar Portrait at Wanstead with its curious History.' It was noticed by Robinson, p. 28 in 1833. In about 1866 the second Marquess of Salisbury dictated the following memorandum about the picture: 'Yew Room. Portrait of Mary Stuart. To protect it from injury it was deemed desirable to glaze it, and for that purpose an old looking-glass was used. In front of the portrait the quick-silver was removed from the glass. A margin, however, was left on the top, bottom and sides of the picture, and to this is due to present singular effect'. (Family Papers, Vol. 15/327).

In the 1868 inventory, 'Mary Queen of Scots at the age of 17 . . . L. de Heere' was No. 33 and was hanging at the west end of the Yew Room.

A miniature copy of this picture was made by Henry Bone (1755–1834) and is now No. M.25 in the Wallace Collection.

54 [21] ill. 36, p. 134

Alessandro Farnese (1545–1592)
Alessandro Farnese, Duke of Parma, was Governor General of the Netherlands from 1578 to 1592

After Titian (?) (*c*.1487/90–1576)

Canvas 20½ × 14¼ in. (52·1 × 36·2 cm.)

A life-size bust portrait, turned to the right. The face is clearly drawn with strong features. The armour is richly adorned. He wears the Order of the Golden Fleece. A label on the back reads: 'Don Ferdinando Alvarez, Duke of Alva, Governor of the Netherlands, 1568'. For the likeness of Alessandro Farnese, see Harrison, *Tudor England*, II, p. 50, based on a painting by Van Vaen (Vaenus), Musées Royaux d'Art et d'Histoire, Brussels.

This painting was erroneously called *Don Fernando Alvarez de Toledo*, Duke of Alva by Holland.

Collection: Mentioned in the 1868 inventory No. 210, under 'Picture not hung up – Duke D'Alva Governor of the Netherlands (1568) Pardenone'.

55 [27]

Henri de Lorraine, Duc de Guise, named 'Le Balafré' (1550–1588)

French School; the original is believed to be in the collection of the Comte de Paris, Château d'Eu

Panel 21¼ × 16¾ in. (54 × 42·5 cm.)

Inscribed top left in Roman letters: 'Henry Dux Guysse'

Life-size bust, turning three-quarters to the right. He has a black patch on his left cheek, a short beard and a dark gown with buttons and plain open collar.

A nineteenth-century label on the back reads: 'Henry Duc de Guise. Uncle on the maternal side to Mary Queen of Scots painted by Pourbus'. A further nineteenth-century label on the back is inscribed: 'Duke de – No. 4'.

The likeness agrees with a drawing reproduced by Harrison, *op. cit.*, II, p. 47, as School of François Clouet, Chantilly, in spite of a different hair style. The features and the expression are similar. He also wears a plain collar in the drawing which was probably worn earlier in France than in England. Guise is known to have been wounded, so the patch on his face supports the identification. This is not a very good picture and is in a bad state of preservation.

Collection: A picture of 'the Duke of Guices' appears in the Salisbury House inventory for 1629 (Box C.8) as in the Gallery. This is repeated for 1645/6 (Box C.4 and 5).

Musgrave and Pennant in 1780 saw *three* 'Dukes of Guise' in the Gallery of Hatfield House (cf. No. 24 [20a] above). In the Hatfield House Inventory for 1823 we find in the Drawing Room the 'Head of Henry, Duke of Guise'. By 1868 it was in the Yew Room, South Side.

Literature: Holland, No. 27, mentions two portraits of Henri de Lorraine, Duc de Guise in the Lenoir Collection: one large head from a painting and a small one from a faint drawing in red and grey chalk, probably by Dumontier.

56 [30] ill. 37, p. 134

Henry III (1551–1589)
King of France

French School; the original is believed to be in the collection of the Comte de Paris, Château d'Eu

COLOUR PLATE VII. **Elizabeth Cecil, Mistress Wentworth,** or **Elizabeth Brook, Lady Cecil,**
*c.*1580–85, painter unknown (Cat. No. 60, p. 67)

COLOUR PLATE VIII. **Philip Herbert, 4th Earl of Pembroke,** *c.*1628, by Daniel Mytens (Cat. No. 86, p. 87)

Panel $21\frac{3}{4} \times 16\frac{3}{4}$ in. ($55 \cdot 2 \times 42 \cdot 5$ cm.)

A life-size bust portrait, turned three-quarters to the right. He wears a black dress with jewelled buttons and a plain open collar, a hanging pearl in his right ear and a brooch with pearls in his black cap.

A label on the back is inscribed: 'Henri III, Roi de France et de Pologne [died] 1589, corrected by Henri d'Orleans (Duc d'Aumale), November 24th, 1859'. An older label reads: 'Brother to the Duc de Guise, painted by P. Pourbus'. On the frame the inscription: 'Duke de Guise' and another label 'No. 7'.

Henry III was the fourth son of Henry II and Catherine de Medici. In 1574 he succeeded his brother Charles IX on the throne of France. He was stabbed to death by a monk at St Cloud.

This portrait is crudely executed and has been much repainted. The identity of the sitter is confirmed by comparison with a drawing in reverse of the King by an unknown artist in the Bibliothèque Nationale, Paris, 1571 (Na 22 rés.).

Collection: Probably always in the family collection. Salisbury House inventory 1629 (Box C.9): 'In the Gallarie – 1: Picture of Hen. 3d. kinge of France'. The same entry in 1639/40 and 1646 (Box C. 4 and 5).

In the eighteenth and nineteenth century this portrait was sometimes called the 'Duke of Guise' (cf. No. 24 [20a] above). In the Hatfield House inventory of 1868: Yew Room, South Side, No. 31, 'Henri 3rd – King of France – F. Pourbus'.

57 [45] ill. 38, p. 134

Louise of Lorraine (1554–1601)

Louise of Lorraine was the daughter of the Count of Vaudemont. She married King Henry III of France on February 15, 1574. Her husband was assassinated in 1589. She then retired from the Court and died on January 29, 1601, at the Château de Moulins

French School

Panel $21\frac{1}{4} \times 16\frac{3}{4}$ in. ($54 \times 42 \cdot 5$ cm.)

This life-size bust is quite well painted in a light orange colouring. According to Dr de Witt it is painted on paper attached to a panel. It is French in style. The likeness agrees with that in Niel's *Personnages Français du XVIe Siècle*, I, No. 15.

A nineteenth-century label on the back reads: 'This lady has been said to be the Queen of Bohemia. I consider it to be some other lady'. Rest deleted. Written on the bottom of the frame are the words: 'Daughter of James the first'.

Collection: It is possible that the following entries refer to this portrait. In 1823 in the Marquess's Sitting Room there was a picture of 'Elizabeth Queen of Bohemia – Janssen'; and in 1868 under No. 93 in the Winter Drawing Room, West End, we find 'Queen of Bohemia, daughter of James 1st – F. Pourbus'.

Her likeness agrees with that of a drawing of Louise of Lorraine in the Bibliothèque Nationale (Na 22 rés.), *c.*1575, attributed to Jean Rabel (1545–1603). The costume appears in the '*Bal a la Cour de Henri III*' in the Museum at Blois.

58 [54] ill. 39, p. 135

A Large Grey Horse, 1594

Painter unknown, probably of Flemish origin

Canvas 96×105 in. (244×267 cm.)

A very well-painted grey stallion, seen in profile, fills almost the whole width of the large canvas. The animal is unsaddled and led on the left-hand side by a man dressed in black with a white collar and holding a black bridle. He is probably a servant of Sir Robert Cecil and is portrayed in a well modelled and realistic way. The scenery is a park landscape, and on the brown ground there are convolvuluses and daisies. The horse is rendered in a silvery colour, and above it,

between the two dark framing trees, the open view into an imaginary hilly landscape appears, which is illuminated by the morning sun. The frame, probably of a later date, resembles that of the 'Ermine Portrait' and bears the inscription 'A⁰ DNI 1594. Reg: ELIZA 36'.

Two different stories about this horse exist. According to one, Queen Elizabeth was once riding it at Tilbury and subsequently presented it to Robert Cecil. According to the other, Cecil is supposed to have bred horses of that type. However the story goes, this is a most interesting picture. In many ways it comes near to a portrait of Henri IV on horseback at Boughton, owned by the Duke of Buccleuch from the Montague Collection. (Before cleaning in 1949 Edward VI's head had replaced that of Henri IV.) The horse he is riding is also white, seen in profile, in a very similar position, but the sex differs and the head is harder and more detailed. There is, however, a certain similarity in the romantic landscape in the background. In France of the sixteenth century the King was often portrayed riding on horseback but in spite of the French tradition the Hatfield House painting is more Flemish than French in style.

Collection: Probably always in the family collection. The first Hatfield House Inventory when it is mentioned as hanging in the Hall is that of June 9, 1629 (Box A.6, f. 8): 'A fair picture of a horse'. In the inventories before that period no pictures were hanging in the Hall. It is further listed, still as in the Hall, in 1638 (Box A.7, f. 28); in 1646 (Box A.8 and 9, f. 15); in 1679/80 (Box A.10, f. 2) as '1 large picture of a Horse and His Keeper'. Further, in 1823 in the Marble Hall: 'A very large Picture, the Portrait of a White Horse, led by a Gentleman'. Robinson, p.19, noticed 'the large grey horse presented by Queen Elizabeth to Robert Cecil in 1594'. Finally, according to the 1868 inventory under No. 178, it was still hanging in the Marble Hall: 'Queen Elizabeth's grey

Horse which she rode at Tilbury Fort at the time of the Spanish Armada'.

Literature: Holland, No. 54.

59 [55] ill. 40, p. 136

An Unknown Lady, *c.*1585–90, formerly called Anne, Lady Hunsdon

Painter unknown

Panel (cleaned 1965) 43½ × 34½ in. (110·5 × 87·6 cm.)

A life-size, three-quarter length figure in full frontal position, standing against a dark background with a green curtain on the right-hand side. She wears a black dress with wide sleeves embroidered, almost embossed, with white flowers with red centres, standing away from the black material. The gown opens above a dark grey skirt, patterned in ochre to make it look like brocade. A three-string pearl chain slips through her right hand, and in her left, which hangs down, she holds a brown feathered fan with a handle painted in gold leaf. A huge closely-fitting wide wheel ruff dates the picture as approximately 1590.

This interesting late-Elizabethan portrait is most impressive and decorative – a proper costume piece – but more plastic and sharper in treatment than many otherwise related pictures. It is therefore difficult to attribute it to any known painter.

A nineteenth-century label on the back says: 'Ann wife of Henry Carey Lord Hunsdon, Cousin to Queen Elizabeth: Painted by Lucas de Heere'.

Collection: Although this portrait cannot be traced in the early inventories, it may be hidden under another name. Only in the nineteenth century, apparently, was it called Lady Hunsdon. The inventory of 1823 mentions 'Lady Hunsdon, Cousin to Queen Elizabeth, a half-Length' as

hanging in the Breakfast Parlour. The inventory of 1868 lists under No. 37 as in the Yew Room, North Side, the portrait of 'Ann Wife to Henry Carey, Lord Hunsden – Lucas de Heere'. The identification of the sitter as Lady Hunsdon is, therefore, only a nineteenth-century suggestion.

An almost identical version of this portrait is, however, at Helmingham in the collection of Lord Tollemache. The only difference is that – though the features of the face are similar – the treatment gives the impression that the Helmingham lady is slightly younger. Otherwise it is an exact replica. This fact may perhaps lead to a possible identification, if one could find a link between the two families concerned. Two different lines seem to suggest themselves.

The 1958 Helmingham Catalogue, written by Professor Ellis K. Waterhouse, lists under No. 39: *A Lady in black and white*, Wood: $43\frac{1}{2} \times 33\frac{3}{4}$ in. (110·5 × 85·7 cm.) The Tollemache fret has been added upper left. The approximate date of the painting is 1585–95. Whereas the 1821 catalogue had suggested Katherine Cromwell, Professor Waterhouse is inclined to think rather of Susan, daughter of Sir Ambrose Jermyn of Rushbrooke, wife of the 3rd Lionel Tollemache of Helmingham (1545–1575) whose second marriage, in 1577, was to Sir William Springe of Pakenham. As to the possible painter the catalogue entry continues: 'It may be by the hand who signed IB (? John Bettes) a portrait of 1587 belonging to St Olave's School, London'. Though there is a similarity in style, it should be noted that 'An Unknown Girl' by JB, reproduced by Auerbach, *Hilliard*, Pl. 234, is much more linear than the Hatfield and Helmingham portraits. In a correspondence between Lord Tollemache and Mr C. Kingsley Adams, the former pointed out that some of his pictures at Helmingham Hall descended from the Mackwilliam family. According to a pedigree of that family, it appears that Henry Mackwilliam of Stambourne Hall, Essex, married Mary, née Hill, the widow of Sir

John Cheke, whose sister, Mary, was the first wife of William Cecil, Lord Burghley, whose portrait is also included in Lord Tollemache's Collection. Lord Burghley's sister-in-law lived from 1533–1617 and her dates would fit our portrait. Again, there is a portrait believed to be that of Mrs Mary Mackwilliam, dated 1567, at Helmingham Hall which could possibly be – according to the late Mr Adams – taken as representing the lady with the wide ruff at a younger date. However, I am more inclined to suggest her daughter Margaret Mackwilliam, wife of Sir John Stanhope, Lord Stanhope of Harrington.

Another link may be with the family of Robert Devereux, 2nd Earl of Essex, from whose daughter the Tollemaches descended. It is just possible – as Miss Carolyn Merion suggests – that the two portraits in Hatfield and at Helmingham might represent Essex's wife Frances Walsingham. The likeness could agree with a possible portrait of her, attributed to Segar and reproduced in Auerbach, *Hilliard*, Pl. 242. After Essex's death in 1601 his widow and her son the 3rd Earl of Essex were closely associated with the Cecils.

Literature: Holland, No. 55, erroneously called Anne, Lady Hunsdon, painted by Lucas de Heere; Waterhouse, *Tollemache Cat.* as described above; Strong, *English Icon*, No. 145, as Mary Hill, Mrs Mackwilliam, circle of Gower.

60 [56] Colour Plate VII, opp. p. 64

Elizabeth Cecil, Mistress Wentworth
(1564–1583), *c.*1580–85
Elizabeth Cecil was the daughter of Lord Burghley and Mildred Cooke

or

Elizabeth Brook, Lady Cecil (1563–1597), *c.*1580–85
Elizabeth Brook was the daughter of William Brook, Lord Cobham and the wife of Robert Cecil

Painter unknown

Panel 41½ × 35 in. (105·4 × 86·4 cm.)

Life-size standing figure in frontal position against a plain background, the face turned three-quarters to the left, eyes looking in the opposite direction. The lady is dressed in a light gold coloured dress with a long stomacher, a farthingale and embroidered sleeves. The pattern in gold and pale green on white shows Tudor roses, carnations and strawberry flowers. The radiating close-fitting lace ruff is of the kind worn between 1580 and 1590. She holds a white lace fan suspended from a brown ribbon, and she wears a long chain of gold and pearls. A pearl diadem sits on curly hair. This is a fine late Elizabethan painting of good quality, probably painted by an Anglo-Flemish artist. It could have been painted by Gheeraerts or de Critz.

As to dates and ages, the identification of the sitter as either the sister or the wife of Robert Cecil, would be possible. There is documentary evidence that a portrait of Mistress Wentworth was in Hatfield House from 1611 onwards.

Collection: If this is a portrait of Elizabeth Wentworth, it is quite likely that it came to Hatfield from Cecil's house at Enfield some time after 1597, when a picture of 'meistris Wentworth' was listed there (Box D.4, Part 2).

When, according to the inventory of 1611, September 30 (Box A.1), no pictures were hanging in the Hall or in the 'Greate Parlor', a picture of Mrs Wentworth is mentioned as hanging in the Ante-Chamber. In July 1612 (Box B.5) it is again listed, and on August 20, 1621 (Box A.4 and 5) 'one picture of Mrs. Waintworth' is hanging in 'your Lo: booke chamber'. In 1629 (Box A.6), 1638 (Box A.7) and 1646 (Box A.8 and 9), among pictures in the gallery, again 'i of Mistris Wentworthes' is included. In 1679/80 (Box A.10) 'i Picture of Mrs. Wentworth, said to be Lord Burleigh's Daughter' is still hanging in the Gallery.

In 1823 we find in the 'Breakfast Parlour' 'Mrs. Wentworth, Sister to the First Earl of Salisbury daughter of Lord Burleigh married to Viscount Wentworth's eldest Son, a half length ... N. Hilliard', and in 1868 'Elizabeth, Lady Wentworth – Lucas de Heere' appears under No. 62.

As to a portrait of Elizabeth Lady Cecil, Sir Robert's wife, there are only a few entries in the Salisbury House inventories. On June 20, 1629 (Box C.8) a picture of 'my Lo: Salisb. mother taffe[ta curtaine]' was hanging in 'my Lords dressinge Chamber' (to which it seems to have been moved from the Wardrobe, cf. f. 6d); and in 1639/40 (Box C.9), and 1646 (Box C.4 and 5) it is mentioned again. Even on August 30, 1692 (Box C.12) three pictures are entered under 'my Lords dressinge Chamber', though the sitters are not named. There is no mention of such a portrait in any of the Hatfield House inventories, and in 1833 Robinson stated that no picture of her existed in the collection. For the identification with Lady Cecil, see also below under No. 61.

Documentary evidence would seem therefore, to point in favour of identifying No. 60 [56] as a portrait of Lady Wentworth. The latter died at the age of eighteen, and the portrait shows a very young person. Her features and her long thin pointed face may even point to a likeness with that of the two portraits of Lady Burghley, her mother.

A third, perhaps remote, possibility emerges from the documents. We know that John de Critz was paid £4 in 1607 by the 1st Earl for painting a portrait of the Earl's other sister, Anne, Countess of Oxford (1556–1588) (Box U.81). See below under No. 66 [60]. There is also evidence that a portrait of the Countess was at Salisbury House from 1629 until 1646. See Introduction, p. 14.

Exhibition: Cat. Portraits 1866, No. 240.

Literature: Holland, No. 56 as Hon. Elizabeth

Cecil, Mrs Wentworth (after 1563–?) – Lucas de Heere.

61 ill. 41, p. 137

Elizabeth Cecil, Mistress Wentworth (1564–1583), *c.*1580–85
or
Elizabeth Brook, Lady Cecil (1563–1597), *c.*1580–85

Painter unknown

Panel 22¼ × 17¼ in. (56·5 × 43·8 cm.)

Identical sitter and bust version to No. 60 [56]. This picture was bought in August 1843 by the 2nd Marquess of Salisbury at the sale of the collection of the Rev. William Carr. It was said to have come originally from Bolton Abbey.

On the painting is an inscription calling it 'Lady Robert Cecil', but the inscription is of the eighteenth or nineteenth century, and therefore too recent to have much authority behind it. The date 1595 could be contemporary although posthumous.

62 [57] ill. 42, p. 137

Henry IV (1553–1610), *c.*1610

King of France

By or after Frans Pourbus the Younger (1569–1622)

Canvas 79 × 44½ in. (201 × 143 cm.)

Henry of Navarre was the son of Antoine de Bourbon and Jeanne d'Albret. He became King of France in 1589. His first wife, Marguerite de Valois, whom he married in 1572, he divorced in 1592. His second wife was Marie de Medici. He was murdered by Ravaillac in Paris.

This is a full-length, life-size standing portrait in an interior, enlivened by two curtains, a chest or table covered by a fringed carpet and a chequered brown, red and white floor. The King wears a black slashed doublet and hat and the Order of St Esprit. A grey beard, blue eyes and red lips give a distinct likeness. In his right hand, strangely turned aside, he is holding a stick. The inscription in the bottom corner on the right hand side reads:

'HENRY THE FOURTH OF FRANCE'

A similar portrait is in the Royal Collection and it is possible that the Hatfield one is a copy of it. There have been, however, some alterations – which might explain the badly drawn position of the King's right hand.

The portrait in the Louvre shows the King without a hat and is altogether different. At Boughton Henry IV is painted on horseback.

The most important portrait painters in France of that period were the Flemish Frans Pourbus the Younger (1569–1622) and Jacques Bunel (1558–1614). To the latter no works can be attributed with certainty at the present time. The author of this portrait is, therefore, difficult to ascertain.

Collection: In the Hatfield House Inventory of 1611 (Box A.1) 'one great picture of the King of France' is mentioned as hanging in 'The Wardrobe Upper Sto:'. It seems very likely that this means Henry IV, who had just died. The same entry is repeated again in 1612 (Box B.5), but there is no reference to such a picture in 1629 or in the immediately following inventories. However, in the inventory of Salisbury House of June 20, 1629 (Box C.8, f.3) 'In the Gallarie' there is hanging '1: Picture of Hen: 4th Kinge of France'. This entry is clear and is repeated in 1645/6 (Box C.4 and 5). It is possible that by 1679/80, May 3 or 24, (Box A.10) this portrait had already been moved back to Hatfield House, where there is a note that '1 Picture of Henry 4th K. of France' is hanging in the Gallery. In 1769 Musgrave saw it in the Lumber Room. Robinson, p.28, mentions it in 1833. In the inventory of

1868 under No. 89 there appears 'Henry IVth King of France . . . N. Lysard' in the Winter Dining Room, West End. Perhaps we can assume that this portrait, hanging first at Hatfield, then at Salisbury House, and again at Hatfield, has always been in the family collection.

63 [59] ill. 43, p. 138

Isabella Clara Eugenia (1566–1633)

Isabella Clare Eugenia was the Infanta of Spain, wife of Albert, Archduke of Austria and with him the ruler of the Spanish Netherlands.

?Gysbrecht (d. 1628) or Otto van Veen (1558–1629)

Canvas $25\frac{1}{4} \times 21$ in. (64·1 × 53·4 cm.)

Bust portrait, Spanish-looking face. She wears a closely fitting radiating ruff, a black and gold embroidered costume, which is adorned with jewellery and completed by an elegant feathered headgear. The picture is well preserved, though in parts repainted. A nineteenth-century label on the back reads: 'Margaret of Austria Painted by Velasquez'.

Despite the label, there is evidence from seventeenth-century inventories that this picture was originally identified as the Infanta Isabella and was a companion portrait to No. 64 [69] below, her husband the Archduke Albert.

Even more important evidence for the identity of the sitter emerges from three letters of Filippo Corsini to Robert Cecil in 1599, to which Miss Talbot has recently drawn my attention. The first one, dated September 13, is an acknowledgement of Cecil's request for the portraits of the Infanta and her husband which Corsini promises to have drawn speedily and secretly. (Cal. IX, 345; Cecil Papers, *73*. 94). In the second, of October 19, Corsini says his friend is carrying out the commission. (Cal. IX, 440; Cecil Papers, *74*. 40). The third, which is the most

interesting, is dated November 14. (Cal. IX, 391; Cecil Papers, *74*. 87). Corsini now announces that the portraits have been completed and have arrived in London from Antwerp, where they were painted from life and by one of the best masters available. ('*Al. naturale et di bono Maestro, dell meglo che sieno in quel paese*'.) He says his friend in Antwerp has made them a gift to him, and he goes on to beg Cecil to accept '*il piccolo dono*' without payment. Corsini again stresses the fact that the business has been done '*con ongni segretezza secondo che ley mia comandato*'.

For what purpose was Cecil commissioning portraits of the Infanta and her husband in 1599? The Earl of Essex at his trial in February 1601 claimed that the Secretary had chosen this lady as the best candidate to succeed Queen Elizabeth. Cecil denied the claim, and later, as is well known, threw his influence onto the scales on the side of James VI of Scotland. But it seems likely that he had ambivalent feelings in 1599 and 1600 (see Fr. Leo Hicks, 'Sir Robert Cecil, Father Persons, and the Succession Question 1600–1', *Arch. Hist. Soc. Iesu XXIV*, 1955, (95–139). Can we accept this picture and No. 64 [69] as the ones acquired for Cecil by Corsini in 1599?

Oliver Millar has pointed out that the portraits of the same sitters by Gysbrecht van Veen were given to James I in 1603 (Millar, p. 14). Probably William Fouler is referring to the latter in February 1604/5 when he tells Cecil (now Viscount Cranborne) that Queen Anne is thinking of giving away 'two pourtracts of the Archdukes and Infantaes'. These can hardly be the portraits at Hatfield, because Fouler describes them as 'verie fayre Large & costlie. And above xiiij Florens paid for the workmanship.' Cal. XVII, 54; Cecil Papers, *188*. 61).

A comparison of this portrait with Renold Elstrack's engraving of the Infanta after Rubens, reproduced by Hind, II, Pl. 98a, is possible, but more conclusive, however, is Isabella, a full-length portrait, engraved by Collaert (F. C.

Caeiro, O *Arquiduque Alberto de Austria*, Pl. 30).

Collection: Hatfield House Inventory, September 1611 (Box. A.1), mentions 'In the East range 2 Sto:' (where the King's rooms were) 'in the Lobbie betwene the great chamber and the Gallery . . . one pickture of the Archduke' and 'one pickture of the infanta etc.' In July 1612 (Box B.5) this entry was repeated. But by 1629 we find the two pictures at Salisbury House (Box C.8, f.3, 15): 'In the Gallarie. 1: picture of the Archduke of Austria. 1: picture of the Infanta'. This is repeated in 1639/40 (Box C.9) and in 1646 (Box C.4 and 5). Nothing further appears until 1823, when the Hatfield House Inventory mentions, in the Drawing Room, 'Margaret of Austria, wife of William [!] the Third of Spain – Velasquez'. In the 1868 inventory, No. 88, 'Margaret of Austria Queen to Philip 3rd of Spain – Velasquez' was hanging in the Winter Dining Room, South Side. It therefore emerges from the documents that only in the nineteenth century was the identification with the Spanish King and Queen suggested.

Literature: Holland, No. 59, as *Margaret, Queen of Spain*. Correction in MS by Mr F. M. Kelly as Infanta Isabella Clara Eugenia, wife of Archduke Albert. Letter from Mr Oliver Millar to Brigadier Trappes-Lomax, dated December 5, 1960, in Hatfield House Documents.

64 [69] ill. 44, p. 138

Albert, Archduke of Austria (1559–1621)
Albert, Archduke of Austria was Governor of the Netherlands

?Gysbrecht (d. 1628) or Otto van Veen (1558–1629)

Canvas 25¼ × 21 in. (64 × 53·4 cm.)

Bust portrait. The sitter wears a black cap with feather, a black cloak, gold-embroidered doublet and a close-fitting radiating ruff. Around his neck hangs a cerise-coloured ribbon – the Order, however, is cut off by the frame of the painting.

This is a companion picture to No. 63 [59]. It also seems to be by the hand of a Flemish painter. A nineteenth-century label on the back reads:

'Philip the third of Spain
painted by Velasquez'

A comparison with Elstrack's engraving of the Archduke of Austria, Hind, II, Pl. 88a, points clearly to the Archduke as the sitter.

Collection: cf. under No. 63 [59].

Literature: cf. under No. 63 [59].

65 [58] ill. 45, p. 139

François Ravaillac (1579–1615)

By an unknown Franco-Flemish artist

Paper (coloured drawing) 10¼ × 8¼ in. (26 × 21 cm.)

Bust under life-size, three-quarter view to the right, eyes looking to the left. The face of a bearded man with a moustache, wearing a flat black cap and a black bodice. A sinister look and appearance fits the sitter, who was the murderer of Henry IV of France, and was executed for that crime in 1610.

A good watercolour drawing with fine shading and modelling by means of hatching. The face in a brownish tint stands out from a plain white paper background. This drawing is the same size as No. 11 [10] but it has no red lines.

Collection: There is no trace of this drawing in the family collection until 1769 when Musgrave saw it in the Gallery. In 1823, however, in the Marquess's Sitting Room hangs a 'Portrait of Ravaillac'. It was noticed by Robinson in 1833. In 1868 under No. 212 'Ravaillac, the assassin of Henry 4th of France' appears under 'Pictures not hung up'.

66 [60] ill. 46, p. 140

Robert Cecil, 1st Earl of Salisbury (1563–1612), 1608

John de Critz the Elder (working from 1568–1641)

Panel 42½ × 36 in. (107·9 × 91·5 cm.)

The life-size, three-quarter length, frontal figure is dressed in full robes of the Order of the Garter. He holds a white wand in his right hand and touches the hilt of his sword with his left. The face is turned three-quarters to the left, and the eyes look at the spectator. He wears a closely fitting ruff, and the oval lesser George of the Garter is suspended from the Garter collar of gold knots and red roses. The motto '*sero sed serio*' in gold Roman letters is painted into the background on the upper left-hand side. Holland mentions this corner of the background, and in addition to the motto, a shield with Cecil's arms, but the shield has now disappeared. The motto was painted in later, apparently in flat gold leaf. There are other traces of damage and over-painting in that corner of the background. As Holland also gives the year of origin as 1608, it is possible that 1608 was part of the original inscription. A nineteenth-century label on the back reads: 'Robert first Earl of Salisbury. Principal Minister to King James the First. Born 1563, died 1612. Painted by Federigo Zuccaro'.

Robert Cecil was the only surviving son of Lord Burghley and Mildred Cooke. As successor to Walsingham, he became Secretary of State in 1596. He was created Lord Cecil of Essendon in 1603, Viscount Cranborne in 1604, and Earl of Salisbury in 1605. In 1606 he became a Knight of the Garter. He was appointed to the office of Lord Treasurer in 1608. He exchanged Theobalds for Hatfield with King James I in 1607 and had his own house built at Hatfield between 1607 and 1611. He died in 1612 without ever having resided there.

The painting is lively, expressive and well modelled. It appears to be conceived as a companion picture to the Garter portrait of Lord Burghley, No. 43 [36] above; but the style is more realistic, harder, stronger and more like a piece of sculpture than No. 43 [36], which shows a softer handling and a more sensitive conception of the likeness. One could, therefore, assume that whilst the painter of Lord Burghley's portrait was Marcus Gheeraerts the Younger, the author of this portrait was John de Critz the Elder. Both artists were of Flemish origin and worked in the same studio.

John de Critz the Elder (working from 1568–1641), came to this country in 1568 with his father as a religious refugee from the Netherlands. On May 11, 1605, he received the grant for life of the office of Serjeant Painter, and he remained in that office up to his death. Already in August 1606 he received payment for three full-length portraits of the King, Queen and Prince, and he is known to have executed many other portrait commissions. (For further details see Auerbach, *Tudor Artists*, p. 148.) He was already well known and appreciated by his contemporaries as early as 1598. His sister Susanna married Marcus Gheeraerts the Elder in 1571, and their son, Marcus Gheeraerts the Younger married a younger sister, Magdalen de Critz in 1590. (As mentioned earlier, No. 51 [52], Isaac Oliver, another member of the same refugee circle, was married to Sara Gheeraerts.)

Among the Hatfield manuscripts (Box U.81) there is a bill of 'Mr. John de Creett; s[erjeant] painter' for 'making of divers pictures for your Honour', dated October 16, 1607. It includes the following items:

'In primis a pictor of the Kings Majestie*ol.*
'Item a pictor of your Lordship which your Honnor gave to the Constable of Castile............*4l.*
'Item for twoo pictures the one of your Lordship the other of the Lord Treasurer your Lordship's Father which pictures were geven to Monsieur

Beaumont Ambassador of Fraunce8*l.*
'Item for altering of a pictor of Queene Elizabeth 1*l.*
'Item a pictor of your Lordship for the Lady Elizabeth Gilford...4*l.*
'Item a other pictor of your Lordship for the Embassador of Venice4*l.*
'Item for a pictor of the Countess of Oxford4*l.*

The bill came to 25*l.* but the Earl of Salisbury has annotated it, 'Pay . . . so farr as comes to 21 pownds', which sum John de Critz testifies that he has received.

In the surviving portraits of Robert Cecil at Hatfield House and elsewhere the same likeness is repeated, and we may suppose that this type was created by John de Critz the Elder. We here seem to stand on well-documented and safe ground.

An interesting fact about the purpose of contemporary portraits emerges from a letter written on April 29, 1609, by Viscount Bindon to the Earl of Salisbury, in which he requests his Lordship's picture in the Garter robes, 'to be placed in the gallery I lately made for the pictures of sundry of my honourable friends, whose presentation thereby to behold will greatly delight me to walk often in that place where I may see so comfortable a sight'. (Cecil Papers, *127. 33.*)

Collection: There are now eight portraits of Robert Cecil, 1st Earl of Salisbury, at Hatfield, including the Italian mosaic picture (No. 67 [61]) in the Library. Three of the portraits in oils (Nos 70, 71 [64], and 72) have been added to the collection in fairly recent times: this leaves four (Nos [63] (mislaid), 66 [60], 68 [62] and 69 to look for among seventeenth-century inventories.

In the Salisbury House Inventory of June 20, 1629, (Box C.8, f. 1d), John Glase notes that there is one picture in 'my Lords bedd chamber'. The sitter has been first described as 'his Lordships grandmother', and then 'grandmother' has been altered to 'father'. It seems most likely that this is the Earl of Salisbury not Lord Burghley, especially since the corresponding entry in the

inventory of 1639/40 (Box C.9) is definitely 'my Lords father'. This is repeated in the inventories for 1645/6 (Box C.4 and 5). Then in the next inventory, covering 1647 to 1663 (Box C.6), a note in the margin next to the entry seems to indicate that it has been transferred to Hatfield, where '1 Picture of Robert Earl of Salisbury' first appears in an inventory of March 24, 1679/80 (Box A.10, f.2), in the Parlour. In the eighteenth-century both Musgrave and Pennant mention a portrait of Salisbury in Garter Robes in the Common Parlour.

In 1823 there was in the Drawing Room 'The First Earl of Salisbury . . . Zucchero' and another portrait of him in 'the Marquess's Sitting Room'. In 1833 Robinson notes No. 66 [60] in Garter Robes on p. 29. In May 1868 there were three portraits of Salisbury at Hatfield House; one under No. 11 in the Summer Dining Room, West End; the second under No. 41 in the Yew Room, North Side; and the third under No. 95 on North Stairs, Lower Entrance. All three were erroneously ascribed to Zucchero. It is not quite clear to which individual portraits of Robert Cecil these inventories refer.

A similar version of this portrait is at Buckland Abbey, Devon, from Lord Clarendon's collection, see No. 43 [36].

Literature: S.S.B. *81*, p. 59. Holland, No. 60 as 'Painted by Marc Gheeraerdts in 1608'. For John de Critz, see Waterhouse, pp. 26 and 27, Pl. 21a; Auerbach, *Tudor Artists*, pp. 114, 119, 133, note 2, 134–5, 143, 148–9; Mercer, pp. 120, 153, 161, 182–3; Piper, *De Critz*, No. 2, pp. 221 ff; Strong; *Cat. N.P.G.*, p. 275, Pl. 541.

67 [61] ill. 47, p. 140

Robert Cecil, 1st Earl of Salisbury (1563–1612), made in Italy *c.*1608

After John de Critz the Elder (working from 1568–1641)

Mosaic 36 × 30½ in. (94·1 × 77·6 cm.)

The mosaic of excellent quality combines two different portrait types. The position of the Earl's left arm repeats in detail that of No. 66 [60], just as do the coat and other details of his garment. His right arm conforms to No. 68 [62], but there is no bell or purse on the table. The Earl's hair is of a lighter brown than on his other portraits. The outlines on the mosaic are much clearer than on No. 66 [60]. On the table lies a letter addressed to Robert Cecil in Italian and '*1608 Aeta 45*' is inscribed at the top of the portrait.

The complete story of this mosaic is fully documented: The following extracts from letters written by Sir Henry Wotton to the Earl of Salisbury are quoted from Logan Pearsall Smith's *The Life and Letters of Sir Henry Wotton*, 1907:

To the Earl of Salisbury
 Venice on good Friday, April 4, 1608
My Lord,

I must give your Lordship humble thanks, apart from the rest of my great obligations, for your picture wherewith it hath pleased you to honour me, which I now expect here within few days, having been long since shipped from thence. And when it cometh I shall be bold to put it into another material. I would likewise beseech your Lordship (if it might so please you) to send me your Coat armour in the true colours with the mantling and crest; for I have thought that being done here in mosaic, it may afterwards be very fitly placed in the front of your buildings over the portal, whereing shall be observed here such breadth and height as you will direct. And I assure your Lordship I have seen the like in this country stand with great decency and dignity . . .' (p. 419).

It is interesting to learn that a mosaic decoration of this kind was originally intended to adorn the outside of Hatfield House.

 Venice, April 24, 1609
'To the Earl of Salisbury,

In the rest of this sheet I will take the boldnes to advertise your Lordship, that having caused your picture to be made in mosaic, as the best present that I could conceive for my Lord of Cranborn, your son, in humble acknowledgment of my great obligations towards your own noble person and memory, and having long expected an opportunity to transport the same into England by sea, I have this week adventured it on a ship called the Thomas of London, bound directly homewards. . . . The picture is made precisely according to the draught of that wherewith your Lordship upon my humble request did honour me; I mean, as nearly as the natural colours of stone can approach to artificial, and so near indeed as I must confess unto your Lordship hath much exceeded mine own expectation. Only there is added a year more unto your Lordship's age, and to your titles *Gran Tresauriere d'Inghilterra*, the rest being likewise in Italian, for the workman would by no means give his consent (nor I neither) to the French superscription. It is directed to your Lordship in this time of my Lord of Cranborn's absence, whom I have advertised thereof by the way of Lions; and it is the workman's special suit and remembrance that it may be set in his true light, and at a little more height from the eye than a coloured picture would require. I will hearken after the success of it on the way, that if it should chance to miscarry (which I hope it will not), yet I may cause another to be made by the same hand and pattern. . .' (p. 452, No. 152).

A third letter was written by Sir Henry Wotton to William, Viscount Cranborne:

 Venice June 22, 1609
'It is long since I undertook (as some about your Lordship are able to tell you) a presumption and yet withal a duty, in causing my Lord your father's picture from a copy of Jhon de Creete's draught, to be transported here by no ill hand into mosaic . . .' (p. 460, No. 160).

He emphasizes that he has caused this to be done because of gratitude to Lord Salisbury who received him into his patronage and whose name he wished to honour.

From these letters the whole story unfolds: on April 4, 1608, Wotton received de Critz's portrait which must have been painted in 1606 when Cecil was made Knight of the Garter, or soon after. The mosaic was dispatched from Venice to London in the week ending April 24, 1609, and Wotton says he had long been waiting for an opportunity to send it to England. He also says the craftsman has added the title of Lord Treasurer. It must, therefore, have been finished sometime after May 1608 when Cecil was appointed to that post.

Collection: The mosaic can be followed up through all the inventories with certainty. Even before the earliest inventory of Salisbury House of 1629 we learn from 'A briefe note of the Stuff sent to Hatfield since the year 1612' (at the end of Box C.29):

'Anº 1617 j: Picktore of moziake worke of the late Lo: thresorare my Lo: his father.'

was among the works of art transferred to Hatfield. In the Hatfield House Inventory of June 9, 1629 (Box A.6, f.3d.) among 'Pictures in the gallerie' '1 of my Lord's fathers of muzaique worke' is mentioned. This entry is repeated in 1638, 1646, and 1679/80 (Box A.7, f.11, A.8 and 9, f. 5d, and A.10, f. 8d). The last entry refers to '1 Picture of Robert Earle of Salisbury in Mosaique worke' which was hanging in the Gallery. In 1769 Musgrave, f. 79v. and in 1780 Pennant, p. 406, still noticed it there. But by 1823 it was already hanging in the Library 'Over the Chimney Piece is a curious Portrait of the First Earl of Salisbury in Mosaic, copied from . . . Zucchero'. In the inventory of 1868 it is not mentioned.

Literature: Holland, No. 61 'A copy of a portrait by John de Critz somewhat similar to preceding done in mosaic at Venice'. Waterhouse, pp. 26 and 27; Mercer, pp. 119–20, Pl. 39a; Piper, *De Critz*, pp. 221 ff; Strong, *Cat. N.P.G*, p. 275.

68 [62] ill. 48, p. 141

Robert Cecil, 1st Earl of Salisbury (1563–1612), *c*.1606–8

John de Critz the Elder (working from 1568–1641)

Panel 35 × 27 in. (89 × 68·7 cm.)

A life-size, three-quarter length figure stands against a dark uniform background. The sitter wears a black suit, a plaited white ruff and a Spanish cloak over his left shoulder. The lesser George of the Order of the Garter is suspended from a blue ribbon around his neck, and his left hand, which he holds in a horizontal position, touches it from above. His right arm is stretched out, and the hand rests on a green-covered table on his right side. On the table there are a handbell, the red purse of office and two letters, one with his name and style of address visible on it.

An inscription in Roman gold letters on the left in line with the eyes reads: SERO, SED SERIO. On the letter on the table is written: 'To the right honorable Robert Earle of Salisburie; Viscounte Cranburn, Baron of Essingdon, principall Secretarie vnto His Matie, Mr. of the Courte of Wards & Liveries, Knight of the Most honorable order of the garter and of his Highness privy Counsell'.

The attribution to John de Critz the Elder is based on documentary evidence quoted under No. 66 [60] above. The face, always of a similar type, shows a long, broad and square shape and very precise and clear features – a very definite likeness, well expressed by an efficient portraitist. The picture has been recently cleaned.

Other versions exist. The earliest type probably belongs to Lord Petre, of Ingatestone Hall, and is dated 1599. It was exhibited at the Stratford-on-Avon exhibition in 1964 under No. 20. Another version is No. 107 in the National Portrait Gallery, dated 1602. Here there is a tassel instead of the Garter badge. This portrait was, there-

fore, painted before 1606 when he became a Knight of the Order.

Collection: See under No. 66 [60].

Exhibition: Cat. Portraits 1866, No. 259.

Literature: S.S.B. *81,* p. 60. Holland, No. 63 as 'Painted by Marc Gheeraerts the Younger'. Piper, *De Critz,* p. 221; Strong, *Cat. N.P.G.,* pp. 274–5, Pls 536 and 538; Strong, *English Icon,* pp. 22 and 260, Pl. 241.

69

Robert Cecil, 1st Earl of Salisbury (1563–1612), *c.*1607

John de Critz the Elder (working from 1568–1641)

Panel 35 × 27 in. (89 × 68·7 cm.)

An identical version of No. 68 [62]. This picture was apparently misplaced and therefore not mentioned by Holland.

70 ill. 49, p. 141

Robert Cecil, 1st Earl of Salisbury (1563–1612)

After John de Critz the Elder (working from 1568–1641)

Panel 22½ × 17⅜ in. (59·7 × 44·1 cm.)

Bought by the present Lord Salisbury. Cleaned and varnished: quite good and lively. Perhaps too many high-lights in hair and eyes.

The picture was inserted into an old frame which once contained Holland No. 63 another version of No. 71 [64].

71 [64]

Robert Cecil, 1st Earl of Salisbury (1563–1612)

After John de Critz the Elder (working from 1568–1641)

Panel 22½ × 17⅜ in. (57·2 × 44·1 cm.)

Bust portrait copied from the de Critz painting. His left hand partly visible. This picture was bought at the sale of pictures belonging to the Rev. John Mayne St C erc Raymond of Walter Belchamp Hall, May 29, 1894, Lot 90.

72 ill. 50, p. 141

Robert Cecil, 1st Earl of Salisbury (1563–1612), after 1606

Companion picture to No. 47

After John de Critz the Elder (working from 1568–1641)

Panel 85½ × 52 in. (217 × 132 cm.)

A life-size full-length figure standing in an interior in front of a draped curtain on a patterned paved floor and with a green-covered table on his left. The portrait-type is identical with that of No. 68 [62]. This is the only full-length portrait and thus the only one which shows Salisbury's slightly deformed figure.

Collection: This portrait was formerly at Woburn Abbey and was presented to Lord Salisbury by the Queen Mother in 1957. It is therefore not included in Holland's catalogue.

Literature: Pennant, p. 357; Robinson, p. 27; Scharf, No. 52; *Walpole Society, III,* 1914, Pl. 38b; Strong, Christie's, Lot 99; *Cat. N.P.G.,* p. 275.

73 [74] ill. 51, p. 142

?George Carew, Earl of Totnes (1555–1629) formerly called Count Gondomar, *c.*1585–90

George Carew, Earl of Totnes was Commander in Ireland

Painter unknown

Now on canvas (transferred from panel, 1870) 44 × 35 in. (111·9 × 89 cm.)

A nineteenth-century label on the back reads 'Count Gondomar Ambassador from the Court of Spain to James the first, painted by Cornelius Jansen'.

A life-size, three-quarter length standing figure, dressed in a closely fitting elegant black suit with falling light-grey collar. He wears a studded and ornamented sword belt and a round golden chain to which no order is attached. His arms, in tight black sleeves, are hanging at his side. His right hand closes upon the handle of a stick, and his left touches the hilt of his sword. His broad face is slightly turned to the left, while the lively hazel eyes face the onlooker directly. He has a slightly curved nose, tight lips, a brown moustache, and a double-forked grey and brown beard. He wears a tall black hat crowned with a feather and an earring in his left ear. Altogether, a very elegant and impressive figure of an English courtier of the period, confident and with an imperious look in his eyes.

The sitter in this painting was wrongly identified by Holland as Diego Sarmiento d'Acuna, Count Gondomar, 1567–c.1623. Gondomar did not arrive in England as Spanish Ambassador until 1613, a year after the death of the first Earl of Salisbury and many years after the date of this picture.

The suggestion by the present Lord Salisbury that the portrait represents Sir Walter Raleigh is an interesting one. Raleigh was Captain of the Guard at Court, so he may have had a stick similar to the one in the picture. But the face of Raleigh as seen in the accepted versions of his likeness is somewhat different; and the colouring of the man here is lighter than that of Raleigh, who is reported by Aubrey to have been very dark.

Another identification may be put forward on the basis of early inventories of the pictures in the family collection (under *Collection:* see below) that of Sir George Carew, afterwards Earl of Totnes, a close associate of the Cecils from 1580 until 1612. He was prominent in Ireland among the 'undertakers' of Munster and in February 1586 was knighted by the Lord Deputy, Sir John Perrott, before being sent to Court to advise the Queen on Irish matters. He returned to Ireland in February 1588 as Master of the Ordnance. The staff in the right hand of the sitter might thus be interpreted as the symbol of the office held in Ireland by Carew.

Later Carew was advanced to greater dignities both in Ireland and England through the patronage of Robert Cecil, whom he accompanied on a special embassy to France in 1598. He served effectively as president of Munster in 1600–1603 and carried on a voluminous correspondence with Cecil, much of which was so secret that it had to be burnt after its first reading by the recipients. (*Calendar of Carew MSS. at Lambeth, 1589–1600*, p. 460, reference from Miss C. Merion.)

Upon the accession of James I he became vice-chamberlain and councillor to Queen Anne. In 1605, the year that Cecil became Earl of Salisbury, Carew was made Baron Carew, and in 1608 he was appointed to the most important post he ever held, the mastership of the ordnance in England. Two further promotions came later in life. In 1616 he became a privy councillor and in 1626 he was created Earl of Totnes. It should be mentioned that he was an antiquary of some note and a collector of books and of historical documents, particularly relating to Ireland. After his death his natural son Thomas Stafford published *Pacata Hibernia*, 1633, written largely from Carew's papers.

A comparison of this picture with the likeness of Carew as seen in the portrait prefixed to *Pacata Hibernia*, see Hind, Vol. III, p. 209, and in the effigy on his tomb in the Clopton Chapel, Holy Trinity Church, Stratford-on-Avon (see

the photograph in Edgar I. Fripp, *Shakespeare, Man and Artist*, 1938, Vol. II, facing p. 894) appears to render this identification plausible, if by no means certain.

The suggestion that Cornelius Johnson is the painter is not entirely convincing, and it is difficult to find the name of a particular Flemish artist, although the general appearance of the portrait might seem to indicate that it was painted abroad rather than by a Flemish painter working in England.

Collection: A portrait of George Carew, Earl of Totnes, can be traced right through the seventeenth-century inventories. In 1629 (Box C.8, f.6d) the portrait of 'the Earl of Totnes' was in the 'Wardropp' of Salisbury House, London. It was still there in 1639/40, in Lord Salisbury's Dining Room (Box C.9). In 1646 (Box C.4 and 5) it is listed as being in the Dining Room below stairs. That is the last we hear of it in the Cecils' House in London, but in 1679/80 (Box A.10) a 'picture of the Earle of Totnes in a playne frame' was in the Wardrobe at Hatfield House.

Musgrave (or his informant) in 1769 and the nineteenth-century cataloguers identified No. 73 [74] as Gondomar, the Spanish Ambassador. It is hard to understand why. Perhaps someone, seeing the Hatfield Inventory of 1679/80 (Box A.10) where '1 P. of a Spanish Ambassador' is mentioned as hanging in the gallery, jumped to the conclusion that this must be Gondomar. (cf. No. 89 [225] under *Collection*.)

74 [65] ill. 52, p. 143

? Sir Walter Cope (1552/3–1614), 1612

An intimate friend of Robert Cecil, 1st Earl of Salisbury

John de Critz the Elder (?) (working from 1568–1641)

Panel 35 × 28 in. (89 × 71·2 cm.)

A middle-aged gentleman, aged 59 in 1612. An elegant half-length figure, turned three-quarters to the right, looking at the spectator. He wears a black silk suit with tight sleeves and a close-fitting ruff, a belt fastened with gold tassels, and frills round his wrists. At the bottom of the painting his right hand, which is only just visible, holds the top of a stick. He rests his left hand on the edge of a table, on which are two red books and an open letter with a seal attached. The writing on the latter cannot be deciphered any more. It may, however, be the address of a letter and read as:

'To . . . Knight'.
 The portrait is inscribed, top left:
 'AETATIS SVA, 59'
and in a horizontal line on the right-hand side:
 'ANNO 1612'
 At shoulder level on the left-hand side a Latin verse is inscribed:
 '. : . *sic.ille.vultum.sic.ora.ferebat . : .*'

The lettering is nicely executed in the gold colour of the tassels. The top line is given in Roman letters, the verse in italics. The verse may be interpreted in the following way:

 'Thus was the face and the countenance
 he had . . .'

The portrait is well painted; the light brown background stands out well against the red of the books. The face is modelled in a lively and expressive way.

The age of the sitter, this time clearly indicated, may have led to the identification of this elegant, sophisticated and dignified man. Who in Robert Cecil's intimate circle – and the collection at Hatfield House comprises mainly relatives, friends, Kings and Queens – was born in 1552/3?. Professor Joel Hurstfield suggested Sir Walter Cope, and Dr H. Passmore, at present engaged on a monograph of Cope confirmed the dates. No other likeness seems to have survived, but what

we know of his personality fits in well with that represented in this portrait.

Vertue, in his *Notebooks* (I, 88) writes that Walter Cope, an Elizabethan gentleman, had purchased from the Queen in 1559 the 'Manor of Kensington'. He was a very rich man and had great estates. Isabella, his daughter and heiress, married Sir Henry Rich, later the Earl of Holland, and Cope's mansion at Kensington became known as Holland House. Carel van Mander, who wrote at the beginning of the seventeenth century, mentioned: 'one Cope, a gentleman, a Curious Collector of pictures', at the time of Queen Elizabeth.

Cope's admiration for Italian art, somewhat qualified by his reluctance to hang pictures with a 'light intention' in 'any place of gravitie', is shown by the following extract from a letter which he wrote to Sir Dudley Carleton at Venice on January 26, 1610/11 (S.P. 14, vol, 61. No. 33):

> 'Yf you meete with any auncient Master peeces of paintinge at a reasonable hand, you cannot send a thinge more gracious, either to the Prince, or to my Lord Treasurer, there fault is, there intentions are a little too light, not fitting for any place of gravitie, otherwise I could be contented, sometimes to bestowe a few crownes for myself, which I will readily retourne, if any such rarities come in your way'. (see Introduction, p. 23)

Apart from his patronage of art, he was an influential man and a great friend of the 1st Earl of Salisbury. He also entertained the Queen at his houses in the Strand and in Kensington. Salisbury appointed him one of the executors of his will and after the Earl's death on May 27, 1612, Cope wrote an apology for him and delivered it to the King. Sir Walter died in 1614: his funeral took place on August 19.

Among the Cecil papers and accounts there are several bills referring to Sir Walter Cope's commissions of pictures, etc.:

(Bills 35) 'Henry Helmes delivered to Sir Walter Cope 5th April 1609 . . . 1 picture': damaged. More details are not known.

Later bills are more explicit:

(Box G.13) Accounts 1611–1612, Gifts and Rewards: Oct. 12, 1611. 'To John de Creet the painter for painteinge and gildeinge a frame for a pickture for my Lord to give to Sir Walter Coope [Cope] to be at Kensington – 40s'.

What apparently refers to the same item is expressed quite differently in the following bill (Box U.74):

'Worke done for the Right Honorable the Lord Viscount Cranburne.

For making on great frame being VIII foot long and VI foot broade with visses of iron for a pickture for his Lordship which is set up at Kensington' 20s.

In different writing: 'Ther was such a frame: W. Cope'.
(Box U.f. 75)

'Item for painting, gilding and rebesking all over A greete Frame beeing 8 foote long and 6 foote brode for A picture of the Right Honorable the Lord of Cranburn whiche is sette up at Kensington – 2 *l.* Walter Cope'.

(Back) 'John de Creete his bill for painteinge and giltinge a greate Frame for a pikture for my Lo: Cranbo: which is set up at Kensington. – 40s'.

Received October 12, 1611, by James Manucii who was at one time joint Serjeant painter with de Critz.

Robert Cecil was Lord Cranborne only from August 20, 1604, to May 4, 1605. Thereafter his son William was usually referred to as Lord Cranborne. The portrait which was set up in Sir Walter's house was therefore, a portrait of William. However that may be, Cope was busy building up his portrait collection and he also engaged John de Critz in this field.

The style of the portrait comes near to that of Robert Cecil by de Critz. Here too are objects on a table and the red colour in the left-hand corner draws the attention towards that side. The general composition resembles de Critz's manner. We learn from bills that the Serjeant Painter was known to Sir Walter Cope, and this painter would, therefore, have been a likely choice. Another possibility might be the Flemish painter Abraham Blyenberch who worked for a time in this country.

Collection: Only in the nineteenth century is there any trace of this portrait in the Hatfield House Collection. In 1823 '1 Portrait of a Gentleman ... 1612' was hanging in 'The Marquess's Sitting Room' and in 1868 under No. 27 'Portrait of gentleman in black ... 1612' was listed as in the Yew Room, South Side.

Literature: Holland, No. 65, as 'Unknown Portrait of a Middle-Aged Gentleman. Painted by Mytens in 1612', but it appears that Mytens did not come to this country until 1614.

75 [66] ill. 53, p. 142

Christophe de Harlay, Comte de Beaumont
(1571–1618), 1605

Marcus Gheeraerts the Younger (?1561–1635/6)

Canvas 78 × 42 in. (1·98 × 1·07 m.)

A full-length, life-size figure standing in front of long curtains, which close off an interior room. He is dressed in a black suit and stockings, and dark shadows fall on the floor. The white sleeves are embroidered, he rests his right arm on his hip and his left hangs down; his left hand is touching the sword belt. The face, pale and framed by a square-cut, full dark-brown beard and hair, is handsome and dignified. The background is green-brown and the lace ruff is well painted. The floor is of light brown colours.

There is an inscription on the left-hand side which reads:

'Comes de Beaumont Legatus
Christiā Gall Regis apud
Ser Magn. Brit Regem Anō
1605. Atatis Suae 34'.

Christophe de Harlay, Comte de Beaumont, came from an aristocratic French family patronized both by Henry III and Henry IV. He was received at the Court of James I on Whitsunday, June 15, 1603.

The style of this refined full-length early Jacobean portrait, including the general colouring and the particular lettering, the pose and the treatment of the likeness, recall clearly the hand of Marcus Gheeraerts the Younger and make the attribution of this portrait to him highly plausible. A Bill of October 16, 1607 (Box U.81), charged by John de Critz for work done for the 1st Earl of Salisbury, shows also the French Ambassador in contact with Cecil: 'Item for twoo pictures the one of your Lordship the other of the Lord Treasorer your Lordship's Father which pictures were geven to Monsieur Beaumont, Ambassador of Fraunce – 8*l*'.

An exchange of important portraits of the Royal Family and the nobility between the various Courts of Europe was customary at this time, and it was a mark of respect for an ambassador to have his portrait painted as a gift to the King or Chief Minister.

Collection: Musgrave in 1769 and Pennant, p. 410, clearly identified this portrait in 1780 as being stored in a Lumber Room at Hatfield. In 1823 there was in the Winter Dining Room a picture of 'Count Beaumont, Ambassador from France to James First – Zuchero'. In the inventory of 1868 under No. 37 'Under Grand Stairs, South Side' there appears 'Count de Beaumont, Ambassador from France to James 1 – D. Mytens'. Before the eighteenth century there is no trace of this portrait in the Hatfield House inventories.

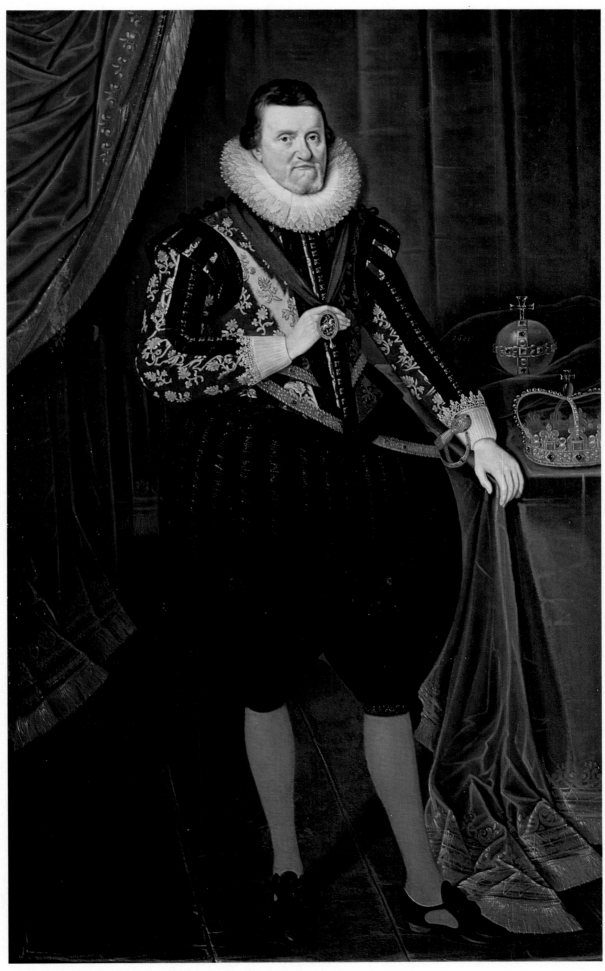

COLOUR PLATE IX. **James I of England and VI of Scotland,** 1623,
?John de Critz the Elder after Paul van Somer (Cat. No. 80, p. 83)

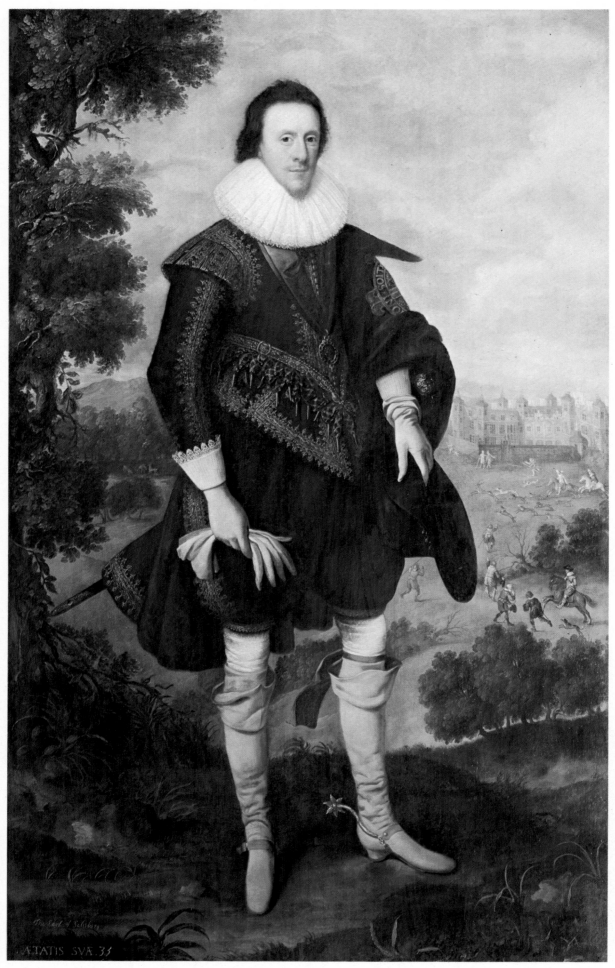

COLOUR PLATE X: **William, 2nd Earl of Salisbury,** 1626, by George Geldorp (Cat. No. 82, p.83)

Literature: Holland, No. 66, 'Painted probably by P. van Somer'. The literature and research on M. Gheeraerts the Younger has much increased recently. Auerbach, *Tudor Artists* on Gheeraerts; Piper, *De Critz*, pp. 221 ff; Strong, 'Elizabethan Painting': An Approach through Inscriptions – III Marcus Gheeraerts, the Younger', *Burl. Mag.*, April 1963, pp. 149–57; Oliver Millar, 'Marcus Gheeraerts the Younger,' *Burl. Mag.*, December 1963, pp. 533–41, attributes this portrait to Gheeraerts the Younger; Strong, *English Icon*, p. 282, No. 273.

76 [67]

Sir Thomas Bennet, Knight (?1541–1627), 1611

Sir Thomas Bennet was a citizen, alderman, and Lord Mayor of London 1603/4

Companion picture to Lady Bennet, No. 78 [68]

Painter unknown

Panel 44 × 29 in. (11·9 × 73·8 cm.)

A three-quarter-length standing figure in frontal position, the face slightly turned to the left. He wears the fur-trimmed red robes of an alderman, a rather high black hat, and a massive gold chain. In his right hand he holds a pair of gloves, and two signet rings adorn the fingers of his left hand.

On a plain background in the top left-hand corner his shield of arms appears, Bennet impaling Taylor. An inscription in Roman letters in the top right-hand corner reads:

'ANNI 1611
AE SVAE 70'

In the bottom left-hand corner in modern white letters is an inscription 'Sir Simon Bennet Painted by Pourbus'.

The name 'Sir Simon Bennet' has been erroneously inscribed.

Sir Thomas Bennet was a well-to-do citizen of London. At the time he wrote his will (P.C.C. 21 Skynner) he gave his residence as in the parish of St Olave, Old Jewry. But some years before his death he had become a landed gentleman as well, acquiring the manors of Beachampton and Calverton, Buckinghamshire, in 1609 and 1616 respectively (*Victoria County History, Buckinghamshire*, Vol. 4, ed. William Page, 1927, pp. 151, 309–10). Some of his correspondence is preserved at the Public Record Office and at Hatfield. Much of his property eventually descended to his great granddaughter Frances Bennet who in 1683 married James, 4th Earl of Salisbury.

This explains the inclusion of the portraits of Sir Thomas Bennet and of Lady Bennet in the Hatfield House Collection.

The portrait is in a very poor state of preservation. The face is well modelled and the strong red is attractive and matched in the red gown of Lady Bennet. The former attribution to Cornelius Ketel can hardly be maintained for stylistic reasons.

Collection: Musgrave in 1769 and Pennant, p. 410, saw and described this portrait in 1780, although accepting it as Simon Bennet. Otherwise only in the inventories of Hatfield House in the nineteenth century do we find traces of Nos 76 [67] and 78 [68]. In 1823 there hangs in King James Room 'Sir Simon Bennet, AETATIS 70. Anno 1611'. Lady Bennet's portrait is not mentioned in 1823. In the 1868 inventory under No. 129 in the Library Left of the Fire Place there is listed 'Sir Simon Bennet – F. Pourbus', and under No. 130 Right of the Fire Place appears 'Lady Bennet – Cornelius Ketel'. Two different painters are here assumed as the authors of these companion pictures.

Literature: Holland, No. 67, as painted by Cornelius Ketel.

77 [67a]

Sir Thomas Bennet, Knight (?1541–1627)

Painter unknown

Panel 45 × 33½ in. (1·15 m. × 85·2 cm.)

Another version of No. 76 [67], in a bad state of preservation and poor condition.

78 [68] ill. 54, p. 142

Mary Taylor, Lady Bennet, 2nd half sixteenth century

Mary Taylor was wife of Sir Thomas Bennet and daughter of Robert Taylor of London, Mercer

Companion to No. 76 [67]

Painter unknown

Panel (two pieces) 44 × 29 in. (111·9 × 73·8 cm.)

The sitter's elaborate fur-trimmed red costume matches the fur-lined red robe which Sir Thomas is wearing, and the latter's gold chain and gloves re-appear on Lady Bennet's portrait. Her standing figure is seen three-quarter length in frontal position. She wears a huge, rigid, radiating ruff, and clearly patterned, wiry grey lace adorns her bodice. A dark crescent-shaped cap sits on her smooth brown hair. Altogether, a very well treated and clearly modelled, outstanding painting. The rather metallic and sharply cut character of this picture does not really suggest the hand of the much softer painterly manner of the Dutch artist Ketel, whose name has been associated with No. 78 [68]. This precise quality comes out best in the big ornamented jewel which incorporates a nude figure blowing a horn.

In the right-hand top corner on a plain background the Taylor coat of arms appear.

Collection: The first reference to this portrait at Hatfield is in Musgrave, f.80 and Pennant, p. 410. It is also mentioned in the inventory of 1868, No. 68. For further details, see under No. 76 [67].

Literature: Holland, No. 68, as 'Painted by Cornelius Ketel'.

79 [70] ill. 55, p. 143

James I of England and VI of Scotland (1566–1625), c.1618

James I succeeded to the throne of England in 1603. He married Anne of Denmark on November 7, 1589

Paul van Somer (c.1577/8–1622)

Panel (cleaned 1969) 31 × 24½ in. (78·8 × 62·2 cm.)

A half-length, life-size figure framed within the panel by an oval frame. The king wears a white satin doublet, slashed and richly embroidered, and a closely fitting radiating lace ruff of c.1616–18 type. The Garter badge hangs from a blue ribbon which he holds in his right hand. The face is well painted in lightly shaded grey colours. An old Label reads:

> 'King James the first painted by
> Daniel Mytens'.

This portrait type and position of the right hand comes nearest to the full-length of James I in Holyrood House by Paul van Somer. (Millar, No. 103, Pl. 43.)

Paul van Somer (c.1577/8–1622), born in Antwerp and working in Holland came to England in 1616. From c.1617 he was in Royal employment and payments to him for Royal portraits are recorded up to the time of his death in 1622.

The likeness of James I, as represented in this portrait, is based on Hilliard's miniatures of c.1612. (see Auerbach, *Hilliard*, Pls 160a and 163.)

Collection: Early inventories of Salisbury House list one portrait of James I without any details. In 1629 June 20 (Box C.8) '1 picture of Kinge James' was hanging in the 'Great Withdrawinge Chamber'. Repeats appear in 1639/40 (Box C.8

and 9) and in 1646 (Box C.4 or 5) until on April 3, 1685 (Box C.7) it was hanging in the Hall of Salisbury House. There are no early entries in the inventories of Hatfield House. The first mention of it at Hatfield is by Musgrave in 1769 when he saw it in the Gallery. Only in 1823 'King James the First – Mytens' was recorded in the Drawing Room, and in 1868 under No. 19 and 85 two portraits of James I were listed, but it is not clear whether they refer to Nos 79 [70] or 80 [71]. 'King James 1st – D. Mytens' was mentioned as hanging in the Summer Dining Room, North Side and 'King James 1st – Vansomer' decorated the South Side of the Winter Dining Room.

Literature: Holland, No. 70, as 'copied by John de Critz after P. van Somer', where de Critz' bill of 1607 is quoted. However, the date of No. 79 [70] is about ten years later than this bill and the style of the portrait of James I as created by de Critz would seem to be nearer to the portrait of the King at Greenwich reproduced by Waterhouse, Pl. 21a.

80 [71] Colour Plate IX, opp. p. 80

James I of England and VI of Scotland (1566–1625), 1623
? John de Critz the Elder (working from 1568–1641) after Paul van Somer (c.1577/8–1622)

Canvas 79 × 49 (2 × 1·25 m.)

A full-length standing figure in an interior. The King wears a black costume with embroidered sleeves, a bright yellow waistcoat, scarlet stockings, black shoes and full balloon breeches. The Garter badge hangs from a blue ribbon which he holds in his right hand. His left rests on the edge of a table, covered with a rich red cloth on which are laid the orb, on a cushion, and the crown. A curtain hangs on the left-hand side. The painting has been recently cleaned, and the colouring is vivid and full of contrasts. Inscribed on the left-hand bottom corner is 'James the FIRST by VAN SOMER' and to the left of the orb the picture is dated on the cushion, 1623.

This portrait seems to be a later version of the Van Somer type of 1618 in Holyrood House (Millar, No. 103, Pl. 43), although it does not appear to resemble it as closely as the half-length No. 79 [70]. The King also holds the lesser George in his hand, a motif which is often repeated in portraits of James I, as e.g. in the Duke of Buccleuch's version at Dalkeith which was exhibited under No. 16 in the 'Kings and Queens Exhibition, Liverpool, 1953'. It is possible that the peculiar shape of the right hand and the harder lines of the face point to de Critz or his workshop for altering this version.

Collection: See under No. 79 [70].

Literature: Holland, No. 71 as 'Painted by Van Somer'; Millar, No. 103, p. 81; Strong, *Cat. N.P.G.*, p. 179.

81 ills 56 and 57, p. 144

James I of England and VI of Scotland, Queen Anne and Prince Charles, after 1612 and before 1618

Simon van de Passe (1595–1644?)

Oval engraving on a thin silver plaque $2\frac{1}{4} \times 1\frac{7}{8}$ in. (5·7 × 4·75 cm.)

A very fine line engraving showing three bust portraits: James I with plumed hat, ruff and Garter chain, three-quarters to the right; Queen Anne with open standing ruff, low-necked dress, turning three-quarters to the left and between his parents Prince Charles, turning to the left. The modelling is very fine.

The reverse shows the arms of England and Denmark and the Prince of Wales' feathers. The circumscription in Roman letters reads: POTENTISS:IACOBVS D.G. MAG:BRIT:ET:HIB:- REX. ET SERENISS. ANNA D.G. MAG.-BRITT.

REGINA VNA CVM ILL: P.CAROLI.M: BRIT.-
PRINCIPis.

This plaque is listed as No. 5 by Hind (see below), p. 279, and reproduced in reverse on Pl. 165. There is a signed pendant representing Frederick V, Elizabeth and Prince Frederick under No. 8 and also reproduced on Pl. 165. Similar plaques to No. 81 are in the collections of the British Museum and Windsor Castle. The engraving in the Hatfield House Collection is not mentioned by Hind.

Simon van de Passe, a well-known engraver, was born at Cologne, *c.*1595, and died in Denmark(?), *c.*1644. Hind, p. 275, mentions the good quality of his silver plates and continues: 'They consist chiefly of portrait busts, of which the most important part centred in James I and his family . . . and the signed examples all come within the years 1615–18'. No. 81 is not signed.

Exhibition: Cat. Liverpool 1953, No. 104.

Literature: Hind, II, pp. 275 ff., Pl. 165. Information from Mr P. E. Hall (18.7.69).

82 [86] Colour Plate X, opp. p. 81

William, 2nd Earl of Salisbury (1591–1668), 1626

William was the son of Robert Cecil, 1st Earl of Salisbury and Elizabeth Brook and he married Catherine Howard on December 1, 1608

Companion to No. 84 [83]

George Geldorp (died 1665)

Canvas 84 × 51 in. (214 × 130 cm.)

Inscription in the left-hand corner:

'THE EARL OF SALISBURY
AETATIS SUAE 35
ANNO 1626'

A full-length, life-size figure, elegantly dressed, turned three-quarters to the right towards its companion, standing in an open landscape, which is easily recognizable as the park of Hatfield House. A stag hunt is taking place. The house itself appears in the background. The Earl wears a brown hunting dress, a radiating, close-fitting ruff, buff boots and the George of the Garter on a blue ribbon (he was made a Knight of the Garter in 1624). His doublet and breeches are richly embroidered. He carries his hat in his gloved left hand and holds the other glove in his right hand. The face is delicately modelled. The sky and the clouds, as well as the trees on the left which frame the scene, are rendered in the Netherlandish manner. Altogether the portrait is of a very fine and impressive quality and anticipates the style of Van Dyck.

George Geldorp, native of Cologne, became a member of the Guild of Antwerp in 1610. In about 1623 he came over to England, where he was active not only as a painter but also as a dealer and an artistic impressario. He was also concerned in keeping the King's pictures. He died in 1665. The portraits of William, Earl of Salisbury and his wife Catherine (No. 84 [83]) can be plausibly ascribed to Geldorp on the strength of bills and accounts in the Hatfield manuscripts. According to Symonds (Egerton MSS 1636, f. 93) Geldorp had a collection of copies of Van Dyck's pictures in his house in June 1653. Lely when he first came here stayed in Geldorp's house and worked for him.

Some extracts from the accounts as far as Geldorp is concerned may be given in the following:

(Accounts 160/6)
'1626. Mr Gildropp for pictures 52*l*'.

Another version of this bill: (Box U.77) – before 1658

'Memoire des paintures que Jay faict pour mon Siegneur de Salisbere
Premièrement le portraict de Monsiegneur de sa hauteur le prisfaict – 15*l*.

Le portraict de Madame, de sa hauteur, 15*l.*
Le portraict de Madame Anna 15*l.*
Le portraict du Siegneur Charles 7*l.*
Le portraict de Madame Elysabet 7*l.*
„ „ „ Mr. Robert 7*l.*
„ „ „ Madame Diana 7*l.*
pour la dorure de 7 bordures que ma
femme a dorée pour l'or et ouvrage 6*l.*
pour la bordure de Madame Bambery 1*l.* 0*s.* 5*d.*
pour ung portraict de Monsiegneur et
de Madame pour Sr William Selliger
(St Leger?) 10*l.*
pour un portraict de Monsiegneur et
de Madame pour Sr Edewart Haulbart
(Herbert?) 10*l.*
pour ung portraict de Madame pour
Mellort Vacs (?Vaux) 5*l.*
[total] 105*l.* 0*s.* 5*d.*
premièrement reçeu de Monsiegneur la
somme de 10*l.*
encore reçeu de Monsiegneur 20*l.*
encore reçeu par Monsieur Sudwert
(Southworth) 10*l.*
[total] 40*l.*
Reste a moy de Monsiegneur 65*l.* 0*s.* 5*d.*
vostre humble serviteur George Geldorp'.

From this account it emerges clearly that Geldorp's portraits of the 2nd Earl and his wife were both full-length, life-size paintings and, therefore, clearly point to Nos 82 [86] and 84 [83].

Amongst Bills 111/2 various payments to Geldorp are recorded:

'Uppon divers occasions
To Mr. Gildropp in parte for pictures 20*l.*
To Mr. Gildropp for a dossen of
glasses 14*s.*
To Mr. Gildropp in parte for pictures 20*l.*
To Mr. Gildropp for a dossen of
glasses 14*s.*
To Mr. Gildrop in parte for pictures 10*l.*
„ „ „ „ „ „ „ 20*l.*
„ „ „ „ „ „ a dossen
of glasses 15*s.*
To Mr. Gildropp in parte for pictures 12*l.*

To Mr. Gildropp in full of
his bill' 10*l.*

The items mentioned included, as well as the three dozen glasses, some embroideries, which again shows Geldorp's interest in collecting and selling rare objects.

Collection: The inventories do not yield as much information about the companion portraits as Nos 82 [86] and 84 [83] as one would expect. In the Hatfield Inventory of June 9, 1629 (Box A.6. f. 3d) amongst 'Pictures in the Gallarie' '1 of my Lords' and '1 of my Ladies' are listed, but they are then crossed out. In this inventory they are followed by the portraits of their children: '1 of my Lady Percies, 1 of my Lord of Cranbornes, 1 of Master Robert, 1 of my Lady Elizabeth, 1 of my Lady Diana' and these entries are likewise crossed out. However, three of the latter, the portraits of Lord Cranborne, Master Robert and Lady Diana appear in the 1629 inventory of Salisbury House (Box C.8) in the Gallery with the remark added in the margin: 'these are standinge pictures' and this remark points again to Geldorp as the painter. In the Hatfield House Inventory (Box A.7 f.11) of September 23, 1638 '1 of my Lord' and '1 of my Lady' were hanging in the Gallery, but as there are several portraits of the couple at Hatfield, it is not clear to which this entry refers. In 1679/80 (March 3 at the beginning of the inventory, March 24 on cover) (Box A.10, f.2) '1 Picture of William Earl of Salisbury' is listed as hanging 'In the Parlour'. There is also '1 Picture of Lord Cranborne and Lady K[atherine] in one frame', which must refer to No. 126 [88]. Here we are not sure which Lord Cranborne is so described, as the 2nd Earl's daughter-in-law was called Jean and not Katherine (Katherine was the name of his wife).

In 1823 only '1 Lady Catherine Howard, Wife of William the Second Earl of Salisbury –

Dobson' was hanging in the Drawing Room. This entry may refer to No. 84 [83]. In 1868 under No. 26 'William, 2nd Earl of Salisbury – Cornelius Jansen' is mentioned as hanging in the Yew Room, South Side and seems plausibly to refer to No. 82 [86].

To increase the confusion, there is under '1847 Misc. Letters' (F.P. 14/62–3) a letter, dated May 29, 1847, which Edmund F. Moore wrote to Lord Salisbury, in which he informs him that he has bought (apparently at Christie's) the pictures of Robert, Earl of Salisbury (29 guineas) and his Countess (26 guineas). There is a view of Hatfield in one. Although it was the 1st Earl who was called Robert and not the 2nd, 'the view of Hatfield' in one picture may point to Geldorp's companion portraits. It therefore appears that these portraits, if they are the same, were reacquired in the nineteenth century.

Literature: Christie's sale catalogue for May 27 to 29, 1847, 'English Historical Portraits', Lots 362 and 363; Holland, Nos 86 and 83; C. H. Collins Baker, *Lely and the Stuart Portrait Painters*, 1912, I, p. 67; II, p. 112; C. H. Collins Baker and W. C. Constable *English Painting 1500–1700*, 1930, p. 43; Waterhouse, pp. 41, 63/4; M. Whinney and O. Millar, *Lely*, 1957, p. 9 ff., Pls 9–11.

83 [87]

William, 2nd Earl of Salisbury (1591–1668)

Another version of the preceding portrait by George Geldorp (died 1665).

Canvas (cleaned 1969) $29\frac{3}{4} \times 24$ in. (75·6 × 61·1 cm.)

Life-size, half-length, within an oval. The Earl wears the same costume as in No. 82 [86]. This picture is inscribed in the top left-hand corner:

'WILLIAM EARLE OF SALISBURYE, AETATIS SUAE 35. 1626'.

Since its recent cleaning the colours come out beautifully, the blue sash, the Garter badge in silver attached on the shoulder of his cloak, contrasting to the gold in his heavily embroidered bodice. The soft treatment of the face strengthens the impression of the fine quality of this portrait.

84 [83] Colour Plate VI, opp. p. 49

Catherine Howard, Countess of Salisbury (d. 1663), 1626

Catherine Howard was the youngest daughter of Thomas Howard, Earl of Suffolk she married William, 2nd Earl of Salisbury on December 1, 1608

Companion to No. 82 [86]

George Geldorp (d. 1665)

Canvas 84 × 51 in. (214 × 130 cm.)

A charming full-length, life-size standing figure seen against a dark curtain, with a view into an open park landscape on the left-hand side. The sitter is dainty and graceful, and she wears a pale mauvy pink embroidered robe over a white dress with red flowers. She holds a lace handkerchief in her left hand, and her right hand rests on the back of a chair. Light and delicate colours stand out from a dark background.

This painting is of a very good quality. The portrait of Anne Bacon at Audley End is probably by the same hand.

Collection: See under No. 82 [86].

Literature: See under No. 82 [86].

85 [78] ill. 58, p. 144

Charles I (1600–1649), *c.*1628
King of England

Daniel Mytens (*c.*1590–before 1648)

Canvas 94 × 56 in. (239 × 143 cm.)

Inscribed by a later hand in the bottom right-hand corner: 'Charles the First by Van Somer'.

Full-length, life-size figure is in a frontal position, the face turned three-quarters to the right. The King stands on a dark checked floor, and there is a red curtain in the background. He wears a costume of brilliant grey embroidered with silver, a closely folded wheel ruff and high grey boots. Prominent is the blue ribbon of the Garter. He has a moustache and a pointed beard and does not wear a hat.

The clarity and simplicity of the figure, which is composed and rather rigid, accords with the King's type usually painted by Mytens at the end of the 1620's. The lively colouring of some of the accessories parallels that in the portrait of Philip Herbert, Earl of Pembroke and Montgomery, No. 86 [75].

Daniel Mytens (Mittens), c.1590–c.1648, was a Dutchman who came to England about 1614. From 1620 to 1633 he received many commissions for portraits of noblemen and members of the Royal Family. With the event of Van Dyck's arrival in this country Mytens's activity decreased, and he finally left the country.

Mrs Charlotte Stopes (*Burl. Mag.*, XVII, pp. 160–3) found a reference in the Lord Chamberlain's accounts which establishes this picture as by Mytens. On April 20, 1629 the King paid Mytens £160 for three pictures, one of which is stated in the account to be a portrait of Charles which was delivered to the Earl of Salisbury on February 19, 1628/9. And in the Hatfield documents (Box F.3, 1629) there is a note as follows: 'To one that carried the King's picture from London to Hatfield, 12s'. Perhaps the best version of this portrait is in the Royal Collection, Windsor Castle, catalogue No. 118. It is signed by Mytens and dated 1628. It was bequeathed by Cornelia, Countess of Craven, to Her Majesty the Queen in 1961. This portrait was exhibited in the 1956/7 Royal Academy of Arts exhibition, *British Portraits*, No. 57.

Collection: We have seen that the portrait of Charles I was brought to Hatfield in 1629. 'King Charles his picture' is the first item in the Gallery in the inventory of 1629 (Box A.6, f.3d). The same picture is given in the same location in the inventories of 1638 (Box A.7, f.11); 1646 (Box A.8 and 9, f. 5d), and 1679/80 (Box A.10, f.8d). Musgrave in 1769 saw a portrait of Charles I 'by Mytens' in the Common Parlour. Pennant saw it in the same place in 1780, p. 404.

Literature: Robinson, p. 28; Holland No. 78; Charlotte C. Stopes, 'Daniel Mytens in England', *Burl. Mag.*, XVII, 1910, pp. 160–3; F. M. Kelly, 'Daniel Mytens and the Portraits of Charles I', *Burl. Mag.*, XXXVII, 1920, pp. 84–9; Millar, No. 118, Pl. 48.

86 [75] Colour Plate VIII, opp. p. 65

Philip Herbert 4th Earl of Pembroke (1584–1650), c.1628

Philip Herbert was Earl of Montgomery and later 4th Earl of Pembroke

Daniel Mytens (c.1590–before 1648)

Canvas (cleaned 1964) 52 × 40 in. (132 × 102 cm.)

A most colourful painting. In a red armchair the life-size, three-quarter length figure of the Earl, clad in a mauve patterned dress and a black coat, is seated. He wears a lace falling ruff and lace cuffs round his wrists. The Garter is visible round his left leg under the knee. His black hat rests on his left thigh. His right hand lies on the arm of the chair and his left holds the strings of his ruff. He wears the badge of the Garter suspended from a blue ribbon. There is a green-blue curtain partly covering a window on the right-hand side showing a landscape receding into the distance. The bearded face is broadly painted, and the style and powerful treatment of the portrait conforms to that of Daniel Mytens.

Philip Herbert, 4th Earl of Pembroke, was a great builder and collector, as well as eminent patron of the arts in general. He and his elder brother William, the 3rd Earl of Pembroke, were the 'incomparable pair of brethren' to whom the First Folio of Shakespeare's plays was dedicated in 1623. Philip was a favourite of James I and in succession to his brother served as Lord Chamberlain under Charles I. But when the Civil War came, he became a Parliamentarian (like the 2nd Earl of Salisbury). He was member of parliament for Berkshire and a member of the Council of State in 1649.

From Accounts of 1629 (Box F.3) it emerges that Mytens worked for the 2nd Earl of Salisbury:

'To Mr Mitton for 4 pictures drawn for my Lord – 17l.
More to Mr Mitton for the frame for the King's Picture – 1l. 10s.
To one that brought 4 pictures of Mr Mittons drawing from London to Hatfield – 4s. 6d'.

Perhaps one of the four pictures Mytens painted for the Earl of Salisbury was No. 86 [75], the portrait of Philip Herbert, 4th Earl of Pembroke.

According to a letter of Mr R. W. Goulding, Librarian at Welbeck Abbey, to the librarian of Hatfield House in October 1908 an almost identical version is No. 101 at Welbeck Abbey.

Collection: The 1638 inventory of Hatfield House (Box A.7, f.11) records under 'Pictures in the Gallery 1 of my Lord Chamberlaines'. In 1646 (Box A.8 and 9, f.19d.) 'In my Ladies Bedchamber' there is mention of '1 picture of my Lord Pembroke'. A more specific statement is contained in the inventory of March 24, 1679/80 (Box A.10), in which 'In the Parlour 1 Picture of Philip E. of Pembroke' is listed. Musgrave saw it in 1769 in the Gallery. In the 1823 inventory 'the Earl of Pembroke, an exceding highly finished and excellent Specimen – Daniel Mytens' was hanging in the Breakfast Parlour. The inventory of 1868 under No. 16. in the Summer Dining

Room, North Side, a portrait of 'Henry Herbert, Earl of Pembroke – Van Somers' is recorded. From these documents it seems that No. 86 [75] was always in the family collection.

Literature: Robinson, p. 28. Holland, No. 75 as 'William Herbert, third Earl of Pembroke' painted by P. van Somer. For literature on Mytens see Waterhouse, pp. 35–8, and Millar, pp. 84–8.

87 [76] ill. 59, p. 145

Anne Cecil (1613–1637), c.1629

Anne Cecil was the eldest daughter of William, 2nd Earl of Salisbury and wife of Algernon Percy, Earl of Northumberland

Companion to No. 88 [114]

Daniel Mytens (?) (c.1590–before 1648)

Canvas $28\frac{1}{2} \times 27$ in. (72·4 × 68·6 cm.)

Bust portrait, life-size, face turned three-quarters to the right, eyes facing left. The portrait of a nicely dressed attractive young woman with fair hair curled into ringlets. She wears pearl earrings, a close-fitting pearl necklace, and a low-cut black gown adorned with a large flat white fichu-like collar and with large bows of ribbon in a pink colour. The face is softly modelled, and shadows give prominence to her features.

The sitter can be identified from her likeness in the portrait of her, her husband and daughter of the Van Dyck Studio at Hatfield (No. 126 [88]). She was born in London and christened at Whitehall. She was married to Algernon Percy, 10th Earl of Northumberland, by 1629 and had five daughters before her early death in 1637.

The strong modelling and the clear style of the picture justify the attribution to Daniel Mytens, whom we know to have been engaged on work for the Earl of Salisbury in 1629 and thereafter.

(Cf. evidence under catalogue No. 85 [78]. This view is strengthened by a communication from Mr Oliver Millar of December 23, 1959.

The authorship of Mytens is more likely than that of Cornelius Johnson, to whom the picture was formerly attributed and whose treatment of portraits is much softer. Another version of both this portrait and No. 88 [114] is at Penshurst.

This portrait was formerly called Frances Cecil (1591–1644), only daughter of Robert, 1st Earl of Salisbury and Countess of Cumberland. It is inscribed, 'Lady Frances Cecil, the only daughter of the first Earl of Salisbury; was married to Henry Clifford, Earl of Cumberland', in a nineteenth-century hand on the back.

Collection: As early as 1629 a picture of Anne Cecil, described as 'my lady Percie', was in the Gallery at Hatfield, according to an inventory of that date (Box A.6, f.3d.). This picture and one of the lady's husband were afterwards transferred to the 'second drawinge Chamber to the dyninge roome' (*ibid.*, f. 9, '1 of my lord Northumberland', '1 of my lady Northumberland', a note added in 1632 or later). They were again listed in the same room in 1646 (Box A.8 and 9, f.16d), although in the meantime the picture of Algernon, 10th Earl of Northumberland seems to have been, at least briefly, placed in the Gallery, according to the inventory of 1638 (Box A.7, f.11).

In 1680 both portraits were hanging in the Parlour (Box A.10, f.2).

In the nineteenth century the identity of the two portraits of Lord and Lady Northumberland seem to have been lost. The portrait of Anne may be the one described in 1823 as 'The Countess of Cumberland, a clear and very interesting Portrait', by 'Old Stone', in the Drawing Room (f.8), and in 1868 as 'Frances, Countess of Cumberland, daughter of the 1st Earl of Salisbury' by Daniel Mytens, in the Summer Dining Room, South Side (No. 3).

Perhaps one should note here that there was another portrait of Anne, Countess of Northumberland in the Cecil family collection in the seventeenth century. It was in the Wardrobe at Salisbury House, London, between 1629 and 1646 and was described in the inventories as 'half-drawn', 'Unfinished' (Box C.8, 9, 4 and 5).

Exhibition: Cat. Portraits 1866, No. 553.

Literature: Musgrave, f. 79 and f. 80; Pennant, p. 404, identifies No. 87 [76] correctly; Robinson, p. 19, as Countess of Cumberland; Holland, No. 66, as Frances Cecil, Countess of Cumberland, 1591–1644.

88 [114] ill. 60, p. 145

Algernon Percy, 10th Earl of Northumberland (1602–1668), *c.*1629

Companion to No. 87 [76]

Daniel Mytens (?) (*c.*1590–before 1648)

Canvas 29½ × 24 in. (74·9 × 61 cm.)

Bust portrait, life-size, face turned three-quarters to the left, eyes facing the viewer. The sitter has light-brown soft, wavy hair, an elegantly drawn moustache, and light-brown eyes. He wears a black-and-white slashed doublet and a falling fluted collar.

The identity of this picture, although confused in the nineteenth century, can be established by comparing it with the Van Dyck studio family portrait at Hatfield (No. 126 [88]) and with portraits of the same sitter at Penshurst and Petworth.

The arrangement and style of this portrait makes it appear to be the companion picture to No. 87 [76]. If the two pictures are put side-by-side, the man and the woman seem to turn towards each other. Also, there is the same lively modelling of the features, and a similar placing of the figure within the frame, leaving a large stretch of background above the head and at the side.

On the back of the picture a nineteenth-century label reads: 'Philip Sidney Earl of Leicester, married Lady Catherine Cecil, daughter of the second Earl of Salisbury, painted by Vandyke'.

Algernon Percy was the son of Henry Percy, the 9th Earl of Northumberland, and Dorothy Devereux. He was married to Anne Cecil, daughter of the Earl of Salisbury, by 1629 (after much opposition from his father, who declared that the blood of Cecil and Percy could not be mixed, even in a bowl. In 1636 he was appointed Admiral of the Fleet by Charles I and afterwards became Lord High Admiral. Later, like William, 2nd Earl of Salisbury, he sided with the Parliament in the Civil War. He made, however, many efforts to reconcile the two adverse parties (C. H. Firth).

Collection: For reference to this portrait in the seventeenth-century inventories, see No. 87 [76] above.

In the inventory of pictures at Hatfield in 1823 the following portrait is listed as being in the Drawing Room: 'Sidney Earl of Leicester, dressed in a black Doublet slashed, the Hair is beautifully expressed, the Colouring Modest and full of Nature – a $\frac{3}{4}$ length . . . Vandyke'. At that time a portrait described as three-quarters could mean head and shoulders only, measuring about 30 × 25 in. (76·2 × 63·5 cm.)

(Information from the late Mr C. Kingsley Adams).

In 1868 'Sidney Earl of Leicester by A. Vandyke' was hanging in the Summer Dining Room, South Side (No. 7).

Literature: Holland, No. 114, as Philip Sidney, Earl of Leicester, 1619–1698.

89 [225] ill. 61, p. 146

Head of a Spaniard

?Giovanni Busi Carriani (active *c.* 1485), after Giorgione (*c.*1476/8–1510)

Panel $15\frac{7}{8}$ × 12 in. (40·3 × 30·5 cm.)

A most attractive bust painting, softly modelled with big eyes and an expressive mouth. The face is all-important, a piece of fur on the left shoulder finishes the composition. Venetian looking and of high quality. An old label reads: 'No. 707. Spanish Head with a Coif Painted by Velentin'.

'Velentin' may be the French painter, Le Valentin, perhaps of Italian origin who lived from *c.*1591–1632 and was influenced by Caravaggio.

Professor Waterhouse, in a letter of December 7, 1959, to Mr David Piper, points out that No. 89 [225] may be a copy of a picture once at Coombe Abbey, called Carriani. There was also a copy ascribed to Rubens in Copenhagen, (Mario Krohn, *Italienske Billeder i Danmark*, 1910, pp. 154/5).

Giovanni Busi Carriani had studied in Venice under Giogione and Palma Vecchio. This type of picture may once have been considered a painting by Giorgione.

Collection: 1611 (Box A.1) in the Wardrobe, Upper Storey 'One Picture of a spaniard'. In the 1868 inventory of Hatfield House under No. 151: 'Billiard Room, East Side: Head of a Spaniard in a Coif – Velentino'. In 1891 this picture was at Arlington Street. 'One picture of a Spaniard' may have led to the erroneous identification of No. 73 [74] as a 'Spanish Ambassador'.

Literature: Holland No. 225 as 'By Valentino, 1600', artist French by birth, but of the Italian 'naturalisti' school.

90 ill. 62, p. 146

John Tradescant the Elder (d. 1638), c.1630

Gardener and collector of curiosities

Painter unknown

Canvas 41 × 36 in. (104·1 × 91·4 cm.)

An elderly gentleman is presented standing three-quarter length, dressed in black and wearing a brown fur-lined gown. He holds up a shell with his left hand, balancing it on his fingertips. Another shell he grasps firmly in his right hand holding it open towards the spectator. His right arm is extended down at the side in a slight curve.

The most imposing feature of the portrait is the face. The sitter has a full silvery-white flowing beard and long white curly hair falling on to the narrow white collar of the black dress. His reddish complexion is well painted in contrast to the white hair, and the shading and modelling emphasize the nose and the cheek bones. The dark eyes seem to follow the spectator, as if he wanted to demonstrate the beauty of his precious shells.

Face and hands are in a very good condition although the canvas is damaged in parts and has become too dark to distinguish all the original details.

John Tradescant the Elder was an interesting personality. He is first mentioned in 1607 at Meopham, Kent, a village close to Cobham Hall, the seat of Lord Cobham who was the father-in-law of the 1st Earl of Salisbury. This connection may have induced Lord Salisbury to employ Tradescant to take charge of the elaborate gardens he planned for Hatfield House. Numerous entries exist in Bills and Accounts from 1609 until about 1615 and bear witness to Tradescant's activity in obtaining and growing trees and flowers, and fruits and vegetables for his patron. In the autumn of 1611 he was sent to the Low Countries and France to collect new varieties of plants and fruits and to procure a supply of decorative shells. He returned shortly before the death of his patron in 1612 and continued to work for the 2nd Earl for several years in the same capacity. In 1618 he travelled to Russia and became interested in collecting all kinds of new and strange objects which led to his famous 'Cabinet of Varieties'. He bought a house in south Lambeth, called Tradescant's Ark, which became well-known because of its curiosities. John Tradescant the Younger (1608–1662) inherited his father's property and continued to add to the collection. After his death Elias Ashmole bought the Ark and most of its contents are now housed in the Ashmolean Museum, Oxford.

The identification of the sitter as John Tradescant the Elder is based mainly on the shells in the picture – objects which are closely associated with the career followed by father and son. There is, however, also an iconographic likeness between No. 90 and two portraits representing Tradescant the Elder at a younger age. They are Nos 9 and 121 in the Ashmolean Museum (reproduced by Mea Allen, *The Tradescants*, 1964). This comparison makes the identification plausible.

The two portraits of the elder Tradescant, together with a group of paintings representing the younger at the Ashmolean, and one at the National Portrait Gallery, are generally attributed to a member of the de Critz family, sometimes called 'Emanuel' – the families of de Critz and Tradescant were related by marriage. But the attribution does not seem to be entirely justified. (Waterhouse, p. 51, Pls 43 and 44B.)

The style of No. 90 is different and the lively treatment of the face and hands comes near in manner to the Antwerp School of the beginning of the seventeenth century. In this connection it may be of interest, that the elder Tradescant was employed in the late 1620's by George Villiers,

Duke of Buckingham. He may easily have come into contact with Rubens, who stayed in this country in 1629/30 and stood in great favour with the Duke.

Collection: The present Lord Salisbury bought this portrait at Christie's, May 1, 1970, Lot 40, 'Portrait of John Tradescant'. It belonged to the Dowager Marchioness of Tweedsdale.

Literature: John Tradescant the Younger, *Museum Tradescantiarum*, 1656; Gunton, 'The Building of Hatfield House'; R. Lane Poole, *Catalogue of Oxford Portraits*, Vol. I, p. 171, Nos 413 and 414 Pl. XXV; Waterhouse p. 51, Pls 43 and 44B; Stone, pp. 25–6; Mea Allen *The Tradescants*, 1964.

91 [51] ill. 63, p. 146

Diana, *c.*1560

Attributed to Frans Floris (*c.*1517–1570)

Panel 43½ × 34½ in. (110·5 × 87·6 cm.)

A half-length, life-size figure in frontal position. In her right hand the goddess holds a hound on a leash, who comes into the picture from the left. Her left hand is raised to keep a large bow vertically upright and the arrows for the bow can be seen in a quiver behind her right shoulder. Other allegorical symbols, such as a yellow skin with a mask of a lion's head in front, a white crescent fastened by pearls to her yellow hair, and the arc-like curve of a thin gauze veil sweeping behind her, complete the traditional appearance of 'Diana'.

This painting is a very well modelled Italo-Flemish allegorical picture with a realistic treatment of the face, the hands, the hair and the dog's head. It projects forward towards the on-looker in a plastic conception and is of an excellent quality and preservation. The particular style is that of Antwerp Mannerism, as it is seen for example in the group of allegorical figures in the clouds in the Courtauld Institute Galleries' 'Sir John Luttrell' by Hans Eworth or the *Goddesses* in the painting dated 1569, of 'Elizabeth I and the Three Goddesses'. A close comparison of 'Diana' with these allegorical figures shows their great likeness.

Holland described this painting erroneously as 'Another Portrait (of Queen Elizabeth) as Diana', painted by Cornelius Vroon, and he supports his view by referring to the inventory of 1611 in which 'a portrait of her late Majesty' is mentioned. The various entries of portraits of Elizabeth I are listed above under No. 50 [50], and it is almost impossible to link them more closely with any individual painting representing the Queen.

It has now been plausibly shown by Dr Dora Zuntz ('A Painting of Diana by Frans Floris, A Discovery at Hatfield House', *Apollo Magazine*, November 1958) that this picture had probably been cut down from a larger picture representing 'Diana Enthroned', painted between 1558 and 1560 in the studio of Frans Floris in Antwerp.

Collection: The inventories of Hatfield House and those of Salisbury House confirm the theory that 'Diana' is represented here in her own right and not as Elizabeth in the guise of the goddess. At Salisbury House in 1629 (Box C.8), 1639/40 (Box C.9), 1645/46 (Box C.4 and 5), and in 1647 (Box C.6), '1 picture of Diana' is mentioned as being in the 'Gallarie' at Salisbury House. In 1685 this painting no longer appears in the inventory. In 1868 a Hatfield House Inventory lists under No. 123 in the Library, left of the Fire Place 'Queen Elizabeth in the character of Diana'. It has to be concluded, therefore, that it was not until the second half of the nineteenth century that this allegorical painting of 'Diana', with all the classical emblems and attributes of that goddess, was considered to represent Queen Elizabeth I. One might add that it would be a compliment to Queen Elizabeth, the 'Virgin Queen', to have a fine picture of Diana hanging in one's house, whether or not the features of the goddess quite resembled hers.

Literature: Holland, No. 51; F. A. Yates *Allegorical Portraits of Queen Elizabeth I at Hatfield House,* Hatfield House Booklet No. 1; Dora Zuntz, *Apollo Magazine,* November 1958, 'A Painting of Diana by Frans Floris, A Discovery at Hatfield House'.

92 [180] ill. 64, p. 147

Leda and the Swan

Painter unknown

Panel (cleaned 1959/60) 29 × 41 in. (73·7 × 104·2 cm.)

Leda is in repose on a settee in a half-upright position attended by the twins Castor and Pollux. The elbow of her left arm rests on brightly painted red and gold material. She turns three-quarters back towards the swan, whose beak lies on her left shoulder and whose wings she caresses with her raised right hand. Her knees, placed close together, are slightly lifted up, the right leg is crossed over the left one. This movement is emphasized by the strange profile position of one of the twins, who is clinging to Leda and who stands on her right foot, so that his leg repeats and co-ordinates the diagonal trend of the composition. The complex movement of the Mannerist period, probably based on an Italian pattern, accords with the style of the Italianate School in the Netherlands. The background is dark and the light flesh tints contrast strongly with it. The modelling is good. A dark piece of cloth is held across part of Leda's nude figure by the second twin.

The painting was cleaned and restored in 1959/60; previously the preservation was poor and there was some flaking and repainting. The varnish is too bright now, but the general appearance is quite good. In style there is a certain resemblance to the seated Venus and Cupid in the right-hand corner of 'Queen Elizabeth I and the Three Goddesses' by H.E., and to some allegorical paintings by Floris.

Collection: The Salisbury House Inventory of 1629 (Box C.8, f.3) mentions as hanging in the Gallery '1 picture of Jupiter and Leda'. The Hatfield House Inventory of 1679/80 (Box A.10, f.d) lists 'In the darke Chamber', '1 picture of Jupiter and Leda'. It therefore emerges that by 1679/80 'Leda and the Swan' had been transferred from Salisbury House to Hatfield, where it remained. In the nineteenth century it appears in the inventories. In 1823 it is recorded in the Breakfast Parlour: 'Jupiter and Leda, painted on Pannel, the Colouring clear, after the manner of L. da Vinci'. In 1868 it is listed under No. 167 in the Billiard Room, South Side as 'Leda caressing the Swan – Julio Romano'.

Literature: Robinson, p. 28; Holland, No. 180, Painted after Giulio Romano.

93 ill. 65, p. 147

Mercury, Argos and Io, 2nd half of the sixteenth century

Painter unknown, perhaps French

Panel 43 × 54¼ in. (110 × 138 cm.)

This is an interesting allegorical picture, which was recently cleaned. The three main figures, Mercury, Argos, and a cow representing Io, are shown as the light falls on them, making them stand out boldly from the dark wooded background. The classical story of the jealousy of Juno, when Jupiter is attracted by Io, has reached the point where Io, transformed into a cow, is being watched by Argos with his thousand eyes. We find Argos seated comfortably against a wall, legs crossed, holding the rope which secures the cow in his right hand and a cowherd's pouch in his left. A dog is sitting beside him. The mournful face of the cow peers out of the darkness

behind him. Argos's face is shown in profile, and the illusion of having a thousand eyes is represented by a net which covers his face. On the left-hand side we see some sheep grazing, and in the foreground the graceful figure of Mercury is posed, legs wide apart, sitting on a rock or ledge, and playing a pipe with the intention of distracting Argos or lulling him to sleep, thereby to liberate Io for Jupiter. Argos regards Mercury somewhat distrustfully.

The composition is based on an engraving by Goltzius (1558–1617), Bartsch 370. The detailed treatment of landscape, figures and animals is broader and more painterly. (I am indebted to Mme S. Beguin for drawing my attention to this engraving.)

The painting is a clear example of the Italianate Mannerist style. This is seen in the strong concentration of the light on the main figures, in Mercury's complex movements, and in the treatment of Argos's hands and of the folds of his garments. It is difficult to say who the painter was or even his origin, but there is a certain affinity to French paintings of the period.

Collection: The picture first appears in the Salisbury House Inventory of 1629 (Box C.8, f.3), where two pictures of 'Mercurie, Argos and Joe' are listed as hanging in the Gallery. The same entry appears in 1639/40 (Box C.9) and in 1645/6 (Box C.4 and 5). At least one picture of this subject was still at Salisbury House in 1685 (Box C.7) and in 1687 (Box C.3). We do not have any way of telling when No. 93 came to Hatfield House from London.

In the nineteenth century it turns up in the Hatfield House Inventory of May, 1868, No. 185, as 'Mercury with his pipe lulling Argos to sleep', which was hanging in the Steward's Room.

Literature: Holland does not mention the picture in his catalogue. Perhaps it had been mislaid at the time he compiled his catalogue.

94 [202] ill. 66, p. 148

Cupid Scourging a Satyr, late sixteenth or early seventeenth century

Painter unknown, Italian Mannerist

Panel 39¼ × 43½ in. (99 × 110 cm.)

The action of the picture takes place in a dark landscape, with a dense bushy woodland on the left and an open view towards the villas and the mountains on the right. In the foreground of the scene Cupid, painted in bright colours, is shown advancing upon a bound satyr and beating him with his bow. The satyr is shown from the back as he shrinks away from Cupid. A little distance off, in the middle ground in the centre of the painting, depicted in much smaller size, is the figure of the maiden in distress whom Cupid has rescued from the satyr. The curving movements of her arms and her downcast expression indicate her grief. All three figures stand out in full light against the dark background of the landscape, and the modelling is achieved with strong contrasts of shadows and light in the chiaroscuro manner of Caravaggio, Carracci, and others.

Probably because of this typically Mannerist treatment it was suggested in the nineteenth century that the painter was the Italian Annibale Carracci.

The painting has recently been cleaned and restored after having been lost for many years. It may very well have been one of the Italian pictures bought and sent to England by Sir Henry Wotton.

Collection: This picture seems to appear in an inventory of the goods of Diana, Viscountess Cranborne of June 2, 1675 and in Bills No. 202. In 1823 it was hanging on the Middle Landing and Gallery and described as 'Cupid correcting Pan'. In 1868 it was No. 186, 'Cupid scourging a Satyr', by A. Carracci; and was hanging in the Steward's Room.

Literature: Holland, No. 202

95 [230] ill. 67, p. 148

Petrarch's Laura

Master of the Female Half-length Figures
(c.1530)

Panel 19×15 in. (48·3×38·1 cm.)

Inscribed at the top in Roman letters:
'LAVRA FVI, VIRIDEM RAPHAEL FACIT,
ATQUE PETRARCHA

This is a charming picture which represents a young woman, shown half-length, sitting at a table reading a book. The book is open and her left arm extends horizontally across the middle of the picture towards the table. Both hands are visible. Her face is almost frontal and her eyes gaze downwards. A transparent veil covers her head. In the left-hand corner on the table the faint outlines of a glass or cup appear, an indication that an original part of the picture has been overpainted.

The attitudes of both hands, the composition, the shading of the face with downcast eyes, the pointed chin and veil are typical of paintings attributed to the Master of the Female Half-length Figures by Max J. Friedländer *Die altniederländische Malerei*, Vol. XII, Pl. XI. (I am indebted to Dr John Shearman for this suggestion.)

The Master of the Female Half-length Figures usually depicts his figures as Magdalenes giving them the symbol of the jar of ointment. In this case the jar has been overpainted and its rosette incorporated into the painting of the book with the aim of turning the Magdalene into Petrarch's Laura. This painting has nothing to do with Raphael.

Collection: A 'picture of Lawra etc.' is recorded as hanging in the Gallery at Salisbury House in the inventory of 1629 (Box C.8.f.3)., therefore the inscription must have been added before that date.

Musgrave in 1769 is the first to record this painting as being at Hatfield House. Pennant describes it in 1780, rather amusingly comparing Laura's character with that of the austere Lady Margaret Beaufort hanging nearby in the Gallery (No. 8 [9]).

In the Hatfield inventory of 1823 it is listed in the Drawing Room and in 1868 in the Billiard Room. Holland, No. 230, as at Arlington Street.

96 [200]

Head of a Philosopher, end of the sixteenth century

Companion picture to No. 97 [200]

Painter unknown

Panel 20 × 13 in. (50·8 × 33·1 cm.) – previously 14 × 10 in. (35·6 × 25·4 cm.)

Inscribed on top: PHILIPPUS

This picture is in a very bad state of preservation. It is crudely painted. A life-size head, eyes half-closed looking down. The sitter has curly hair and wrinkles, and the modelling brings out strong contrasts of light and shade. Some highlights may have been put in slightly later. A misty colour prevails. This picture was at some time extended in size as indicated above.

Collection: In the inventory of 1868 the 'Head of Philippus' was hanging in the Steward's Room under No. 189.

Literature: Holland, No. 200.

97 [200]

Head of a Philosopher

Companion picture to No. 96 [200]

Painter unknown

Canvas 20 × 13 in. (50·8 × 33·1 cm.)

A similar head resembling No. 96 [200]. The philosopher appears almost in profile with a long

beard. There is a big hole in the canvas, and the preservation is worse than No. 96 [200], and in fact this picture is almost destroyed. Dark shades and a brownish colouring can be seen.

Collection: In the inventory of 1868 the 'Head of Socrates' was hanging in the Steward's Room under No. 188.

Literature: Holland, No. 200.

Both pictures (Nos 96 [200] and 97 [200]) may be identifiable with 'one other picture of Plato the philosopher and one other picture of Aristotle the philosopher' which, in addition to one portrait of Queen Elizabeth, Burghley bought from the heir of Thomas Wilson the Queen's Principal Secretary in 1582 (Legal 16/6); see above p. 54.

98 [175] ill. 68, p. 149

Adam and Eve, 1543

Marcellus Coffermans (working from 1543–after 1575), after the engraving by Albrecht Dürer (1471–1528)

Panel 78 × 68 in. (198 × 173 cm.)

This painting in rather dark colours is a very close copy of Dürer's engraving of Adam and Eve of 1504. The tablet which is shown in the engraving below a branch of the tree on the left-hand side of the picture has disappeared here, however, and is replaced by the inscription: 'Marcellus Coffermaus pinxit 1543' which runs along the tree on the left of Adam's head. Only in small details does the picture differ from the engraving: Adam is older and bearded, the scenery is more realistic and the apple-tree between the couple is shown more to the foreground. The various animals populating the scene in the engraving, such as the cat and the mouse, the rabbit, the ox and the deer, and even the parrot, reappear in the painting, but again are more realistic and simplified. An interesting comparison can be

made with a nineteenth century impression of Dürer's engraving which hangs next to this work.

Marcellus Coffermans was an Antwerp painter of the sixteenth century. His style is usually Flemish, and the exact copying of a work by Dürer is an exception.

Collection: In the following survey of documents and inventories it is not always quite clear whether the entries refer to No. 98 [175] or No. 99 [176]. In Hatfield House inventories from 1611 to 1646 '1 faire lardge picture of Adam and Eve' is mentioned which first hung in 'the Wardrobe Upper Storey' (Box A.1, Sept. 30, 1611 and Box B.5, 1612 or after) and then on 'the Great stairs on the Kinges side' (Box A.6, June 9, 1629, f.8; Box A.7, Sept. 23, 1638, f.28; Box A.8 and 9, July 25, 1646.) On March 3 or 24, 1679/80 (Box A.10, f.8d and f.9) two pictures are listed: In the Gallery – '1 Picture of Adam and Eve driven out of Eden' and in the Lobby at the end of the Gallery – '1 large Picture of Adam and Eve'. By that time one painting must have been brought to Hatfield from Salisbury House.

Salisbury House inventories from 1629 to 1646 list '2: pictures of Adam and Eve one with a curtaine' as in the Gallery (Box C.8, June 20, 1629, f.3; Box C.9, 1639/40 and Box C.4 and 5, 1646). Bills 254 (1652) contains 'The Picture drawers bill for renewing the pictures at Salisbury House and stopping the picture of Adam and Eve 1l. 5s.'.

But, despite the fact that in 1680 there were two pictures of Adam and Eve at Hatfield, in 1685 (Box C.7) there was still '1 Piece of Adam and Eve' in the Hall of Salisbury House. Did the Cecil family originally own three paintings of Adam and Eve?

In the nineteenth century the situation becomes clearer. In the Hatfield House Inventory of 1823 two pictures are rather vaguely listed as hanging on the staircase:

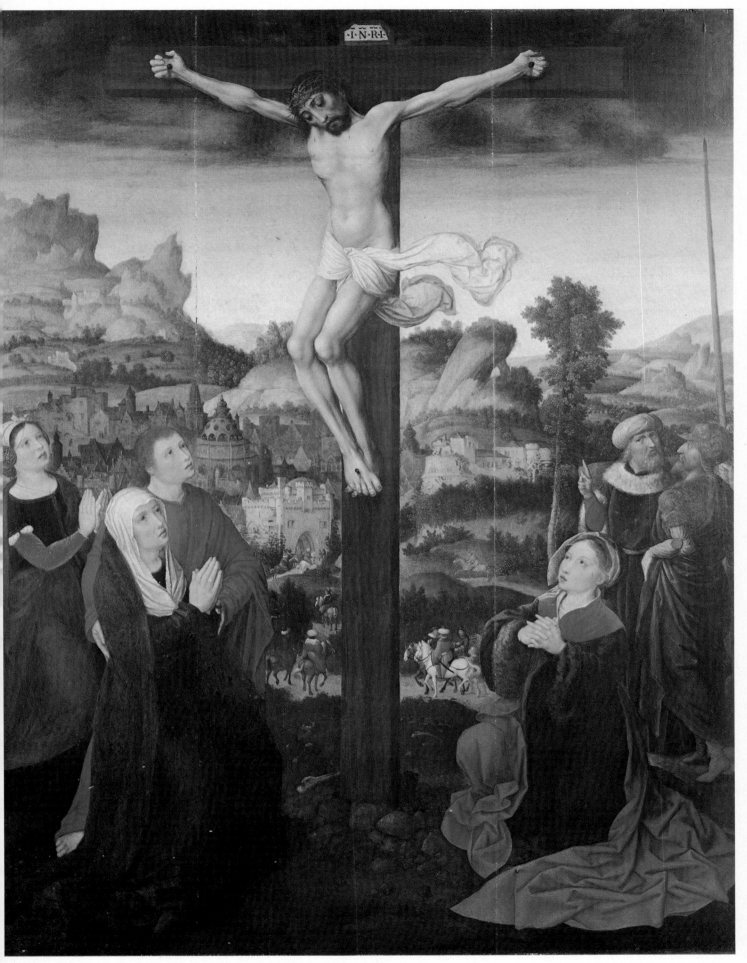

COLOUR PLATE XI. **Crucifixion,** *c.*1530, by Adrian Isenbrandt (Cat. No. 100, p. 98)

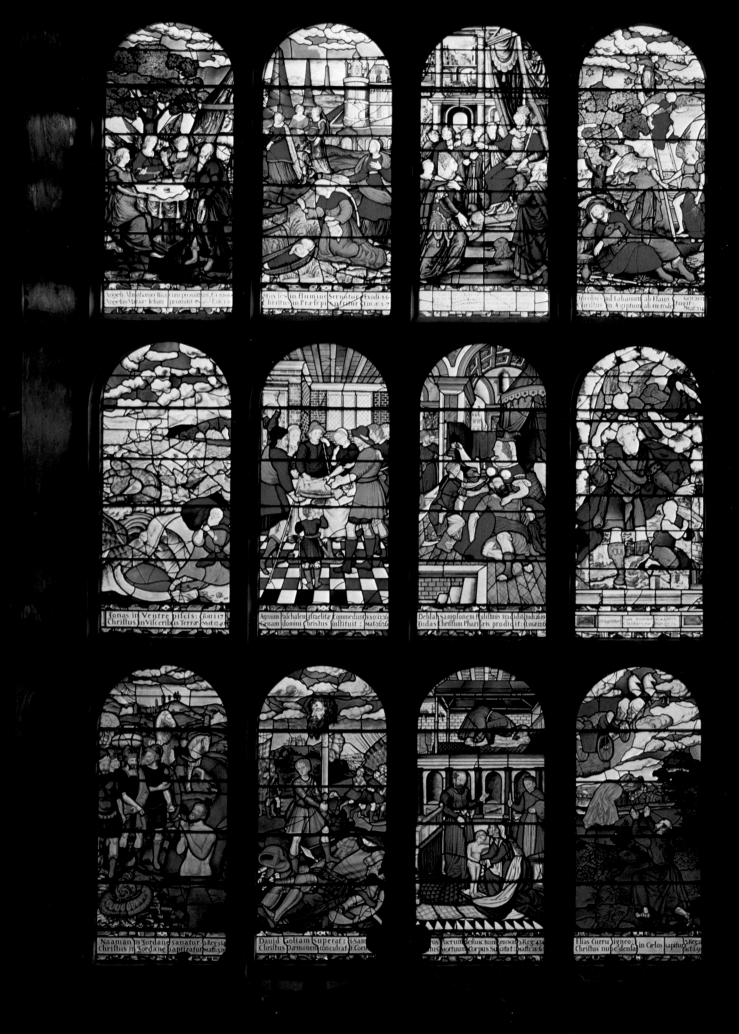

'A large Picture, Adam and Eve, an ancient Painting on Pannell, damaged.
Ditto larger...'

In 1833 Robinson, p. 28, distinguishes between the two, describing No. 98 [175] as by Dürer and calling No. 99 [176] 'A large picture of Adam and Eve marked AW with an inscription in Dutch implying that union gives power'.

In 1868 the inventory follows Robinson. At that date both pictures were hanging in the Marble Hall.

Literature: Holland, No. 175

99 [176] ill. 69, p. 149

Adam and Eve

Attributed to Jan van Scorel (1495–1562)

Panel 67 × 56 in. (171 × 143 cm.)

The two life-size, well-modelled nude figures are placed towards the left, where they are supported by the big twisted trunk of the apple tree whose branches, near the top of the picture, stretch over to the right-hand side. The serpent, winding itself round the tree, looks down on Eve. The foreground is kept rather dark in contrast to a rocky landscape and a light sky. There is a golden brown tone predominating and the Mannerist Italianate style is typical of the Dutch School of the beginning of the sixteenth century. The painting is not at all well preserved.

Inscribed and ornamented on the original black frame is AW in bold Roman letters interlaced on top and at the bottom EENDRAGHT.GH EEFT. MAGHT with two shields of arms and a symbol of clasped hands. Putti appear as supporters.

The inscription, translated as 'Union gives strength', together with the shields of arms and the clasped hands, point to the fact that this painting was originally designed as a betrothal picture.

J. Bruyn, *Bulletin Rijkmuseum* 1954, No. 3, attributes this picture to Jan van Scorel and assumes that it celebrates the marriage of Andries van Sonnevelt with Wilhelmina Paling in 1516.

Jan van Scorel lived from 1495 to 1562. He was trained in Amsterdam and, in 1517, was resident in Utrecht. Later he went to Nuremberg and visited Dürer. He travelled to Venice and Rome where he was patronized by Hadrian VI, the Utrecht Pope. By 1524 he was back in Utrecht. In 1527 Marten van Heemskerk was his pupil.

According to Bruyn, *op. cit.*, an inventory of a Haarlem convent in 1571 mentions amongst other pictures 'Een tafereel van Adam en Eva, gemacht bij Mr. Jan Scorel'. Two years later the convent was plundered by the Spaniards. In October 1573 some pictures turned up in the hands of an Amsterdam merchant and were brought into the Utrecht house of Sir Frederik van Wittenham where an inventory mentions, amongst other pictures, 'Een tafereel van Adam en Eva, met vergulden lijske gesneden, bij Scorel gescildert'. How the picture made its way to England is unknown, but from the inventories quoted under No. 98 [175], we may presume that the Cecil family acquired it some time in the seventeenth century. By 1611, if not before, this painting may have reached Hatfield House.

The attribution to Scorel is plausible for stylistic reasons. It bears great resemblance to Scorel's 'St Magdalene' in the Rijksmuseum, Amsterdam. Apart from the modelling of the faces, the composition and background of No. 99 [176] fully conform to those of the Amsterdam picture. The placing of the figure or group of figures in an open landscape in front of a tree on one side, the dark colours in the foreground, the distinctive handling of the middle ground with the slightly lighter stretch of land, again contrasted with still lighter rocks, and the bright sky. All these motifs repeat themselves in both paintings. The brownish tone on the Hatfield picture shows, in addition, a Venetian influence

COLOUR PLATE XII. **Stained Glass Window,** by 'Lewis Dolphin, a French painter' (probably Louis Dauphin), Richard Butler of Southwark, and Martin van Bentheim, Dutch, of Emden (Cat. No. 117, p. 107) See also ills 87–92, p. 156

which is often characteristic of Scorel's work.

Collection: Notes in the inventories are mentioned under No. 98 [175]. Only in the nineteenth century can the two 'Adam and Eve' pictures be distinguished from each other.

Literature: Holland No. 176 as 'Painted in the Dutch School'. J. Bruyn, *Bulletin Rijksmuseum,* 1954, No. 3 'Enige Werken van Jan van Scorel mit zijn Haarlemse tijd (1527–1529)'.

100 Colour Plate XI, opp. p. 96

Crucifixion, *c.*1530

Adrian Isenbrandt (d. 1551)

Panel 33 × 26 in. (83·9 × 66·1 cm.)

An interesting early Flemish religious painting, of the 1530's. The figure of Christ on the cross dominates the group of figures in the foreground of a landscape painting. The cross is in the centre and almost extends the whole height of the picture. The two groups of figures below Christ are placed symmetrically on either side: on the left, St John and the Virgin Mary, and behind them a woman who kneels in prayer; on the right, St Mary Magdalene is worshipping, and behind her two soldiers are in conversation. On both sides of the cross, in the middle ground, riders are shown in a much smaller size, suggesting considerable distance. They move on a winding path towards the fortified gate of the imaginary city of Jerusalem. The scenery as it recedes into the background, in layers, is characterized by a number of buildings in the city, by trees and by rocks of assorted shapes, above which a light sky is visible. The sky darkens towards the top of the painting over the head of Christ.

As to the style, the figures are calm, placid and motionless. Only the garment of Mary Magdalene and the loin-cloth of Christ still show the flowing, angular Gothic drapery. The men and women looking up at Christ all have small round heads, straight noses, and very small mouths. The rocks in the landscape have a bizarre form and seem to have been put into the ground diagonally. The buildings are also strangely shaped. The attribution to the painter Adrian Isenbrandt is convincing: all the above-mentioned features can be seen in other works by him.

On November 29, 1510, Adrian Isenbrandt became a free master of the Guild of Painters in Bruges. He seems to have come to settle in Bruges from another city in the Netherlands, because he is mentioned in the documents of Bruges as 'stranger'. He died in Bruges in July 1551. It would appear he was a pupil of Gerard David, whose works he imitated and in his landscape paintings he was also influenced by Joachim Patinir. He was the last painter in the great Bruges tradition and shortly after his death, or already during his lifetime, Antwerp became the chief centre of painting in the Netherlands. Max J. Friedländer in *Die altniederländische Malerei,* Vol. IX, 1931, gives a good analysis of his life and work and it appears from Friedländer's article that a number of versions of the Crucifixion are in existence. 'The Crucifixion' in Hatfield House resembles the painting of the same subject in *ibid.,* Pl.65, from the collection of J. Goldschmidt.

Collection: Given to the Hatfield House Chapel in 1934 by Violet, Viscountess Milner in memory of her first husband, Lord Edward Herbert Cecil (1867–1918), and their son George Edward Cecil (1895–1914). Bought at Christie's in June 1934 from Bleemore House, Hampshire, as by Rogier van der Weyden.

101 [178] ill. 70, p. 149

Boy Reposing on a skull

Painter unknown

Panel (cleaned 1959) 23 × 30 in. (58·5 × 76·2 cm.)

A little boy half-reclining in a horizontal position on a kind of table supports his head by resting his right elbow on a skull. With his left hand he holds up a standard inscribed: 'Nascendo. Morimvr'. Dark shadows help the modelling of the strangely foreshortened figure. In the background there is a thick draped curtain on the left-hand side and on the right a window is open to show a house nearby, with a woman standing at the door, and beyond the house a light landscape view. There is a definite contrast of verticals and horizontals in the Renaissance style. This is an allegorical picture, as sometimes depicted by the Flemish School. A label on the back reads: 'Boy with a skull'.

This picture was in a poor condition and was cleaned in 1959, but the colours now appear to be slightly too bright. There are several versions, the nearest in composition to No. 101 [178] being one which once belonged to Mr Arthur Kay, and was in a sale at Roos, Amsterdam, April 16, 1912. It has been attributed to H. Goltzius. There is also a related version, which was in a sale of Lepke, Berlin, May 10, 1921, and was then attributed to Jan van Scorel. Another was attributed to Frans Floris, *Art Bulletin*, September 1937.

Collection: No. 101 [178] has been in Hatfield Collection at least since 1611 (Box A.1), when it was mentioned as hanging in the 'West range 2 Sto', the 'passage to the upper Closett'. In the following years, until July 25, 1646 (Box A.8 and 9), it was either hanging in the 'Lobbie Roome att the end of the gallerie by the Chapple' (Box A.6, June 9, 1629, f.3d.) and again (Box A.8 and 9, July 25, 1646) or in the 'withdraweing Chamber the Queens side' (Box A.7, September 23, 1638, f.15). In the inventory of 1823 'A Sleeping Boy reclining on a Scull, in the manner of . . . L. da Vinci' was hanging in the Breakfast Parlour. In 1868 under No. 172 there is the entry 'Boy sleeping on a scull – Hans Huet'. Hans Huet

sometimes refers to Hans Eworth, but there is no version of No. 101 [178] by Eworth known.

Literature: Holland, No. 178.

102 [192] ill. 71, p. 150

Holy Family with an Angel playing the Lute, *c.1514*

Antonio da Solario (working from 1502 to 1518)

Panel $17\frac{1}{4} \times 21\frac{3}{4}$ in. (43·8 × 55·2 cm.)

The child is sitting erect with horizontally outstretched legs on a table in the centre, held by his mother who appears behind him in a frontal position, turning her head three-quarters to the left and looking down, while she offers him an apple. The boy looks towards the left where an Angel plays the lute, which he rests on the table. On the right Joseph is visible, his bearded face in profile, holding a strong staff in his left hand and a lily in his right. All three figures are half-lengths. The background is dark in colour. Behind the Virgin, dressed in a red dress, stretches the vertical part of a baldachin, patterned with horizontal light lines. On the left-hand side there is a square window-like opening revealing the view of a fortified castle surrounded by an attractive landscape.

An inscription in Roman letters along the square edge of the Virgin's dress reads: LOVE AND DRED. IHS and lower down on the seam of her dress: EX HOC FUIMUS.

The composition of this picture conforms to that of the Venetian Madonna paintings of the beginning of the sixteenth century. It also closely agrees with the Holy Family in the Withypole Triptych, now in the City Art Gallery, Bristol, which is signed: *Antonius Desolario, Venetus, 1514*. (See entry, *Cat. British Portraits 1956–57*, No. 8, where the relevant literature is included.)

Here also is an angel, with a viol to which the corresponding one in the Hatfield painting bears

great resemblance. The types of the figures are also similar and some peculiarities, such as the pointed chin of the baby and the shapes of the mouths, as well as the general expression of the features, are very much alike. The attribution to Antonio da Solario was first suggested by Dr Pamela Tudor-Craig.

Antonio da Solario, active 1502–1518, was a painter from Venice who may have visited England in about 1514. This assumption is based on the fact that some of Solario's paintings of that date are recorded in English collections.

Collection: It is possible that No. 102 [192] was in Henry VIII's collection (No. 105 in the 1542 inventory, see under Shaw below). A reference in the 1611 Hatfield House Inventory of September 30 (Box A.1) may point to No. 102 [192]: 'In the Wardrobe upper Story' there was 'One picture of Christ and the virgin Mary without a frame'. In 1679/80 (Box A.10) we find on f.3 'In the next great withdrawing room' (next to the Parlour) the following painting, *viz.* '1 Picture of the B. Virgin and our Saviour in her arms'. In 1868 under No. 163 it is recorded that in the Billiard Room East Side 'Holy Family with an Angel playing a lute – A. Dürer' was hanging.

These references show that No. 102 [192] may have been in the family collection from the beginning of the seventeenth century. It also emerges that in the nineteenth century this painting was believed to be by Dürer.

Exhibition: Royal Academy of Arts Exhibition: *Italian Art in Britain*, 1960, No. 26.

Literature: Holland, No. 192, without indicating the name of the painter; W. A. Shaw, *Courtauld Institute Texts*, I, 1937. Catalogue Royal Academy Exhibition: *Italian Art in Britain*, 1960, No. 26 as Antonio da Solario.

103 [185]

Virgin and Child

Painter unknown

Panel 33¾ × 23¼ in. (85·7 × 58·5 cm.)

The Madonna is seen in a frontal position, three-quarter-length. She holds the Child on her left hand. He sits upright, embracing his mother.

'The Madonna, del Granduca', the painting from which this is copied, belongs to Raphael's Florentine period. No religious accessories or symbols are given, and the painting is humanist in feeling.

104 [186]

Visitation of Elizabeth to Mary

Painter unknown

Panel 33¾ × 23 in. (85·7 × 58·5 cm.)

The picture is a copy of one painted by Mariotto Albertinelli (1474–1515) in 1503 now in the Uffizi, Florence.

Albertinelli was a Florentine painter who worked in partnership with Fra Bartolommeo and later abandoned painting, supposedly to become an inn-keeper. His 'Visitation' of 1503 is thought to be his best picture.

Literature: Holland, No. 186.

105 [189] ill. 72, p. 150

The Virgin and Child and three attendant children serving fruit, *c.*1550

Giovanni Battista Rosso (1495–1540)

Canvas 32½ × 26½ in. (82 × 67·3 cm.)

This painting is of a very good quality. Characteristic counter-movements, especially in the position of the child holding an apple are typical of sixteenth-century Mannerism.

A nineteenth-century label reads: 'Virgin and Infant Christ with Females presenting Fruit. Painted by Leonardo da Vinci'.

Collection: 1823 Breakfast Parlour: 'The Virgin and Child, attended by Angels in the style of Leonardo da Vinci – Garrafalo'. 1868 under No. 170: Billiard Room, South Side: 'Holy Family with females presenting fruit. L. da Vinci'.

IO6 [220] ill. 73, p. 150

Christ and the Woman of Samaria

?Paris Bordone (1500–1570)

Canvas 19¾ × 15½ in. (50·2 × 39·4 cm.)

This charming picture shows the two main figures in an open landscape in lively conversation. The well appears on the right-hand side, decorated with a piece of sculpture. In front of it a little boy is playing with a vase. On both sides there are huge trees which open in the centre to give a view into wide-stretching lake scenery with clouds. Smaller figures can be seen in the distance. Venetian colouring and soft shading. Diagonal, contrasting movements determine the whole composition. It is compatible with the style of Bordone.

Paris Bordone was born in Treviso and lived and died in Venice. He was a pupil of Titian and Giorgione.

Collection: 1868, inventory of Hatfield House mentions under No. 161 'Christ at the Well with the woman of Samaria – Paris Bourdone'.

Literature: Holland, No. 220, at Arlington Street.

IO7 [221]

The Virgin and Child in a Pastoral Scene

?Paris Bordone (1500–1570)

Canvas 20 × 15 in. (50·8 × 38·1 cm.)

In a wooded pastoral landscape the Madonna is shown nearly in profile to the right, leaning over the child on her lap. She wears a narrow white band round her head. Her dress is white above the waist and turns into blue-green in the lower part. A cherub appears above the Madonna's head and a white rabbit is partly seen on the left-hand side.

The intimate atmosphere, the soft shading and modelling conform to the style of No. 106 [220]. The attribution to the same painter, the Venetian trained Paris Bordone, is, therefore, likely, see biographical note under No. 106 [220].

A nineteenth-century label on the back reads 'Madonna dela Coniglio painted by Corregio'.

Collection: In the Hatfield House Inventory of 1868 it is mentioned as hanging in the Billiard Room, East Side under No. 155 as Madonna della Coniglio – Corregio.

Literature: Holland, No. 221 as painted by Paris Bordone.

IO8 [218] ill. 74, p. 151

Christ at Emmaus, formerly called Christ Entertained by Martha and Mary

Jacopo (?) Bassano (c.1510/18–1592)

Canvas 29¾ × 42½ in. (75·6 × 107·9 cm.)

On the right-hand side Christ sits at the table with two pilgrims in dark colouring. A view opens into the evening landscape with a reddish sky. On the left is a kitchen interior with brass utensils of various kinds and four women working hard, and in the foreground a cat and dog are chasing each other. A man seated in an armchair in the middle ground and looking towards the group round the table bridges the two separate parts of the composition.

The contrasting chiaroscuro, the genre scene,

combining figures, animals, utensils and a stormy landscape as the background of a religious subject clearly indicates the style of a member of the Bassano family of Venetian painters. The most important artist of the family was Jacopo (*c.*1510/18–1592) who may have been the author of this interesting picture. For further details see under No. 109 [219] which probably was a companion picture although larger in size.

A good version, attributed to J. Bassano, is in the Brera Gallery, Milan, though differing in a few points. Another, more similar to No. 108 [218], is in the Doria Gallery, Rome, and there are several abbreviated variants.

Collection: Only mentioned in the Hatfield House inventories of the nineteenth century. In 1823: Breakfast Parlour: Interior with figures – Bassano; Robinson, p. 28; in 1868 under No. 169 as hanging in the Billiard Room, South Side: 'Christ entertained by Martha and Mary. Bassano'.

Literature: Holland, No. 218, as 'Christ entertained by Martha and Mary' and hanging in 1891 at Arlington Street.

109 [219] ill. 75, p. 151

The Departure of Abraham, formerly called Jacob wandering with Family and Flocks

Jacopo (?) Bassano (*c.*1510/18–1592)

Canvas 52 × 69 in. (132 × 176 cm.)

This subject was often painted by 'Il Bassano'. The picture is in good condition and of a fine quality. The light thrown on the woman on the horse, the dog and the flock in the foreground, and especially on the very well-painted woman holding the panniers in the right-hand corner, emphasizes the diagonal movement of the procession into the depth. Some figures are seen from the back. In the distance are the outlines of mountains in reddish or blue tints, illuminated by the fading light, and the figure of Jehovah in the clouds pointing the way to Canaan. Again, as in No. 108 [218], we see Bassano's strong chiaroscuro and the precisely drawn rustic figures, animals and utensils. In a letter to Lord Salisbury of March 30, 1965, Mr Cecil Gould, of the National Gallery, points to various existing versions, two at Vienna, which are attributed to one of the Bassano sons, Francesco, and he suggests that there might be 'a vacancy for a Jacopo prototype'. There are other versions in the Brera, in Stockholm, and elsewhere.

Collection: In 1629, Salisbury House Inventory, (Box C.8, f.3d.) '1 picture of Jacob returning from Laban'. This entry was repeated in 1639/46 (Box C.9). In 1679/80 (Box A.10, f.2d) the same picture is listed as hanging 'in the next withdrawing Room' at Hatfield. In 1823 it was hanging in the Breakfast Parlour and was ascribed to Giacomo Bassano. In 1868 under No. 157 'Abraham on his Journey to Canaan, Bassano' was hanging in the Billiard Room, East Side.

Nos 108 [218] and 109 [219] may have come to be in the family possession due to the influence of Sir Henry Wotton, who was familiar with Venetian painting of the sixteenth century, and who collected pictures in Venice while Ambassador there, and sent them to his friends in England. Robert, 1st Earl of Salisbury, and his son William, the 2nd Earl, were amongst those for whom Wotton was busily collecting during his stay at Venice. We know that in 1608/9 he had caused a mosaic to be made by an Italian artist on the pattern of De Critz's portrait of Robert, which hangs now in the Library at Hatfield, see above, p. 70. He was apparently an appreciative admirer and collector of Bassano. To an anonymous friend he gave, 'a piping shepherd done by Cavalier Bassano', and in his will he bequeathed 'The Four Seasons' 'by old Bassano' to Eton College (John Buxton, *Elizabethan Taste*, p. 95).

Literature: Robinson, p. 28. Holland, No. 219,

as 'Jacob wandering with Family and Flocks' at Arlington Street.

I I O [193 and 198] ills 76 and 77, pp. 152–3

The Annunciation

Rowland Bucket (working from 1599 to 1639)

Canvas 67¾ × 49½ in. (172 × 126 cm.)

This subtly coloured Mannerist painting is of a very good quality. The life-sized figures of Mary and the angel are shown in complex movements and with exaggerated gestures reflecting the style of Venetian or Milanese painters of the second half of the sixteenth and the beginning of the seventeenth centuries. There is also the dark background, the effects of light and the in-between tones of purple and green. One might think of the influence of a painter such as Prospero Fontana (1512–1597), who lived in Bologna and was, at one time, invited to Fontainebleau by Primaticcio. Whatever the background of the artist may have been we know that his name was Rowland Bucket. In Accounts (Box G.13) we find under gifts and rewards from September 1611 to March 1612 a payment to Rowland Bucket 'for painteinge two picktures upon cloth, the one is the Angells salutacon to the Virgin Marie and thother is the Angell ap[peareth] to the Sheppards for the Chappell at Hatfield and done by My Lords appointment'.

He is first heard of in 1599 in Instanbul where he was reported to be engaged on a portrait of Queen Elizabeth I for the Sultan's wife (Henry Lello to Sir Robert Cecil, September 22, 1599 S.P. 94/4f.). His father Michael Bucket, a German emigrant, was described as being 'of London, Cordwainer' when made a denizen in 1572.

On Rowland's return to England he became an active member of the Painter Stainers' Company. He was the versatile artist who, apart from painting huge religious pictures, was mainly concerned with the decorative interior architec-ture of the Chapel and other parts of Hatfield House. He also drew 'patterns for the Chappell windows at Salisburie House' in November 1611 (Box G.13). Before, in 1609, he worked there again on the gilding of a chimney-piece. In December 1609, he decorated 'Brittains Burse' and he was paid for 'preparcons made against the King and Queen and prince their cominge with other Nobles to Brittains Burs'. According to Bills 77 (from January 1, 1611/12 to the last of May 1612) he was paid 31l. for 'the gildinge and payntinge of the Chymney peece in the greate Chamber one the East syde and workinge of the Kyngs picture lyke copper, and for payntinge and gildinge the freeze in the saide chamber'. He was also paid '33l.' for gilding and painting work 'donne in the lower parte of the Chappell on the wall, and one the sydes of the windowe, they are wrought with figures of the small prophetts and with borders and skrowles gilded about them and very muche other worke'. The interior of the Chapel must have offered a magnificent sight, as gold was applied lavishly, and the figures representing prophets at the east end, flanking the stained glass windows, still bear witness to the great skill and ability of Rowland Bucket.

Rowland Bucket was constantly engaged on work for the 1st Earl and later for his son. Money was paid out to him in large sums in 1613 (Accounts 115/21) and in October 1614 (Accounts 14/3). In October 1612 he painted 'a maigestey for the state' at his master's funeral (Bills 71). On September 24, 1611, the grant of a lease was given to Rowland Bucket, citizen and painter-stainer, of a newly-erected house and ground in Swan Close near St Martin's Lane in the parish of St Martin-in-the-Fields 'for special considerations moving me' at a rent of 16s. 5d. per annum (Box G.13). On October 18, 1624 (Accounts 123/16) he paid 'his halfe yares rent for one house in St Martin's due at Michas last 1624' which came to 8s. 3d. His active career was

closely bound up with the building activities of his patrons and he was greatly supported by them, even to the point of being their tenant.

Collection: This painting was always in the collection at Hatfield House. In July 1612 (Box B.5) amongst pictures in the 'Chappell' at Hatfield House there was 'A faire lardge picture of the Salutacon of the Angell Gabriell to the Blessed Virgin Mary'. The entry was repeated on June 9, 1629 (Box A.6, f.6d.) with an additional, probably later, marginal remark: 'let them be inventoried in the wardrobe'. On September 23, 1638 (Box A.7, f.22) it was hanging in the 'lower Chappell' and on July 25, 1646 (Box A.8 and 9, f.38d.) in the Wardrobe, but 'belonging to the Chapel'. In 1679/80 (Box A.10) No. 110 [198] is listed as hanging in the Chapel. In 1823 it hung in the Chapel Gallery and in 1868 under No. 184 in the Chaplain's Room, where it is still hanging, let into the wall as part of an overmantle. The entry of April 3, 1685, referring to Salisbury House (Box C.7) states 'In the great Chamber above Staires' there were 'two pictures of the Salutation of the Angell and the Blessed Virgin in a guilded frame' may concern other paintings.

No. 110 [198] is one of '8 Large religious pictures' which already in 1611 (Box A.1) were mentioned as being in the Chapel. In 1612 (Box B.5), 1629 (Box A.6), 1638 (Box A.7), 1679/80 (Box A.10) and 1684 (Box A.11) they were all still included and their titles listed, such as the Annunciation, the Visitation, the Nativity and the Adoration of the Kings, the Angels appearing to the Shepherds, the Agony in the Garden, the Baptism, Christ riding to Jerusalem, and Christ preaching in the Temple. In 1823 a selection of five are still mentioned as being in the Chapel and in the inventory of 1868, apart from the Annunciation in the Chaplain's Room, the remaining seven are listed under Nos 144–50 'in the Chapel Gallery' as being painted by Erasmus Quellinus

who was a painter from Antwerp, born in 1607. Holland, No. 193, mentions seven pictures on canvas and gives their subjects. He suggests that they were presented to Robert Cecil by Sir Henry Wotton, according to a letter in the possession of the Marquess of Salisbury, and may even have been painted by an Italian painter. This letter can not be traced. It is, however, quite clear that the 'Annunciation' and the 'Angel appearing to the Shepherds' were painted by Rowland Bucket according to the bill of 1612 mentioned above. In 1611 he also painted a big picture of 'Christ and the Apostles'. Apart from the 'Annunciation' the remaining seven are still in the Chapel, huge canvasses, much damaged, but still showing good quality, although restoration could be of great advantage. There seem to be different hands; the 'Agony', 'Baptism' and 'Christ riding to Jerusalem' have lighter backgrounds, large heads and hands and shorter figures. Bucket appears to have been a strong colourist and more subdued and gentle in movements and expressions. The style of the 'Visitation', probably by him, comes near to the Venetian School.

Literature: Holland, No. 198. For biographical notes on Bucket see E. Croft-Murray, *Decorative Painting in England*, I, 1962, pp. 50–1, Pls 194a–195b; pp. 122 ff.

I I I ills 78, 79, 80 and 81, pp. 153–4

Chapel Wallpaintings

Rowland Bucket (working from 1599 to 1639)

The following four wallpaintings are singled out for consideration and illustration in this separate catalogue entry.

The roundels comprising busts of apostles and prophets, ills 78 and 79, painted on plaster, decorate with others the wall below the wooden ballustrade of the Gallery in the Chapel and form

part of the whole scheme of lavish ornamentation. They are soft and subdued in colour and tone in well with the general light grey-green shading.

The two illustrations 80 and 81 show two of the six grisaille paintings on the jambs of the stained-glass window, ill. 80 on the right and ill. 81 on the left, facing each other. Each has one painting above it and one below. They are most interesting and illustrate the high standard of Bucket's work. Amos, ill. 80, suggests a full-length figure standing in a niche, like a statue throwing a dark, clearly outlined shadow on the wall. He is accompanied by three sheep, has a long staff, and an open book which he holds against his hip, so that his right hand seems to overlap the frame of the niche. The painting is full of contrasts in movement and shading and shows the chiaroscuro of the Venetian painters of the end of the sixteenth and the beginning of the seventeenth century. The other, ill. 81, depicts Obadiah, who blows his trumpet with vigour. He stands, three-quarters turned to the left, towards the interior of the Chapel, and again suggests the fully plastic appearance of a piece of sculpture. The liveliness of this figure is strengthened by the movement of a scroll and the sweeping curves of the garments. The wall-paintings in the Hatfield House Chapel by Rowland Bucket are a good example of a branch of art otherwise not much practised in such an impressive way in this country at that period.

Collection: See under No. 110 [198].

Literature: See Croft-Murray, *ibid.*

112 [179] ill. 82, p. 155

Interior of a Church in Antwerp

Peter Neefs the Elder (1578–1656)

Canvas 19¾ × 26½ in. (52·7 × 67·3 cm.)

A very good Flemish church interior. The wide perspective view of a Gothic nave receding towards a choir-screen, beyond which the light choir ending is clearly visible, is precisely painted in light grey colours. In the left-hand side we look into one of the spacious aisles and the other aisle appears in perspective through the narrowly spaced columns of the nave. The Gothic windows with their traceries complete the picture of an interesting interior. There are also altar pieces, facing east, and a good many very nicely painted small figures moving here and there, a genre-like group of people on the left, a priest in the centre, a font just in front of the opening of the screen through which the light high-altar is seen. A very good Flemish painting of the beginning of the seventeenth century, before 1629. Inscribed on the back we read: 'Interior of a Church in Flanders painted by Peter Neefs'.

Peter Neefs the Elder, was born in Antwerp in 1578 and died there in 1656. He was probably a pupil of H. van Steenwyck the Elder, who also painted architecture. He is known to have painted a good many Gothic church interiors. The figures were sometimes added by other contemporary painters.

Collection: Already in 1629 according to the inventory (Box C.8, f.3) this picture was hanging in the gallery at Salisbury House as '1: prospective picture of a Cathedrall Church'.

It is also listed in the later inventories of 1639/40 (Box C.9) and 1646 (Box C.4 and 5) in a similar way. In the nineteenth-century inventories of Hatfield House it is also listed. In 1823 it was hanging in the Breakfast Parlour of Hatfield House as 'Interior of a Flemish Church – P. Neefs'. Robinson, p. 28, noted that Neefs was well-known because of his skill in perspective. In 1868 it is mentioned under No. 168 as hanging in the Billiard Room, South Side: 'Interior of a Cathedral in Flanders. Peter Neefs'. From 1629 onwards this picture has been in the family collection.

MINIATURES

I I 3 [5] ill. 83, p. 155

William Cecil, 1st Baron Burghley (1520–1598)

Later copy, perhaps after Isaac Oliver (d. 1617)

Vellum 2 × 2 in. (5·1 × 5·1 cm.)

The miniature fits into a circular locket. Bust portrait, frontal position, face turned three-quarters to the left. The sitter appears in a black hat and Garter robes as in No. 43 [36] above. The chain of the Order has the lesser George attached. The face of the sitter is clearly recognizable.

The Cecil arms and motto are given as in No. 43 [36] but on the left instead of the right-hand side. In fact the portrait represents the reverse of No. 43 [36], either directly or as derived from a miniature which might have been painted by Isaac Oliver.

I I 4 [9] ill. 84, p. 155

An Unknown Lady, 1605

Nicholas Hilliard (1581–1640)

Vellum 1¾ × 1½ in. (4·4 × 3·8 cm.) oval

Inscribed: $ qui bien aim(e) tard oublie $ 1605

A charming miniature with a blue background and lovely gold lettering, fitting well into the oval frame. The standing lace collar is painted delicately to suggest transparency and three bows in terracotta colour adorn the finely drawn and attractive low-cut bodice of the lady. A little gold ornament is pinned with gold clips to the lace edging of the neckline. The face, precisely drawn, is the likeness of a beautiful woman. This exquisite miniature shows that even as late as 1605 Hilliard was still master of supreme delicacy in miniature painting.

Who the sitter was we can only guess. It may be Frances, Lady Clifford, Robert Cecil's daughter. We know that Hilliard was paid 10l. on June 15, 1611 'for 3 pictures which were maid for my Lady Clifford' (Accounts 160/1). On the other hand, we could infer from the tender inscription around the edge of the blue background that the lady who loved Cecil so well may have been a close friend and admirer rather than a member of the family. I would therefore like to suggest a name, based on an entry in his will, in which he singled out one woman from the circle of his family and servants as the recipient of an annuity of 160l. and other favours: Audrey, Lady Walsingham. Born in 1568, the daughter of Sir Ralph Shelton of Norfolk and Mary Woodhouse, she married Thomas, later Sir Thomas, Walsingham of Scadbury, Kent, in about 1594. She had apparently close contacts in her own right with the Court, and according to information given to me by Miss Jane Apple, was a second cousin of the Queen: the Queen's grandfather, Thomas Boleyn, was the brother of Audrey's great-grandmother Margaret Boleyn. She entertained the Queen in 1597 and again in 1602 (E. K. Chambers, *The Elizabethan Stage*). In 1608 William, the 2nd Earl of Salisbury, was married at her house, and there was also a close connection between her and Sir Walter Cope. If the lady herself commissioned the miniature from Hilliard as a gift to Salisbury, the ornamental $ in the inscription may even be interpreted as pointing to his new dignity, the earldom of Salisbury, an honour which was granted to him precisely at that time, in the year 1605.

Collection: Probably always in the family collection.

Exhibition: Reynolds No. 90.

Literature: Holland, Case of Miniatures, No. 9 as 'a lady in Elizabethan costume, with motto '*qui bien aime et tard oublie*'. Reynolds, *Hilliard and*

Oliver, No. 90, Pl. XXIIIc; Auerbach, *Hilliard*, pp. 152–3, No. 152, Pl. 146.

I I 5 [10] ill. 85, p. 155

Thomas Coventry, Lord Keeper (1578–1640)
Thomas Coventry became Lord Keeper in 1625

Laurence Hilliard (1581–1640)

Vellum 1½ × 1¼ in. (38 × 3·1 cm.)

This fine miniature was formerly called Lord Bacon. The sitter can, however, be identified as Lord Keeper Coventry from a similar but bigger version in the Wallace Collection (No. 202). In both cases the Keeper of the Great Seal is seen holding the important instrument of his office. The version in the Wallace Collection also shows part of the left hand and a crude inscription surrounding the face in an oval double line; 'Dominus Thomas Coventrie. Custossigilli. Ditissimus Thesaurus Cordis Conscientiasana'.

The oval miniature at Hatfield House is smaller and signed in gold lines on the blue background with the monogram H.L. 'A Lady wearing a wide-brimmed Hat' in the Victoria and Albert Museum (Winter, *Elizabethan Miniatures*, Pl. 16; Auerbach, *Hilliard*, Pl. 188) shows exactly the same type of monogram. The rather sketchy and lively treatment of the face, the lace ruff and the application of gold in the lettering and the seal agree closely with the work attributed to Laurence Hilliard. See Auerbach, *Hilliard*, Pls 187–194). The Wallace Collection version is of a less good quality than No. 115 [10]. Surely the latter is the original from which the former is a copy (cf. entry in the Wallace Collection Catalogue, No. 202 and miniature in possession of Lady Carew-Pole of Antony House).

Collection: Probably always in the possession of the family.

Literature: Holland, Case of Miniatures, No. 10, as Lord Bacon.

I I 6 ill. 86, p. 155

Charles I (1600–1649)
Painter unknown

Metal 2 × 1¼ in. (5·1 × 3·2 cm.) oval

Head and shoulders in an oval using an oil medium. The face is based on the type seen in No. 85 [78]. The background is dark brown, the modelling is lively with some shading. The falling collar appears to be a yellow-cream colour. The miniature is of good quality.
Collection: This portrait miniature in a silver locket was bought by the Marchioness of Salisbury from Colnaghi and Company of 23 Cockspur Street for 15s. in June 1835. There was also a miniature of Henrietta Maria (now lost) included in the locket. The original bill of March 31, 1836, has survived.

I I 7 Colour Plate XII, opp. p. 97; ills 87–92, p. 156

Stained Glass Window

'Lewis Dolphin, a French painter' (probably Louis Dauphin), Richard Butler of Southwark, and Martin van Bentheim, Dutch, of Emden

The east window of the Chapel consists of twelve different compartments representing stories from the Old Testament, which do not seem to form a general unit, although the whole appearance is one of brightness of colours, and each story is told with clarity and precision.

The following subjects occur and are arranged from left to right in three rows of four, one on top of the other:
(1) Visit of the Angel to Abraham
(2) Moses in the Bullrushes
(3) Solomon and the Queen of Sheba

(4) Jacob's Dream
(5) Jonah and the Whale
(6) Passover of the Israelites
(7) Samson and Delilah
(8) Abraham Offering up Isaac
(9) Naaman in the River Jordan
(10) David and Goliath
(11) Elisha Raising the Widow's Son
(12) Elijah in the Fiery Chariot

The inscriptions underneath take up two lines in Latin, the first referring to the Old Testament, the second pointing to a relevant New Testament story.

An exception is (3) Solomon and the Queen of Sheba, which has a four-line inscription in French verse and no reference to a Bible text. Part of the background conforms, according to M. J. Adhémar, to the *Bible de Jean de Tournes* by Bernard Salomon, 1553.

Solomon and the Queen of Sheba is the most interesting subject in the whole window and clearly shows a very clever and complex composition according to the Mannerist style. It has certain affinities with the work of the French painter Antoine Caron, and its author, whom we may assume to be Louis Dauphin, emerges as an artist of considerable ability. No other compartment seems to be by the same hand, but the payments to Dauphin for the window as a whole were very substantial, and the French influence which can be discerned here and there must be due to Dauphin's general oversight of the composition.

The second painting which we can single out and ascribe to a definite artist is (5) Jonah and the Whale, for which Richard Butler of Southwark submitted a bill for eight guineas. This picture is unusual in that two scenes of the story are shown, first, in the background a landscape, the sea, a ship, and the whale swallowing Jonah, and secondly, in the foreground, Jonah kneeling on the beach, having escaped from the mouth of a most ferocious-looking whale, portrayed with sharp teeth and a long curving tail. The land-scape in the background shows traces of Flemish influence.

Richard Butler, an Englishman, is mentioned by Henry Peacham in his book *Graphice*, London, p. 162, as an 'excellent artist' used by the Earl of Salisbury 'for the beautifying of his houses, especially his Chappell at Hatfield'.

It is possible, but by no means certain, that (8) Abraham Offering up Isaac (which was repaired in the eighteenth century) is also by Butler.

The third artist mentioned in the documents related to the window is the Dutchman Martin van Bentheim or Benton, who was paid 3*l.* 6*s.* 8*d.* for making three cartoons which were supposed to be sent to France to be made up. Van Bentheim's hand is not easy to recognize in the window, except that some of the compartments, such as (2) Moses in the Bullrushes, (10) David and Goliath (12) Elijah in the Fiery Chariot show a Flemish bias.

In 1835 William Warrington, a stained glass painter, renewed (11) Elisha Raising the Widow's Son, after this panel had been damaged by fire.

Literature: The accounts referring to the commissioning of the window can be found in Stone, pp. 122–3, and also in Alfred L. Wilkinson, 'The Great East Window of the Chapel of Hatfield House', *Journal of the British Society of Master Glass-Painters*, XII, No. 4, 1958/9.

SCULPTURE

118 ill. 93, p. 157

William Cecil, 1st Baron Burghley (1520–1598)

Sculptor unknown

Marble height 24 in. (61 cm.)

A very fine life-size bust, depicting Lord Burghley as he appeared in middle age. He wears a closely fitting ruff, standing a little away from the neckline, a fur-trimmed coat with slightly bulging sleeves. His features are well

modelled, his pointed beard is comfortably embedded in the ruff. Buttons run along the middle of the coat. The reflection of the light and the shading may suggest a slightly later period.

Collection: In 1833 Robinson, p. 28, noticed 'a white marble contemporary bust of Lord Burghley as being at foot of the grand stairs'. As in 1629 (Box C.8) 'one picture of Aristotle in white marble' was in Salisbury House (see p. 3 above), it may just be possible that this bust was meant to represent Aristotle in the guise of Burghley as a token of flattery and respect.

119 ill. 94, p. 157

Bust of Christ, before 1629

Sculptor unknown

Marble 14½ × 9½ in. (36·8 × 23·8 cm.) including the base

The marble bust of the head and shoulders of Christ is fixed on a modern base. His head is slightly bent, and the features of his face are refined: a straight nose, eyes looking downwards, a pointed beard, and waves of curls falling over his shoulders and back. A piece of garment is draped below the breast to give the statue its natural length. This bust is of an excellent quality. The complex movement of Christ's head, the curved and full curls, the classic and sophisticated expression of the face, speak for an Italian artist of the early Baroque period.

Collection: In the Salisbury House Inventory of 1629 (Box C.8, f.3d) '1 cast piece of our Saviours face and breast' is mentioned as being in the Great Chamber. This entry is repeated in the inventory of March 1639/40 (Box C.9, f.10) which clearly refers to this piece of sculpture. Sir John Summerson wrote to Lord Salisbury on August 17, 1969, and confirms, after having consulted Professor Dr R. Wittkower, that this is seventeenth-century Italian.

120 ill. 95, p. 158

Fireplace in King James's Drawing Room

Maximilian Colt (d. 1649)

Marble

This excellent French sculptor worked in England from *c.*1590 to *c.*1619. On January 9, 1607 he received the grant of denization (see Auerbach, *Tudor Artists*, p. 159). On July 28 in the same year he was appointed for life to the office of 'Master Sculptor' or 'Master Carver'. The petition of Maximilian Colt for this office has survived amongst the Cecil Papers (Vol. 196, f.111). It is addressed to the Earl of Suffolk, Lord Chamberlain and to the Earl of Salisbury. It is undated, but proved to be successful in 1607. As a court sculptor Colt was commissioned to design and erect various interesting tombs and monuments, such as the tomb of Christopher Hatton, old St Paul's (destroyed in the Fire), that of Queen Elizabeth I, Henry VII's Chapel, to mention only two. The 1st Earl of Salisbury who was such a keen patron of another court official, the Serjeant Painter John de Critz, would have been naturally expected to patronize Maximilian Colt too. The sculptor's close connection with the building of Hatfield House emerges constantly from the Accounts and Bills.

The most outstanding chimney-piece Colt made for Hatfield House is that in King James's Drawing Room. It is a monumental architectural construction of two tiers. The lower one is of white and veined marble flanked by black columns with white Doric capitals. Above, three bays of grey and cream coloured marble, intersected by four black columns with Corinthian capitals. The middle one is wider and projects and forms a domed niche, in which the bronze-painted, life-size statue in Caen stone of James I in Garter robes is standing. The bases of the columns are decorated with four cartouches

containing terracotta plaques. The third terminating layer shows volutes and two roundels comprising the black profiles of Julius and Augustus Caesar in relief.

There is an excellent likeness of the King, a skilful application of classic orders and the Italo-Flemish treatment of details. It has recently been cleaned and traces of gold on the statue beneath the bronze colour were noticed.

Collection: Various bills and accounts refer to the craftsmanship of Maximilian Colt. The earliest is dated November 1, 1609 (Bills 35/2). Further, MS. Transcript January 15, 1611/12 (Building of Hatfield House, p. 92), 'The painters worke to doe'. It includes: 'And the chimney peece with the King's picture if it so please his Lordship to have it done . . .'. Amongst Bill 77 (May 31, 1612) there is one fragment to Rowland Bucket: 'Item for the gildinge and payntinge of the Chymney peece in the great chamber one the East syde and workinge of the Kyng's picture lyke copper, and for payntinge and gildinge the freeze in the saide chamber, 31*l*.'

In another account (Bills 69) the charges of the three chimney-pieces include, apart from White Marble, Alabaster, Touch Stone, Devonshire Stone, 'Caen Stone for the picture 20 foote, 1*l*. 10*s*.'. The bronzing of the statue was done in the eighteenth century. Account of Messrs. Beckwith and France, of Great St Martin's Lane, January 1781 to 1790. 'Bronzing the figure of King James and 2 medallions'. (Accounts 151/23.)

Literature: Musgrave, f. 79; Robinson, p. 19; James Lees-Milne, *Tudor Renaissance*, 1951, pp. 89 ff., 106 and 107, Pls 1 and 81; Auerbach, *Tudor Artists*, p. 159; Mercer, pp. 242, 244 (tomb), 252, 257; Stone, p. 121; M. L. Whinney, *Sculpture in Britain 1530–1830*, the Pelican History of Art, 1964, p. 20, *et seq.* In note 42 Dr Whinney mentions erroneously the plaster (?) statue of

James I'. See also her Hatfield House Handbook *Sculpture at Hatfield*, p. 4.

121 ill. 47, p. 140

Chimney-piece with Mosaic Portrait of Robert Cecil (1563–1612), 1610

Maximilian Colt (d. 1649)

197 × 120 in. (501 × 305 cm.)

According to contemporary bills and accounts three chimney-pieces in Hatfield House were commissioned from Maximilian Colt. In one account of 1610 (Bills 36) four mantelpieces are mentioned. Colt designed another one 'for the Quenes Closet at Somerset House which my Lord commanded me to doo'. Colt received for marble and other hard stone 50*l*. From 1609 to 1611 (Building of Hatfield House, pp. 127, 128, 133, 143) 'Mr, Coult, the Stone Cutter' received various sums for his chimney-pieces. His account for stone and for the workmanship of various chimney-pieces (Cecil Papers *,143*. 129) includes: 'Mem. that I have Received of mie Lord Thresauror to paie for his use for stone and Kariages wich I have paid as folow the the som of 51*l*. 13*s*. 6*d*.'.

He then lists his expenses:

'Item paied for 34 foote of Tuche at 8*s*. the foote—
13*l*. 12*s*.
Item paied for 8 lodes of Alebaster at 4*l*. 10*s*. the lode 36*l*.
Item paied for the Kariage of 8 lodes of Albaster from Islington to my house and for men to helpe to lode and unlode
1*l*. 12*s*.
Item for the Kariage of 3 lodes of Tutche from Billingsgate to my house and for the Cranage and Wharfage
9*s*. 6*d*.
Sum Totall is: 51*l*. 13*s*. 6*d*.'

He must have indeed had a workshop in his house for these huge amounts of stone and marble.

The large mantelpiece in the Library is of black and white marble. It consists of two orders, Doric and Ionic, with black columns and a plain cornice. The mosaic was transferred to the Library some time after 1780 and before 1823, as the inventories show. (Cf. Catalogue No. 67 [61].)

Pennant still saw the mosaic in the Long Gallery in 1780. It is possible as Miss C. Talbot suggests, that the frame enclosing the picture of young Mary, Queen of Scots, now part of the fireplace in the Yew Room, originally framed the mosaic when the latter was in the Gallery, as the measurements fit the mosaic portrait.

Literature: Report of the Royal Commission on Historical Monuments, 1910, pp. 385, et seq; Reproduced in Mercer, Pl. 39a.

122 WINTER DINING ROOM

Two Chimney-pieces
Both Chimney-pieces are not of such quality as the one in King James's Drawing Room, No. 120. They have various additions from other houses

Maximilian Colt (d. 1649)

May have come from Quickswood and may have been partly destroyed in the nineteenth or twentieth centuries. It is a large mantelpiece with classic figures of female caryatids accompanied by putti. The figures in high relief resemble those on Robert Cecil's tomb. A huge coat of the Cecil arms placed in the middle of the upper part consists of two parts of other mantelpieces.

ill. 96, p. 158 VAN DYCK ROOM

According to the notes dictated by the 2nd Marquis of Salisbury in 1866/7, the chimney-piece in the Van Dyck Room was made of the frieze of an old house at Woodhall which had

been pulled down by his father. The material is Derbyshire alabaster and various pieces of marble. The lower part of pink, black, white and yellow marble shows clearly Colt's style. The caryatids flanking the lower part, a female figure holding a cornucopia on the right, a male figure with a goose on the left, in their classic attire confirm the resemblance to Colt's work. The outline of the upper part including the two caryatids speak also for Colt's authorship. The more classical and flat inner relief, however, may have been transferred here from another house.

123 ills 97–9, pp. 159–60 ST ETHELDREDA'S CHURCH, HATFIELD

The Tomb of Robert Cecil, 1st Earl of Salisbury (1563–1612), c.1615

Maximilian Colt (d. 1649)

In his will of 1604 Robert Cecil had arranged for 'this earthlie bodie of myne' to be disposed of by his executors in the Parish Church of Hatfield 'without any extraordinary shewe, a faire monument to be made for me, the charge thereof not exceeding two hundred pounds'. This sum of money did not prove, of course, to be sufficient and had to be greatly increased. The monument itself in honour of this great Elizabethan is still dignified and impressive enough to show how well Maximilian Colt interpreted the wish of his patron. On a black marble table lies the white, reclining figure, clad in Garter robes holding the white staff of the office of Lord Treasurer and revealing an excellent likeness, based on the pattern created by John de Critz and preserved in many portraits at Hatfield House. The black slab on which the Earl rests in a horizontal position is supported at the four corners by the kneeling life-size female figures of the Cardinal Virtues, Justice, Prudence, Temperance, and Fortitude. They are beautifully modelled in white marble, together with their symbols, and

wear classic garments. Their hair is dressed in a greek manner, and the bodies are clearly articulated – the breasts bare in the case of Prudence and covered but projecting in that of Temperance. There is certainly an elegant and fluent manner of treatment to be seen in these Greek inspired allegorical figures. In a sharp contrast to the free and progressive spirit of the classic taste we find on the low fundament in black marble immediately beneath the slab carrying the Earl's image, the white marble figure of a skeleton stretched out horizontally on straw. Thus we are being reminded of mortality in spite of the grandeur of worldly achievements; a strangely medieval thought still prevailing in that advanced atmosphere gained at the beginning of the seventeenth century and often mirrored even in Shakespeare's work.

The prototype of Robert Cecil's tomb was to be found on the Continent at an earlier period. The tomb of Count Engelbert of Nassau at Breda in 1520 by an Italian, Romaso Vincidor, had a black bier supported by four warriors. There are also other examples of standing figures of virtues supporting a bier known in the Netherlands.

On November 1, 1609 (Bills 35/2) Thomas Wilson in a letter to the Steward mentions 'Mr. Colt having this morning brought my Lord a Modle of his tombe' and this is probably the earliest date when the model of the tomb was submitted.

The amount of money finally paid to Colt comes, however, to more than £400, which means double the sum which Robert Cecil had in mind. On April 3, 1614 (Accounts 128/1) 'Coulte the Stone Cutter' received 'in part of 400 *l*. which he is to have for making a tomb for your late father – 100 *l*.'. In the next year, 1615 (Accounts 15/1), he was paid 50 *l*. in part for his work on the monument. On January 4, 1613/14, an 'Estymate of the charge and stone for the Tomb for the late Lord Treasurer' was drawn up by Simon Basyll (endorsed on the back) which sheds an interesting light on the process of workmanship during that period (Cecil Papers, *206.62*).

'An note of shuche stone as is required for the fynishinge of the intended tombe accordinge to a moddle thereof made for the Right honorable the late Lord Treasurer of Englande with an estymate of woorkmanshipp and setting vpp

Of white marble for the 6 figures	– 140 foot
Of tuche for bothe the tables	– 70 foot
Of rance (red marble) for enrichment	3 foot

The charge of sawinge and carving of the 6 Figures if the[y] bei done according to arte and true proportion are woorth 60*l*. a peece – 360*l*.
The two tables of tuche, with sawing, pollishing, and the woorkmanshyp of the rance – 60*l*.
The cariage of the sayd tomb to Hattfeild, setting of it uppe and fynishing – 40*l*.

 Sum totall is 460*l*.'
 This estimate is signed by
 Sy. Basyll

Then follows a P.S.

'It is very requisitt that there should be modells made of the figures first, to see whether the[y] are according to proportion, wch. if they bee made ther must be consideration hadd of that charge.'
On January 16, 1616/17, Colt received (Bills 107) 200*l*.
Again, before Michaelmas in 1618, he was paid (Bill 108) 100*l*.
and in the same year another (Bills 109) 150*l*.

It is interesting to learn that Robert Cecil had approved of his own tomb and had certainly spent some thought on its style. After his death his executors were much interested in the proper execution of the monument. Maximilian Colt emerges as a foreign artist schooled in the Italo-Flemish tradition.

Literature: Lees-Milne, *Tudor Renaissance*, p. 89,

(In a note, No. 3, Mr Lees-Milne refers to the tomb of Count Engelbert of Nassau in Breda Cathedral); Mercer, p. 244; John Buxton, *Elizabethan Taste*, 1963, pp. 166–7; M. Whinney, *Sculpture at Hatfield*, Hatfield House Booklet No. 2.

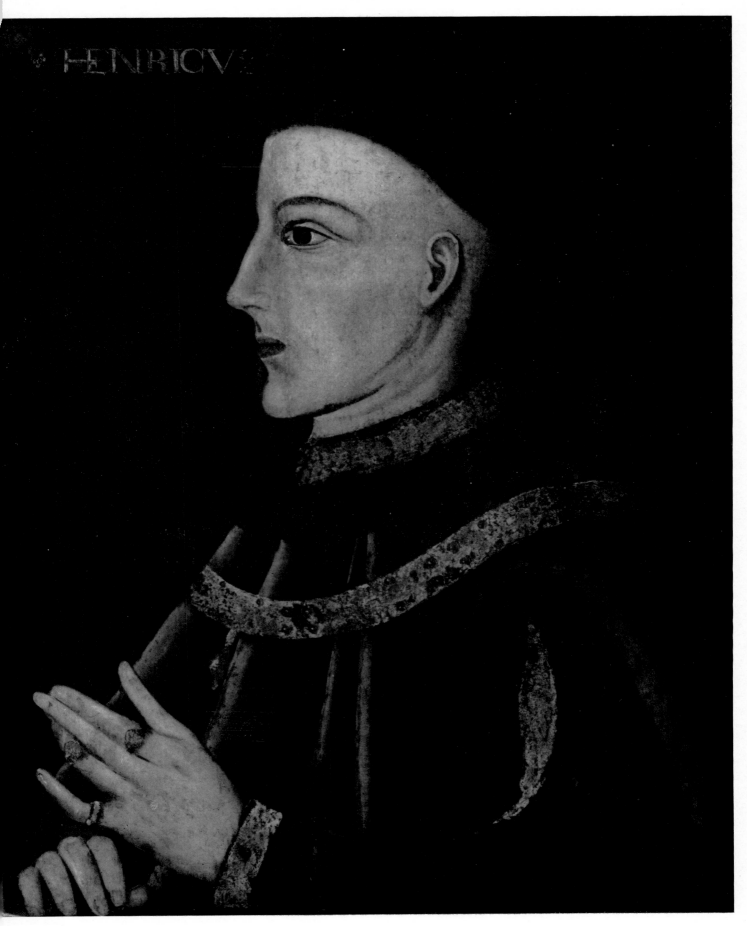

Ill. 1. **Henry V,** painter unknown (Cat. No. 1, p. 25)

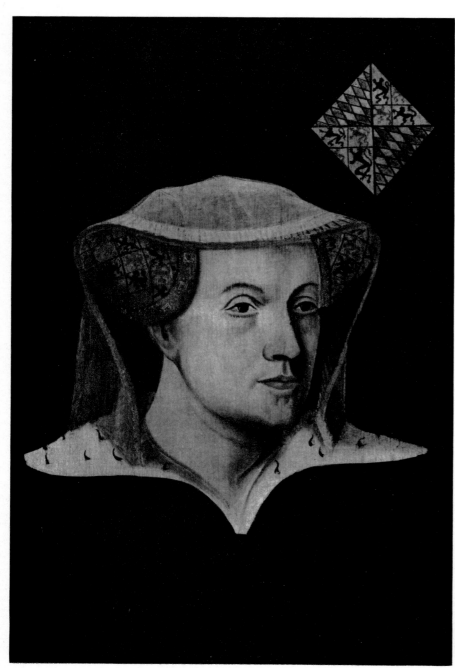

(left) Ill. 2. **Jacqueline of Bavaria (Jacoba van Beiren)**, *c.*1430, after Jan van Eyck (Cat. No. 2, p. 29)
(below) Ill. 3. **Jacqueline of Bavaria (Jacoba van Beiren)**, *c.*1430, after Jan van Eyck (Courtesy Städelschen Kunstinstituts, Frankfurt/M.)

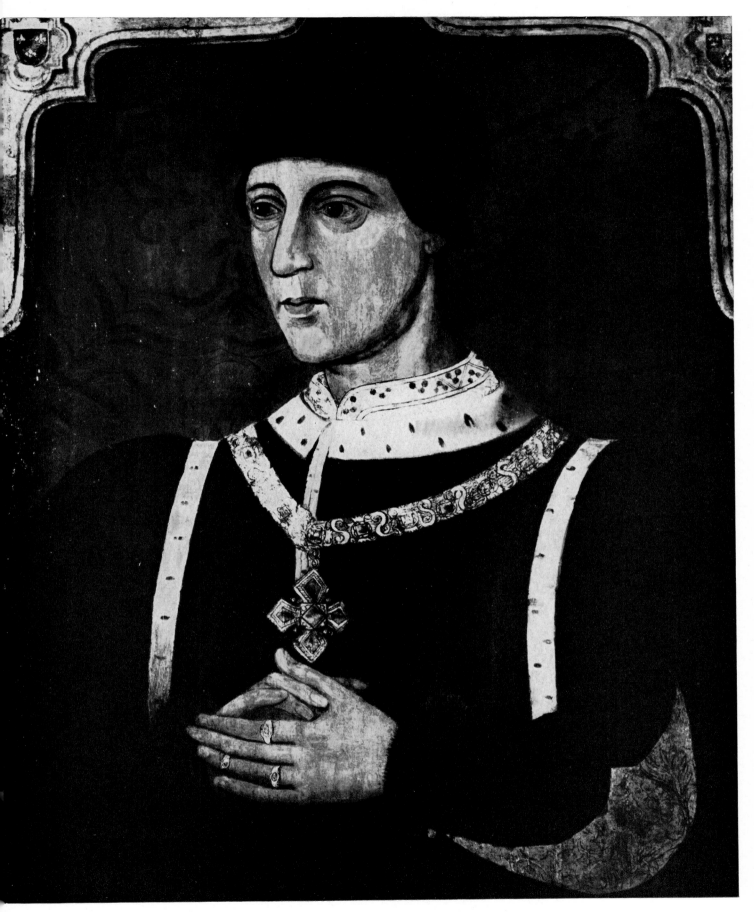

Ill. 4. **Henry VI,** painter unknown (Cat. No. 3, p. 30)

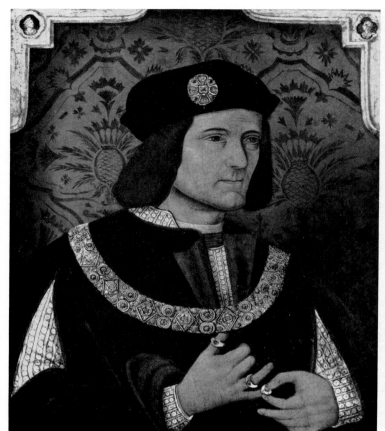

(above left) Ill. 5. **Richard III,** painter unknown (Cat. No. 5, p. 31)
(above right) Ill. 6. **?Caterina Cornaro,** painter unknown, perhaps a copy of Titian or Paris Bordone (Cat. No. 6, p. 32)

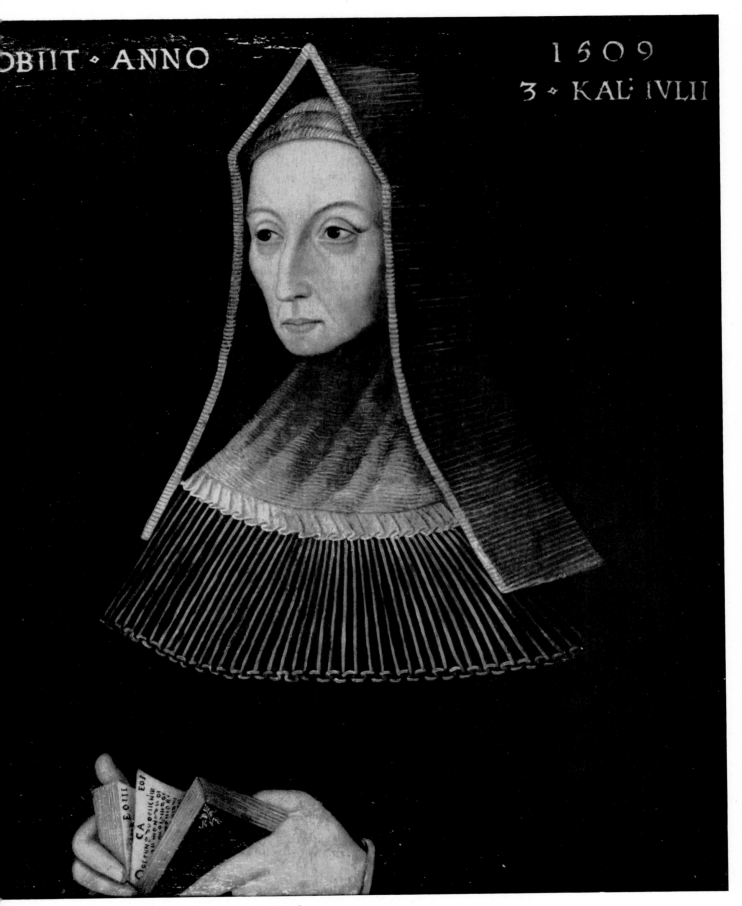

OBIIT · ANNO 1509
3 · KAL· IVLII

Ill. 7. **Margaret Beaufort, Countess of Richmond and Derby,** *c.*1509,
by Maynard Waynwyk (Cat. No. 8, p. 33)

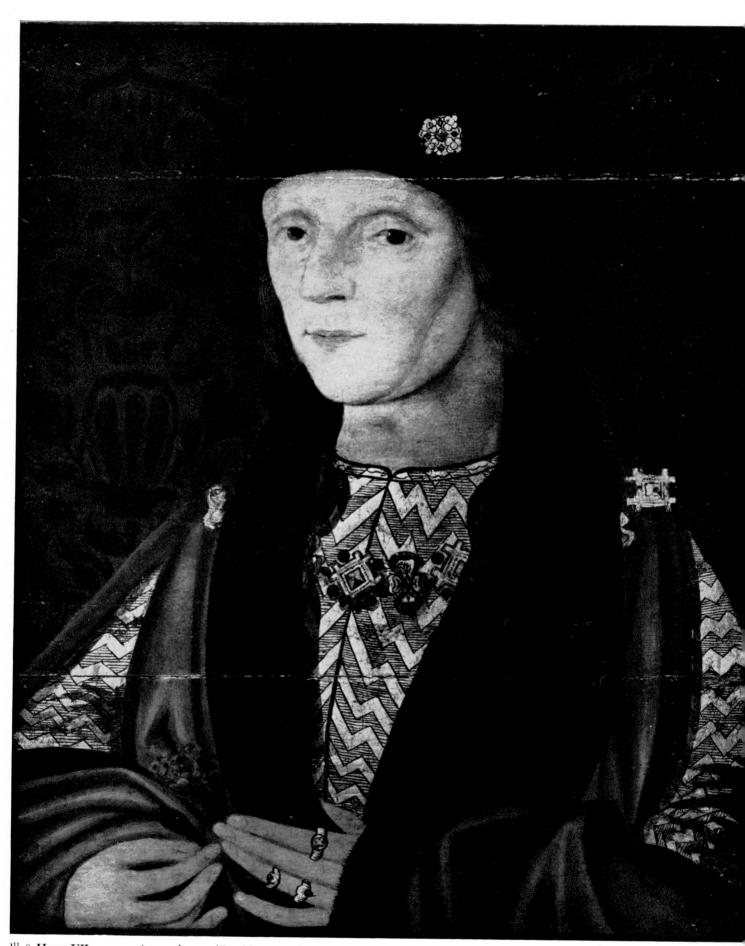

Ill. 8. **Henry VII,** *c.* 1500, painter unknown (Cat. No. 9, p. 34)

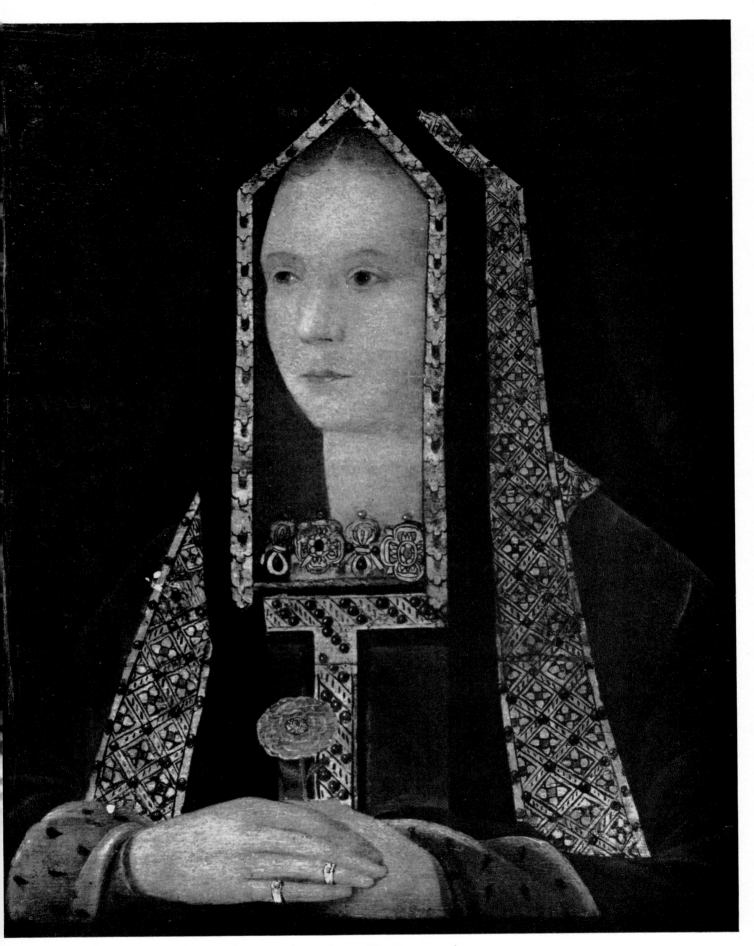

Ill. 9. **Elizabeth of York, Queen of Henry VII,** *c.*1500, painter unknown (Cat. No. 10, p. 34)

(above) Ill. 10. **Johannes Froben,** *c.*1640, after Hans Holbein the Younger (Cat. No. 11, p. 35)
(right) Ill. 11. **Frederick II, called The Wise,** painter unknown (Cat. No. 21, p. 38)
(top) Ill. 12. **Catherine de Medici,** after François Clouet (Cat. No. 22, p. 39)

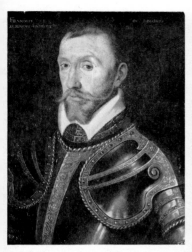

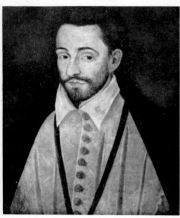

(top) Ill. 13. **François de Cologni, known as Dandelot,** French School, sixteenth century (Cat. No. 23, p. 39)
(above) Ill. 14. **?Charles IX,** French School, sixteenth century (Cat. No. 24, p. 40)
(right) Ill. 15. **?Robert Dudley, Earl of Leicester,** *c.*1560, painter unknown (Cat. No. 30, p. 42)

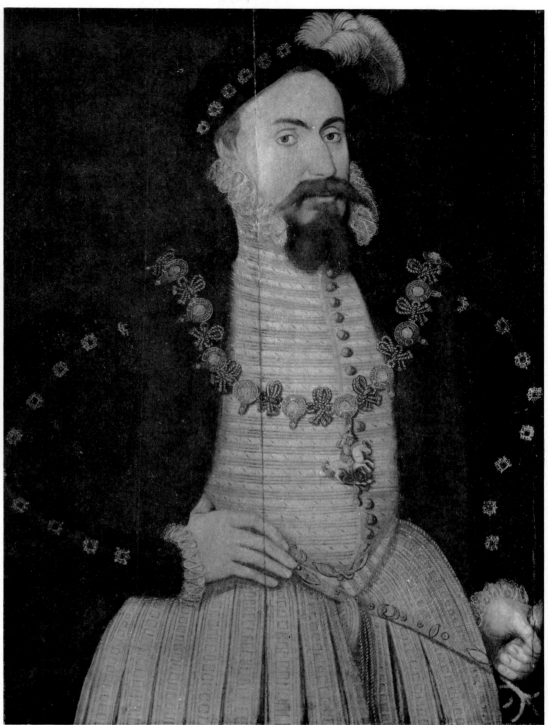

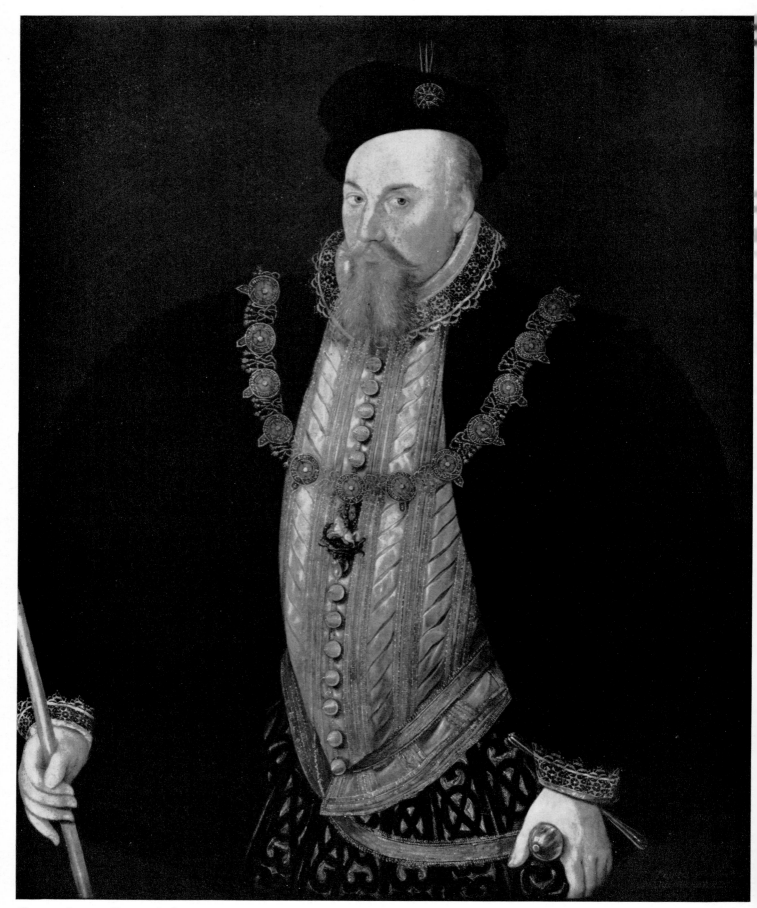

Ill. 16. **Robert Dudley, Earl of Leicester,** *c.*1585, by ?William Segar (Cat. No. 31, p. 42)

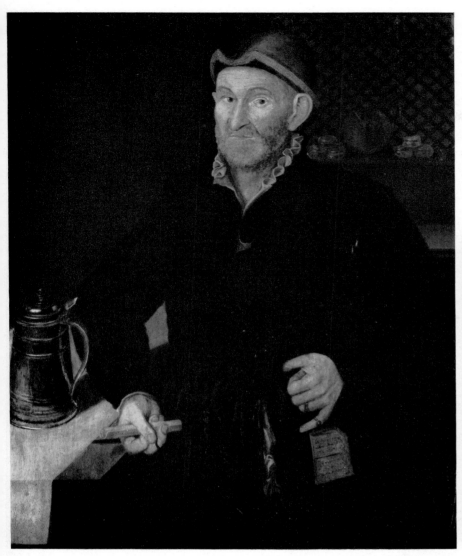

(above left) Ill. 17. **'An Old Man'**, *c.*1550, painter unknown (Cat. No. 32, p. 43)
(above right) Ill. 18. **Jane Heckington, Mrs Cecil,** painter unknown (Cat. No. 33, p. 44)

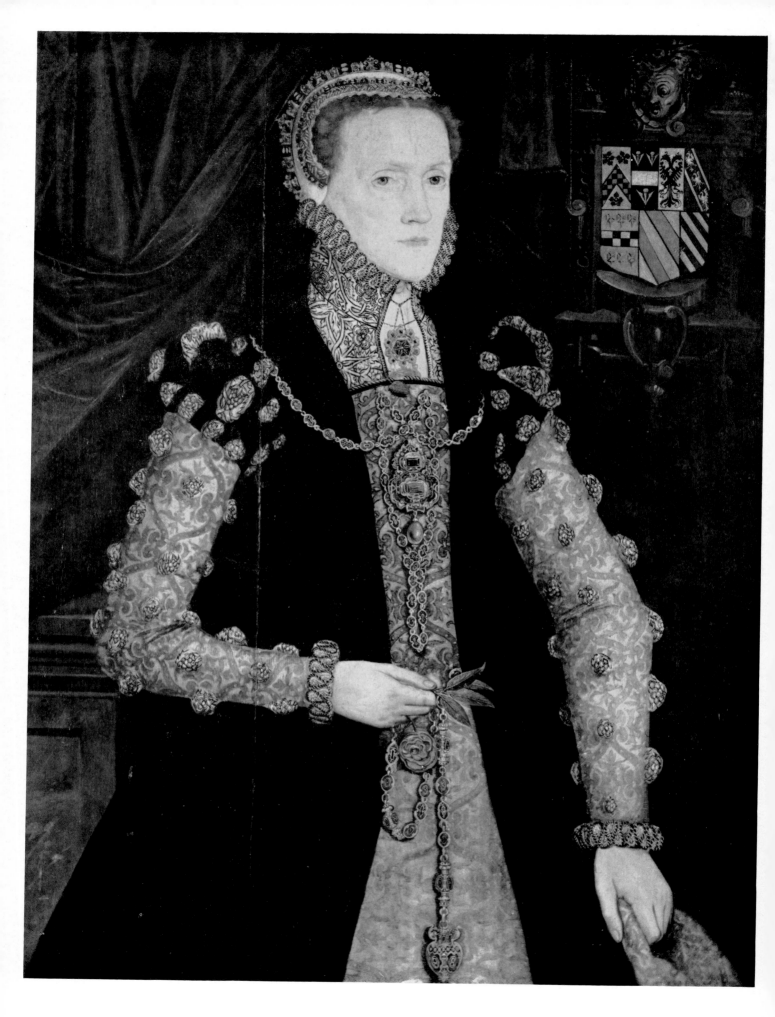

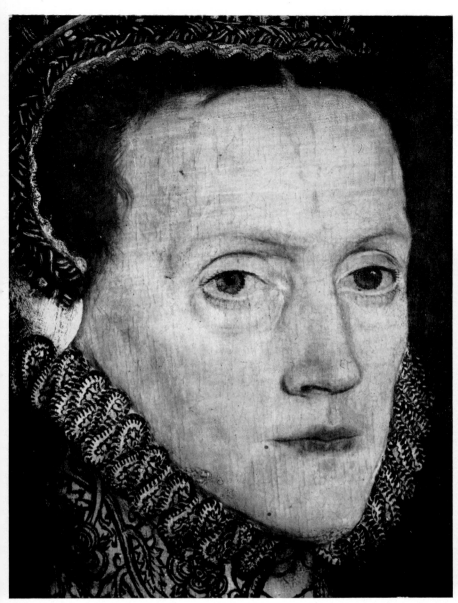

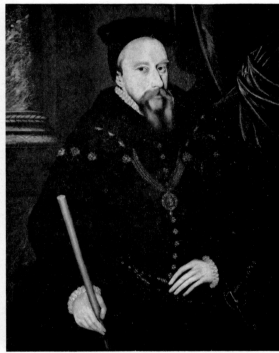

(above left) Ill. 20. Detail of Ill. 19
(above right) Ill. 21. **William Cecil, 1st Baron Burghley,** 1573, by Arnold van Brounck-
hurst (Cat. No. 37, p. 48)

(opposite) Ill. 19. **Mildred, Lady Burghley,** c.1562, by Hans Eworth (?) (Cat. No. 34, p. 44)

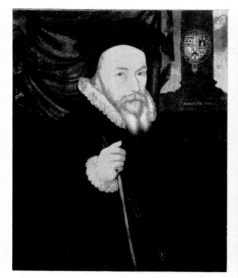

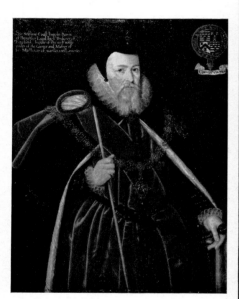

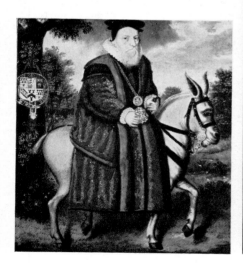

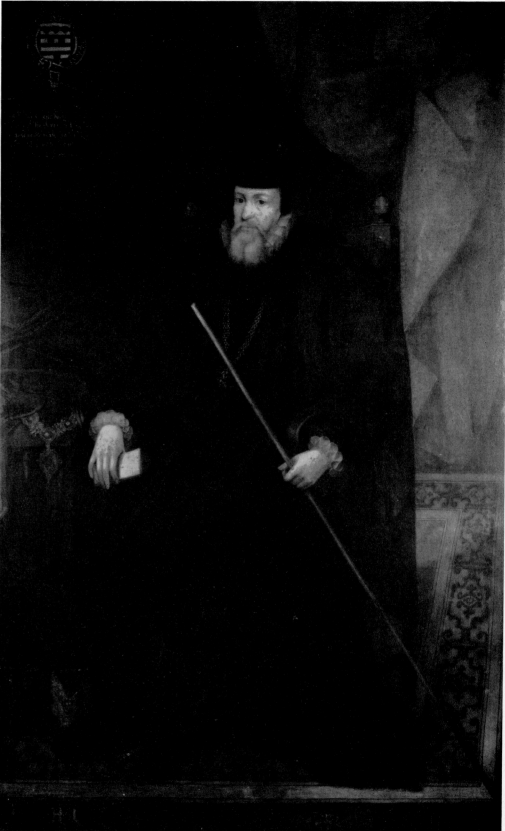

(top left) Ill. 22. **William Cecil, 1st Baron Burghley,** painter unknown (Cat. No. 39, p. 49)
(centre left) Ill. 23. **William Cecil, 1st Baron Burghley,** c. 1590, by Marcus Gheeraerts the Younger or John de Critz the Elder (Cat. No. 43, p. 50)
(bottom left) Ill. 24. **William Cecil, 1st Baron Burghley, riding his grey mule,** painter unknown (Cat. No. 46, p. 51)
(above right) Ill. 25. **William Cecil, 1st Baron Burghley,** by ?John de Critz the Elder (Cat. No. 47, p. 52)

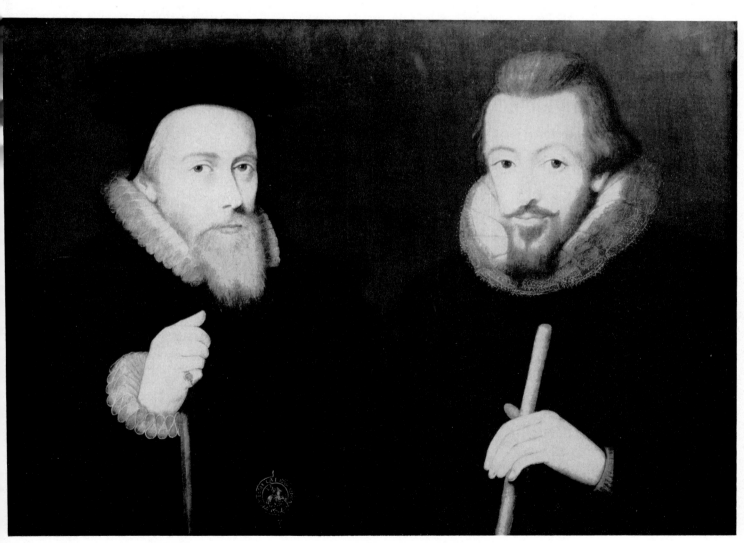

Ill. 26. **Double portrait of William Cecil, 1st Baron Burghley and Robert Cecil 1st, Earl of Salisbury,**
after 1606, painter unknown (Cat. No. 48, p. 52)

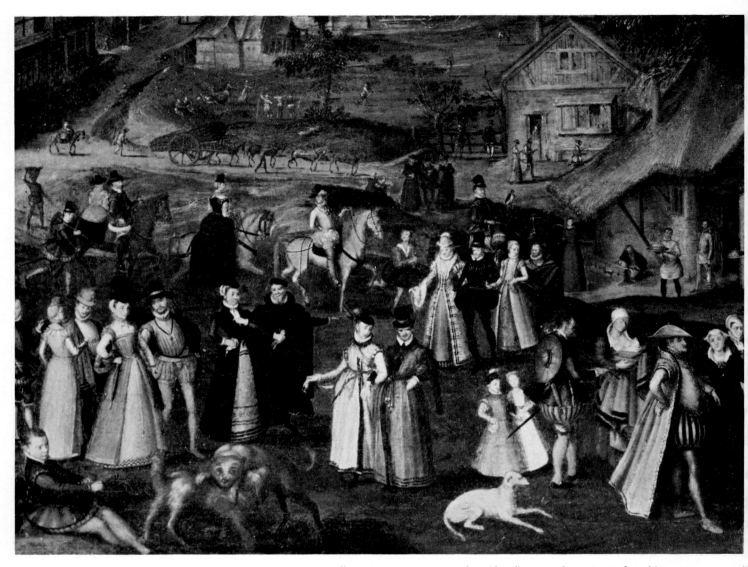

Ill. 27. **A Fête at Bermondsey** (detail), *c.*1570, by Joris Hoefnagel (Cat. No. 49, p. 53)

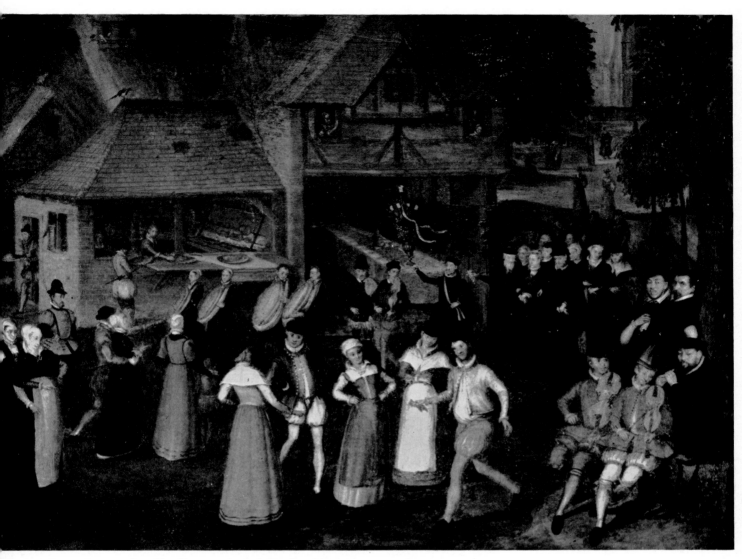

Ill. 28. **A Fête at Bermondsey** (detail), *c.*1570, by Joris Hoefnagel (Cat. No. 49, p. 53)

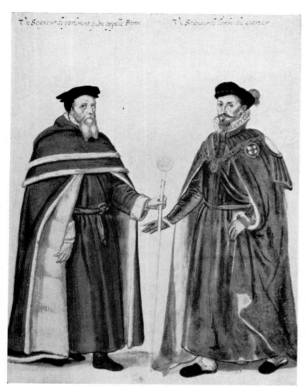

Ill. 29. *Un Seigneur de Parlement qu'en appelle Baron, Un Seigneur de Londre du guartier*, by Lucas de Heere (MS 2466) (Cat. No. 49, p. 53). The University Library, Ghent

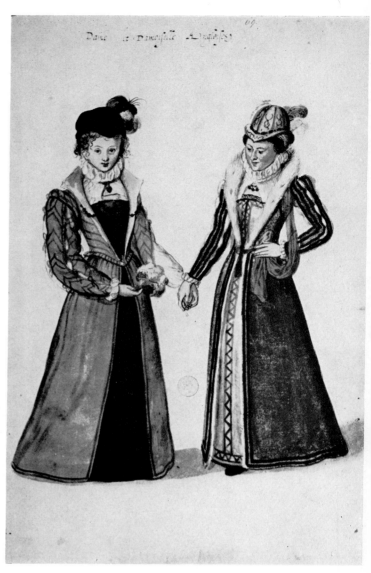

Ill. 30. *Dame et Demoiselle Angloises*, by Lucas de Heere (MS 2466) (Cat. No. 49, p. 53) The University Library, Ghent

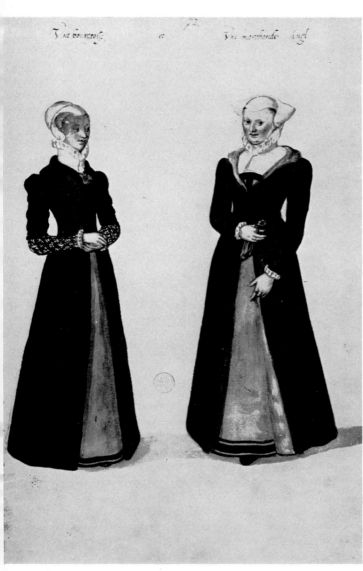

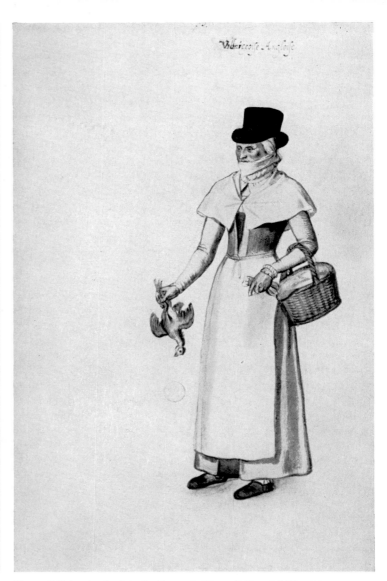

Ill. 31. *Une bourgeoise et Une marchande Angl'*, by Lucas de Heere (MS 2466) (Cat. No. 49, p. 53) The University Library, Ghent

Ill. 32. *Villaigeoise Angloise*, by Lucas de Heere (MS 2466) (Cat. No. 49, p. 53) The University Library, Ghent

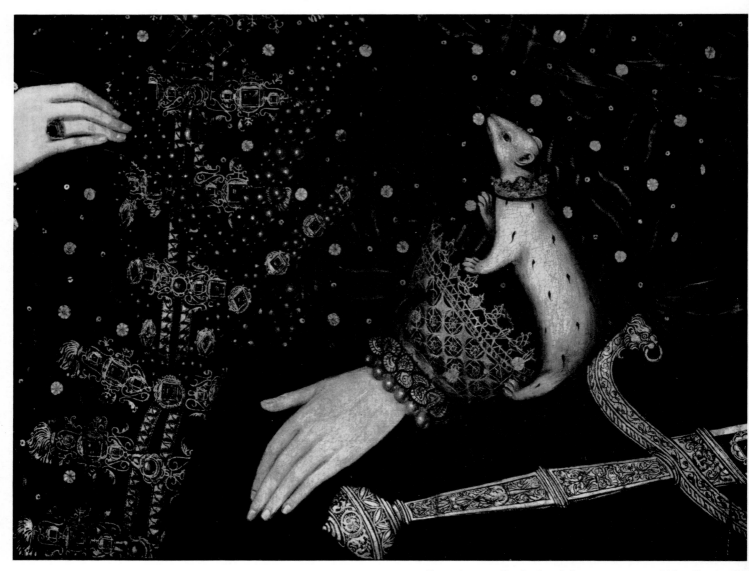

Ill. 33. **Queen Elizabeth I,** 'The Ermine Portrait' (detail), 1585, by Nicholas Hilliard (?) (Cat. No. 50, p. 55)

(opposite left) Ill. 34. **Mary, Queen of Scots,** painter unknown (Cat. No. 52, p. 61)
(opposite right) Ill. 35. **?Mary, Queen of Scots aged 17,** painter unknown (Cat. No. 53, p. 63)

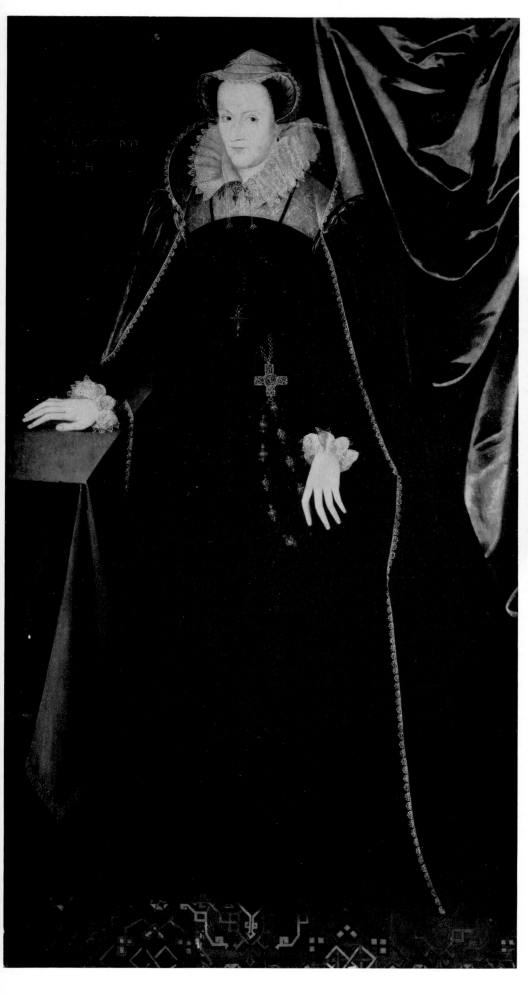

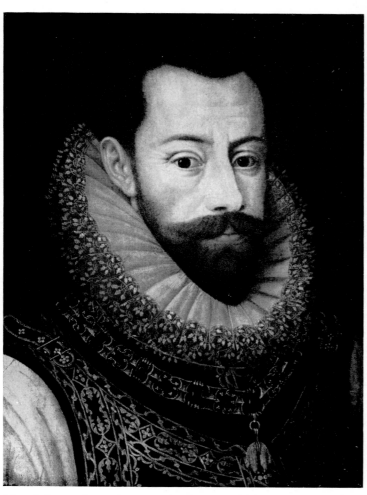

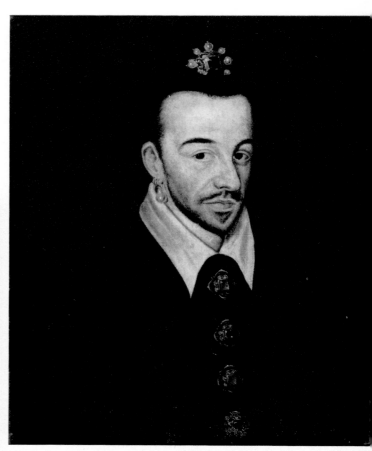

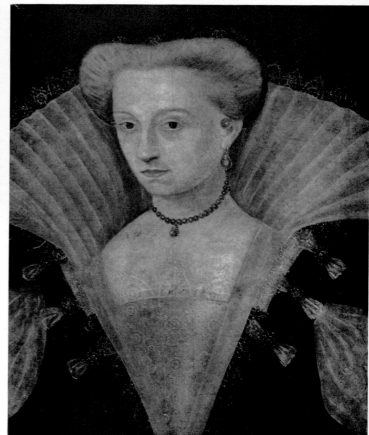

(above) Ill. 36. **Alessandro Farnese,** after Titian (?) (Cat. No. 54, p. 64)
(top right) Ill. 37. **Henry III,** French School (Cat. No. 56, p. 64)
(right) Ill. 38. **Louise of Lorraine,** French School (Cat. No. 57, p. 65)

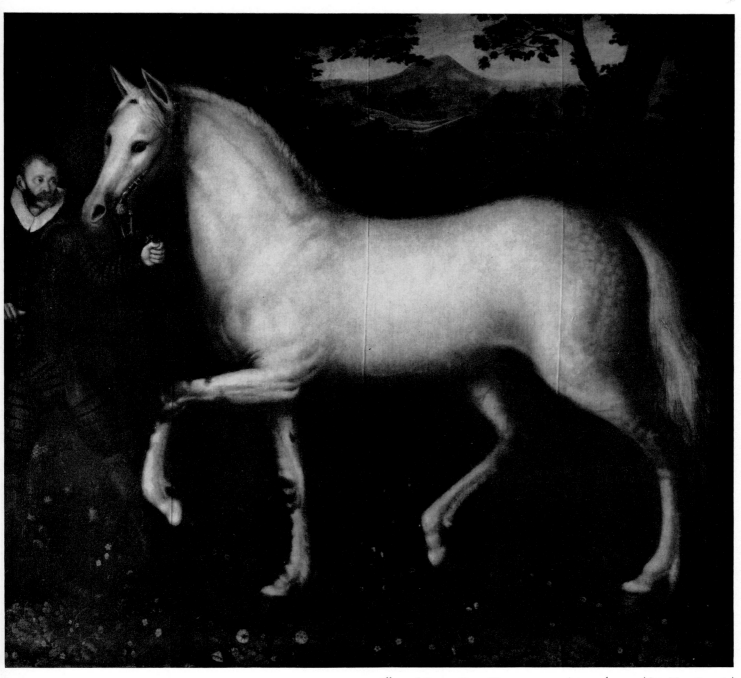

Ill. 39. **A Large Grey Horse,** 1594, painter unknown (Cat. No. 58, p. 65)

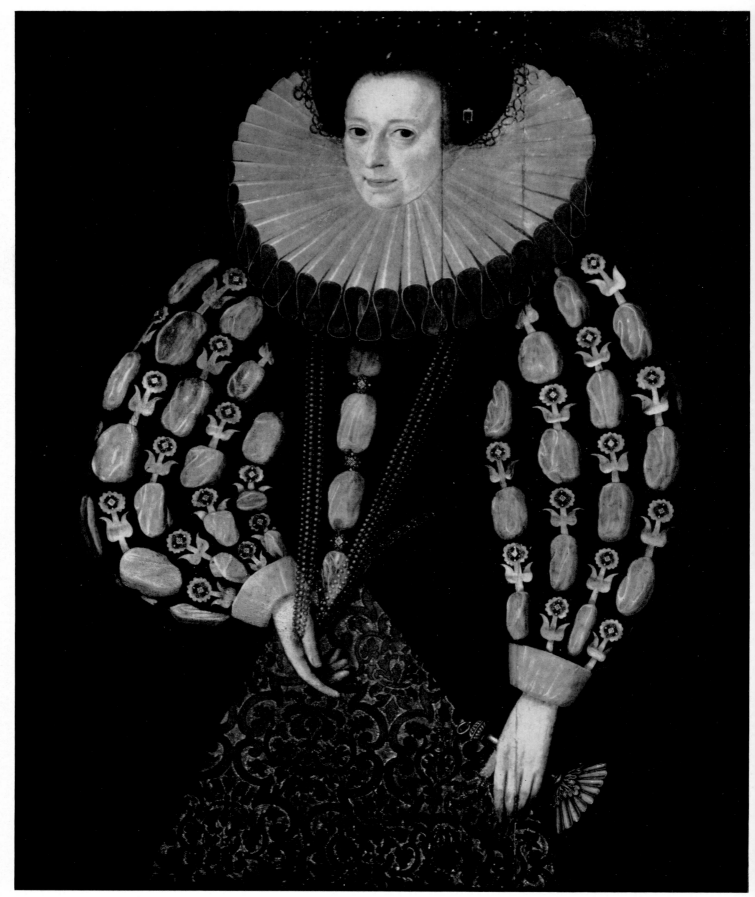

Ill. 40. **An Unknown Lady,** *c.*1585- 90, painter unknown (Cat. No. 59, p. 66)

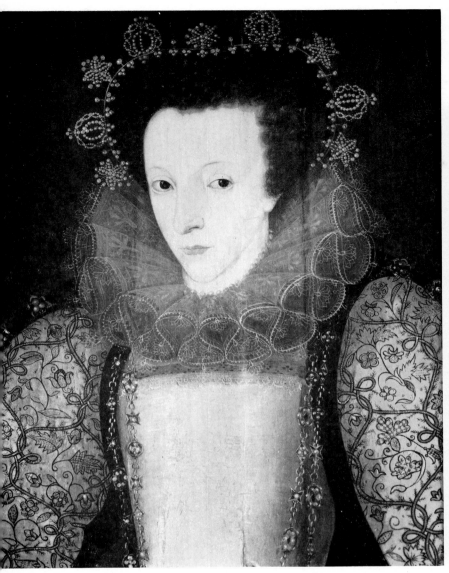
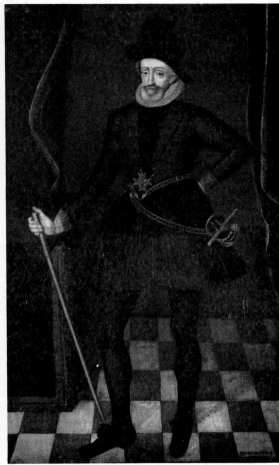

(above left) Ill. 41, **Elizabeth Cecil, Mistress Wentworth,** *c.*1580–85, **or Elizabeth Brook, Lady Cecil,** *c.* 1580–85, painter unknown (Cat. No. 61, p. 69)
(above right) Ill. 42. **Henry IV,** by or after Frans Pourbus the Younger (Cat. No. 62, p. 69)

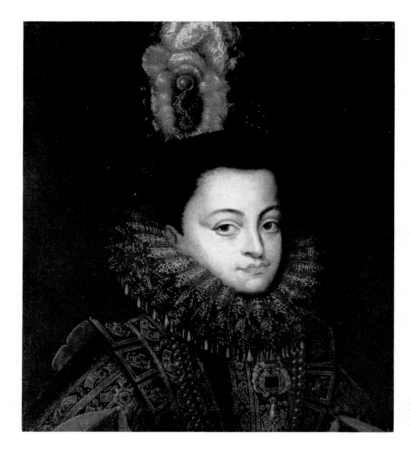

Ill. 43. **Isabella Clara Eugenia,** by ?Gysbrecht or Otto van Veen (Cat. No. 63, p. 70)

Ill. 44. **Albert, Archduke of Austria,** by ?Gysbrecht or Otto van Veen (Cat. No. 64, p. 71)

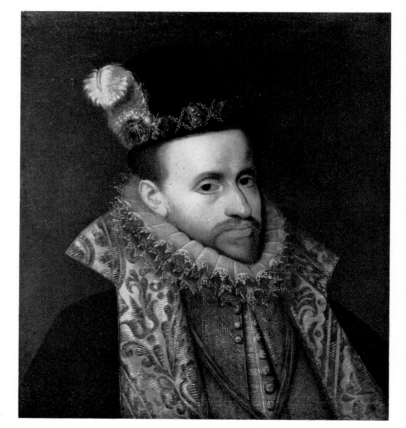

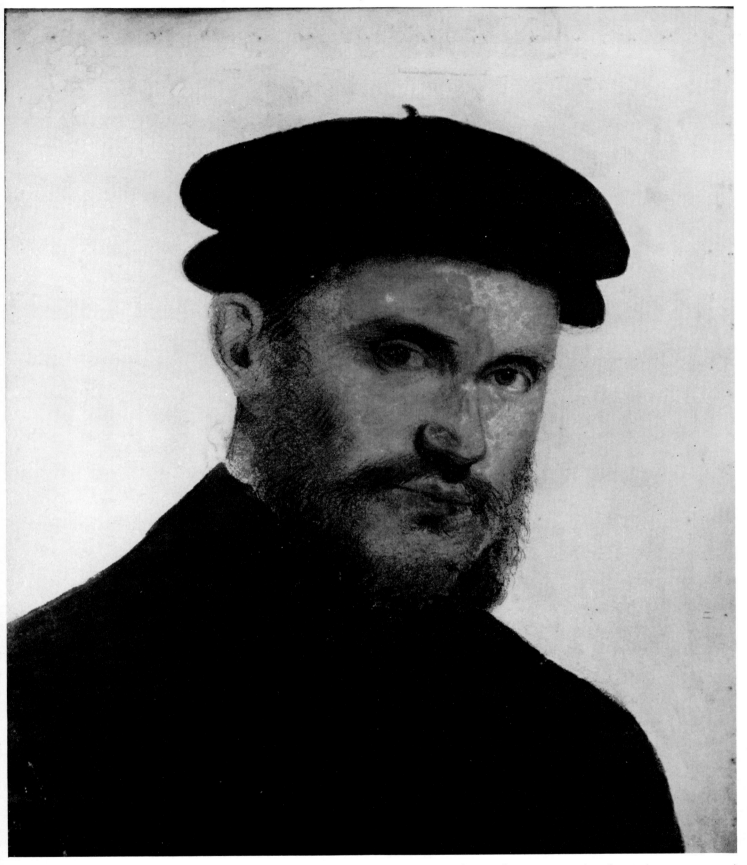

Ill. 45. **François Ravaillac,** by an unknown Franco-Flemish artist (Cat. No. 65, p. 71)

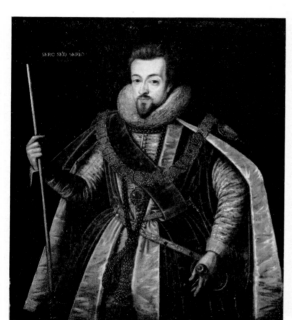

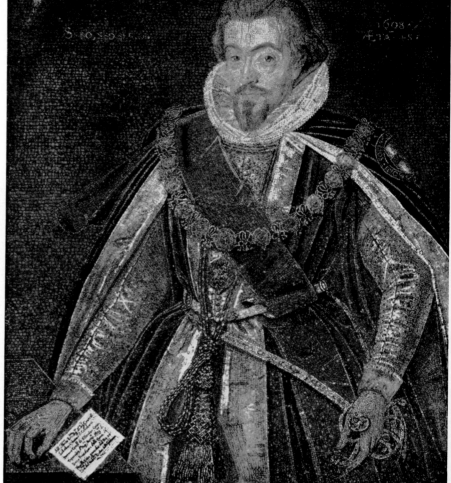

(above left) Ill. 46. **Robert Cecil, 1st Earl of Salisbury,** 1608, by
John de Critz the Elder (Cat. No. 66, p. 72)
(above right) Ill. 47. **Robert Cecil, 1st Earl of Salisbury,** *c.*1608, after
John de Critz the Elder (Cat. No. 67, p. 73 and Cat. No. 121, p. 107)

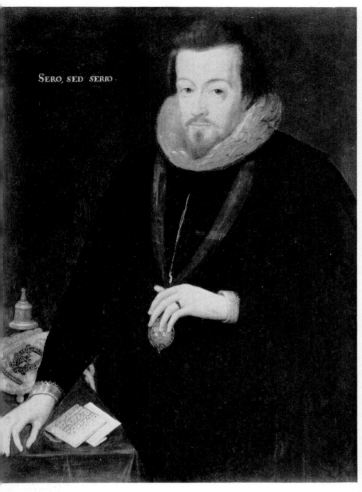

SERO, SED SERIO.

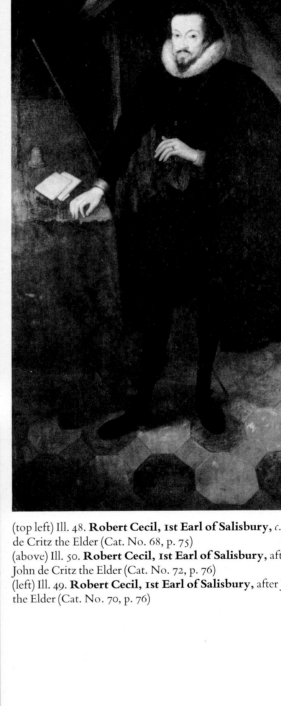

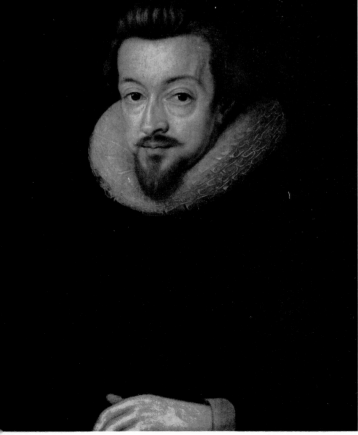

(top left) Ill. 48. **Robert Cecil, 1st Earl of Salisbury,** *c.*1606–8 by John de Critz the Elder (Cat. No. 68, p. 75)
(above) Ill. 50. **Robert Cecil, 1st Earl of Salisbury,** after 1606, after John de Critz the Elder (Cat. No. 72, p. 76)
(left) Ill. 49. **Robert Cecil, 1st Earl of Salisbury,** after John de Critz the Elder (Cat. No. 70, p. 76)

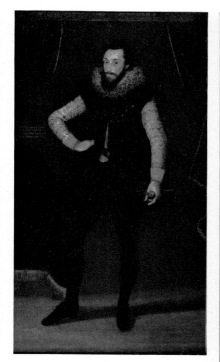

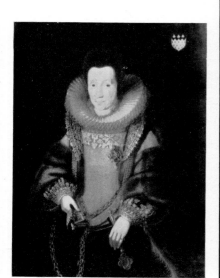

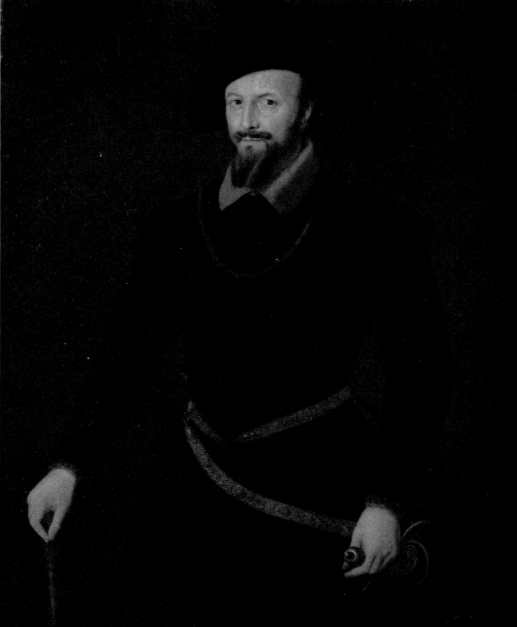

(top left) Ill. 53. **Christophe de Harlay, Comte de Beaumont,** 1605, by Marcus Gheeraerts the Younger (Cat. No. 75, p. 80)
(above left) Ill. 54. **Mary Taylor, Lady Bennet,** 2nd half sixteenth century, painter unknown (Cat. No. 78, p. 82)
(above) Ill. 51. **?George Carew, Earl of Totnes,** c.1585–90, painter unknown (Cat. No. 73. p. 76)

(left) Ill. 52. **?Sir Walter Cope,** 1612, by John de Critz the Elder (?) (Cat. No. 74, p. 78)

(above) Ill. 55. **James I of England and VI of Scotland,** c.1618, by Paul van Somer (Cat. No. 74, p. 82)

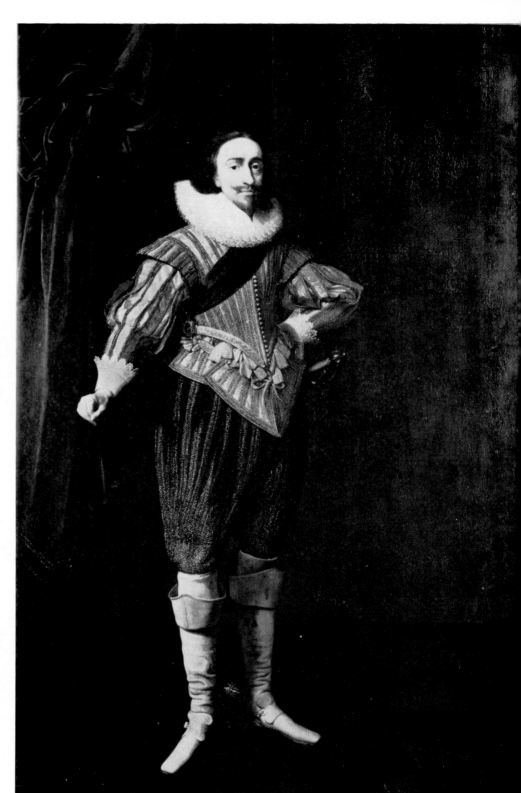

(top left) Ill. 56. **James I of England and VI of Scotland, Queen Anne and Prince Charles,** after 1612 and before 1618, by Simon van de Passe (Cat. No. 81, p. 83)

(above left) Ill. 57. Reverse side of Ill. 56

(above) Ill. 58. **Charles I,** *c.*1628, by Daniel Mytens (Cat. No. 85, p. 86)

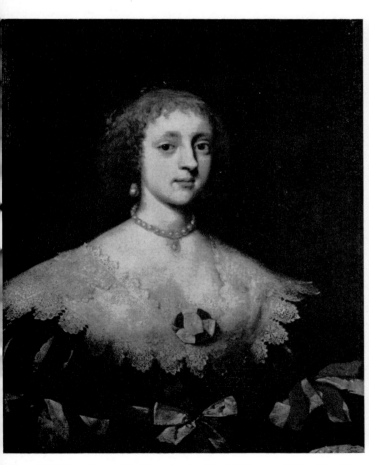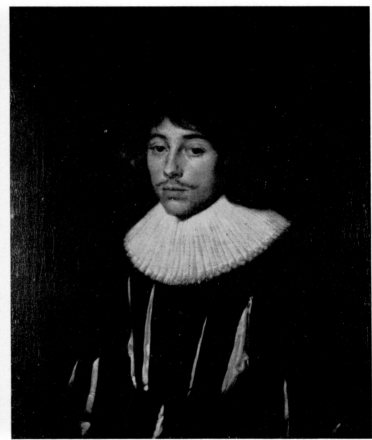

(above left) Ill. 59. **Anne Cecil,** *c.*1629, by Daniel Mytens (?) (Cat. No. 88, p. 88)

(above right) Ill. 60. **Algernon Percy, 10th Earl of Northumberland,** *c.*1629, by Daniel Mytens (?) (Cat. No. 88, p. 89)

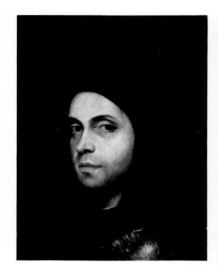

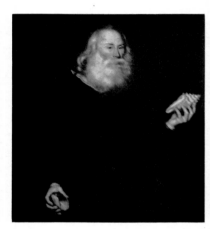

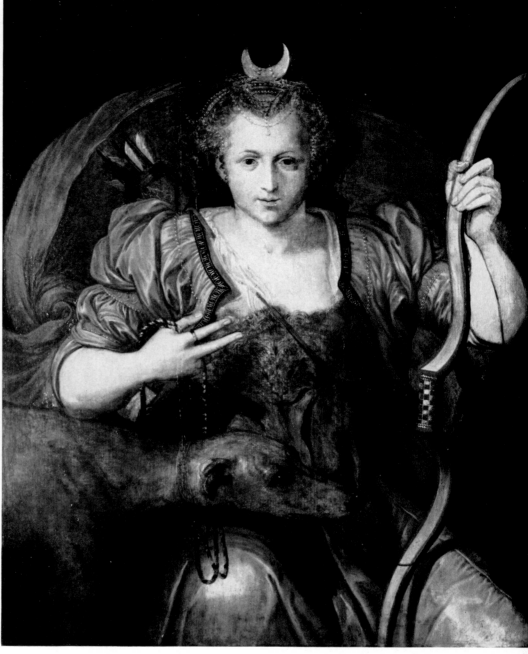

(top left) Ill. 61. **Head of a Spaniard,** by ?Giovanni Busi Carriani, after Giorgione (Cat. No. 89, p. 90)
(above left) Ill. 62. **John Tradescant the Elder,** *c.*1630, painter unknown (Cat. No. 90, p. 91)
(above) Ill. 63. **Diana,** *c.*1560, attributed to Frans Floris (Cat. No. 91, p. 92)

(opposite above) Ill. 64. **Leda and the Swan,** painter unknown (Cat. No. 92, p. 93)
(opposite below) Ill. 65. **Mercury, Argos and Io,** 2nd half of the sixteenth century, painter unknown (Cat. No. 93, p. 93)

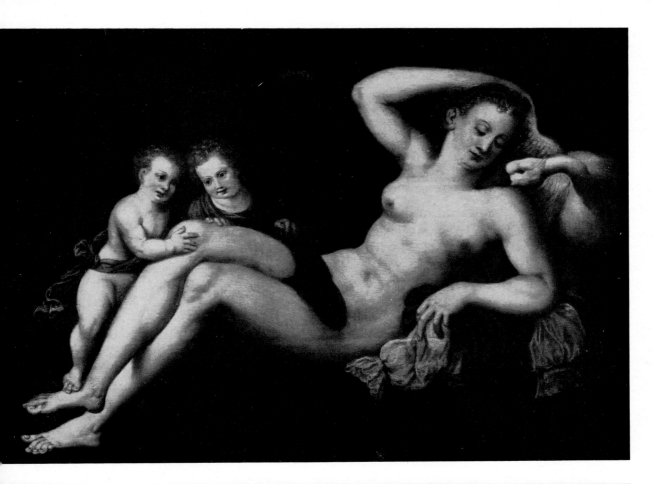

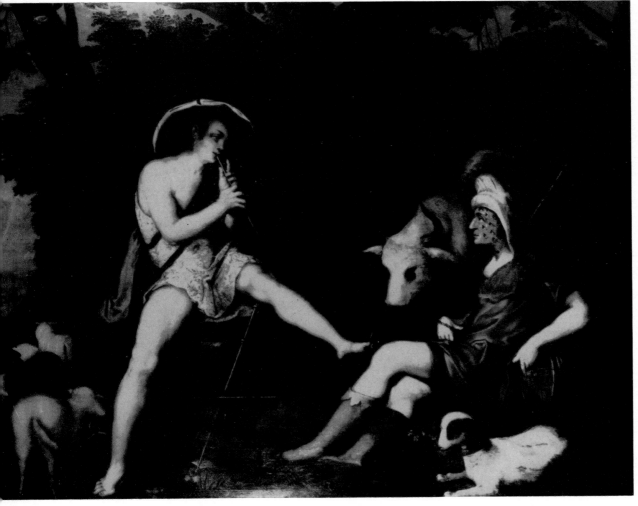

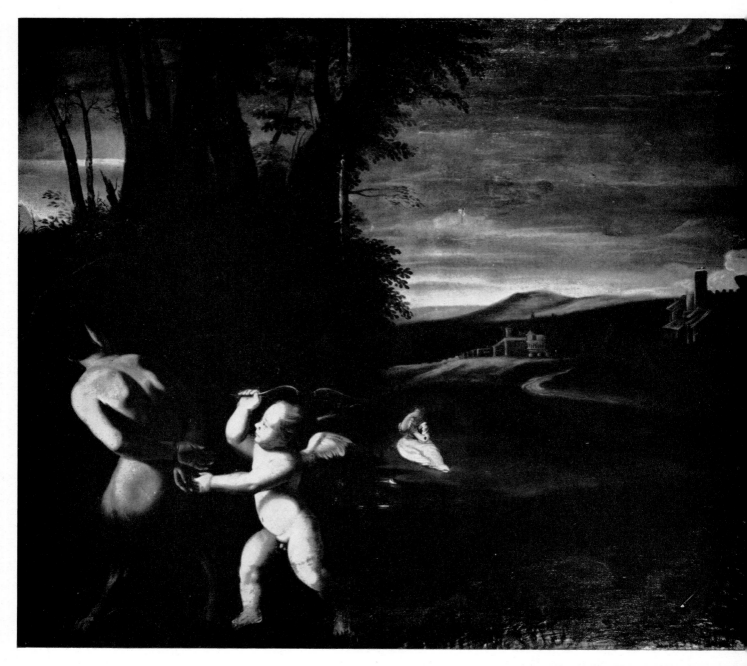

(above) Ill. 66. **Cupid Scourging a Satyr,** late sixteenth or early
seventeenth century, painter unknown (Cat. No. 94, p. 94)
(right) **Petrarch's Laura,** by Master of the Female Half-length Figures
(Cat. No. 95, p. 95)

(opposite above left) Ill. 68. **Adam and Eve,** 1543, by Marcellus
Coffermans (Cat. No. 98, p. 96)
(opposite above right) Ill. 69. **Adam and Eve,** attributed to Jan van
Scorel (Cat. No. 99, p. 97)
(opposite below) Ill. 70. **Boy Reposing on a Skull,** painter unknown
(Cat. No. 101, p. 98)

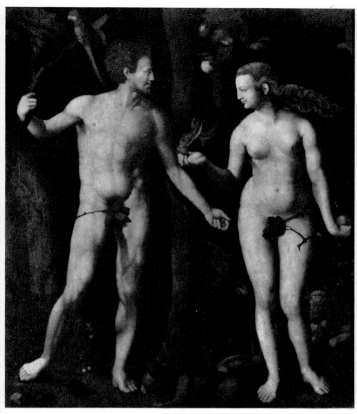
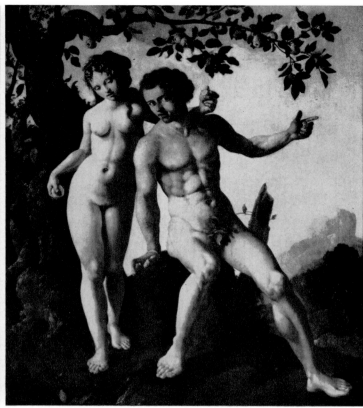
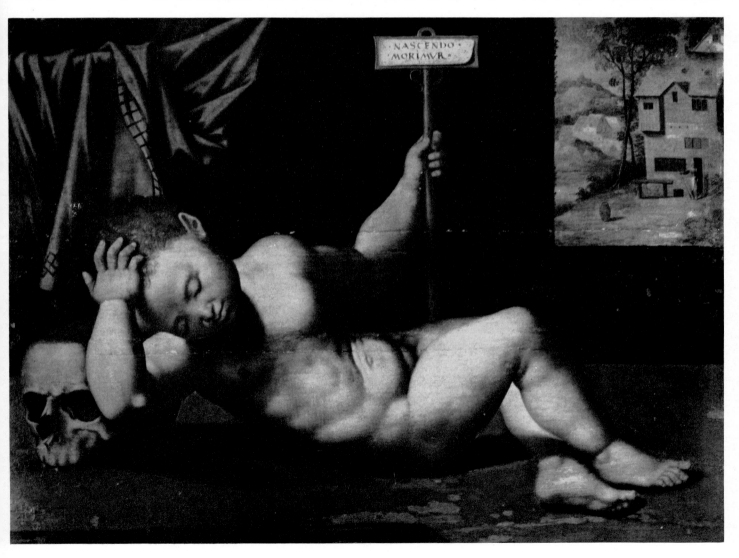

149

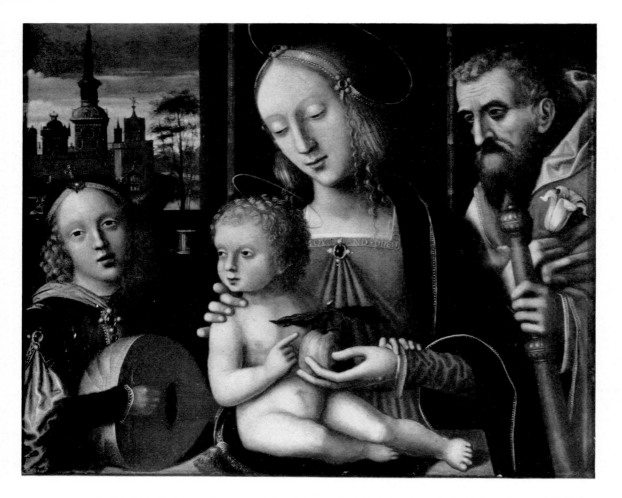

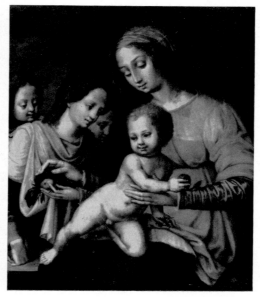

(top) Ill. 71. **Holy Family with an Angel playing the Lute,** *c.*1514, by Antonio da Solario (Cat. No. 102, p. 99)

(above left) Ill. 72. **The Virgin and Child and three attendant children serving fruit,** *c.*1550, by Giovanni Battista Rosso (Cat. No. 105, p. 100)

(above left) Ill. 73. **Christ and the Woman of Samaria,** by ?Paris Bordone (Cat. No. 106, p. 101)

(opposite above) Ill. 74. **Christ at Emmaus,** by Jacopo(?) Bassano (Cat. No. 108, p. 101)

(opposite below) Ill. 75. **The Departure of Abraham,** by Jacopo(?) Bassano (Cat. No. 109, p. 102)

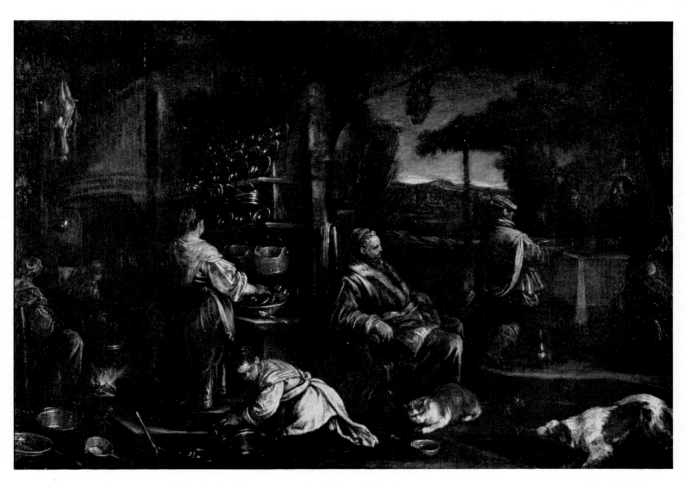

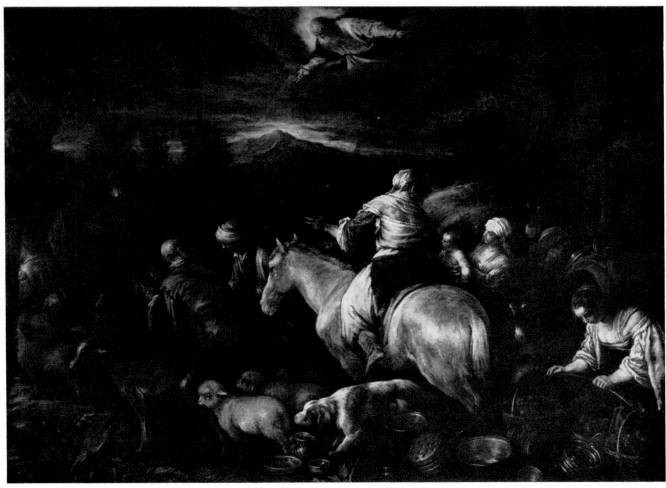

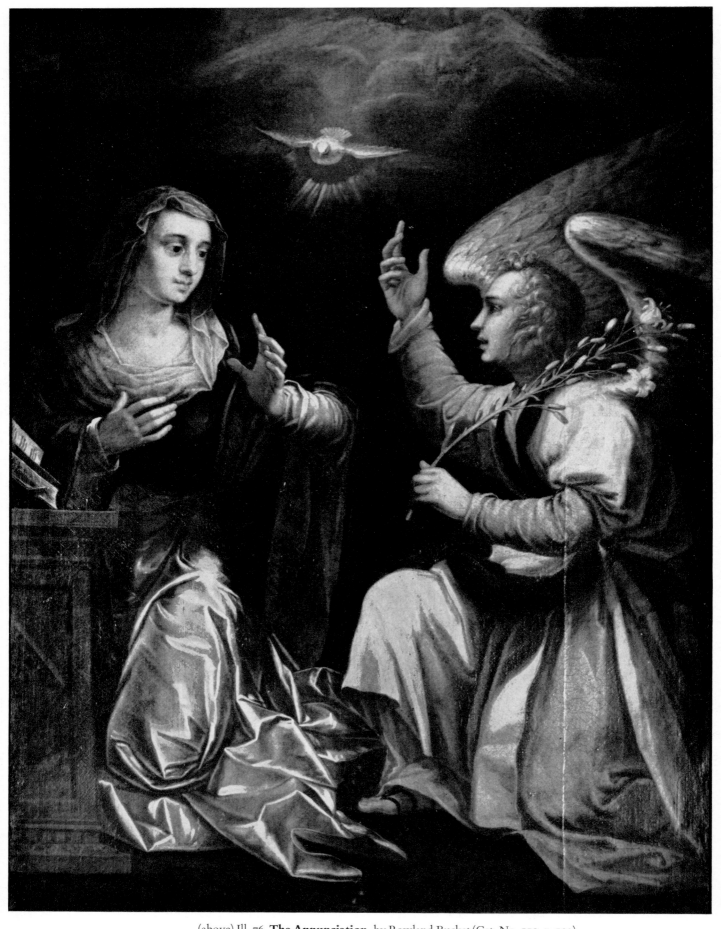

(above) Ill. 76. **The Annunciation,** by Rowland Bucket (Cat. No. 110, p. 103)

(opposite above) Ill. 77. **The Annunciation to the Shepherds,** by Rowland Bucket (Cat. No. 110, p. 103)

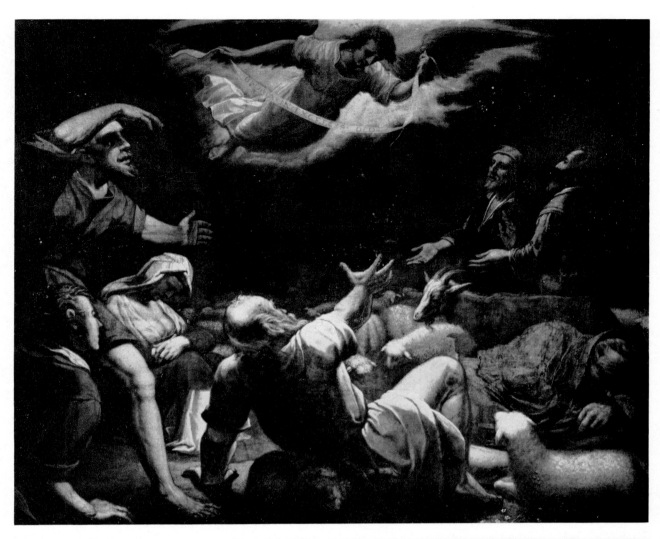

(above left) Ill. 78. **St Andrew,** by Rowland Bucket (Cat. No. 111, p. 104)
(above right) Ill. 79. **St Luke,** by Rowland Bucket (Cat. No. 111, p. 104)

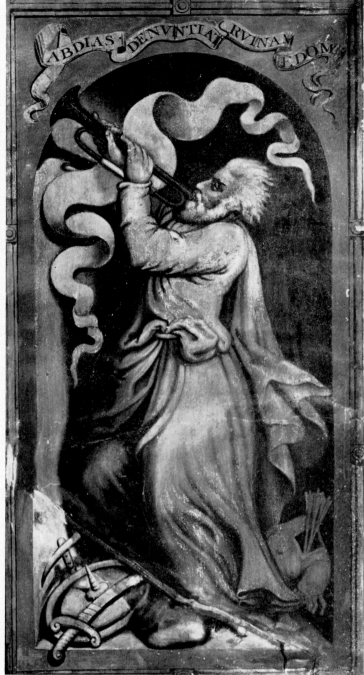

(above left) Ill. 80. **The Prophet Amos,** by Rowland Bucket
(Cat No. 111, p. 104)
(above right) Ill. 81. **The Prophet Obadiah,** by Rowland Bucket
(Cat. No. 111, p. 104)

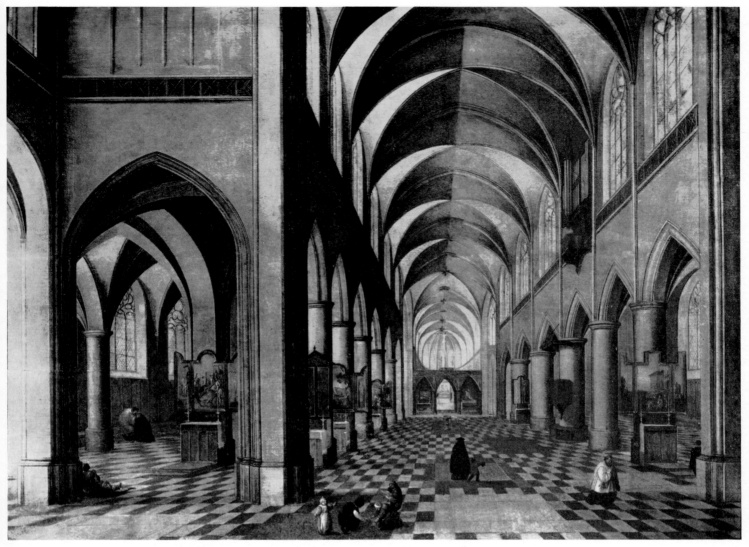

(above) Ill. 82. **Interior of a Church in Antwerp,** by Peter Neefs the Elder (Cat. No. 112, p. 105)

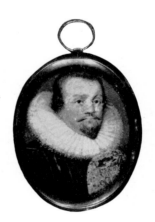

(from left to right) Ill. 83. **William Cecil, 1st Baron Burghley,** later copy (Cat. No. 113, p. 106); Ill. 84. **An Unknown Lady,** 1605, by Nicholas Hilliard (Cat. No. 114, p. 106); Ill. 85. **Thomas Coventry, Lord Keeper,** by Laurence Hilliard (Cat. No. 115, p. 107); Ill. 86. **Charles I,** painter unknown (Cat. No. 116, p. 107)

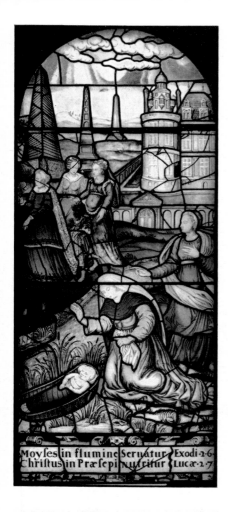

Moyses in flumine Seruatur Exodi 2 6
Christus in Præsepi nutritur Lucæ 2 7

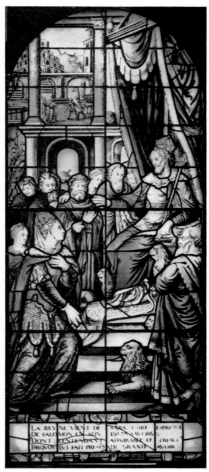

LA REYNE VIENT DE | SARA FAIRE ESPREVVE
DE SALOMON EN SON | DE LVY SAVOIR
DONT L'ENTENDANT | ADMIRABLE IL TREVVE
PRONONTIVE FAIT PRESES | DE GRAND SAVOIR

Jonas in Ventre piscis: Jon 1 17
Christus in Visceribus Terræ Mat 12 40

Agnum pascalem Israelitæ Commedunt Exo 12 26
Cenam domini Christus instituit : Mat 26 26

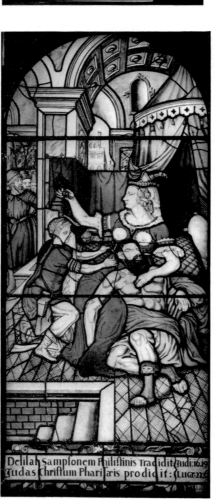

Delilah Sampsonem Philistinis Tradidit Judi 16 19
Judas Christum Pharisæis prodidit : Luc 22

Dauid Goliam Superat : 1 Sam 17 50
Christus Dæmonem conculcat 1 Corint 15 57

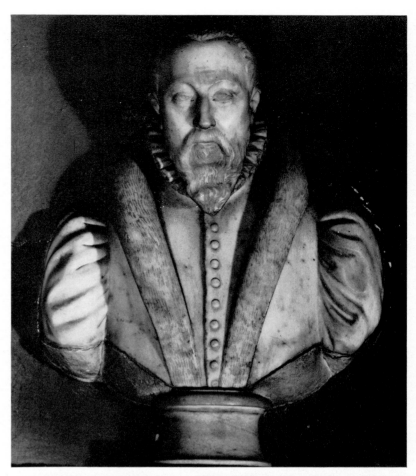

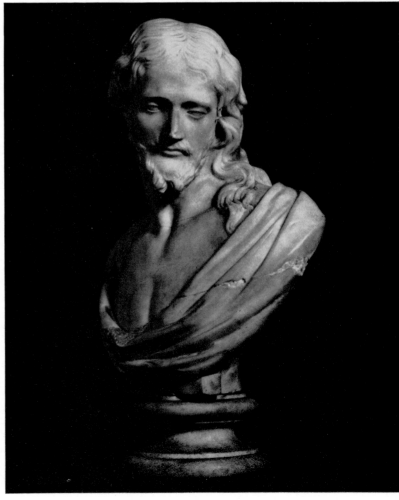

(opposite above left) Ill. 87. **Moses in the Bullrushes**
(Cat. No. 117, p. 107)
(opposite above centre) Ill. 88. **Solomon and the Queen of Sheba**
(Cat. No. 117, p. 107)
(opposite above right) Ill. 89. **Jonah and the Whale**
(Cat. No. 117, p. 107)
(opposite below left) Ill. 90. **Passover of the Israelites**
(Cat. No. 117, p. 107)
(opposite below centre) Ill. 91. **Samson and Delilah**
(Cat. No. 117, p. 107)
(opposite below right) Ill. 92. **David and Goliath**
(Cat. No. 117, p. 107)

(above) Ill. 93. **William Cecil, 1st Baron Burghley**
(Cat. No. 118, p. 108)
(below) Ill. 94. **Bust of Christ,** before 1629, sculptor unknown
(Cat. No. 119, p. 109)

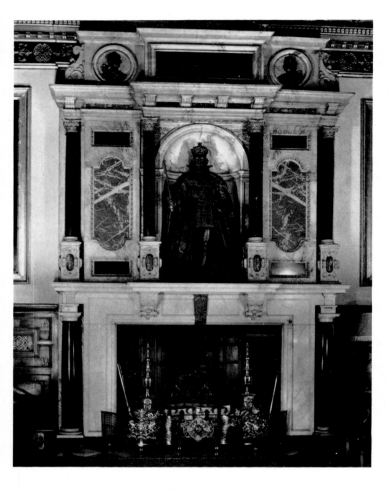

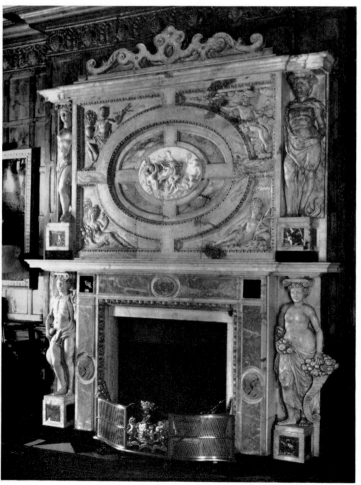

(above) Ill. 95. **Fireplace in King James's Drawing Room,** by Maximilian Colt (Cat. No. 120, p. 109)
(below) Ill. 96. **Chimney-piece in the Van Dyck Room,** by Maximilian Colt (Cat. No. 122, p. 111)

(opposite above) Ill. 97. **The Tomb of Robert Cecil, 1st Earl of Salisbury,** St Etheldreda's Church, Hatfield, *c.*1615, by Maximilian Colt (Cat. No. 123, p. 111)
(opposite below) Ill. 98. Detail of Ill. 97

(overleaf) Ill. 99. Detail of Ill. 97

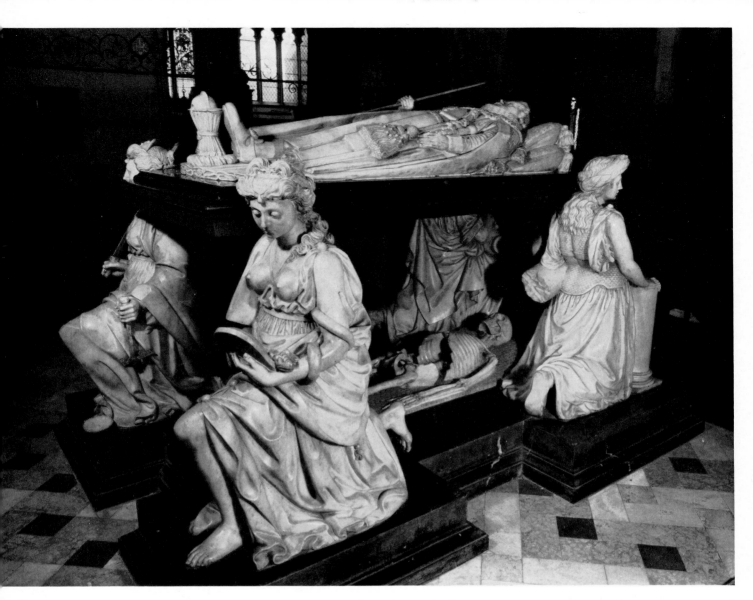

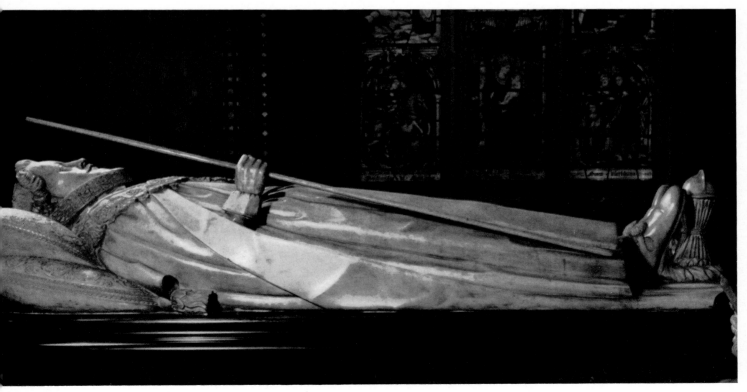

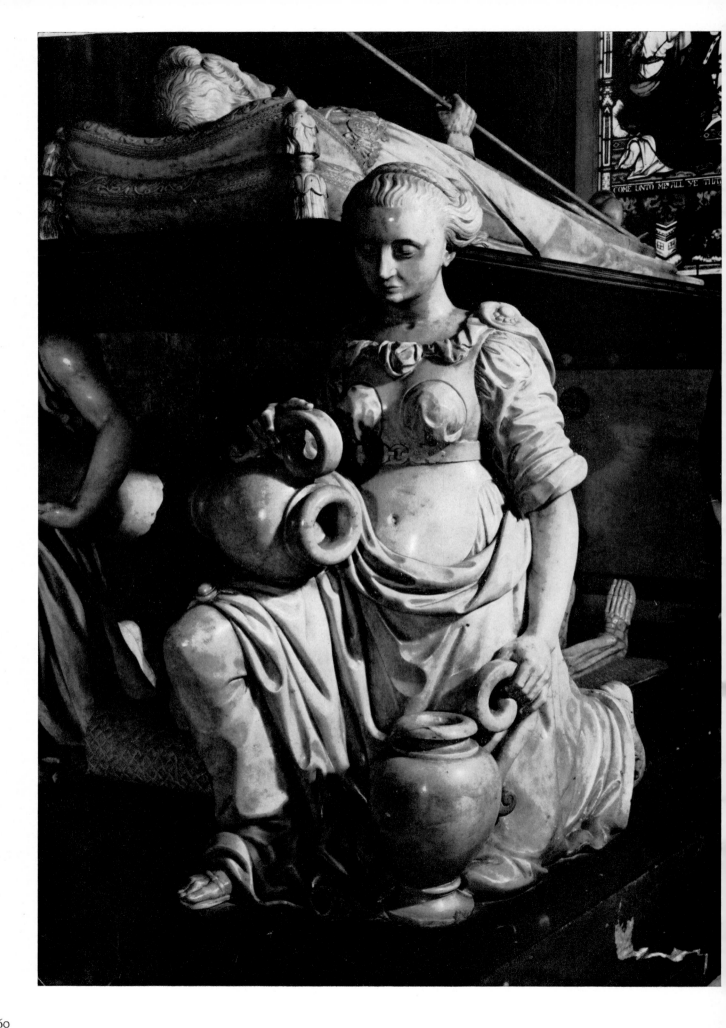

Part Two

BY C. KINGSLEY ADAMS

Part Two

BY C. KINGSLEY ADAMS

INTRODUCTION

The second part of this catalogue is of paintings, drawings and sculpture from *c.*1630 to the present day, a period of 340 years. A noticeable feature is the unbroken continuity of the portrait series. At no time in this period has twenty years passed without a member of the family being painted. The title and Hatfield House has descended always in the male line from father to son except in one case when a grandson succeeded. All holders of the title have been portrayed as well as the two Lord Cranbornes who died in the lifetimes of their fathers. All their consorts have also been portrayed, with one or possibly two exceptions. Hatfield House is of such proportions that it can and does house life-scale whole-length portraits of all the Earls and Marquesses up to the recent past with the one exception of the 6th Earl. Six of their consorts are portrayed similarly as well as a number of royalty and some other members of the family; all by painters of high standing in their day.

The portrait collection consists very predominantly of members of the Cecil family and of 'in-laws' closely related to some of the ladies. Very few portraits have come into the collection by marriage of heiresses; the largest number, some half dozen or so, came from the family of the Gascoyne heiress, the first wife of the 2nd Marquess.

Another feature of the family is noticeable in the portrait collection. Until the last half of the nineteenth century the male line did not multiply. Few younger sons married and had families.

Hatfield House is, of course, remarkable for its vast collection of papers of Lord Burghley and the 1st Earl of Salisbury. The accounts and many family papers for the greater part of the time since then have also been preserved, so there exist records of a number of payments to artists, picture dealers and restorers and in some cases their receipts. Many seventeenth-century inventories also survive. A note of the inventories and other lists is given separately, but a little more may be said about them here. Throughout the seventeenth-century at fairly short intervals inventories were made and kept of the chattels in Hatfield House, Salisbury House and other family houses. In the earlier of these the portraits and other paintings are itemized; later only the numbers of paintings in different rooms are given. Though the painters' names were not stated these inventories have proved most useful in providing evidence that certain portraits and other paintings were in the collection by particular dates. The inventories do not appear to have been complete; for instance no portrait of the 2nd Countess of

Salisbury was inventoried after the Lely portrait was painted until 1823: but there is a record of a payment to Lely for such a portrait and there is little doubt about the identity of the portrait of her by Sir Peter Lely.

There is a gap in inventories between 1702 and 1823. This is filled to a great extent by the detailed bill of Mr Chauncy for restoring paintings between 1718 and 1724 and by lists made by a number of visitors. In particular Sir William Musgrave's list of portraits which he made in 1769 is very valuable. This is the first list in which many artists' names were given.

One would much like to know whether there were tablets on the frames or how the portraits were labelled before the nineteenth-century. When Musgrave made his list either the portraits were well labelled or someone very knowledgeable in the house gave him the information.

In 1823, on the death of the 1st Marquess of Salisbury, a very detailed and most useful inventory was compiled in which artists' names are given. It is curious that no inventory is known of what the first wife of the 2nd Marquess inherited and brought into the collection. There is some doubt whether certain oil paintings other than family portraits came through her and much doubt about which miniatures were inherited by her. A number of the latter are said to be members of the Glanville family.

The 2nd Marquess had a manuscript catalogue made in 1845 of the paintings. In this there are plans for the walls showing how the paintings were hung. Though not drawn closely to scale, the plans give a fair indication of the sizes of the paintings. This catalogue was made in the interval between the death of the 2nd Marquess's first wife and his re-marriage. It must have been about then that inscriptions naming sitter and artist were painted on many portraits in large near-white capital letters. When this was done can be dated fairly closely: for as well as some Cecil portraits, some of the portraits which came through the 2nd Marquess's first wife bear this kind of inscription by the same hand. A few have earlier inscriptions, but the canvases were not systematically inscribed at an earlier date, as is the case in many other old family collections.

The 2nd Marquess's second wife had a few copies of the 1845 catalogue printed in 1865 for private circulation. On the death of the 2nd Marquess, a vast inventory was compiled of the contents of Hatfield and in this the 1845 catalogue was copied almost word for word. A few pictures not in the catalogue were included in this inventory, but most were not described sufficiently well to be identified.

The 3rd Marquess employed Lawrence Gifford Holland to make a new catalogue that was printed in 1891. Holland was Sir George Scharf's young assistant at the National Portrait Gallery. He did some good work on this catalogue, but there are many avoidable errors in it. He was probably a sick man and could not devote enough time to it. He died two years later. Holland's catalogue has not been superseded until now.

Interest in the collection has taken different forms at different periods. From the early seventeenth century inventories it is clear that the 1st Earl of Salisbury acquired many paintings illustrative of the Bible story. Most of these disappeared rapidly. Payments are recorded late in the seventeenth century for many flower paintings which were purchased for small sums. These are likely to have been of only mediocre quality and were not kept. Diana, Lady Cranborne (d. 1675) had her own collection, of which an inventory, made at her death, has survived. Some of her possessions were retained, notably the two Huymans copies after Van Dyck. There is no clue as to when most of the small collection of seventeenth

century Dutch and Flemish paintings were acquired. These were first listed in 1823 but there is no list between the late seventeenth century and then in which they would appear.

At the close of the seventeenth century, during the minority of the 5th Earl, Salisbury House was closed and its more important contents removed to Hatfield House. Soon after he came of age, the 5th Earl had the collection of portraits thoroughly overhauled by Mr Chauncy. This Earl appears to have been a very intelligent observer of European affairs, though he did not take an active part in them. He must have acquired the portraits of Peter the Great and Charles XII of Sweden. The portrait of the latter was stated to have sent him by Count Gyllenborg, sometime Swedish Ambassador in London.

The 6th Earl became estranged from his wife and lived elsewhere. His Countess continued to reside at Hatfield with her children. Margaret (née Cecil), Lady Brown is said to have acted in some way as a go-between and the house was kept in reasonably good order. Visitors in that period like Horace Walpole and Sir William Musgrave did not criticise the condition of the house or its contents.

When the 7th Earl and 1st Marquess inherited in 1780, he immediately had the house and its contents overhauled and the grounds re-designed. This is recorded by Thomas Pennant in his *Journey from Chester*, 1782, p. 411. Pennant names Mr Tomkins as the restorer of the paintings and Mr Donowell as the architect in charge of the work on the house. It was then that many of the paintings were removed from their frames, and placed in frames of standard patterns. No doubt the Earl or his architect liked all the pictures in a room to be framed alike.

From the 1823 inventory it can be seen that little apart from new portraits of members of the family and a few friends were acquired until recent years; but the collection has been well maintained.

In this century in particular the collection has been and is being well looked after and it is scarcely possible that it can ever have been in better condition and better arranged.

As regards this catalogue I would like to say, what all who have catalogued collections always feel, that there is much more that could be done and that too many problems have been left unsolved, some of which should be solved with further research.

In conclusion I wish to render my thanks to Lord Salisbury and Lord Cranborne for all the help and encouragement they have given me and for their great patience and forbearance in not pressing for greater speed. I wish also to declare my great indebtedness to Miss Clare Talbot for her very great help throughout, and especially for the large number of extracts she made from the archives and many days she devoted to guiding me round the collection and indeed in helping in every other possible way.

I am very much indebted too for help in various ways to many friends, to name them all individually would make an overwhelmingly long list. I should like particularly to record my great indebtedness to my wife for her constant help and encouragement and to my daughter, Mrs Mary Duckworth for successfully carrying through several pieces of research at a time when I could not. I must name before all others my collaborator, Dr Erna Auerbach, with whom all matters affecting us both were worked out in perfect harmony. Then I wish to record my thanks to: Mr Edward Archibald, Assistant Keeper at the National Maritime Museum; Sir Antony Blunt, Director of the Courtauld Institute of Art; M. Bossard of Versailles; Miss Anne Buck, Keeper, Gallery of English Costume, Platt Hall, Manchester; Mr James D. Burke; Mr Malcolm Cormack, Keeper of Paintings and Drawings, Fitzwilliam Museum; Miss Dorinda Evans; Mrs Daphne Foskett; Dr C. A. H. Franklyn; Dr Ragnhild

Hatton, Professor of International History at the London School of Economics; Mademoiselle Anne de Herdt, Assistante, Musée d'Art et d'Histoire, Geneva; Mr Terence Hodgkinson, Keeper, Department of Sculpture, the Victoria and Albert Museum; Mr E. H. L. Jennings; Miss Jane Langton; Dr W. S. Lewis; Mr Gregory Martin, Assistant Keeper, the National Gallery; Mr Oliver Millar, Deputy Surveyor of the Queen's Pictures; Mr Francis Needham; Mr John Nevinson; Mr Vesey Norman, Assistant Director of the Wallace Collection; Mr H . V. T. Percival, the Wellington Museum, Apsley House; Mr David Piper, Director of the Fitzwilliam Museum; Mr Gordon Roe; Mrs Ruby Rollings; Professor Alastair Smart, Department of Fine Art, Nottingham University; Mr Eric J. Stanford, Art Assistant, the Museum and Art Gallery, Reading; Mr J. D. Stewart, the Department of Art History, Queen's University, Kingston, Ontario; Mr P. L. Sumner, Deputy Keeper, the Department of Transport, the Science Museum; Professor Ellis K. Waterhouse, lately Professor of Fine Art, Birmingham University; the Duke of Wellington; Dr Roy Strong, the Director of the National Portrait Gallery and the staff of the National Portrait Gallery where I was always welcomed and very willingly helped in carrying out much of my research work, and Dr Pamela Tudor-Craig who had prepared some of the ground for the catalogue, and lastly Miss Mary Anne Norbury of George Rainbird Limited for miraculously reading and with extreme speed putting into ordered typescript my disordered and much scribbled over manuscript and for much other help throughout.

Part Two

CATALOGUE

124 [85] ill. 100, p. 265

William Cecil, 2nd Earl of Salisbury, K.G.
(1591–1668), 1654

William Cecil was the only son of Robert Cecil, 1st Earl of Salisbury. He married Catherine Howard, youngest daughter of Thomas Howard, Earl of Suffolk in 1608. He was made a Knight of the Garter in 1624. He sat in Cromwell's House of Lords in 1645–48.

Sir Peter Lely (1618–1680)

Canvas 48½ × 39½ in. (123·2 × 100·3 cm.)

Three-quarter length, standing, turned to the left looking at the spectator. He has long, light brown hair, moustache and chin tuft and brown eyes and wears a black and white vertically slashed suit, a flat plain lawn collar, and a black cloak, Garter ribbon around his neck and badge of the Garter on his cloak. He strokes a black and white dog's head with his right hand. An inscription noted in the 1891 catalogue has since been cleaned off.

In the Hatfield Estate papers (Box M.4) is a record of a payment in 1654: 'To Mr Lilly for my Lord's and Lady's pictures with gilt frames £30. 0. 0.'.

The portrait is listed in the Hatfield inventory of 1679/80 when it was in the Parlour. The artists were not named in the inventory. In the 1769 Musgrave list it is given to Van Dyck. This attribution was retained in the nineteenth-century inventories and catalogues.

Literature: John Smith, *Catalogue Raisonné of the Works of Sir Anthony Van Dyck*, 1831, No. 543, p. 154; Jules Guiffrey, *Antoine Van Dyck*, 1882, No. 820, p. 277; Lionel Cust, *Anthony Vandyck*, 1900, p. 282; Emil Schaeffer, *Van Dyck*, 1909, reproduced p. 387; R. B. Beckett, *Lely*, 1951, p. 60, Pl. 12.

125 [84] ill. 101, p. 265

Catherine (Howard), Countess of Salisbury
(d. 1672/3), 1654

Catherine Howard was the youngest daughter of Thomas Howard, Earl of Suffolk. She married the 2nd Earl of Salisbury on December 1, 1608

Sir Peter Lely (1618–1680)

Canvas 44 × 34 in. (111·8 × 86·3 cm.)

Three-quarter length, seated turned to the right but looking at the spectator, she has medium brown hair and brown eyes and wears a low-cut brown dress with full sleeves, a pearl brooch at her breast and a black, jewelled waist-belt; a tree

and stormy sky are seen to the right. Inscribed in capitals above her left arm: 'CATHERINE COUNTESS OF SALISBURY' and in the lower left corner: 'Sir Peter/LELY'.

At Hatfield is a record of a payment in 1654: 'To Mr Lilly for my Lord's and Lady's pictures with gilt frames £30. 0. 0.'. No portrait of the 2nd Countess of Salisbury is mentioned in Hatfield inventories after the Lely portrait was painted until 1823. The portrait is there listed as hanging in the Drawing Room and stated to be by Dobson. This attribution was retained in the 1891 catalogue, but in the 1845 manuscript catalogue, No. 23, it is given to Lely. There is little doubt that it is the work of Lely and the costume is right for the 1650's.

Literature: R. B. Beckett, *Lely,* 1951, p. 60, Pl. 11.

126 [88] ill. 102, p. 265

Algernon Percy, 10th Earl of Northumberland, K.G. (1602–1668) his wife **Lady Anne (Cecil)** (1612–1637) and one of their daughters, *c.*1634/5.

Algernon Percy succeeded his father in 1632, and was made a Knight of the Garter in 1635. He married Lady Anne Cecil, the second daughter of the 2nd Earl of Salisbury before 1630. She had five daughters. Her sister Catherine, married the Earl of Leicester.

Studio of Sir Anthony van Dyck (1599–1641)

Canvas 52 × 68 in. (132 × 172·7 cm.)

The Earl has brown hair, is dressed in black and wears the blue ribbon of the Garter around his neck. The Countess also has brown hair, her dress is blue, with a grey scarf, she has roses in her lap. Their little girl on the right is in profile to the left, in white.

The child is generally said to be Elizabeth, their fifth daughter who married Arthur Capel, 1st Earl of Essex, in 1653, but as the Petworth group was painted before Northumberland became a Knight of the Garter (April 23, 1635) and the child is about 2 years of age she must be one of the older daughters.

A painting of Lord and Lady Northumberland and one of their children is first recorded in an inventory of the chattels at Salisbury House in 1639/40. It was hung in the Wardrobe. It was in the Parlour at Salisbury House in 1685. George Vertue noted it at Hatfield on his visit in 1734 (Walpole Society, Vertue, Vol. VI, p. 12).

The fine Hatfield painting was long looked upon as Van Dyck's original but the original, at Petworth, was painted before Northumberland became a Knight of the Garter. Other versions all showing him with the Garter ribbon are at Burghley and Gorhambury. Others were at Kimbolton and Hardwick Hall. A preliminary sketch of Lady Northumberland is in the British Museum.

Exhibitions: National Portrait Exhibition, 1866, No. 719. Royal Academy, Old Masters, 1870, No. 40.

Literature: John Smith, *Catalogue Raisonné of the Works of Sir Anthony Van Dyck,* 1831, No. 610, p. 177; Jules Guiffrey, *Antoine Van Dyck,* 1882, No. 723, p. 177; Lionel Cust, *Anthony Vandyck,* 1900, p. 280; reproduced in an article on the Hatfield House Collection in the *Connoisseur.* Vol. vii, 1903, p. 231 as by Vandyck.

127 [89] ill. 103, p. 266

Mary Cecil, Lady Sandys (*c.*1631–*c.*1676), 1655

Mary Cecil was the fifth daughter of William Cecil, 2nd Earl of Salisbury. She married William, 6th Lord Sandys of the Vine, Hampshire. William died, c.1668, without issue and the title became extinct

Sir Peter Lely (1618–1680)

Canvas 46 × 38 in. (116·8 × 96·5 cm.)

Three-quarter length, seated to the right; she has auburn curls, and pale brown eyes; she wears a grey dress with pale red-grey lining.

In the Estate Papers, Box M.5, is a note of a payment in 1655: '. . . . to Mr Lilly for my Lady Sands' picture, by my Lady's command £12; for a gilt frame for it £2. 10.'.

The first inventory in which this is mentioned is that of Hatfield in 1679/80. No artists were named in this. In Mr Chauncy's account for cleaning pictures between 1718 and 1724 he listed it as in the Drawing Room where it was when the 1823 inventory was made. In the latter it is listed as by Old Stone. It was attributed to him again in the 1891 catalogue. In the 1845 catalogue, No. 21, it was correctly stated to be by Lely.

Literature: R. B. Beckett, *Lely*, 1951, No. 468.

128 [80] ill. 104, p. 266

Charles Cecil, Viscount Cranborne (1619–1660), *c*.1645/55

Second, but first surviving, son of the 2nd Earl of Salisbury, he was made K.B. at the coronation of Charles I 1625/6. He married in 1639 Diana Maxwell, No. 130 [82], daughter of James Maxwell who was created Earl of Dirleton, No. 229 Lord Cranborne died in his father's life-time

Sir Peter Lely (1618–1680)

Canvas $47\frac{1}{4} \times 35\frac{1}{2}$ in. (120 × 90.2 cm.) sight

A three-quarter length: he is standing turned to the left, looking at the spectator. He has long fair hair and wears black drapery. Neither the ribbon or jewel of the Order of the Bath is seen in the portrait. A dark curtain background with sky and park to the left.

In 1961 Dr Martin de Wild removed some wooden additions and reduced the frame to the size of the original canvas.

Portraits of Lord Cranborne are mentioned in

Salisbury House inventories of 1629 to 1646. In these his portrait is listed with those of his brother, Robert, and his two sisters, Ladies Elizabeth and Diana. These were the eldest four children of the 2nd Earl of Salisbury who were painted in or just before 1626 by George Geldorp. These portraits were later moved to Hatfield and appear in the 1679/80 Hatfield inventory as hanging in 'Lady Katherine's Chamber'. No artist's names were mentioned in any of these inventories. The portraits do not appear in any later list. (See No. 82 in Part I.)

No. 128 is presumably the portrait mentioned in the Hatfield 1679/80 inventory as hanging in the 'Parlour' with portraits of the 1st and 2nd Earls of Salisbury and Lord Burghley. It appears in Musgrave's list of 1769 as by Van Dyck and continued to be attributed to him in later lists and catalogues including that of 1891. It and No. 130 which pairs with it conform to Lely's early style and there is little doubt from the costumes that they were painted *c*.1645/55.

Literature: Jules Guiffrey, *Antoine Van Dyck*, 1882; Lionel Cust, *Anthony Vandyck*, 1900, p. 273; Emil Schaeffer, *Van Dyck*, 1909, reproduced p. 389; R. B. Beckett, *Lely*, 1951, p. 42, Pl. 10.

129 [81]

Called **Charles Cecil, Viscount Cranborne** (1619–1660)
See No. 128

Painter unknown

Canvas $49 \times 39\frac{1}{2}$ in. (124.5 × 99 cm.)

Three-quarter length, standing, he has fair curling hair and wears a black doublet and cloak or drapery, and full white sleeves. He rests his right hand on a red covered table, his left is on his hip. There is a landscape background with rocks on the left.

Only one portrait of Lord Cranborne was

mentioned in known lists of portraits at Hatfield until the 1845 manuscript catalogue when this and No. 128 were both catalogued as of him by van Dyck (Nos 6 and 52).

This might be the portrait of Algernon Cecil (*c*.1629–1676) for which a gilt frame was purchased on September 29, 1656 (Estate Papers, Box M.7) when it hung in the Drawing Room and which is in the 1679/80 Hatfield inventory as in the Withdrawing Room next but one to the Parlour. Mr Chauncy charged 5*s*. for work on it in 1718. He called it a half-length (i.e. size 50 × 40 in. (127 × 101·6 cm.)). That is the last known reference to a portrait called Algernon Cecil. He was the sixth son of the 2nd Earl of Salisbury.

I30 [82] ill. 105, p. 266

Diana (Maxwell), Viscountess Cranborne (*c*.1623–1675)

Diana Maxwell was the second daughter and co-heiress of Sir James Maxwell (d. 1650), created Earl of Dirleton in 1646. She married Lord Cranborne (No. 128) in 1639 and had seven sons and five daughters

Sir Peter Lely (1618–1680)

Canvas 49½ × 36¾ in. (125·7 × 93·3 cm.) sight

Three-quarter length; she is turned to the right but looks at the spectator. She holds a chaplet of flowers; her brown hair, dressed with pearls, falls in curls to her shoulders; she wears a pearl necklace, blue dress, and grey scarf. On the right a stone figure of a boy pours water from a dolphin(?) the background is brown.

In 1961 Dr. Martin de Wild removed some wooden additions and reduced the frame to the size of the original canvas.

No portrait of Lady Cranborne is mentioned in any inventory before 1823. In the 1823 inventory it is listed in the Drawing Room in these words: 'Lady Jane Cranborne, Daughter of

James Maxwell, Earl of Dirleton, doubtless as to the delicacy of colouring and correct elegance equal to the best of his works Vandyck'. In the 1845 manuscript catalogue, No. 2, it is ascribed to Van Dyck and continued to be until recent years. It pairs with No. 128 *q.v.*

Literature: Lionel Cust, *Anthony Vandyck*, 1900, p. 273; Emil Schaeffer, *Van Dyck*, 1909, reproduced, p. 388; R. B. Beckett, *Lely*, 1951, p. 42, Pl. 9; Reproduced in an article on the Hatfield House Collection in the *Connoisseur*, Vol. vii., Dec. 1903, p. 229 as by Vandyck.

I3I

A Brother of the 3rd Earl of Salisbury (?), *c*.1670/80

Painter unknown

Canvas 24 × 19¾ in. (61 × 50·2 cm.)

Whole-length, seated, the sitter fronts the spectator, his head is turned and he looks three-quarters to the left; he leans on a table covered with a green cloth on which is some fruit, his right leg is crossed over his left; he wears a long fair wig; loose pale red coat; a classic statue of a lady is in the parklike background to the right, and there is a green curtain to the left.

The portrait was found in the house in recent years. The sitter's wig and costume conform to a style in fashion *c*.1670–80, so the sitter, if a Cecil could be a brother of the 3rd Earl of Salisbury. It has been attributed to Caspar Smitz.

I32 [222] ill. 106, p. 267

Called **Catherine (Cecil), Countess of Kinnoull** (*c*.1640–45–*c*.1683) and her son **Lord Dupplin** (d. 1687)

Catherine Cecil, elder daughter of Charles, Viscount Cranborne, married as his second wife, after 1665, William Hay, 4th Earl of Kinnoull (d. 1677). She had two sons, the 5th and 6th Earls of Kinnoull. She

is here depicted with her elder son, then Lord Dupplin who died in Hungary in 1687

Caspar Smitz (d. 1707)

Canvas 64 × 36 in. (162·9 × 91·4 cm.)

Small-scale whole-lengths in a wooded landscape. Lady Kinnoull is seated to the left of centre turned slightly to the right, looking at the spectator. She has medium-brown hair, and wears a low-cut dark-blue dress or drapery over a white chemise exposing her bosom. Her fair haired infant son in the centre brings towards her some fruit and flowers. Held by him is some light blue drapery, this and with some thin white drapery is his only clothing. On the left are two statues of boys, the nearer one (winged cherub) is blowing a curved horn. An indistinct inscription in the lower left hand corner appears to read: 'Countes Kinnoul/Lady Bowyer/and her son Lord Dupplin'. Near the lower right corner are the faint remains of a signature: 'c. Sm'.

Among the pictures in the inventory of Lady Cranborne's goods made after her death in 1675 were 'Two, one of the Countess Kenoule, the other Lady Frances £10'. These may be Nos. 131 and 132. This is presumably the painting, 'Countes of Kinnoule & Ld. Upling in a landskip' listed in the Hatfield 1679/80 inventory. It does not appear again under her name in any Hatfield list but is included in the 1891 catalogue, No. 222, without any names attached and without mention of the inscription.

133 [93] ill. 107, p. 268

James Cecil, 3rd Earl of Salisbury, K.G. (1646–1683), 1680 or 1681

James Cecil, was the son of Charles, Viscount Cranborne, and succeeded his grandfather in 1668. K.G. 1680. He married c.1665 Lady Margaret Manners, 3rd daughter of John, 8th Earl of Rutland. She died in 1682. There is no portrait called her at Hatfield House

Sir Godfrey Kneller (1646 or 9–1723)

Canvas 93½ × 58½ in. (237·5 × 148·6 cm.)

Whole length standing turned to the right, looking at the spectator; with his left hand he touches his plumed hat on a cloth-covered table to the right; he wears a long dark brown wig and robes of a Knight of the Garter.

In the 1681 Privy Purse accounts at Hatfield (Estate Papers Accounts 131/8) are the following payments: 'Mr Kneller for drawing his Honour's picture £35, carved gilt frame to the picture £11', and 'To Mr Leesage for a carved gilt frame to his Honour's picture £11'. The portrait was given as by Lely in Brayley's list, 1808, in the 1823 inventory when it was in the Winter Dining Room, and in the 1845 catalogue, No. 126. In 1891 it was catalogued as by Wissing.

On an engraving by J. Brown in Drummond's *Histories of Noble British Families*, 1846, the painter is given as Wissing.

134

Called **James Cecil, 3rd Earl of Salisbury, K.G.** (1646–1683), 1681

See No. 132

David Loggan (c.1635–1692)

Plumbago on vellum 5 × 4¼ in. (12·7 × 10·8 cm.) oval sight

Head and shoulders to the right, looking at the spectator; the sitter wears a long wig, lace cravat and loose gown. He appears to be about 30 years of age. The picture is signed and dated low on the right 'DL/1681'.

Bought at Christie's sale of November 16, 1962, Lot 6, among 'Different Properties'. It was catalogued as the 3rd Earl of Salisbury. Under the entry is 'Collection George Yardley'. The features agree well with the Earl's in No. 133, but there is no sign of the ribbon of the Garter which

almost rules out the possibility that it was rightly named for the Earl was made a K.G. in 1680. There is no indication in the sale catalogue of the grounds for the identification.

135 [98]

Called the **Hon. Robert Cecil** (1667 or later–1715/16), c.1700

Robert Cecil was the second son of James, 3rd Earl of Salisbury. He married Elizabeth, daughter and heiress of Isaac Meynel of Langley Meynell, Derbyshire, and relict of William Hale of King's Walden, Hertfordshire. He left a son, Charles (d. 1737), Bishop of Bristol, 1732–1734, and of Bangor, 1734–1737, and a daughter, Margaret (1692–1782) who married Sir Robert Brown, Bart. The 2nd Earl of Egmont, in his diary, January 24, 1736/7 noted that he was 'commonly called fat Cecil'

Painter unknown

Canvas 49½ × 39½ in. (125·7 × 100·3 cm.)

Three-quarter length, seated to the right, looking at the spectator, wearing a large brown wig, loosely tied neckcloth, brown coat and drapery over his right arm, aged about forty. Inscribed in capitals in the lower left corner: 'ROBERT, BROTHER TO THE FOURTH EARL OF SALISBURY BY RILEY'.

The wig and neck cloth are of c.1700 or soon after, which rules out Riley (d. 1691) as the painter. It may be by Thomas Murray (1663–1735) who had worked in Riley's Studio.

A portrait of this Robert Cecil is listed in Musgrave's list of 1769 as being in the Gallery. Only one portrait of him is mentioned in the 1845 catalogue, No. 112. It is given as by Riley. There are now four called by his name.

It is not possible at present to identify with certainty the paintings, Nos 134–141, which may all represent brothers of the 4th Earl of Salisbury: William (d. 1691), Robert, Charles,

and George. Miniature No. 401 should be rightly named Robert for it belonged to, and was inscribed with his name by Horace Walpole who knew his daughter.

136 [11]

Called the **Hon. Robert Cecil** (1667 or later–1715/16), c.1690–95

See No. 135

Painter unknown

Canvas 30 × 25 in. (76·2 × 63·5 cm.)

Head and shoulders to the left, looking at the spectator. The sitter is wearing a brown wig and a lace neck cloth; the background is brown drapery. The style of wig and neck cloth are near 1690–95.

This portrait is not in the Hatfield 1891 catalogue and it has not been found in any earlier list.

A tablet on the frame names the sitter as the Hon. Robert Cecil and gives the artist as Dahl.

137 ill. 108, p. 268

Called the **Hon. Robert Cecil** (1667 or later–1715/16), 1689

See No. 135

Charles Beale the Younger (1660–1694)

Canvas 30 × 25 in. (76·2 × 63·5 cm.)

The head and shoulders are in profile to the left; the head three-quarters to the left; the sitter looks at the spectator, he wears a long brown wig, lace cravat and brown drapery. This work is painted in an oval and signed at the bottom in the centre: 'Carolus Beale fecit 1689'.

This is not in the 1891 catalogue, and it cannot be identified with certainty in any earlier catalogue or inventory. It or No. 136 may be the

portrait called Charles, brother of the 4th Earl of Salisbury by G. Kneller, No. 27 in the 1845 manuscript catalogue.

138 [99]

Called the **Hon. Robert Cecil** (1667 or later–1715/16)

See No. 135

Attributed to Sir Godfrey Kneller (1648–1723)

Canvas 29 × 24 in. (73·7 × 61 cm.) oval

Head and shoulders turned to the left looking at the spectator. The sitter has brown eyes, and is wearing a full dark wig and armour, with the ends of his plain white neck cloth tucked into the top of his armour. Inscribed in capital letters in the bottom left-hand corner of the picture is 'ROBERT CECIL/BROTHER TO THE/FOURTH EARL/ KNELLER'. The sitter's age is about 30 and the style of wig and neck cloth near 1700.

This portrait was catalogued in 1845, No. 51, as by Kneller and in 1891 as by Michael Dahl. From the style Kneller is the more likely artist.

139 [97] ill. 109, p. 268

Called the **Hon. William Cecil** (1673–1691)

The Hon. William Cecil was the third son of the 3rd Earl of Salisbury. He died in France, unmarried, after a quarrel with his brother Charles, in which both were badly hurt

William Wissing (1656–1687)

Canvas 48 × 39 in. (122 × 99 cm.) sight

Three-quarter length, standing, turned to the left looking at the spectator. The sitter has dark brown eyes, and is wearing a dark brown full wig, lace cravat and breast armour, with red drapery. The picture is signed just below his hand on the left: 'W. Wissing fecit' and a label at the back reads: 'Wm. Cecil, brother to the fourth Earl of Salisbury, by W. Wissing'.

The first known record of this portrait is in the 1845 catalogue, No. 103, as the Hon. William Cecil by Wissing. Wissing died when William Cecil was 14. It is not impossible that the sitter is so youthful but the wig and neck cloth are of a style in fashion *c.*1680 or earlier. The portrait bears great resemblance in features to the miniature No. 401 by Arland of his elder brother, Robert.

140 [105]

Called the **Hon. William Cecil** (1673–1691)

See No. 139

Painter unknown

Canvas $48\frac{1}{4}$ × $38\frac{3}{4}$ in. (122·6 × 98·4 cm.) sight

Three-quarter length, standing, fronting the spectator; the sitter wears a brown wig, a Roman cuirass and thigh pieces and a red cloak; there is a park in the background.

141

A Brother of the 4th Earl of Salisbury (?), *c.*1700/5

Painter unknown, School of Sir Godfrey Kneller (1646–1723)

Canvas 95 × 59 in. (241·3 × 148·9 cm.)

Whole-length standing, turned slightly to the left looking at the spectator. The sitter is wearing a long dark wig, a blue gold-embroidered coat with pink drapery round him and a gold-embroidered sword belt.

The portrait is given in the 1845 catalogue, No. 102, as the Hon. William Cecil by Kneller. This is the first known record of it. The portrait may be dated from the style of wig and costume

as *c.*1700–10 and may represent one of the other brothers of the 4th Earl.

142 [102] ill. 110, p. 268

Called **Lady Frances (Cecil), wife of Sir William Halford (or Holford)** (*c.*1668–1698)

Lady Frances was the second daughter of the 3rd, Earl of Salisbury. She married Sir William Halford (or Holford) 1st Bart., of Welham, Leicestershire, and had issue.

Attributed to William Wissing (1656–1687)

Canvas 48¼ × 39½ in. (122·6 × 100·3 cm.) right

Three-quarter length, seated, with face turned to the right looking at the spectator. She has dark brown hair, dressed in ringlets, and grey-blue eyes and wears a low-cut loose brown dress and on her lap is the corner of a blue curtain with wide brown fringe, drawn from behind. She is plucking a flower from a single peony plant in a pot low on the right with her left hand.

This portrait and another called Lady Halford [101] burnt at Cranborne in 1945. They were Nos 104 and 143 in the 1845 catalogue. No portrait is included under Lady Frances Cecil's name in the 1823 inventory or in earlier lists post 1680.

143 [102a]

Called **Lady Frances (Cecil), wife of Sir William Halford (or Holford)** (*c.*1668–1698)

A copy of No. 142

144 [126] ill. 111, p. 269

Lady Margaret (Cecil), Countess of Ranelagh (1672–1727/8)

Lady Margaret was the third daughter of James, 3rd Earl of Salisbury. She married in 1691, the 2nd Lord Stawel (d. 1692) and in 1695/6, Richard, 1st Earl of Ranelagh (d. 1711). She had no children

Sir Godfrey Kneller (1646 or 9–1723)

Canvas 92 × 57 in. (233 × 144·8 cm.)

A whole-length portrait. Lady Ranelagh stands, slightly to the right her head turned and looking three-quarters to the left. She has dark brown hair with a tress down her back; she wears a green low-cut dress with blue and red shot-silk drapery over her left shoulder, falling to the ground on the left. Sky and trees are seen to the right. She is aged about twenty with a hair style of the 1690's.

The first record found of this portrait is in a short list Horace Walpole made on his visit in 1761. It is also in Musgrave's 1769 list where it is said to hang in the Gallery. There were two portraits called Lady Ranelagh in the Hatfield 1823 inventory; both were catalogued as by Kneller, one hung in the King James Room, the other in the Winter Dining Room. It is No. 56 in the 1845 catalogue. Her portrait is in the series of Hampton Court Beauties by Sir Godfrey Kneller.

145 [108] ill. 112, p. 269

James Cecil, 4th Earl of Salisbury (1666–1694) 1687 or shortly before over an earlier portrait of **James, Duke of Monmouth** (1649–1685)

James Cecil was son of the 3rd Earl and succeeded his father in 1683. He was converted to the Roman faith in 1688. He married Frances Bennet, a wealthy heiress, in 1683 and died in 1694

William Wissing (1656–1687)

Canvas 89 × 54 in. (226 × 136·2 cm.)

Whole-length, standing turned to the right, his head is three-quarters to the right and he looks at the spectator, wearing a full brown wig, a blue robe and white hose. He points to an Earl's coronet on a red-covered table to the right. The portrait was painted over one of the Duke of Monmouth. The overpaint was partially removed

in 1840 revealing Monmouth's head and shoulders (of a type painted by Wissing) on the left, wearing a brown wig and black armour. There are pillars on the left and sky to the right. Inscribed at the bottom: 'The Duke of Monmouth by Wissing' and 'Fourth Earl of Salisbury, painted by Dahl'.

This portrait must be one of the portraits referred to in the following record in 1687 of a payment to Wissing (Estate Papers, Accounts 138/5): 'To Will Wissing fo; 2 Originall pictures of the Earle and Countesses & for two coppies of the Earles 60/–/–.' and 'Paide to John Norvis for 2 frames for the Earle and Countess' pictures 7/10/–'.

The portrait is in Musgrave's list of 1769 as by Kneller. In 1823 it was listed in the Winter Dining Room and given to Dahl. It is No. 111 in the 1845 manuscript catalogue, given to Wissing. In 1891 it was again catalogued as by Dahl.

The portrait of Monmouth is similar to one in the Clarendon collection for which see *Descriptive Catalogue of the collection of Portraits at The Grove*, No. 65, p. 374 of Vol. 3, of *Lives of the Friends and Contemporaries of Lord Chancellor Clarendon* by Lady Theresa Lewes, 3 Vols, 1852.

Why Wissing painted his portrait of the Earl of Salisbury over a portrait he had painted of the Duke of Monmouth is not known. It could have been at Lord Salisbury's wish. It is more likely that he had Monmouth's portrait on his hands after Monmouth's execution and painted over it to save the expense of purchasing canvas.

No. 149 is probably the portrait of Lady Salisbury mentioned in the payment to Wissing.

The 4th Earl of Salisbury's first cousin, the 5th Earl of Exeter, was a patron of Wissing and Wissing died at his house.

146

James Cecil, 4th Earl of Salisbury (1666–1694)
See No. 145

William Wissing (1656–1687)

Canvas 28½ × 23¼ in. (72·4 × 59 cm.)

Head and shoulders in profile to the right, head three-quarters to right looking at the spectator. The sitter has brown eyes and wears a brown wig and an embroidered brown coat over which is blue drapery. There are painted corner spandrels.

The portrait is very similar to the head and shoulders of No. 145 and may be Wissing's original painting for which the Earl sat. It is not in the 1891 catalogue but is No. 22 in that of 1845. It is not traceable in earlier lists.

147 [140] Colour Plate XIII, opp. p. 176

James, Cecil, 4th Earl of Salisbury (1666–1694) and his eldest sister, **Lady Catherine (Cecil), Lady Downing** (c.1663–1688), c.1668/9
See No. 145

Lady Catherine married Sir George Downing, Bart. in 1683

Michael Wright (1617(?)–1700)

Canvas 62¾ × 51 in. (159·9 × 129·5 cm.)

Whole-lengths, the boy, aged about two, is sitting on a low upholstered chair with a carved footstool holding a toy horse on wheels on his knees. His sister stands on the left offering him a large apple in her left hand with some flowers grasped upside down in her right hand. The boy has brown hair and eyes, and he wears a pale blue plumed head-dress and white frock. His sister has dark hair and brown eyes and wears a pale blue dress. She is older than her brother.

This must be the portrait listed in the Hatfield 1679/80 inventory: '1 Picture of Lord Cranborne and Lady Katherine in one frame' as hanging in the Parlour. No mention of it has been found from then till 1845 when it was catalogued, No. 97, as the 6th Earl and his sister Ann by Hudson.

The painting can be dated as fairly close to 1668/9. The detail is typical of that in the finer paintings by Michael Wright.

Exhibition: as by John Michael Wright in *The Age of Charles II*, Royal Academy, 1960/61, No. 64.

148 [118] ill. 113, p. 270

Frances (Bennet), Countess of Salisbury (d. 1713), 1695

Frances (Bennet) married the 4th Earl of Salisbury, in 1683. She was the third daughter and co-heiress of Simon Bennet, of Beckhampton, Buckinghamshire. After the death of her husband she travelled much on the Continent

Sir Godfrey Kneller (1646 or 9–1723)

Canvas 47 × 37½ in. (119·4 × 95·2 cm.) sight

Three-quarter length, seated, slightly to the right, her head turned and looking slightly down to the left. The sitter has greying brown hair and is wearing black with a widow's black veil over the back of her head.

The painting is signed and dated about a foot from the bottom right-hand corner: 'G. Kneller/ 1695'.

The first record found of the portrait at Hatfield is in Musgrave's 1769 list 'Css of Salisbury in weeds'. In 1823 it was in the Breakfast Parlour; No. 13 in the 1845 catalogue.

Engraved in mezzotint by John Smith about the time it was painted.

149 [96] ill. 114, p. 270

Frances (Bennet), Countess of Salisbury (?) (d. 1713), c.1686
See No. 148

William Wissing (?) (1656–1687)

Canvas 94 × 59 in. (238·8 × 149·9 cm.)

A girl of about 20, whole-length, advancing slightly to the right, her head slightly to the left, looking at the spectator, she wears a decolleté brown gown with blue drapery over her right arm around her back and across her legs. The head and shoulders of a carved lion spouting water is seen above a sill to the right; parkland behind.

The portrait was catalogued in 1845 (No. 114) and in 1891 as representing Lady Mildred (Cecil), Lady Corbet, by Sir G. Kneller. Lady Mildred, fifth and youngest daughter of the 3rd Earl of Salisbury, married Sir Uvedale Corbet, 3rd Bart. in 1693. He died in 1701. Secondly she married Sir Charles Hotham, 4th Bart. (d. 1722/3). There is no record in any earlier Hatfield lists or inventories of any portrait of her. It is probably one of the two portraits called Lady Ranelagh by Kneller in the 1823 inventory. There is a fairly close resemblance in features to the engraved portrait of the 4th Countess of Salisbury No. 148 and this may be the portrait of the Countess for which a payment to Wissing was recorded in 1687, see under the 4th Earl No. 145.

150 [129] ill. 115, p. 270

James Cecil, 5th Earl of Salisbury (1691–1728), 1695

James Cecil was the son of James Cecil, 4th Earl of Salisbury whom he succeeded in 1694. He married Lady Anne Tufton (See No. 156) in 1709

Sir Godfrey Kneller (1646 or 9–1723)

Canvas 49 × 39 in. (124·5 × 99 cm.)

Whole-length of a small boy standing, fronting the spectator, in a purple classical tunic and blue cloak. On the left is a plumed helmet on a pedestal on the front of which is carved a shield bearing the Cecil arms. The painting is signed on the pedestal: 'G. Kneller ft. 1695'.

In Musgrave's 1769 list portraits of the 5th

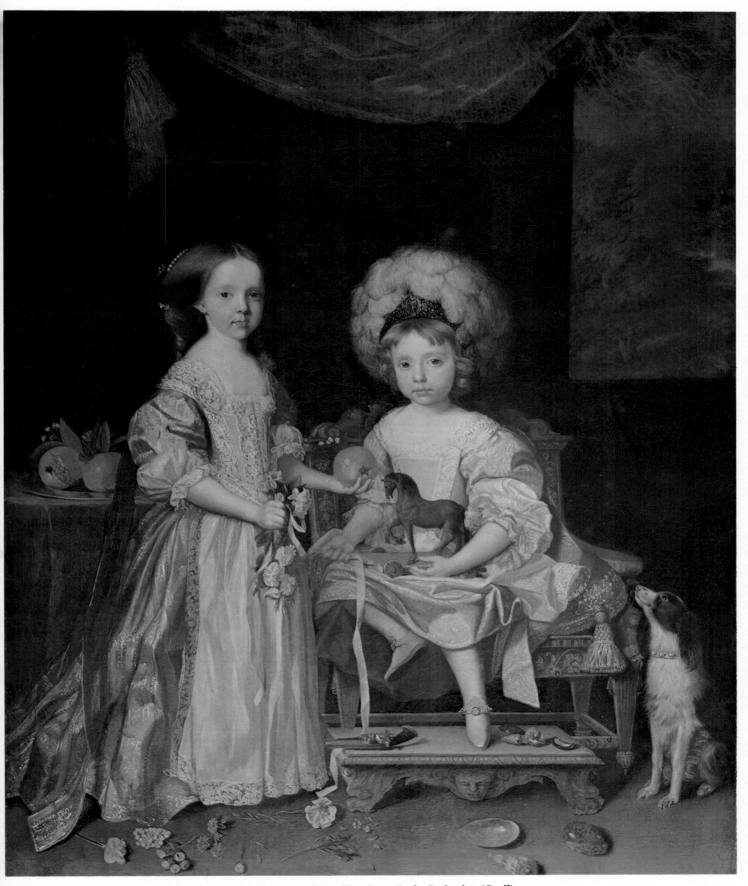

COLOUR PLATE XIII. **James Cecil, 4th Earl of Salisbury and his elder sister, Lady Catherine (Cecil), Lady Downing,** 1668/9, by Michael Wright (Cat. No. 147, p. 175)

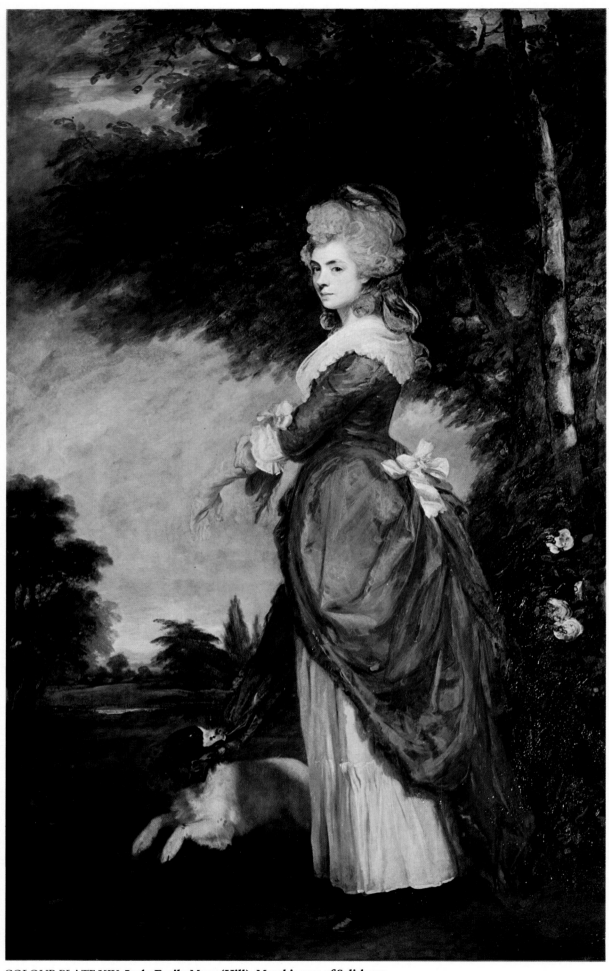

COLOUR PLATE XIV. **Lady Emily Mary (Hill), Marchioness of Salisbury,**
1780 or later, by Sir Joshua Reynolds (Cat. No. 168, p. 182)

Earl at the ages of two and five are recorded in the Waiting Room. No portrait at two years of age has survived, but Musgrave added against the other 'with helmet and plume wh. len. by Kneller'. It was in the Winter Dining Room when the 1823 inventory was made. In the 1845 manuscript catalogue, No. 98, the date 1695 is given.

This painting was engraved in mezzotint by John Smith at about the time it was painted.

151

James Cecil, 5th Earl of Salisbury (1691–1728), 1699

See No. 150

Sir Godfrey Kneller (1646 or 9–1723)

Canvas 29¾ × 25 in. (75·6 × 63·5 cm.) oval

Head and shoulders, slightly to the right; his head is turned and he looks three-quarters to the left. He has long fair hair and brown eyes and wears an open shirt and scarlet drapery over his blue coat.

This must be a portrait paid for on December 15, 1699. The receipt is at Hatfield in Family Papers, Bills 391:

'Lord Salisbury's picture in oval £16. 0. 0
and a copy of the same £ 8. 0. 0
to which a burnisht gilt frame £ 2. 0. 0

in all £26. 0. 0

This receipt is signed by Byng on Kneller's behalf.

This is likely to be the portrait in Musgrave's 1769 list called 'Wᵐ D. of Gloucester son to 2 Anne', when it hung in the Gallery. It is not traceable in the 1823 inventory. In the 1845 catalogue, No. 49, it is given as the 5th Earl when young, by Kneller.

152 [130] ill. 116, p. 271

James Cecil, 5th Earl of Salisbury (1691–

1728), c.1703

See No. 150

Attributed to Charles Jervas (1675?–1739)

Canvas 49 × 39¾ in. (124·5 × 101 cm.) sight

Three-quarter length standing fronting the spectator; his head is turned slightly to the left, he looks at the spectator. The sitter is wearing a fair wig or his own dressed hair, a loosely tied neck cloth, a green coat unbuttoned to the waist and drapery over his right arm and around his back; he holds one end of this to his waist with his left-hand; he caresses a white dog sitting in profile to the right on a low pedestal on the left. There is a high colonnade in the background to the left. The painting is inscribed in capitals in the lower right corner: 'JAMES FIFTH EARL/OF SALISBURY/BY KNELLER'.

This portrait is listed in the 'Lady's Dressing Room' in Musgrave's 1769 list: 'Jas late Ld Wᵗʰ a Greyhound', to which he added: 'about 14 or 15 yrs old by Kneller'. In the 1823 inventory it is given in the Winter Dining Room as 'Young Gentleman and Dog' by Kneller. It is not traceable in the 1845 manuscript catalogue.

Charles Jervas has been suggested as the artist and it bears similarity to his work. It was probably painted c.1703 when the Earl was 12 years old.

153 [107] ill. 117, p. 271

James Cecil, 5th Earl of Salisbury (1691–1728), 1705–7

See No. 150

William Sonmans (died 1709)

Canvas 49 × 39½ in. (124·5 × 100·3 cm.)

Three-quarter length, head to the right, looking at spectator. The sitter is of youthful appearance with brown eyes. He wears a dark brown wig,

a gold-embroidered blue coat, over which is a sleeveless gold-embroidered gown, and he holds a college cap with a gold tassell in his left hand.

On the back of the picture is a label which reads 'James, 4th Earl of Salisbury, painted in his University dress by W. Souyiens'. Inscribed in capitals in the lower left hand corner of the picture is 'JAMES FOURTH EARL OF SALISBURY PAINTED BY W. SOUYIENS'.

The costume and hair-style are of *c.*1705/10, so the portrait cannot represent the 4th Earl as labelled, and as catalogued in 1845 No. 48, and in 1891. There is no known artist of the name Souyiens as formerly catalogued. At Hatfield is the record of a payment in 1709 made to Mrs 'Sonman' 'for the Earl's head and canvas. £5.7.6.' Family Accounts 80/14. William Sonmans died that year so the payment is presumably for a portrait painted by him shortly before his death.

The 5th Earl of Salisbury entered Christ Church, Oxford, in 1705. The M.A. degree was conferred on him on March 27, 1707. The apparent age of the sitter in this portrait accords with the 5th Earl's age at that time.

I54 [127] ill. 118, p. 272

James Cecil, 5th Earl of Salisbury (1691–1728)

See No. 150

Michael Dahl (1656–1743)

Canvas 89½ × 55 in. (227·3 × 139·7 cm.)

A whole-length portrait. Lord Salisbury is standing, fronting the spectator, his head turned and looking three-quarters to the left. He is wearing a powdered shoulder-length wig, blue coat and gold-embroidered flowered waistcoat. A greyhound on the right, tail to the spectator, looks up at him. There is a column to the left. Lord Salisbury appears to be about 35 years old. The painting is inscribed in capitals in the lower left-hand corner 'FIFTH/EARL OF SALISBURY/PAINTED BY DAHL'.

This is in Musgrave's 1769 list where it is recorded as the late Earl with a greyhound, hanging in the Lady's Dressing Room. No artist is named. In the 1845 catalogue, No. 61, the painting is ascribed to Dahl.

Recorded in *Michael Dahl* by W. Nisser, 1927 on p. 39.

I55 [128] ill. 119, p. 272

James Cecil, 5th Earl of Salisbury (1691–1728)

See No. 150

Michael Dahl (1656–1743)

Canvas 30 × 25 in. (76·2 × 63·5 cm.)

The Earl's head and shoulders only. He has brown eyes and wears a powdered wig, blue coat and gold and blue waistcoat. The portrait has painted corner spandrels.

The painting is somewhat similar to the head and shoulders of No. 154 It is inscribed in the top left-hand corner 'James the Vth/Earl of Salisbury' and in the top right-hand corner 'The Original/Picture by Dhall'.

This portrait is not mentioned in Hatfield lists before the 1845 manuscript catalogue, where it is No. 10. It is not mentioned in *Micheal Dahl* by W. Nisser, 1927. When painting No. 154 Dahl probably took the head from this portrait.

I56 [137] ill. 120, p. 272

Lady Anne (Tufton), Countess of Salisbury (1693–1757)

Lady Anne Tufton was the second daughter of the 6th Earl of Thanet. She married the 5th Earl of Salisbury in 1708/9

Charles Jervas (?) (1675(?)–1739)

Canvas 89 × 55 in. (226 × 140 cm.)

Whole length standing slightly to the left; she has turned her head three-quarters to the right

and looks at the spectator; she has dark brown hair and black eyes. The sitter wears coronation robes, and holds her coronet in her right hand. The North transept of Westminster Abbey is seen to the left. The painting is inscribed in capitals in the lower left corner: 'ANN/FIFTH/ COUNTESS OF SALISBURY/PAINTED BY DAHL'.

The Countess looks quite young. The portrait must have been painted soon after the coronation of King George I. No. 157 was used for the head. No mention of the portrait has been found prior to the 1845 manuscript Hatfield catalogue, No. 60, in which it is given as by Dahl.

157 [138] ill. 121, p. 272

Lady Anne (Tufton), Countess of Salisbury (1693–1757)

See No. 156

Charles Jervas (?) (1675(?)–1739)

Canvas 30 × 25 in. (76·2 × 63·5 cm.)

To the waist, fronting spectator, she has turned her head three-quarters to the right, and looks at the spectator. She has nearly black hair and brown eyes and wears a low-cut dress crossed over in front. The Cecil arms are painted in the top left corner.

This is very similar to part of the three-quarter length portrait believed to be by Jervas at Holkham, in the possession of the Earl of Leicester, a collateral descendant of Lady Anne's sister, Lady Margaret, Countess of Leicester. No mention of it has been found at Hatfield prior to the 1845 catalogue, No. 14, in which the artist is named as Dahl. As the Countess looks very young this may well have been painted from life at the time of her marriage in 1708/9, and the head used for No. 156, painted a few years later, as well as for the Holkham portrait.

158

Called **Lady Anne (Tufton), Countess of Salisbury** (1693–1757), *c.*1740–50

See No. 156

Artist unknown

Pastel 23¼ × 17 in. (59 × 43·2 cm.) enlarged to 26 × 19¼ in. (66 × 48·9 cm.) sight

Head and shoulders, turning slightly to the right, looking to the spectator's right. She has black hair bound with blue ribbon, and wears a pearl necklace and a white dress; the background is pale blue. The hair style is of *c.*1740–50.

This portrait is not in the 1891 catalogue nor has it been found in any earlier catalogue or list under any name. From comparison with other portraits of the Countess it appears to be rightly named. It got into a bad state and was restored at which time its size may have been increased. The costume has been redrawn and now has an early nineteenth century appearance.

159 [134]

The Hon. William Cecil (1714 or later–1740), *c.*1740

William Cecil was the younger son of the 5th Earl of Salisbury. He died unmarried at Montpelier on May 3, 1740 and is buried at Hatfield. His doctor's bill is at Hatfield (Accounts 94/2)

John Vanderbank (1694(?)–1739)

Canvas 49½ × 40 in. (125·7 × 101·6 cm.)

Three-quarter length standing to the right looking at the spectator. The sitter wears a short wig, neck cloth and shirt frill, a brown coat and green embroidered waistcoat; he wears a glove on his left hand; a column is seen to the left and sky and trees to the right.

The painting is inscribed in the lower right

corner: 'The Hon/William Cecil Younger Son of James/Earl of Salisbury by his Wife the Lady/Anne Tufton 2d Daughter of Thomas/Earl of Thanet'.

The sitter is aged about twenty and wears a costume of near 1740. The first record of the portrait is in the 1845 catalogue, No. 110, where it is stated to be by Vanderbank.

160 [133] ill. 122, p. 273

A daughter of the 5th Earl (?), c.1740
Thomas Hudson (1701–1779)

Canvas 42 × 39 in. (106·7 × 99 cm.)

Three-quarter length standing fronting the spectator; her head is turned three-quarters to the left and she looks at the spectator. She has dark hair and wears a white dress decorated with blue ribbon. The painting is inscribed in capitals in the lower left corner: 'LADY MARY/CECIL/BY/HUDSON'.

No mention of this portrait is to be found before 1845, No. 115 in catalogue, which gives it as Lady Mary Cecil by Hudson. In the 1891 catalogue it is called Lady Mary Forester (c.1670–1740), third daughter of the 3rd Earl of Salisbury by Hudson.

The portrait represents a young woman wearing a costume and hair style of near 1740. From her age she could be one of the three daughters of the 5th Earl of Salisbury. Musgrave in an addition of post 1780 to his 1769 list of Hatfield portraits mentions: 'Ladies Ann Cath and Margt Cecil, sisters of the late Earl'. It is not clear whether this referred to a group or three separate portraits.

161 [141a] ill. 123, p. 274

James Cecil, 6th Earl of Salisbury (1713–1780), 1733

James Cecil was the son of the 5th Earl of Salisbury, *whom he succeeded in 1728. He married Elizabeth Keet (No. 164) in 1744/5. They had two daughters who died unmarried and an only son who succeeded him*

Rosalba Carriera (1675–1757)
Chalk 22½ × 17¾ in. (57·1 × 35·1 cm.)

Head and shoulders slightly to the left his head slightly to the right looking at the spectator; he wears a short powdered wig, and an Earl's ermine and scarlet robe over a flowered vest.

This must have been drawn by Rosalba Carriera when the Earl was in Venice in July, 1733. (Family Accounts 89/11)

In the 1734 Hatfield accounts there is a record of a payment to: 'Mr Swymmer of Venice for 44 sequins' he had paid Rosalba for two pictures the Earl bought when abroad in July 1733.

In the 1823 inventory this is listed in the Marchioness's Summer Red Room. It is omitted from the 1845 catalogue. No. 162 is based on this portrait.

162 [141]

James Cecil, 6th Earl of Salisbury (1713–1780)

Painter unknown

Canvas 50 × 40 in. (127 × 101·6 cm.)

Three-quarter length standing slightly to the left, he turns his head slightly to the right and looks at the spectator. He wears a powdered neck-length wig and Earl's coronation robes with his coronet on the table to the left. The canvas has not been lined and was probably painted in the early nineteenth century.

The head is based on the pastel by Rosalba Carriera, No. 161, which was the only portrait of the 6th Earl mentioned in the Hatfield lists before 1845.

In the 1845 manuscript catalogue this portrait is listed, No. 140, as by Vanderbank.

163 [103] ill. 124, p. 274

Elizabeth (Keet), Countess of Salisbury (?)
*c.*1721–1776), 1774

Elizabeth Keet was the daughter of Edward Keet of Canterbury and sister of the Rev. John Keet, Rector of Hatfield. She married the 6th Earl of Salisbury in 1744/5

Benjamin van der Gucht (d. 1794)

Canvas 30 × 25 in. (76·2 × 63·5 cm.)

Head and shoulders to the left, looking at the spectator; her eyes are grey, a light blue feather decorates her hair. She wears a blue-grey dress, an ermine cloak(?) is over her right shoulder, which she touches with her left hand. There are painted spandrels in the corners. The work is signed in the top right corner: 'B. van d'Gucht px 1774 (the last figure is not clear).

The portrait is listed as of an unknown lady in the 1891 catalogue. From her age it is possible that Elizabeth (Keet), Countess of Salisbury is represented. No portrait of her is recorded. It was painted too late to be included in Musgrave's 1769 list. It is not traceable in the 1823 inventory and the 1845 catalogue.

The portrait was cleaned in 1965 when the artist's signature was found.

164

James Cecil, 7th Earl and 1st Marquess of Salisbury (?) (1748–1823)

See No. 165

Artist unknown

Pastel on paper 23¼ × 18 in. (59 × 45·7 cm.)

Head and shoulders turned to the right, looking at the spectator. He has brown hair and blue eyes and wears a pale blue unbuttoned coat with a turnover silvery collar, narrow lace turnover shirt collar and silver-coloured waistcoat.

Bought by the 4th Marquess of Salisbury in 1918 from Alexander Reid, the Glasgow picture dealer, as a portrait of the 6th Earl of Salisbury by Joseph Highmore, 1729. From the hair-style and costume the portrait appears to be of the 1760s and might be too late for the 7th Earl. Why it was so named and attributed is not known. The portrait was said to have come from Agnew who had had it for some time (see letters dated October 24 and November 25, 1918 from Thomas Fraser Campbell at Hatfield House).

165 [152] ill. 125, p. 275

James Cecil, 7th Earl and 1st Marquess of Salisbury, K.G. (1748–1823), 1781–83 or a little later

James Cecil the only son of the 6th Earl whom he succeeded in 1780 held the position of Lord Chamberlain of the Household from 1783 to 1804. He was created Marquess in 1789 and a Knight of the Garter in 1793. He married Lady Emily Mary Hill (No. 168), in 1773. He was Member of Parliament for Hertford from 1817 to 1820

George Romney (1734–1802)

Canvas 93 × 57 in. (236·2 × 144·8 cm.)

A whole-length portrait; Lord Salisbury is standing in profile to the left, his head three-quarters to left looking at the spectator; he holds his white staff, emblem of his office of Lord Chamberlain. His white flowered waistcoat and scarlet breeches are seen under his Earl's coronation robes. There are columns and a balustrade in the background. The portrait is inscribed in capitals: 'JAMES FIRST MARQUESS OF SALISBURY PAINTED BY ROMNEY'.

The portrait is in the 1823 inventory and No. 107 in the 1845 catalogue.

In *George Romney*, by H. Ward and W. Roberts, 1904, Vol. I, p. 139 sittings by Lord Salisbury to Romney are recorded on the following days:

1781, April 2, 9, June 4–10, July 4, 8, 12, December 13; 1782, March 20, 26, April 4, 13, May 14; 1792, March 25, 28, April 25. He paid Romney £89.5.0 in August 1785. As in the portrait he holds a white staff as Chamberlain of the Household. This was presumably added at the 1792 sittings.

166

James Cecil, 7th Earl and 1st Marquess of Salisbury, K.G. (1748–1823)

See No. 165

Painter unknown

Canvas 20½ × 14 in. (52·1 × 35·6 cm.) sight

Three-quarter length, Lord Salisbury is standing turned full three-quarters to the left, his white staff of office is in his right hand; he has powdered hair with a curl over his ears, and wears a blue coat with upright collar and silver lacing, and a light embroidered waistcoat.

The costume is of the early 1790's and as Lord Salisbury was created a K.G. in 1793 and he does not wear any insignia of the Garter, this portrait must have been painted shortly before that date.

Miss Dorinda Evans has kindly given the information that the Massachusetts Historical Society possesses a letter from Mather Brown to his Aunts in Boston, Massachusetts, July 25, 1791, in which he wrote that he had shown his portrait of the Marquess of Salisbury to the Queen. This could be the portrait.

The portrait is not included in the 1891 catalogue. It may be the portrait of the 1st Marquess recorded in the 1871 inventory, p. 69, as in the Walnut and Oak Bedroom. The artist is not named.

167 [153] ill. 126, p. 275

James Cecil, 7th Earl and 1st Marquess of Salisbury, K.G. (1748–1823), 1803

See No. 165

Sir William Beechey (1753–1839)

Canvas 93 × 57½ in. (236·2 × 146 cm.)

Whole-length; he has turned to the left and is looking at the spectator; he wears Garter robes; his plumed hat is on a yellow covered table to the left. His white Lord Chamberlain's staff is in his right hand.

This portrait was exhibited at the Royal Academy in 1805, No. 171. It was engraved in mezzotint by William Say (1768–1834); on the print the date of the painting is given as 1803. It is included in the Hatfield 1823 inventory and is No. 65 in the 1845 catalogue. It was cleaned in 1965.

In the Hatfield Family and Estate Papers Box U/74/81 is a letter of 1820 from Sir William Beechey to Lord Salisbury stating his terms and saying that he was free to give as many sittings as convenient to him. It does not appear, however that another portrait of him was painted by Beechey.

Exhibition: The National Portrait Exhibition, 1867, No. 859.

Literature: *Sir William Beechey* by W. Roberts, 1907, p. 86.

168 [155] Colour Plate XIV, opp. p. 177

Lady Emily Mary (Hill), Marchioness of Salisbury (1750–1835), 1780 and later

Lady Emily Mary Hill was the elder of the two surviving daughters of Wills Hill, 1st Marquess of Downshire, No. 236. She married the 1st Marquess of Salisbury in 1773. She lost her life in the fire at Hatfield House in 1835

Sir Joshua Reynolds (1723–1792)

Canvas 94 × 57½ in. (239 × 146 cm.)

A whole-length portrait. Lady Salisbury is

walking to the left in a park, her head is three-quarters to the left and she is looking at the spectator whilst drawing on her left glove. She has powdered hair and wears a brown dress looped up and displaying a white skirt; a spaniel on the left pulls at her dress.

Exhibited at the Royal Academy in 1781, No. 241; Horace Walpole noted it as 'good' in his catalogue. Sittings by Lady Salisbury are recorded in Reynolds's sitter books in 1780, November 24 and December 1; 1781, January, 23, 26, 29, February, 3, 12, 28, and March, 31; and again on May 25 and 27, 1787. Reynolds recorded payment for it in his ledger: 'Dec 24, 1781 Lady Salisbury 200. 0. 0.'. (Walpole Society Vol. XLII, 1970, p. 164.) The portrait was engraved in mezzotint by Valentine Green. There was later presumably some dissatisfaction with the hair as first painted and the sittings in May 1787 were for an alteration to be made by Reynolds. The mezzotint shows the portrait before the alteration.

The portrait is included in the 1823 inventory and is No. 66 in the 1845 catalogue.

Exhibited at the National Portrait Exhibition, 1867, No. 617.

Literature: W. Cotton, *Sir Joshua Reynolds and his Works* 1856, p. 158; C. R. Leslie and T. Taylor, *Life and Times of Sir Joshua Reynolds*, 1865, Vol. IV, p. 326; C. Phillips, *Sir Joshua Reynolds*, 1894, p. 296. A. Graves and W. V. Cronin, *History of the Works of Sir Joshua Reynolds*, 1899–1901, Vol. III, p. 864. The Connoisseur, Vol. I, 1901, pp. 103–4, for a note by Algernon Graves about the alteration; *Reynolds*, by E. K. Waterhouse, 1941, p. 72.

169

Lady Emily Anne Bennet Elizabeth (Cecil), Marchioness of Westmeath (1789–1858)

Lady Emily Cecil was the second daughter of the 1st Marquess of Salisbury. She married the 8th Earl and Marquess of Westmeath in 1812.

Painter unknown

Canvas 30 × 25 in. (76·2 × 63·5 cm.) oblong in an oval mount sight

Head and shoulders, three-quarters to the right, looking slightly to the spectator's right; she has dark brown hair parted in the centre and blue eyes; she wears a dark blue décolleté dress; the background is dark brown.

170 [164]

James Brownlow William Gascoyne-Cecil, 2nd Marquess of Salisbury, K.G. (1791–1868), 1818 or 19

James Brownlow William Gascoyne-Cecil succeeded his father in 1823. He assumed the additional name Gascoyne on his marriage to Frances, daughter and co-heiress of Bamber Gascoyne. He was made a Knight of the Garter in 1842. He was Member of Parliament for Weymouth from 1813 to 1817 and for Hertford from 1817 to 1823

Robert Trewick Bone (1790–1840)

Canvas 36 × 28 in. (91·4 × 71·1 cm.)

A half-length portrait three-quarters to the left. Lord Salisbury has blue eyes and dark brown hair, and is wearing a dark grey unbuttoned coat, a white shirt with 'Byron' collar and a pink vest. The head of a dog in profile to the right is seen in the lower left corner.

This is not in the 1845 manuscript catalogue; it or another portrait of the Marquess by Robert Bone was offered for sale to him by H. Rodd in 1854 and was not bought.

The portrait is reproduced in *The Gascoyne Heiress*, by Carola Oman, 1968, opp. p. 49.

R. T. Bone exhibited a portrait of Lord Cranborne at the Royal Academy in 1819, No. 60.

171 [163] ill. 127, p. 275

James Brownlow William Gascoyne-Cecil, 2nd Marquess of Salisbury, K.G. (1791–1868), 1844

See No. 170

John Lucas (1807–1874)

Canvas 92½ × 57½ in. (254 × 146 cm.)

Whole-length standing, fronting the spectator, his head is turned and he looks three-quarters to the left. He has black hair and side whiskers, his head is balding. He wears Garter robes and is touching his plumed hat which rests on a table to the left. His sheathed sword is in his right hand; there is a dark brown curtain in the background and a window to the left.

In the correspondence files of the 2nd Marquess of Salisbury at Hatfield House is a letter of December 13, 1843, from Lord Mahon enclosing a letter from John Lucas stating his charges, etc., and a letter from John Lucas dated September 28, 1844, stating that he will return the Garter robes the following week and that 'the picture will be finished on Monday'.

The portrait is not mentioned in the 1845 catalogue from which all portraits of living members of the family were omitted.

Literature: John Lucas, by Arthur Lucas, 1910, p. 47, Pl. XXXVII.

172 [158] ill. 128, p. 275

Frances Mary (Gascoyne), Marchioness of Salisbury (1802–1839), 1828 or 9

Frances Mary Gascoyne was the daughter and heiress of Bamber Gascoyne Jun., No. 249. She married the 2nd Marquess of Salisbury in 1821.

Sir Thomas Lawrence (1769–1830)

Canvas 94 × 56 in. (238·8 × 142·2 cm.)

A whole-length portrait; Lady Salisbury is standing, fronting the spectator, resting her right arm on a high pedestal to the left, over which is draped her peeress's robe, a red curtain of the same colour is suspended from above. She has black hair dressed in ringlets, and wears a white dress under a black sleeveless mantle. The background is sky with a distant landscape to the right.

The portrait was exhibited at the Royal Academy in 1829, No. 193, and engraved in line by W. Ensom for the *Literary Souvenir*, 1831. It is No. 70 in the 1945 Hatfield Catalogue.

Literature: Sir Thomas Lawrence, by Lord Ronald Sutherland Gower, 1900, p. 157. *Lawrence* by Sir Walter Armstrong, 1913, p. 161. *Sir Thomas Lawrence*, by K. J. Garlick, 1954, p. 56, *Walpole Society*, vol. 39, 1964, a catalogue of Lawrence's work by Kenneth Garlick, p. 172.

173

Frances Mary (Gascoyne), Marchioness of Salisbury (1802–1839), 1829

See No. 271

Miss C. H. Burton (fl. 1829)

Charcoal on paper 29¾ × 24½ in. (75·6 × 62·2 cm.) sight

Head and shoulders fronting the spectator; her head is turned and she looks three-quarters to the left. Her dark curly hair is parted in the centre, she has bare shoulders with drapery fastened over her right shoulder and a broad jewelled gold bracelet on her right upper arm. The drawing is signed to the right on a level with her shoulder: 'C. Burton fecit/1829'. The paper on which it is drawn has turned from white or near white to brown. At the back of the frame is a tie-on label inscribed in ink: 'Miss C. H. Burton/14'.

The portrait is reproduced in *The Gascoyne Heiress*, by Carola Oman, 1968, opp. p. 68.

174 [166] ill. 129, p. 276

Lady Mary Catherine (Sackville-West), Marchioness of Salisbury and later Countess of Derby (1824–1900), 1850

Lady Mary was the second daughter of the 5th Earl De La Warr. She married the 2nd Marquess of Salisbury in 1847 as his second wife. They had three sons and two daughters. In 1870 she married Edward Stanley, 15th Earl of Derby (1826–1893)

James Rannie Swinton (1816–1888)

Canvas 50 × 40 in. (127 × 99 cm.)

A three-quarter length portrait, the Marchioness is seated fronting the spectator, her head is turned and she looks a little to the left. She has dark hair and wears a white dress and a very dark shawl over her shoulder. The painting is inscribed on the back of the stretcher: 'Mary Catherine, Marchioness of Salisbury/painted by J. R. Swinton/April 1860'.

In the correspondence files of the 2nd Marquess of Salisbury, at Hatfield, is a letter undated but believed to be of 1850, asking for payment for Lady Salisbury's portrait. A portrait of her by Swinton was exhibited at the Royal Academy in 1850, No. 187. A portrait somewhat similar to that at Hatfield but head and shoulders only was reproduced as frontispiece to *A Great Lady's Friendship*, by Lady Burghclere, 1933. It then belonged to Captain Arthur William James Cecil, her grandson.

175

Lady Mary Catherine (Sackville-West), Marchioness of Salisbury and later Countess of Derby (1824–1900)

See No. 174

Artist unknown

Chalk and sanguine 19¼ × 15¾ in. (48·9 × 40 cm.)

A head and shoulders portrait, she has turned three-quarters to the right and looks in that direction.

The paper on which this work is drawn has become somewhat brown with age.

176

Lady Mary Catherine (Sackville-West), Marchioness of Salisbury and later Countess of Derby (1824–1900)

See No. 174

Painter unknown

Canvas 31 × 26 in. (78·7 × 66 cm.) sight

Half-length, seated, to the right, her head is turned three-quarters to the left and she looks in that direction; she has an open book in her hands; she wears a grey dress with white collar and cuffs and a gold cross on her dress close to her collar. The portrait is signed in red with an artists' monogram near the lower left corner.

This was given to Lord Salisbury by the late Angela Cecil, great grand-daughter of the sitter.

177

Lady Mildred Arabella Charlotte Gascoyne-Cecil, later **Lady Mildred Beresford-Hope** (1822–1881) and her sister **Lady Blanche Mary Harriett Gascoyne-Cecil,** later **Lady Blanche Balfour** (1825–1872), *c*.1825

The eldest two daughters of the 2nd Marquess of Salisbury. Lady Mildred married the Rt. Hon. Alexander James Beresford-Hope in 1842. Lady Blanche married James Maitland Balfour of Whittinghame in 1843 and was the mother of the Prime Minister, Earl Balfour of Whittinghame.

The Hon. Olivia Cecilia de Ros (later Countess Cowley) (1807 or 8–1885)

Watercolour on paper 6⅝ × 6½ in. (16·9 × 16·5 cm.) sight

Whole-lengths, ages about 3 and 2. The elder in blue in profile to the right draws a wheel-barrow, the younger in white is turned slightly to the left; both have curly hair. The artist's name is written in ink on a label at the back.

178 [161]

James Emilius William Evelyn Gascoyne-Cecil, Viscount Cranborne (1821–1865), 1850

The eldest son of the 2nd Marquess of Salisbury. He was afflicted with blindness. Though so handicapped by ill health he became a writer of some repute who contributed to the Quarterly Review; he was also a notable bibliophile adding some of the most important volumes to the Hatfield House Library. He died in his father's lifetime. He did not marry

Reuben Sayers (1815–1888)

Canvas 50 × 40 in. (127 × 101·6 cm.)

A three-quarter length portrait, Lord Cranborne is seated to the right resting his left arm on a table; an open book is on his knees. He has fair hair; his eyes are half shut; he wears a black coat. Inscribed on the back of the canvas is: 'The Rt. Hon^ble Viscount Cranborne/Reuben Sayers Pinxit/1 St Peter's Square/Hammersmith/1850'.

179

James Emilius William Evelyn Gascoyne-Cecil, Viscount Cranborne (1821–1865)

See No. 178

Reuben Sayers (1815–1888)

Canvas 30 × 25 in. (76·2 × 63·5 cm.)

Head and shoulders, similar to the head and shoulders of No. 178. Inscribed in ink on a label on the back of the frame is 'Viscount Cranborne e.s. of the 2nd Marquess of Salisbury b.1822

d.1865. Painted by Reuben Sayers. This picture formerly hung in King James's room at Hatfield was given to Edmund Charles Johnson by Mary second wife of the 2nd Marquess of Salisbury. The picture now at Hatfield is a replica'. Printed at the bottom of this label is 'The Property of Stuart Johnson 4 Eaton Place, SW1'.

The portrait was given to the 5th Marquess of Salisbury by Lord Rockley.

Owing to Lord Cranborne's affliction he needed a constant companion. E. C. Johnson served him in that capacity.

180 [162] ill. 130, p. 276

James Emilius William Evelyn Gascoyne-Cecil, Viscount Cranborne (1821–1865), 1850

See No. 178

Reuben Sayers (1815–1888)

Canvas 36 × 28 in. (91·4 × 71·1 cm.)

A half-length portrait; he has turned slightly to the right, and looks down three-quarters to the left; he has fair hair and hazel eyes. The sitter wears a black coat, cream coloured vest and a black bow tie. The painting is signed in the lower right corner: 'Reuben Sayers/pinxit/1850'.

At the National Portrait Gallery are records of one and possibly two other portraits of Lord Cranborne by Reuben Sayers in addition to those at Hatfield.

181 ill. 131, p. 277

Robert Arthur Talbot Gascoyne-Cecil, 3rd Marquess of Salisbury, K.G. (1830–1903), 1861

Third son of the 2nd Marquess and Frances Mary (Gascoyne) he succeeded his father in 1868. He was made a Knight of the Garter in 1878. He was Prime Minister three times between 1885 and 1902 and was Chancellor of the University of Oxford from 1869.

George Richmond (1809–1896)

Black and white sanguine chalk 23 × 17 in. (58·4 × 43·2 cm.)

The head, nearly in profile to the right. The drawing is signed in the lower right corner, 'Geo Richmond'.

This drawing by George Richmond was made in 1861 and was engraved in stipple by William Holl for the Grillions Club series of portraits. The Marchioness of Salisbury bought it from Richmond in December, 1868.

Reproduced as frontispiece to *Robert, Marquess of Salisbury* by Lady Gwendolen Cecil, 1921, Vol. I.

182 [167] ill. 132, p. 277

Robert Arthur Talbot Gascoyne-Cecil, 3rd Marquess of Salisbury, K.G. (1830–1903), 1870/2

See No. 181

George Richmond (1809–1896)

Canvas 93 × 57 in. (236·2 × 144·8 cm.)

A whole-length portrait, Lord Salisbury is standing, fronting the spectator; he has hazel eyes and black hair and a beard. He wears the black and gold robes of Chancellor of the University of Oxford. There is a crimson upholstered chair to the left and a table covered with a patterned dark green cloth to the right.

The National Portrait Gallery has a photo-copy of the record that George Richmond kept of receipts. In this he recorded receiving £210 in 1871 as first payment for a whole-length in Chancellor's robes; £420 in 1872 for a portrait for All Souls College, Oxford; and a final payment of £420 in 1872 for the whole-length in robes for Hatfield House. The two portraits cost £1050 in all. He received £250 in 1887 for the portrait for Lady Salisbury's jubilee present

to the Queen; for this Richmond was presented to the Queen at Hatfield House.

The Hatfield House portrait was exhibited at the Royal Academy in 1873, No. 290; and at the Palace of Art, Wembley Exhibition, 1925, reproduced on p. 104 of the catalogue. The portrait was also reproduced in *William Cecil, Lord Burghley*, edited by Dr F. P. Barnard, 1904, p. 104.

Two copies of this were made by Dorofield Hardy for the 4th Marquess who presented one made in 1909 to the Carlton Club; the other was made in 1927.

183 [168]

Robert Arthur Talbot Gascoyne-Cecil, 3rd Marquess of Salisbury, K.G. (1830–1903), 1878

See No. 181

Anton von Werner (1843–1915)

Canvas 25 × 20½ in. (63·5 × 52·1 cm.)

The head and shoulders; the sitter fronts the spectator but looks down slightly to the right. He has dark brown hair and beard and wears a black coat. The background is dark brown. The painting is signed and dated half way up on the right: 'A. V. W./July/1878'.

A study for the head in the picture of the Berlin Congress, 1878, that was painted for Wilhelm I, the German Emperor.

Reproduced in *Salisbury*, by A. L. Kennedy, 1953, opp. p. 124.

184

Robert Arthur Talbot Gascoyne-Cecil, 3rd Marquess of Salisbury, K.G. (1830–1903), 1886

See No. 181

Horsburgh (fl. 1886)

Canvas $49\frac{1}{2} \times 39\frac{1}{4}$ in. ($125\cdot7 \times 99\cdot7$ cm.) sight

Three-quarter length seated turned to the right. looking at the spectator, he has dark greying, hair and beard, he wears a black suit; his right hand is on an octavo book on his knee, his left hand is on a sill to the right, above which are seen the Houses of Parliament and Westminster Bridge. The painting is signed near the lower left corner 'HORSBURGH/PINXT 1886'.

This was not included in the Hatfield House 1891 catalogue. The artist's name is not to be found in dictionaries of artists.

185

Robert Arthur Talbot Gascoyne-Cecil, 3rd Marquess of Salisbury, K.G. (1830–1903), 1887

See No. 181

Emily Barnard (fl. 1887)

Pencil on off-white paper $17\frac{3}{4} \times 13$ in. ($45\cdot1 \times 33\cdot1$ cm.) sight

Head and half shoulder slightly to the left, looking at the spectator, he wears the Garter ribbon under his coat; vignetted; signed below in the centre: 'Salisbury', and signed below this by the artist: 'by Emily Barnard/1887'.

186

Robert Arthur Talbot Gascoyne-Cecil, 3rd Marquess of Salisbury, K.G. (1830–1903), 1889

See No. 181

Violet, Duchess of Rutland (1856–1937)

Pencil on paper $13\frac{1}{4} \times 9\frac{1}{4}$ in. ($33\cdot7 \times 23\cdot5$cm.) sight

Head and half shoulders in profile to the left signed with the artist's monogram initials 'V.G.' (when Marchioness of Granby), and dated 1889.

Exhibited at the third exhibition of the Society of Portrait Painters, 1893, Cat. No. 150F. Reproduced in *Portraits of Men and Women*, by the Marchioness of Granby, N.D., p. 3.

187

Robert Arthur Talbot Gascoyne-Cecil, 3rd Marquess of Salisbury, K.G. (1830–1903)

See No. 181

Painter unknown

Canvas 12×9 in. ($30\cdot5 \times 22\cdot9$ cm.)

Head and shoulders turned slightly to the left, but looking at the spectator; he is balding, with grey hair. He has hazel eyes and wears a black cravat, coat and waistcoat. The background is dark.

188 ill. 133, p. 278

Robert Arthur Talbot Gascoyne-Cecil, 3rd Marquess of Salisbury, K.G. (1830–1903), 1910

See No. 181

E. Fuchs (1856–1929)

Soft pencil on paper $12\frac{3}{4} \times 9$ in. ($32\cdot4 \times 22\cdot9$ cm.)

A half-length, the sitter is seated in profile to the right, writing at a table. The drawing is signed low towards the right: 'Salisbury/Dec. 13, 1901' and signed by the artist at the bottom near the left: 'E. Fuchs/1901'.

189

The 3rd Marquess of Salisbury figuring in five drawings by Sir John Tenniel (1820–1914) for cartoons in Punch

a The Ministerial Mess

Pencil 6⅛ × 8 in. (15·6 × 20·3 cm.)

Signed with monogram and dated 1876.
Inscribed on label at the back 'The Ministerial Mess. (The first Course before Easter.) Benjamin "Really its not really as bad as they say! I rather like it!" *Punch*, April 29, 1876'

b The Awkward Squad

Pencil 6⅛ × 8 in. (15·6 × 20·3 cm.)

Signed with monogram and dated 1877. Inscribed on label on back; 'The Awkward Squad. Sergeant "On your Eastern question Right about turn!" Company Officer (aside) "Oh they always were slow at their facings!" Sergeant to himself "Must get in a round somehow". *Punch*, February 24, 1877.'

c The Start

Pencil 8 × 6⅛in. (20·3 × 15·6 cm.)

Signed with monogram and dated 1886. Inscribed at the back; 'The Start, Great race between the G.O.M. and "The Markiss". *Punch*, July 3, 1886.'

d Little Mephistopheles

Pencil 6⅛ × 8 in. (15·6 × 20·3 cm.)

Signed with monogram and dated, 1886. Inscribed at the back: 'Little Mephistopheles. "That's the sole danger, *Our* true bond and tether. Is this; Drink steadily, and all together!" *Punch*, November 6, 1886'

e Salisbury Sisyphus ill. 134, p. 278

Pencil 6⅛ × 8 in. (15·6 × 20·3 cm.)

Signed with monogram and dated 1887. Inscribed at back: 'Salisbury Sisyphus Unending Task! The sullen slow ascent, the swift rebound, *Punch*, April 9, 1887.'

These five drawings were purchased from Mr Bernard Halliday of Leicester in 1936.

190 [170] Colour Plate XV, opp. p. 192

Georgina Caroline (Alderson), Marchioness of Salisbury (*c.*1827–1899) with her eldest son, later **4th Marquess of Salisbury** (1861–1941), 1873–7

Georgina Caroline was the eldest daughter of Sir Edward Hall Alderson, Baron of the Court of Exchequer. She married the 3rd Marquess of Salisbury in 1857

George Richmond (1809–1896)

Canvas 93 × 57 in. (236·2 × 144·8 cm.)

Whole-lengths, pausing in a walk to the left in a park landscape; Lady Salisbury holds her son's right hand and rests her right hand on a sundial (?). She has auburn hair and wears a black hair ribbon, a black dress and a white blouse. Her costume is derived from the 'Rubens' costume in which many women were painted in the mid eighteenth century with a high waistline of 1873. Her son has light brown hair and wears a buff smock with crimson cuffs, a blue ribbon stretches across his breast from his right shoulder.

The painting was exhibited at the Royal Academy in 1877, No. 951.

191

Georgina Caroline (Alderson), Marchioness of Salisbury (*c.*1827–1899)

See No. 190

George Richmond (1809–1896)

Black, white and sanguine chalk on paper 25½ × 18 in. (64·8 × 45·7 cm.)

Head and shoulders, turned slightly to the left, looking at the spectator, vignetted. The drawing

is signed and dated in pencil in the lower left corner 'Geo. Richmond, R.A./1873 Tuesday ...' (the rest hidden by the frame).

Either No. 191, 192 or 193 was acquired from the artist by Lady Salisbury in 1882 to give to Lord Cranborne. See the artist's letter to her dated October 6, 1882, at Hatfield.

One of these three drawings was given December 22, 1919 to the 4th Marquess by Lady Frances Balfour (see her letter of that date at Hatfield). She had it from 'the widow of old Richmond's brother, a good Scot'.

192

Georgina Caroline (Alderson), Marchioness of Salisbury (c.1827–1899)

See No. 190

George Richmond (1809–1896)

Pencil and white chalk on paper 10 × 8¼ in. (25·4 × 21 cm.)

Two studies, each is of her face only, fronting the spectator.

193

Georgina Caroline (Alderson), Marchioness of Salisbury (c.1827–1899)

See No. 190

George Richmond (1809–1896)

Pencil and white chalk on paper 13 × 9 in. (33 × 22·9 cm.) sight

Inscribed in pencil at the bottom: 'Study for portrait of Lady Salisbury by George Richmond 18.'

194

Georgina Caroline (Alderson), Marchioness of Salisbury (c.1827–1899)

See No. 190

Painter unknown

Sepia on paper 13⅜ × 10⅝ in. (34 × 27 cm.)

Head only, vignetted, turned to the right, Lady Salisbury is looking at the spectator. Her hair falls to her neck and is parted in the centre. Her name is typed on a label on the back, but the artist is not named.

195 [171]

Georgina Caroline (Alderson), Marchioness of Salisbury (c.1827–1899) with her brother, **Pakenham** (d. 1876) and her sister, **Louisa,** 1839–40

See No. 190

Henry Perronet Briggs (1793–1844)

Canvas 57¾ × 46 in. (146·7 × 117·9 cm.)

Three children. The future Lady Salisbury is seated on a brown pony; her brother is holding its bridle; her sister only is seen behind them, looking at the spectator. Lady Salisbury has long fair curls and wears a black hat and dress; her brother has fair hair and wears a maroon velvet suit her sister is dressed in grey.

Exhibited at the Royal Academy in 1840, No. 18.

196 ill. 135, p. 279

Lord Edgar Algernon Robert Gascoyne-Cecil, Viscount Cecil of Chelwood (1864–1958), 1919

Lord Edgar Algernon Robert was the third son of the 3rd Marquess of Salisbury. He married in 1889 Lady Eleanor Lambton daughter of the 2nd Earl of Durham. He held various offices in the Government, was Chancellor of the University of Birmingham, 1918–44 and President of the League of Nations Union,

1923–1945. He was created Viscount Cecil of Chelwood in 1923

Augustus John (1878–1961)

Canvas 31½ × 23½ in. (80 × 59·7 cm.)

Head and shoulders, turned and looking three-quarters to the left; he has pale brown eyes; he wears a soft black felt hat, a stiff linen wing collar; his coat is only indicated; the background is pale brown. A label of the Chenil Gallery, Chelsea, is attached to the stretching frame. On this is a typed note stating that if not sold the painting was to be returned there.

This sketch in oils was done in one sitting at a time when Lord Cecil was attending a League of Nations Conference, in 1919. Another sitting could not be arranged.

The portrait was acquired from the artist's family after his death.

197 ill. 136, p. 279

Lord Edgar Algernon Robert Gascoyne-Cecil, Viscount Cecil of Chelwood (1864–1958), 1932

See No. 196

Philip Alexius de László (1869–1937)

Canvas 30 × 23¾ in. (76·2 × 60·3 cm.)

Head and shoulders full three-quarters to the left, balding, with grey hair; wearing a suit and tie, and his gown as Chancellor of the University of Birmingham. The painting is signed and dated near the lower right corner: 'de László/1932'.

The portrait was presented to Lord Cecil in 1932 by a body of friends and admirers, and he gave it to Lord Salisbury shortly before he died.

198 ill. 137, p. 279

Lord Hugh Richard Heathcote Gascoyne-Cecil, Baron Quickswood (1869–1956), 1920

Lord Hugh Richard was the fifth son of the 3rd Marquess of Salisbury. He represented Oxford University in Parliament, 1910–1937 and was Provost of Eton, 1936–1944. He was created Baron Quickswood in 1941

John Singer Sargent (1856–1925)

Charcoal on paper 24½ × 18¼ in. (60·2 × 46·4 cm.)

Head and shoulders, to the left, looking at the spectator; he is balding, he has a slight moustache, and wears a stiff upright wing collar, dark tie, coat and waistcoat. The drawing is vignetted and it is signed and dated actoss the bottom in large letters: 'John S. Sargent 1920'.

At Hatfield is a letter from Sargent, December 22, 1920 fixing a sitting for December 31, and another letter, January 14, 1921, thanking Lord Hugh for his cheque for £80.

199

'The Cecils Cross Over' – Lord Robert and Lord Hugh Cecil

See Nos 196 and 198

Sir Max Beerbohm (1872–1956)

Pencil and watercolour on paper 14 × 9½ in. (35·6 × 24·1 cm.) sight

Whole-lengths; Lord Robert and Lord Hugh Cecil are striding to the left, Lord Hugh is on the near side, Lord Robert is slightly behind him; their arms are linked. They appear to be stepping out of a frame within which the background is tinted blue. In the distance in the frame Lloyd-George is standing fronting the spectator, scowling and with folded arms. Beerbohm has inscribed near the bottom towards the right below the above-mentioned frame: 'The Cecils cross over'.

A study for the finished drawing now in the

Ashmolean Museum, Oxford, which is in reverse to this; the other has the following words issuing from Lloyd George's mouth: 'Let me have about me men that are fat, sleek-headed men and such as sleep o'nights.'

The occasion was in 1921 when Lord Robert and Lord Hugh broke with Lloyd George's Coalition Government on the Irish question and joined the opposition.

200

An Oxford Memory of 1890 – Lord Hugh Cecil and Henry Brodribb Irving (1870–1919), 1926

Irving was the elder son of Sir Henry Irving. He made his career on the stage after being called to the Bar

Sir Max Beerbohm (1872–1956)

Pencil and grey wash on paper 12 × 8 in. (30·5 × 20·3 cm.)

Whole-lengths, both are striding in profile to the left, Lord Hugh is on the far side of H.B. Irving and is much taller than Irving, he has turned his head to look at the spectator; he is wearing his undergraduate's gown; Irving carries his gown over his left arm. The full moon is seen near the top left corner. On the paper under the drawing Beerbohm has written: 'An Oxford Memory 1890/Lord Hugh Cecil and Mr H. B. Irving/walking away from the Union together (deeply impressive to a freshman's heart)'. Below this is his signature and the date: 'Max 1926'.

201

James Edward Hubert Gascoyne-Cecil, 4th Marquess of Salisbury, K.G. (1861–1947), c.1867

The eldest son of the 3rd Marquess, he succeeded his father in 1903. He married Lady Alice Gore in 1887. Lord Salisbury held several leading government offices in periods when the Conservatives were in power between 1900 and 1929

Artist unknown

Pencil on paper 18 × 14 in. (45·7 × 35·6 cm.)

His head only, when about six years old, nearly in profile to the left, looking down. The drawing is vignetted.

202

James Edward Hubert Gascoyne-Cecil, 4th Marquess of Salisbury, K.G. (1861–1947), 1873

See No. 201

George Richmond (1809–1896)

Black, white and sanguine chalk on paper 23½ × 17¾ in. (59·7 × 45·1 cm.)

Head only in profile to the left. The drawing is inscribed in pencil in the top right corner: 'July 24, 1873'. About six inches up on the left is a faint inscription in pencil, part of which reads: '8 inches full/56 full/7 heads high'.

Given by the artist to Lady Salisbury in 1882, see his letter dated October 6, 1882, in the Hatfield archives.

203 ill. 138, p. 280

James Edward Hubert Gascoyne-Cecil, 4th Marquess of Salisbury, K.G. (1861–1947), 1874

See No. 201

A. Bishop (fl. 1874)

Canvas 30½ × 25 in. (77·5 × 63·5 cm.)

Seated on a pony, three-quarters to the left, he

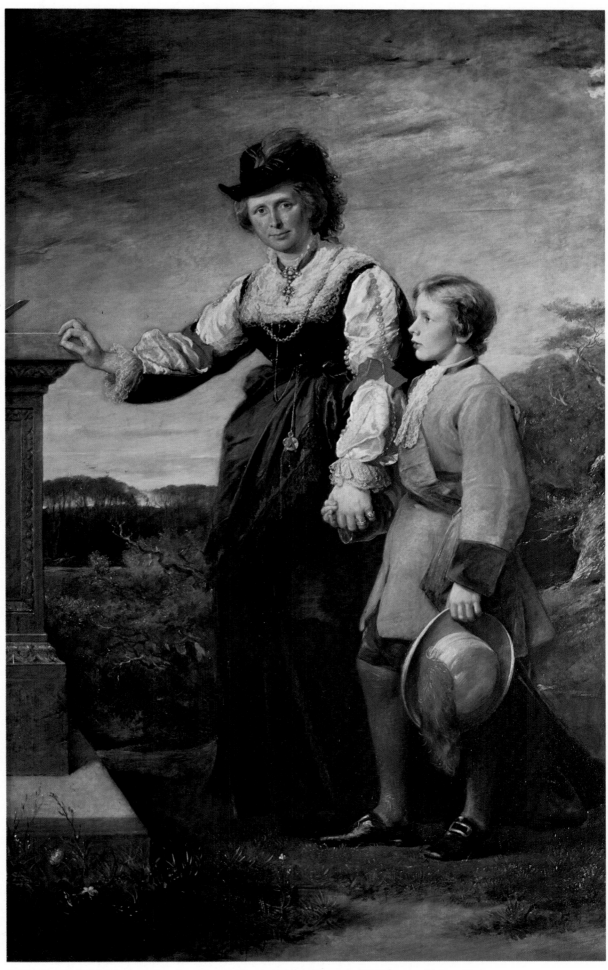

COLOUR PLATE XV. **Georgina Caroline (Alderson), Marchioness of Salisbury** with her eldest son,
later **4th Marquess of Salisbury,** 1873/7, by George Richmond (Cat. No. 190, p. 189)

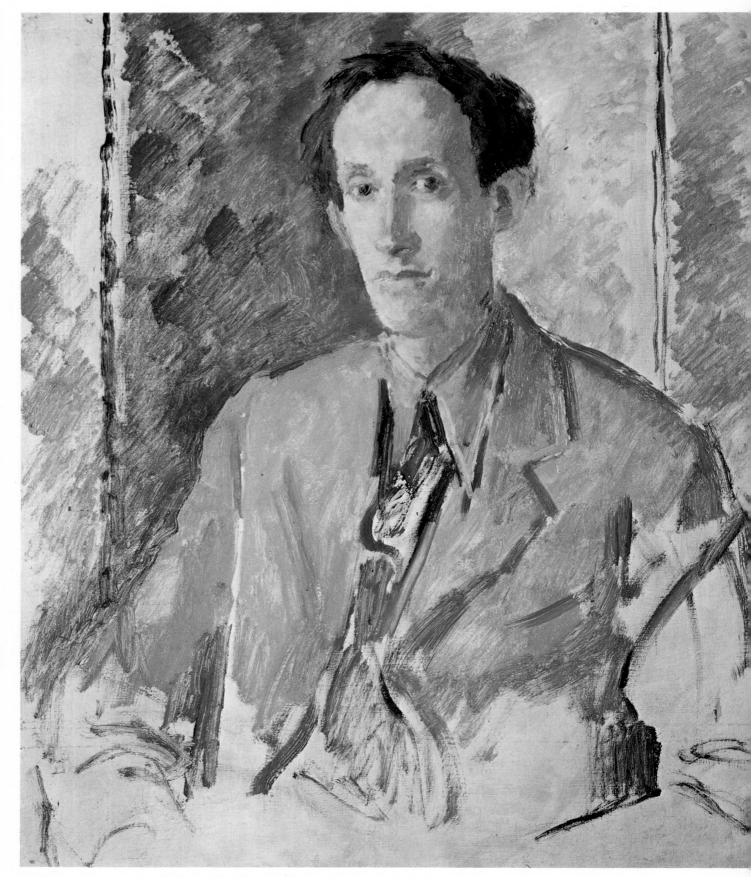

COLOUR PLATE XVI. **Lord Edward Christian David Gascoyne-Cecil, C.H., Litt. D.,** *c.*1943, by Augustus John (Cat. No. 212, p. 195)

looks at the spectator. His pony stands in the high inner arch of the West Porch of the Old Palace at Hatfield, then, and for many years previously a stable, also in a doorway to the right and a little further back a groom is standing holding the rein of a dark brown horse. The boy has auburn hair and blue eyes and wears a scarlet coat and biscuit-coloured vest and breeches; the groom wears a dark blue coat with silver buttons.

There is a small closed door up two steps on the left; this leads to the tower. The painting is signed in the lower left corner: 'A. Bishop 1874'.

204 [172]

James Edward Hubert Gascoyne-Cecil, 4th Marquess of Salisbury, K.G. (1861–1947), 1882

See No. 201

Sir William Blake Richmond (1842–1921)

Canvas 44 × 34 in. (111·8 × 86·3 cm.)

A three-quarter length portrait, Lord Cranborne (as he was then) is standing to the right, looking at the spectator, holding the hilt of his sword with his left hand, wearing the uniform of a lieutenant of the Hertfordshire Yeomanry Cavalry, a scarlet jacket with silver lacing, dark blue trousers with a red stripe down the side. A tapestry forms the background.

This picture was presented to Lord Cranborne by the Hertfordshire and Essex Tenantry on his attaining the age of 21, October 23, 1882.

A portrait of Lord Cranborne by Sir W. B. Richmond was exhibited at the Grosvenor Gallery Summer Exhibition, 1884, No. 205.

205

James Edward Hubert Gascoyne-Cecil, 4th Marquess of Salisbury, K.G. (1861–1947)

See No. 201

Sir Leslie Ward 'Spy' (1851–1922)

Watercolour on paper 18⅞ × 12 in. (47·9 × 30·5 cm.) sight

A whole-length standing full three-quarters to the left; he has brown hair and brown eyes; he wears a frock coat, wing collar, and black tie, a watch-chain is across his waistcoat.

The drawing is similar to Spy's drawings for *Vanity Fair*.

206 ill. 139, p. 281

James Edward Hubert Gascoyne-Cecil, 4th Marquess of Salisbury, K.G. (1861–1947), 1917

See No. 201

Glyn Warren Philpot (1884–1937)

Canvas 96 × 58¾ in. (243·8 × 146·7 cm.) sight

A whole-length portrait, Lord Salisbury is fronting the spectator, his head is turned and he looks three-quarters to the right; he wears a Marquess's parliamentary robes. The painting has a plain background and is signed and dated, 'Glyn Philpot 1917', near the lower left corner.

The sittings were given late in 1916 and early in 1917. The portrait was exhibited at the Royal Academy in 1917, No. 128, and reproduced in the 1917 *Royal Academy Illustrated*, p. 17.

207

James Edward Hubert Gascoyne-Cecil, 4th Marquess of Salisbury, K.G. (1861–1947), 1916 or 17

See No. 201

Glyn Warren Philpot (1884–1937)

Canvas 11 × 9⅜ in. (28 × 23·8 cm.) sight

Head only, turned and looking to the right,

brown hair, brown eyes. On the brown paper backing the artist has written in ink: 'Study for the portrait of/the Marquess of Salisbury/Painted AD 1917/Glyn Philpot'.

208

James Edward Hubert Gascoyne-Cecil, 4th Marquess of Salisbury, K.G. (1861–1947), 1916 or 17

See No. 201

Glyn Warren Philpot (1884–1937)

Canvas $23\frac{1}{2} \times 13\frac{1}{4}$ in. (59·7 × 33·7 cm.) sight

Whole-length sketch for the full-scale portrait.

209 ill. 140, p. 281

Cecils in Conclave, 1913

James Edward Hubert Gascoyne-Cecil, 4th Marquess of Salisbury, K.G. and his brothers Lord Robert Cecil, Viscount Cecil, and Lord Hugh Cecil, Lord Quickswood

Sir Max Beerbohm (1872–1956)

Black and white wash on pale blue paper 16 × $9\frac{7}{8}$ in. (40·6 × 25·1 cm.)

Lord Robert Cecil is on the left in profile to the right Lord Salisbury is in the centre, head three-quarters to the right, Lord Hugh Cecil is on the right, in profile to the left. Inscribed 'Cecils in Conclave' fairly low down on the right and signed: 'Max/1913'.

Exhibited at the Beerbohm Exhibition at the Leicester Galleries, London, May 1913, No. 38 and reproduced in *Fifty Caricatures*, by Max Beerbohm, 1913, plate 24.

210 ill. 141, p. 281

James Edward Hubert Gascoyne-Cecil, 4th Marquess of Salisbury, K.G. and his three Brothers, 1928

James Edward Hubert Gascoyne-Cecil, 4th Marquess of Salisbury (1861–1947). Lord Robert Ernest William Gascoyne-Cecil, Bishop of Exeter (1863–1936), Lord Edgar Algernon Robert Gascoyne-Cecil, Viscount Cecil of Chelwood (1864–1958) and Lord Hugh Richard Heathcote Gascoyne-Cecil, Baron Quickswood (1869–1956)

Frederick Hawksworth Sinclair Shepherd (c. 1877–1948)

Canvas 20 × 24 in. (50·8 × 61 cm.)

The four brothers are before the fireplace in the Van Dyck room at Hatfield. They are, from left to right of the spectator: Lord Quickswood, leaning on the Chesterfield settee, Lord Cecil of Chelwood seated on the arm of the Chesterfield, Lord Salisbury, standing in front of the fireplace and the Bishop of Exeter seated nearly in profile to the left in a round-backed chair on the right. The painting is signed, 'F. H. Shepherd', in the lower right corner.

On a label at the back the artist has written 'The original version of this picture was presented to University College, Oxford, by the Master, Sir Michael Sadler. F. H. Shepherd 25.8.28.'

This replica was commissioned by Lord Salisbury and was painted by the artist before he sent the original to the College.

211 ill. 142, p. 282

Lady Cicely Alice (Gore), Marchioness of Salisbury (1867–1955) and her younger son, **Lord Edward Christian David Gascoyne-Cecil** (b. 1902), 1908

Lady Cicely Alice Gore was the second daughter of Arthur Saunders William Fox Gore the 5th Earl of Arran. She married the 4th Marquess of Salisbury in 1887. They had two sons and two daughters. Lady Salisbury was Lady of the Bedchamber to Queen Alexandra.

Sir James Jebusa Shannon (1862–1923)

Canvas 93 × 56½ in. (236·2 × 143·5 cm.) sight

Whole-lengths, Lady Salisbury is seated three-quarters to the left, her head turned and looking slightly to the spectator's right, she rests her right hand on an open book in her lap; she has dark brown hair and wears a low-cut evening dress. She rests her left hand on the shoulder of Lord David Cecil who sits close to her on a stool to the spectator's right; he has fair hair and hazel eyes, and wears a brown satin suit with a white collar. A crimson curtain forms the background, the painting is signed 'J. J. Shannon/1908'.

212 Colour Plate XVI, opp. p. 193

Lord Edward Christian David Gascoyne-Cecil, C.H., Litt.D. (b. 1902), c.1943

Younger son of the 4th Marquess of Salisbury. Professor of English Literature at the University of Oxford from 1948 to 1969. Author of numerous biographies

Augustus John (1878–1961)

Canvas 30 × 25 in. (76·2 × 63·5 cm.)

Head and shoulders vignetted, slightly to the left looking at the spectator. He has dark brown hair and blue-grey eyes and wears a buff coat and plain dark tie. Sketchy background.

The portrait which is unfinished was begun in 1943 or 4. It remained in the artist's possession and was purchased by Lord Salisbury at the sale of some of the works of Augustus John, Christie's, July 20, 1962, Lot 170.

Another portrait of Lord David Cecil by Augustus John, painted seven or eight years earlier, is in the Tate Gallery.

213

Lord Edward Christian David Gascoyne-Cecil, C.H., Litt.D. (b. 1902), 1967

See No. 212

Cecil Beaton (b. 1904)

Canvas 24¾ × 14¾ in. (62·9 × 37·5 cm.) sight

Head and shoulders, three-quarters to the left, looking at the spectator wearing a yellow velvet cloak and wide Elizabethan ruff; the background is red.

The portrait is based on a photograph taken by Cecil Beaton in the mid 1930's. It was painted in 1967 when Lord David sat to him for two other portraits, one of which was No. 110 in the 1969 exhibition of the Royal Society of Portrait Painters. It was acquired from the artist.

214 ill. 143, p. 282

Robert Arthur James Gascoyne-Cecil, 5th Marquess of Salisbury, K.G. (b. 1893), 1914–19

Robert Arthur James Gascoyne-Cecil succeeded his father in the Marquessate in 1947 but was previously called to the house of Lords in 1941 as Baron Cecil of Essendon. He has held various high offices of State

Sir William Orpen (1878–1931)

Canvas 30½ × 25¼ in. (282 × 234 cm.) sight

Head and shoulders, seated to the left, his head is slightly to the left and he is looking at the spectator, his right hand is on his left arm; he has dark brown hair, hazel eyes, a slight moustache, grey coat, green tie; a blue curtain forms the background. The painting is signed in the top left corner: 'ORPEN'.

A tablet on the frame is inscribed 'Presented upon the occasion of his coming of age to Robert Arthur James Cecil Viscount Cranborne by his Hertfordshire friends and neighbours. Painted by William Orpen, R.A.'.

The portrait was commissioned in 1914 but was not completed till later.

In *Sir William Orpen* by P. G. Konody and S. Dark, 1934 p. 271, the portrait is given under 1919 in a chronological list of Orpen's works.

215

Robert Arthur James Gascoyne-Cecil, 5th Marquess of Salisbury, K.G. (b. 1893), 1915

See No. 214

John Singer Sargent (1856–1925)

Black chalk on paper $23\frac{1}{2} \times 18\frac{1}{2}$ in. ($59\cdot7 \times 47$ cm.) sight

Head, three-quarters to the left, looking slightly to the spectator's right; vignetted. Signed and dated along the bottom: 'John S. Sargent, 1915'.
This pairs with No. 220

216

Robert Arthur James Gascoyne-Cecil, 5th Marquess of Salisbury (b. 1893), 1915

See No. 214

John Singer Sargent (1856–1925)

Pencil on near white paper $7\frac{1}{8} \times 5\frac{5}{8}$ in. ($18\cdot1 \times 13\cdot4$ cm.)

Head, slightly to the left, looking at the spectator; vignetted. The drawing is signed and dated low down towards the right: 'J. S. Sargent 1915'.

217

Robert Arthur James Gascoyne-Cecil, 5th Marquess of Salisbury (b. 1893), 1950

See No. 214

Henry Lamb (1883–1960)

Black and sanguine chalk on paper $14 \times 9\frac{1}{4}$ in. ($35\cdot6 \times 23\cdot5$ cm.)

Head and half shoulders, vignetted, fronting spectator, head turned looking slightly to the spectator's right. Signed and dated: 'H. Lamb/50', low on the left.

218

Robert Arthur James Gascoyne-Cecil, 5th Marquess of Salisbury (b. 1893), 1967

See No. 214

Derek Hill (b. 1916)

Canvas 48×36 in. ($121\cdot9 \times 91\cdot4$ cm.)

Three-quarter length, standing slightly to the right, head turned and looking three-quarters to the right, wearing the collar of a Knight of the Order of the Garter and the collar of the Chancellor of the Order over Garter robes, brownish-red background.
Lord Salisbury gave the first sittings for this portrait at Hatfield during the week-end February 17–20, 1967. It was completed in the ensuing months.

219 ill. 144, p. 283

The 5th Marquess of Salisbury with his brother, **Lord David Cecil,** and his two sisters, **Beatrice Edith Mildred, Lady Harlech,** and **Mary Alice, Duchess of Devonshire,** 1951

Lady Harlech married the 4th Baron Harlech in 1913. The Duchess of Devonshire, married the 10th Duke of Devonshire in 1917

Edward Irvine Halliday (b. 1902)

Canvas 28×36 in. ($71\cdot1 \times 91\cdot4$ cm.)

Three-quarter length figures. Lord Salisbury in a dark suit is seated on the far side of a round table in the dining room at Swan Walk. His two sisters are seated on either side of the table, on which are coffee cups and finger bowls. Lord David

Cecil stands to the right against the fire-place, a coffee cup and saucer in his right hand and a cigarette in his left. Lady Harlech in a dark green dress is on the spectator's left and the Duchess of Devonshire in a yellow dress is in the centre of the painting. The painting is signed and dated in the lower right corner 'Edward I. Halliday 1951'.

Exhibited at the Royal Society of Portrait Painters Exhibition, 1951, No. 101, entitled: 'Conversation at Swan Walk'.

220

Elizabeth Vere Cavendish, Marchioness of Salisbury, 1915

Elizabeth Vere Cavendish was the eldest daughter of Lord Richard Frederick Cavendish. She married the 5th Marquess of Salisbury, when Lord Cranborne, in 1915

John Singer Sargent (1856–1925)

Black chalk on paper 23½ × 18½ in. (59·7 × 47 cm.) sight

Head and shoulders fronting the spectator; vignetted. Signed and dated along the top: 'John S. Sargent, 1915'.

This pairs with No. 215 a drawing of the 5th Marquess.

221 ill. 145, p. 238

Elizabeth Vere Cavendish, Marchioness of Salisbury, 1917

See No. 220

Ambrose McEvoy (1878–1927)

Canvas 40 × 30 in. (101·6 × 76·6 cm.)

Full half-length standing to left, head slightly to the right and looking to the spectator's right, wearing a pale blue dress with a pink waist-sash. The background is pale blue.

The portrait was finished in June 1917 and was

included in the National Portrait Society's Exhibition held in the autumn of 1917.

Reproduced in *The Works of Ambrose McEvoy,* 1919, Vol. I, plate 60. This was a privately printed work limited to sixteen copies.

222

The Hon. Michael Charles James Gascoyne-Cecil (1918–1934), 1920

The Hon. Michael Charles James was the second son of the 5th Marquess of Salisbury

Dora Noyes (fl. 1920)

Sepia and chalk on paper 10⅞ × 9¼ in. (26·4 × 23·5 cm.)

Head and half shoulders; vignetted. Signed low on the left: 'DN/1920'.

223

The Hon. Michael Charles James Gascoyne-Cecil (1918–1934), *c.*1930

See No. 222

Sir Thomas Monnington (b. 1902)

Sepia on paper 7¾ × 6½ in. (19·7 × 16·5 cm.) sight

Nine small heads, some very faint, on one piece of paper, drawn when about twelve years of age.

224

The Hon. Michael Charles James Gascoyne-Cecil (1918–1934)

See No. 222

Sir Thomas Monnington (b. 1902)

Sepia and pencil on paper 9¼ × 7in. (23·5 × 17·8 cm.) sight

Head and half-shoulders fronting the spectator, wearing a shirt open at the neck. He is about fifteen years of age. This was not drawn from life.

225

The Hon. Richard Hugh Vere Gascoyne-Cecil (1924–1944), 1942

The Hon. Richard Hugh Vere was the third son of the 5th Marquess of Salisbury. He served in the Royal Air Force in World War II. He died as the result of an accident

Henry Lamb (1883–1960)

Black and sanguine pencil on paper 13 × 10½ in. (33 × 26·7 cm.) sight

Head and half shoulders, three-quarters to the left. Signed and dated 'H. Lamb/Xmas 1942'.

226

The Hon. Richard Hugh Vere Gascoyne-Cecil (1924–1944)

See No. 225

Artist unknown

Pencil 7⅞ × 9¾ in. (20·1 × 24·8 cm.)

Head and half shoulders.

227

Robert Edward Peter Cecil Gascoyne-Cecil, Viscount Cranborne (b. 1916), 1931

Violet, Duchess of Rutland (1856–1937)

Pencil on paper 11¼ × 7⅝ in. (28·6 × 19·4 cm.) sight

Head in profile to the left; vignetted. Inscribed low on the right: 'Robert Cecil/Violet Rutland/ 1931'.

228 ill. 146, p. 283

Robert Edward Peter Cecil Gascoyne-Cecil, Viscount Cranborne (b. 1916), 1943

See No. 227

William Dring (b. 1904)

Gouache 18¾ × 12⅜ in. (47·6 × 31·4 cm.) sight

To the waist, three-quarters to the right, looking at the spectator; his arms are crossed in front of him; he wears a black soft cap and khaki uniform. The drawing is signed in the lower left corner: 'W. Dring 43'. At the time Lord Cranborne was a Lieutenant in the Grenadier Guards.

229 [72] ill. 147, p. 284

James Maxwell, Earl of Dirleton (before 1600–1650)

James Maxwell married before 1622 and died without male issue in 1650. His second daughter and co-heiress, Diana (No. 130) married Charles, Lord Cranborne (No. 128) in 1639

Painter unknown

Oil on canvas 50 × 40 in. (127 × 101·6 cm.)

Three-quarter length seated, turned to the left looking at the spectator. The sitter has white hair, hazel-brown eyes, a white moustache and short pointed beard. He wears a black coif, a black gown and a broad plain white collar.

This portrait and No. 230 [73] are almost undoubtedly mentioned in the inventory of the goods and chattels which belonged to Diana (Maxwell), Lady Cranborne (Family and Estate Papers Box A.14). The inventory was made on June 2, 1675, shortly after her death. The entry referring to them reads: 'two [portraits] of the Earl Dirltons one half the other less per Tisham £20'. The sizes would fit. Portraits roughly 50 × 40 in. (127 × 101·6 cm.) in size like No. 229 were called half-lengths till the early nineteenth cen-

tury, and No. 230 is smaller. A portrait of Lord Dirleton is recorded in the Parlour in the Hatfield inventory of 1679/80 and another in the Parlour at Salisbury House in 1685. In Mr Chauncy's bill of 1718 for cleaning and mending pictures at Hatfield he includes two portraits of 'Lord Macclesfield' one in the Great Parlour, half-length; and the other on the staircase. This suggests that Maxwell got corrupted to Macclesfield in the early eighteenth century. George Vertue, in his short list made in 1731 (Walpole Society Vertue, Vol. IV, p. 16) recorded the portrait as 'Ld James Maxwell ½ len a fine old head P'. The monogram stands for Sir Peter Lely. In Sir William Musgrave's list of 1769 two portraits are called Lord Macclesfield, one an old man, 'said to be by vDyck', and the other a head; but he added a pencil note suggesting that these may represent 'Jas. Ld Maxwell of Darlton'.

The identification as Charles Gerard, 1st Earl of Macclesfield (1618/9–1694) stuck for a considerable time and the portraits became known, the larger as an original van Dyck and the smaller as a copy by Kneller. The identification obviously would not hold and in Holland's 1891 Hatfield catalogue they were given a new name, Sir John Coke (1563–1644), with the statement that they bear a striking resemblance to the engraving by R. Dunkarton of a portrait of Coke earlier in life, and that Robert Cecil, the 2nd Earl of Salisbury and Sir John Coke were on friendly terms.

The portraits must have been painted very near the end of Lord Dirleton's life. The larger one might be an early work by Sir Peter Lely as suggested by Vertue. It is also possible that the portrait is by Peter Tyssens and that the compiler of the 1675 inventory spelt his name phonetically as 'Tisham'.

Exhibited as by van Dyck at the Royal Academy Old Masters Exhibition, 1870, No. 109. *Literature:* John Smith, *Catalogue Raisonné of Vandyck's works*, 1831, No. 615, p. 178; Jules Guiffrey, *Antoine Van Dyck*, 1882, No. 615, p. 27,

both as Lord Macclesfield. Reproduced in an article on the Hatfield House Collection in the *Connoisseur*, Vol. vii, 1903, p. 230, as Sir John Coke by Vandyck. C. H. Collins Baker, *Lely and the Stuart Portrait Painters*, 1912, Vol. I, p. 158 by Lely; R. B. Beckett, *Lely*, 1951, pp. 9 and 52 naming it as probably Lord Dirleton.

230 [73]

James Maxwell, Earl of Dirleton (before 1600–1650)

See No. 229

Painter unknown

Canvas 29½ × 24½ in. (74·9 × 62·3 cm.)

This copy is of the head and shoulders of No. 229 within a painted sculptured oval.

For the reasons for the identification of the portrait see No. 229. In Musgrave's Hatfield list of 1769 the copy was given as by Kneller. The type of sculptured oval suggests a date for the copy shortly before its mention in the inventory made after the death of his daughter, Lady Cranborne in 1675, and in various inventories and lists of Hatfield portraits since that date always with the same name as was given to No. 229. In Musgrave's 1769 list and later the copy was said to have been made by Kneller. This is unlikely if it was painted before 1675.

231 [124] ill. 148, p. 284

Called **Lady Elizabeth (Boyle), Countess of Thanet** (d. 1725)

Lady Elizabeth was the second daughter of Richard Boyle, Earl of Cork and Burlington. She married in 1664 Nicholas Tufton, 3rd Earl of Thanet who died in 1679

Attributed to William Wissing (1656–1687)

Canvas 49 × 39 in. (125 × 99·1 cm.)

Three-quarter length, seated to the left, looking at the spectator, holding a spud (?) upright in her right hand. Her hair is brown, a mop of curls is parted in the centre; she wears a low cut white chemise a brown dress loosened from her left shoulder and blue drapery. There is a rock behind her and trees and sky to the left. The sitter's age is about eighteen and her hair style of *c.*1675.

The first identifiable mention of this portrait is in the 1823 Hatfield inventory where it is called 'A Lady, half-length, daughter of the Earl of Burlington . . . Lely'. It then hung in the Drawing Room. In 1845 it was catalogued, No. 109, as Lady Elizabeth Boyle by Wissing.

232 [131] ill. 149, p. 284

Thomas Tufton, 6th Earl of Thanet (1644–1729)

Thomas Tufton succeeded his father in the Earldom in 1684. The same year he married Lady Catherine Cavendish, No. 233. His daughter, Lady Anne Tufton, No. 156, married the Earl of Salisbury in 1708/9

Attributed to John Closterman (1660–1711)

Canvas 50 × 40 in. (127 × 101·6 cm.)

Three-quarter length, standing slightly to the left looking at the spectator; he wears a long dark wig, and an Earl's coronation robes; his coronet is on a table to the left. The painting is inscribed in the upper right corner: 'Thomas Earl of Thanet/Aetatis 75' and in capitals in the lower left corner: 'THOMAS SIXTH/EARL OF THANET/ PAINTED BY CLOSTERMAN'.

The painting appears to be rightly ascribed to John Closterman who died in 1711. The style of the wig is that of *c.*1700–10 and the Earl's age near or probably over sixty, so the portrait would have been painted soon after Queen Anne's coronation. Portraits of Lord and Lady Thanet were in the Drawing Room in Musgrave's list of 1769 and were noted by Horace Walpole on

his visit in 1761 (Walpole Society, Vol. XVI, p. 35). Neither mentioned the artist's name. See also No. 233.

233 [117] ill. 150, p. 284

Lady Catherine (Cavendish), Countess of Thanet (1665–1712), *c.*1690–95

Lady Catherine was the younger daughter of Henry Cavendish, 2nd Duke of Newcastle, she married in 1684. She was the mother of Anne, who married the 5th Earl of Salisbury in 1708/9

Attributed to John Closterman (1660–1711)

Canvas 50 × 40 in. (127 × 101·6 cm.)

Three-quarter length seated, fronting and looking at the spectator, but she has turned her head slightly to the left; she has dark brown hair and dark blue eyes; she wears a loose blue low-cut dress, with red drapery; she touches a rope of pearls at her breast with her left hand. There are rocks to the right and sky to the left. Lady Thanet appears to be about 25–30 years of age and her hair style is of *c.*1690–95.

The earliest reference to this portrait is an entry in Musgrave's 1769 list of a portrait in the Drawing Room of the wife of the 'late E. of Thanet'. In the 1823 inventory and the 1891 catalogue it was given as by Kneller. In 1845 it was catalogued, No. 106, as by Closterman as is that of her husband (See No. 232). It is a likely attribution for the Earl of Thanet. This may be his work of about ten years earlier.

234 [123] ill. 151, p. 285

Sir Robert Brown, Bart. (d. 1760)

Sir Robert Brown was a merchant who made his fortune in Venice and became British Consul there. He returned to England and was created a baronet in 1732. He married Margaret Cecil in 1725

Attributed to Jonathan Richardson (1665–1745)

Canvas 30 × 25 in. (76·2 × 63·5 cm.)

Head and shoulders to the left, looking at the spectator. A man of about forty in the costume of the 1730's, the sitter wears a grey wig to his shoulders, a grey coat, turned back showing a blue lining and a grey waistcoat; his black tricorn hat is under his left arm. The picture has painted corner spandrels. The bottom of the frame is inscribed: 'Painted by Hudson'.

This and No. 235 must be by the same hand. This is not to be found recorded in any Hatfield list before 1845. Then it was catalogued, No. 131, as by Hudson. In 1891 it was catalogued as by Richardson.

235 [122] ill. 152, p. 285

Margaret (Cecil), Lady Brown (c.1698–1782)

Margaret Cecil was the only daughter of Robert Cecil, second son of James, 3rd Earl of Salisbury, and his wife Elizabeth (Meynel). She married Sir Robert Brown, Bart., in 1725. She was widowed in 1760. She was a frequent visitor to Hatfield when the 6th Earl of Salisbury and his Countess had separated and the Countess and children lived there

Attributed to Jonathan Richardson (1665–1745)

Canvas 29¾ × 25¼ in. (75·6 × 64·1 cm.)

Head and shoulders, to the left, looking at the spectator, the sitter is aged about thirty or slightly over. She has dark hair drawn back fairly tightly, a white dress with tight bodice and loose sleeves with a blue bow on the breast. The costume and hair style are of c.1740–45, the sitter looks less than forty.

On the back is a label which reads: 'Lady Margaret Brown, wife of Sir Robert Brown, BY Hudson'. The frame is inscribed 'Painted by Hudson'.

These portraits are not known in any Hatfield list before 1845; this was No. 141. The attribution to Richardson was made in the 1891 catalogue in

which is a quotation from a letter of hers to Thomas Coke: 'I hope you will sit for your picture at Richardson's'. A little more might be quoted. In the letter dated Venice October 12, 1725, she wrote: 'The first day I have my best looks on I will obey your commands in sitting for my picture, and will send it you as soon as it is done . . . I must take this opportunity to remind you of a promise which when performed will give me much pleasure . . . I hope you will sit for your picture at Richardson's'. (Historical Manuscript Commission 12th Report, *MSS of the Earl Cowper at Melbourne Hall*, Vol. iii, 1889, pp. 129–130).

The Hatfield portrait is by an English hand and Richardson may well be the painter.

236 [121]

Margaret (Cecil), Lady Brown (c.1698–1782)

See No. 235

Canvas 28½ × 23¼ in. (72·4 × 59 cm.) sight.

Attributed to Thomas Bardwell (1704–1767)

Head and shoulders to the left looking at the spectator. She is elderly, her hair is powdery grey. She wears black, including a black bonnet or drapery over a white cap or bonnet. She is depicted in a painted oval. The painting is inscribed in capitals in the lower right-hand corner 'MARGARET BROWN/PAINTED BY RICHARDSON'.

The first mention of portraits of Sir Robert and Lady Brown (Nos 234 and 235) is found in the 1845 catalogue, Nos 131 and 134 respectively, given as by Hudson. There is little doubt that these are Nos 123 and 122 in the 1891 catalogue. They each have 'Painted by Hudson' on their frames though later labels ascribe them to Richardson as in the 1891 catalogue. The first mention of No. 236 appears to be in the 1891 catalogue in which it is given to Hudson.

237 [144]

Wills Hill, 1st Marquess of Downshire (1718–1793)

Wills Hill was the son of the 1st Viscount Hillsborough whom he succeeded in 1742, he was created Earl Hillsborough in 1772 and Marquess of Downshire in 1789. He was the father of Lady Emily Mary Hill (1750–1835) wife of the 1st Marquess of Salisbury

John Rising (1756–1815) after George Romney

Canvas 32½ × 26½ in. (82·5 × 67·3 cm.)

Head and shoulders, fronting the spectator, his head is turned and he is looking full three-quarters to the right. He has dark sepia eyes and wears a powdered wig with one curl over the ears and a peer's parliamentary robe; there is insufficient of it to show his rank in the peerage. Inscribed on the left, level with his shoulder: 'Wills Marqus of/Downshire/ob. 8 Oct/ A.D. 1793'. It is signed in the bottom left corner: 'Rising'. It is a copy of a kit-cat size portrait by George Romney for which Lord Downshire sat in 1791 and which passed down in the Annesley family from a friend with whom he is said to have exchanged portraits.

The first record of this portrait is in the 1845 catalogue No. 64.

Exhibited the National Portrait Exhibition, 1867, No. 497.

238 ill. 153, p. 285

Wills Hill, 1st Marquess of Downshire (1718–1793), 1786

See No. 237

John Downman (1750–1824)

Watercolour on paper 14¼ × 10 in. (36·2 × 25·4 cm.) sight, oval

Three-quarter length standing in the open air to the left looking at the spectator. He has brown eyes and wears a powdered wig with a curl over the ear, a blue coat and a near white waistcoat. He has a hat in his right hand, a glove in his gloved left hand. There is a stone wall behind him with landscape to the left. The drawing is signed and dated on the right about half way up: 'J. Downman/Pt 1786'. This is not included in the 1891 catalogue or earlier Hatfield lists.

239

Georgina (Drewe), Lady Alderson (d. 1871)

Georgina Drew was the daughter of the Rev. Edward Drewe, Rector of Willand, Devon. She married Sir Edward Hall Alderson (1787–1857) in 1823. She was the mother of Georgina Caroline, Marchioness of Salisbury, No. 190

Henry Perronet Briggs (1793–1844)

Canvas 29½ × 24½ in. (74·9 × 62·2 cm.) sight

A half-length, Lady Alderson is turned to the right and is looking at the spectator; she has brown hair and grey-hazel eyes. She wears a pale grey-green dress; a plain green curtain forms the background.

240

Pakenham Alderson (d. 1876), 1847

A brother of the 3rd Marchioness of Salisbury

George Richmond (1809–1896)

Watercolour 14¼ × 10¼ in. (36·8 × 27·3 cm.)

Head and shoulders, vignetted, fronting the spectator, head turned and looking three-quarters to the right. The hair is fair, the eyes blue, and the sitter wears a black stock, grey coat and near-white waistcoat. The work is signed and dated near the lower left corner: 'George Richmond delint 1847'.

241

Sir Charles Henry Alderson, K.C.B. (1831–1913), 1852

A brother of the 3rd Marchioness of Salisbury. H.M. Chief Inspector of Schools, 1882–5, Chief Charity Commissioner for England and Wales, 1900–3

George Richmond (1809–1896)

Watercolour 15 × 12 in. (38·1 × 30·5 cm.)

Half-length, vignetted, seated to the right, looking at the spectator. The hair is fair, the eyes blue and the sitter wears a grey-brown coat and black stock. The work is signed and dated near the lower left corner: 'Geo. Richmond delt 1852'.

242 ill. 154, p. 286

Arthur James Balfour, 1st Earl Balfour of Whittinghame, K.G., O.M. (1848–1930)

Prime Minister, 1902–1905. He held high office in all conservative governments from 1881 until 1929. His mother was a sister of the 3rd Marquess of Salisbury

Sir Winston Churchill (1874–1965)

Canvas 20¼ × 16¼ in. (51·4 × 41·3 cm.)

Head and shoulders sketched in pale blue paint.

Given to Lord Salisbury by Lady Spencer Churchill in September, 1966.

This is reproduced in *Churchill his Paintings* by David Coombs, 1967, p. 102, No. 33.

243 [232]

Called **Sir Gilbert Ireland** (1634–1675)

Sir Gilbert Ireland of Hutte and Hale, Lancashire, left no issue. His estates and those of his wife, Margaret (neé Ireland of Bewsey), passed to Gilbert Aspinwall, son of Sir Gilbert's younger sister, Margaret, who married Edward Aspinwall. Her great-great-granddaughter, Mary Green, married

Bamber Gascoyne I, No. 249

Painter unknown

Canvas 30 × 25¾ in. (76·2 × 65·4 cm.)

To the waist, head three-quarters to the left looking at the spectator, wearing long brown hair, a lace-ended neck cloth and armour; in a painted oval. Inscribed with biographical particulars at the back of the canvas.

If the portrait is rightly named it came into the collection after the marriage of Frances Mary Gascoyne and the 2nd Marquess of Salisbury in 1821. One portrait of him, No. 24 is included in the 1845 manuscript Hatfield catalogue. It may be either this or No. 91 in the 1891 catalogue in which there appears to have been some confusion, and two portraits, now Nos 138 and 243, turned into three [91] [99] and [232].

244 [184]

Unknown Man, stated to be a member of the Glanville family, *c.*1730

Painter unknown

Canvas 29 × 24 in. (73·8 × 61·1 cm.) sight

Head and shoulders slightly to the left, his head is turned three-quarters to the right and he looks at the spectator; he has blue eyes and wears a long wig; his coat is brown as is the background. This picture was stated in the 1891 catalogue to be identical with the miniature No. 409, but it is not, though it may represent the same man.

245 [135] ill. 155, p. 286

Dr John Bamber, F.R.S. (1667–1753), 1739

Dr John Bamber was a wealthy physician, anatomist and accoucher. He married Mary Hill (1677–1736) in 1698. His daughter, Margaret, (b. 1705), married Sir Crisp Gascoyne, No. 247. Dr Bamber entailed his

property on her eldest son, Bamber Gascoyne, No. 249

William Verelst (died 1756)

Canvas 49 × 39½ in. (124·5 × 100 cm.)

A three-quarter length portrait, Dr Bamber is sitting slightly to the right in a high-backed chair, and is looking at the spectator. He wears a powdered shoulder-length wig, and a black gown over his purple-brown coat which is un-buttoned to the waist. His eyes are brown. A book on a pile of books on a table to the right is lettered: 'CELSUS/DE RE/MEDICA'. The painting is signed on the pile of books: 'Wᵐ Verelst/ Pinxit 1739', and is inscribed in capitals in the lower left corner: 'DR BAMBER/ BY VERELST'. About two inches were added to the bottom of the canvas before the inscription was painted.

The portrait is in the Hatfield 1845 catalogue, No. 53, in which the artist and date are given.

246 [136] ill. 156, p. 287

Margaret (Bamber), Mrs Gascoyne (?) (1705–1740), 1743

Margaret Bamber was the daughter of Dr John Bamber, No. 245. She married Sir Crisp Gascoyne, No. 248

William Verelst (d. 1756)

Canvas 30 × 25 in. (76·2 × 63·5 cm.)

To the waist the sitter is turned slightly to the right, her head to the left, she looks at the spectator. She has dark hair and hazel eyes and wears a low cut blue dress folded across the front. The picture is signed and dated: 'Wm Verelst/pt 1743'. It is inscribed in capitals in the lower right corner: 'MRS BAMBER/BY VERELST/1743'.

This must have come to Hatfield among the Bamber and Gascoyne family portraits. The inscription on it is similar to many others at Hatfield put on after 1821. The first known record of it is in the 1845 manuscript catalogue,

No. 120, in which it is called Mrs Bamber, whose death in December 1736 is recorded in the *Gentleman's Magazine* for that year, p. 749. The sitter's age appears to be about forty. This would accord better with the portrait representing Dr Bamber's daughter Margaret, Mrs Gascoyne but she was buried October 10, 1740 (*Burke's Landed Gentry* 1937, p. 868).

Another possibility is that it represents Bridget (Raymond), 2nd wife of William Evelyn-Glanville I of St Clere and mother of Sarah who married Chase Price (see No. 249) in 1766. Her birth and death dates have not been found.

247 [132]

Frances (Evelyn-Glanville), Mrs Boscawen (1719–1805), 1745

Frances was the only child of William Evelyn of St Clere (b. 1686) and his first wife, Frances Glanville (d. 1719, aged 22). She married in 1842 Admiral the Hon. Edward Boscawen (1711–1761). Her half-sister, Sarah, married Chase Price (see No. 249).

Copy after Allan Ramsay (1713–1784)

Canvas 29½ × 24 in. (74·9 × 61 cm.)

Head and shoulders fronting the spectator; her head is turned and she looks three-quarters to the left. Her brown hair is dressed back and her eyes are blue. The sitter wears a pearl necklace and broad Van Dyck lace collar on a black dress with mauve drapery. The corners have painted spandrels. The painting is inscribed in capitals 'This lady is of the Gascoyne family'.

In the 1845 catalogue, No. 117, this is called a lady of the Gascoyne family, In the 1891 catalogue it is called Mrs Bridget Glanville, wife of William Evelyn-Glanville. It is, however, a copy of the Allan Ramsay portrait of Mrs Boscawen, signed and dated 1745. No. 26 in the Allan Ramsay exhibition at the Royal Academy in 1964.

The latter, which was lent by Major Richard Leveson Gower, has descended to him from Mrs Boscawen's elder daughter, Frances, who married Admiral the Hon. John Leveson Gower.

248 [139] ill. 157, p. 287

Sir Crisp Gascoyne (1700–1761), 1753

Sir Crisp Gascoyne was knighted in 1752 and was Lord Mayor of London, 1752/3, being the first to reside in the Mansion House. He married Margaret, see No. 246, daughter and heiress of Dr John Bamber, No. 245

William Keable (fl 1753–4)

Canvas 49 × 37 in. (124·5 × 94 cm.)

Three-quarter length standing slightly to the left, looking at the spectator. He has blue eyes and wears a powdered neck-length wig, and the Lord Mayor's SS chain of office over his alderman's brown fur-trimmed scarlet gown over a white satin waistcoat. A green curtain forms the background.

The portrait is similar to a whole-length mezzotint by James Macardell, 1753, inscribed as of a portrait of Sir Crisp Gascoyne by W. Keable. It may be that the whole length was cut down to this size. It would have come to Hatfield at the same time as Nos 245 and 246. It was No. 47 in the 1845 catalogue. No other version is known.

Very little is known of the artist who was a member of the St Martin Lane Academy in 1754.

249 [154] ill. 158, p. 287

Chase Price (?) (1731–1777)

Chase Price, Member of Parliament from 1759 to 1777, married Sarah, daughter of William Evelyn-Glanville I, March 21, 1766. They had an only child Sarah, No. 251, who married Bamber Gascoyne II. Mrs Price was half sister of Mrs Boscawen, No. 247

Sir Joshua Reynolds (?) (1723–1792) extended by another hand

Canvas 50 × 39 in. (127 × 99 cm.)

Three-quarter length, standing slightly to the right; his head is turned and he looks three-quarters to the left. He has dark brown hair and hazel eyes and wears a black gown over a dark brown coat, his linen collar and cuffs are seen. There is sky to the right. There is a partially illegible inscription in the lower right corner which reads: 'BAMBER GASCOYNE/ . . . NORTHCOTE'. The hair style suggests a date c. 1765–70, the sitter appears to be about forty.

Northcote kept a record of his paintings which is printed as an appendix to *Memorials of an 18th Century Painter: James Northcote* by Stephen Gwynn, 1898, but no portrait of Bamber Gascoyne is mentioned. The first known record of it at Hatfield is in the 1845 catalogue in which it is listed as Bamber Gascoyne (but not specifying which) by Northcote. It is entered in the 1891 catalogue as Bamber Gascoyne II (1758–1824).

The portrait is almost certainly of Chase Price, being the original by Sir Joshua Reynolds, or a copy, extended from 30 × 25 in. (75·8 × 63·5 cm.) to its present size. Entries for Mr Chase Price, Mr C. Price and Mr Price occur in Reynold's sitter books (belonging to the Royal Academy) on November 23, December 2, 6, 1765, June 18, 28 and 30, 1766, July 5 and 8 and November 7 and 9 1768. In Reynold's ledger a first payment of £25 for a portrait of Mr Chase Price is recorded under July 1764 and a second payment of £11. 15. 0 under 1767. (Walpole Society, Vol. XLII, 1970, pp. 131–2.) No mention of any portrait of Chase Price has been found at Hatfield or elsewhere. As the first wife of the 2nd Marquess of Salisbury was the only child of Chase Price's only daughter, Sarah, one would expect to find the Reynolds portrait at Hatfield. It is probable that the 2nd Marquess had been told by his first wife that this represented her grand-

father and he mistakenly gave it her paternal instead of maternal grand-father's name. By 1871 (Inventory p. 169), when it hung on the Grand Staircase, it had become: 'Bamber Gascoyne Father to the Second Marchioness of Salisbury'. The portrait fits Chase Price for date. Thirty-five guineas was Reynolds's price for a 30 × 25 in. portrait at the time of the sittings, which is the sum Reynolds received. The portrait shows distinct signs of having been extended from 30 × 25 in., but the canvas appears to be in one piece.

250A ill. 159, p. 288

Bamber Gascoyne I (1729–1791)

He was the son of Sir Crisp Gascoyne, No. 248; he inherited the property in Essex of his maternal grandfather, Dr John Bamber, No. 245, in 1753. He married Mary Green, the heiress of Childwall and Hale, Lancashire, and was the father of Bamber Gascoyne II, No. 250B. He was an M.P. 1761–1765 and 1770–1779, and a Commissioner of the Admiralty, 1779–1782

J. Sayer (1748–1823)

Etching, plate mark $6\frac{7}{8} \times 4\frac{1}{8}$ in. (17·5 × 11·5 cm.)

Whole-length, standing, turned slightly to the left, wearing his black hat, he has his hands in his coat pockets; signed 'JS ff.' in monogram in the lower left corner, inscribed in the lower right corner: 'published 6th April 1782 by Bretherton'.

250B ill. 160, p. 288

Bamber Gascoyne II (1758–1824), 1820

The son of Bamber Gascoyne I, No. 250A, he married Sarah Price, No. 251. His daughter, Frances Mary, No. 172, married the 2nd Marquess of Salisbury in 1821

Richard Dighton (1795–1880)

Coloured etching on paper, plate mark $11\frac{1}{8} \times 7\frac{1}{8}$ in. (28·5 × 18·1 cm.)

Whole-length standing on paving stones in profile to the right, wearing his hat; he has dark hair and side whiskers and wears glasses. The etching is inscribed: 'Mr Gascoigne', and below this: 'Drawn, Etchd & Pubd by Richard Dighton 1820 Augst'. Below this is: 'An Exotick at the Green House Leadenhall Street /I do begin to fear 'tis you/ Not by your individual whiskers/ But by your dialect and discourse'.

251 [143] ill. 161, p. 289

Sarah Bridget Frances (Price), Mrs Bamber Gascoyne (1766–1820), 1770

Sarah Price was the daughter of Chase Price, M.P., and his wife Sarah, the daughter of William Evelyn-Glanville. She married Bamber Gascoyne II. Frances Mary 2nd Marchioness of Salisbury was their only child

Sir Joshua Reynolds (1723–1792)

Canvas 49 × 40 in. (124·5 × 101·6 cm.)

Whole-length of a little girl aged three or four, standing facing the spectator with her hands crossed in front of her. She has dark brown hair and brown eyes, and wears a pink dress with a blue petticoat and a brown scarf. She is in a park setting, with a large urn on a pedestal on the right, two lambs are close to her on the left.

Visits by 'Miss Price' are entered in Reynolds's sitter books on February 15, 20 and 25, March 2, 10, 15, 18, 23 and 30, April 8, 11 and 18, May 1, 1769, and on January 25, February 3, March 13, 17, 20, 24, and April 9, 1770. Reynolds entered payment for the portrait in his account book of April 7, 1770: 'Miss Price 73. 10. 0' (Walpole Society, Vol. XLII, 1970, p. 132). Seventy guineas was his charge for a 50 × 40 in. painting at that time. There are so many sittings that Reynolds possibly painted two portraits, the

second of which was purchased by Chase Price. The other may be a portrait of a girl of about two which was Lot 107 of Sotheby's Sale of March 8, 1944, and which was catalogued as Miss Price as a shepherdess by Reynolds. The portrait was in the 1770 Royal Academy Exhibition. Horace Walpole noted 'Never was there more grace and character than in this incomparable picture, which expresses at once simplicity, propriety, and fear of her clothes being dirtied, with all the frailty of a poor little innocent'.

The portrait remained in the possession of her mother Mrs Sarah Price, who died in 1826. In her will she directed that 'it be carried to Childwall Hall and there to remain as she was the chief designer and director of that house'. It is No. 54 in the 1845 Hatfield catalogue.

Engraved in mezzotint by James Watson, 1770.

Exhibited at the British Institution, 1813, No. 16; the International Exhibition, London, 1862; and the Reynolds Exhibition, London, 1937 reproduced in the catalogue, Plate 41.

Literature: W. Cotton, *Sir Joshua Reynolds and his Works*, 1856, p. 107 ;C. R. Leslie and L. Taylor, *Life and Times of Sir Joshua Reynolds* 1865, Vol. 1, p. 357; C. Philips, *Sir Joshua Reynolds*, 1894, p. 141; Graves and Cronin, *History of the Works of Sir Joshua Reynolds;* 1899, Vol. ii, p. 773; Sir W. Armstrong, *Sir Joshua Reynolds*, 1900, p. 225; E. K. Waterhouse, *Reynolds*, 1941, p. 61.

252 [156] ill. 162, p. 289

Sarah Bridget Frances (Price), Mrs Bamber Gascoyne (?) (1766–1820), 1769

See No. 251

Francis Cotes (1726–1770)

Canvas 24½ × 19½ in. (62·2 × 49·5 cm.) oval

A girl aged two or three seen to the waist, turned to the left, looking at the spectator. She has light flaxen hair and hazel eyes and wears a pink dress trimmed with white. The painting is signed on the right: 'F. Cotes R.A. Pxt/1769'. The 'F' and 'C' are in monogram.

The portrait was catalogued as early as 1845, No. 183, as representing the first Marchioness of Salisbury (1750–1835), but the little girl is far too young to be her in 1760. It might well be another portrait of Sarah Price, Mrs Gascoyne.

253 [115]

William III (1650–1702)

King of England from 1689

Studio of Sir Godfrey Kneller (1646 or 9–1723)

Canvas 89½ × 55½ in. (227·3 × 141 cm.) sight

Whole-length, standing, to the right, looking at the spectator; he wears a yellow (gold?) and ermine robe. His crown is on a red-covered table to the right.

This and the companion portrait of Queen Mary II (No. 254) are first recorded at Hatfield in the 1845 manuscript catalogue. They are versions of the portraits for which sittings were given in 1689–90. Many copies were made in Kneller's studio and may be seen in city halls and stately homes.

254 [109]

Queen Mary II (1662–1694)

Queen Mary was the daughter of King James II and Anne Hyde. She married King William III in 1677. She reigned conjointly with her husband from 1689

Studio of Sir Godfrey Kneller (1646 or 9–1723)

Canvas 91 × 56 in. (231·1 × 142·2 cm.) sight

Whole-length, standing, turned to the left, looking at the spectator, wearing a blue and ermine royal robe over a white dress. Her right hand

touches a red-covered table on which a crown and sceptre rest.

Companion to the portrait of King William III No. 253 q.v.

255 [106]

George I (1660–1727)

King of England from 1714

Studio of Sir Godfrey Kneller (1646 or 9–1723)

Canvas 29¾ × 25 in. (75·6 × 63·5 cm.)

The head and shoulders are in profile to the right. The King wears a full wig, and armour with red drapery over his shoulders; in a painted oval.

Catalogued in 1891 as representing Brownlow Cecil, 7th Earl of Exeter, it may have lost its true identity as early as 1769 for Musgrave's list of that year includes a portrait of an Earl of Exeter, but no portrait of George I. It is not traceable in the 1823 inventory or the 1845 catalogue. The original is unlocated. There are versions in the Royal Collection and the National Portrait Gallery. It was engraved by Chereau the Younger and is believed to be of 1714 or thereabouts.

256 [149]

George III (1738–1820), 1779
King George III succeeded his grandfather, George II as King in 1760

Studio of Joshua Reynolds (1723–1792)

Canvas 93 × 57 in. (236·2 × 144·8 cm.)

A whole-length; the King is seated in coronation robes. The original and the companion portrait of Queen Charlotte were painted in 1779 and exhibited at the Royal Academy in 1780, and were given to the Royal Academy by King George III.

At the end of Sir Joshua Reynolds's 2nd ledger under the date, November 28, 1789, is a list of

persons for whom copies were made and last on this list is entered: 'Lord Salisbury. Sent home'. See Walpole Society, Vol. XLII, pp. 167–8. So it appears that Lord Salisbury received them in or before 1789. The two copies were included in the 1823 inventory.

257 [151]

George III (1738–1820), 1781

See No. 256

After Thomas Gainsborough (1727–1788)
Canvas 92¾ × 59 in. (240·5 × 150 cm.) sight.

A whole-length portrait, the King is standing nearly fronting the spectator, he has his head turned three-quarters to the right. He is wearing blue Windsor uniform.

The originals of this and No. 260 were exhibited at the Royal Academy in 1781 and are in the Royal Collection. There are many copies. The earliest known record of the Hatfield copies is in the 1891 catalogue.

258 [150] ill. 163, p. 289

George III (1739–1820), 1800

See No. 256

Sir William Beechey (1753–1839)

Canvas 93 × 57 in. (241·5 × 145 cm.)

A whole-length portrait; the King is standing fronting the spectator, his head turned and looking full three-quarters to the left. He is in military uniform and wears a cocked hat, he holds a cane in his right hand. Hatfield House from the South is seen to the left.

This portrait is No. 80 in the 1845 catalogue. It is stated in the 1891 catalogue to have been given by the King to the 1st Marquess of Salisbury to commemorate his visit on June 13, 1800. The figure of the King is similar to a portrait by

Beechey in the Royal Collection which was exhibited at the Royal Academy in 1800.

Literature: W. Roberts, *Sir William Beechey*, 1907, p. 70; Oliver Millar, *The Late Georgian Pictures in the Collection of Her Majesty the Queen*, 1969, Text volume, p. 6.

259 [147]

Queen Charlotte (1744–1818), 1779

Charlotte Sophia, daughter of the Grand Duke of Mecklenburg-Strelitz, married George III in 1761

Studio of Sir Joshua Reynolds (1723–1792)

Canvas 93 × 57 in. (236·2 × 144·8 cm.)

A whole-length portrait, the Queen is seated in coronation robes.

For a note on the original and this copy see No. 256, George III, which is a pair with this.

260 [148]

Queen Charlotte (1744–1818), 1781

See No. 259

After Thomas Gainsborough (1727–1788)

Canvas 92¾ × 59 in. (240·5 × 150 cm.) sight

A whole-length; the Queen is standing to the left in a white satin dress; a dog is on the left.

For a note on this and the companion portrait of King George III, see No. 257

261 [120] ill. 164, p. 289

Charles XII (1682–1718), 1717

Charles XII, King of Sweden, succeeded his father in 1697 and had a reign troubled by wars. He was shot dead before Frederickshall, December 1718, while surveying the siege

Studio of David von Krafft (1655–1724)

Canvas 94½ × 59 in. (240 × 149·9 cm.)

Whole-length, standing, his head turned to the right, looking at the spectator, he rests his right hand on the edge of a cloth-covered table to the left, and grasps the hilt of his sword with his left hand. His head is balding, and he wears a blue military coat, buff gauntlets and high black boots. The painting is inscribed on the right above knee level: 'Charles ye 12 King of Sweden/sent by Count Gyllenborg', and in the lower right corner: 'CHARLES THE TWELFTH/OF SWEDEN'. The canvas is of three pieces joined horizontally.

The first known mention of the portrait at Hatfield is in Musgrave's 1769 list. It was then in the Lumber Room with some of the other whole-length foreign portraits. In the 1823 inventory it is listed in the Winter Dining Room, thus: 'Charles the Twelf of Sweden. Sent by Count Gytenborgh'. It is No. 76 in the 1845 manuscript catalogue. Its provenance is not given there but the artist is named as 'Lionell, Com. de Dysert'. The reason for this strange attribution, which was retained in the 1891 catalogue, is not known.

Carl Count Gyllenborg (1679–1746) who is stated to have sent the portrait was Charles XII's Ambassador in London. He was forced to leave early in 1717 on the discovery of his involvement in a plan for Charles XII to invade the country in the spring of that year to set Prince James Edward Stuart on the throne. He had an English wife.

The portrait is very close to the whole-length of Charles XII at the royal palace at Drottningholm, Sweden, painted in Lund early in 1717 by David von Krafft, which is reproduced in *Charles XII of Sweden* by Professor R. M. Hatton, 1968, p. 492. Professor Hatton states on p. 6 that this portrait 'was much copied and used for Swedish embassies abroad and in official buildings at home during Charles XII's own lifetime'.

262 [125]

Peter Alexiowitz (Peter the Great), Czar of Russia (1672–1725), 1698

Studio of Sir Godfrey Kneller (1646 or 9–1723)

Canvas $94\frac{1}{2} \times 59$ in. (240 × 149·9 cm.)

This work is a copy of the original painting of 1698 at Hampton Court. The first known mention of this painting at Hatfield is in Musgrave's 1769 list when it was in the Lumber Room next to Charles XII of Sweden. The original was engraved in mezzotint by John Smith.

263 [157] ill.

Charles X (1757–1836)

Charles X was the youngest son of Louis the Dauphin and grandson of Louis XV. He succeeded his brother Louis XVIII as King of France in 1824. He was driven to take refuge in England in 1830 and abdicated in favour of Louis Philippe the same year

François, Baron Gérard (1770–1837)

Canvas 102 × 70 in. (259·1 × 177·8 cm.)

A whole-length portrait, the King is standing on a dais, turned three-quarters to the right looking at the spectator, wearing imperial blue robes on which fleurs de lys are embroidered in gold; he rests his right hand on the end of his sceptre the other end of which is on a purple cushion on a low stool on which is his crown; there are red curtains in the background. The fore-part of his throne is seen on the left.

The portrait was given by Charles X to the 1st Marchioness of Salisbury and it was bequeathed by her to her son the 2nd Marquess. It was No. 50 in the 1845 catalogue as by Gérard.

There are portraits of Charles by Baron Gérard in Apsley House, London and the Bowes Museum, Co. Durham. In these, which are similar to each other, the same robes and regalia are

depicted as at Hatfield but the backgrounds differ.

264 [174]

Wilhelm II, German Emperor (1859–1941)

Rudolf von Wimmer (1849–1915)

Canvas 99 × 60 in. (251·5 × 152·4 cm.)

A whole-length, the Emperor is standing, facing the spectator, wearing an English Admiral's full-dress uniform, holding a telescope under his left arm. He is on the deck of the Imperial yacht. The painting is inscribed on the left: 'Nach dim haben gemalt/Rud von Wimmer/1889'.

This portrait was presented by the Kaiser to the 3rd Marquess of Salisbury in commemoration of the Kaiser's visit to England on the occasion of the Naval Review, August 1889.

265 [234]

Phra Paramindr Maha Chulalokorn, King of Siam (1853–1910)

This king's name is given in various forms in books of reference. In Whitaker's Almanack for 1891 it is set out as Phrabat Somdet Phra Paramindr Maha Chulalon Korn Phra Chula Chom Klao Phra Chow Yuhua. He succeeded to the throne in 1868 and reigned until his death. He visited England only once, in 1897

Painter unknown

Canvas $28\frac{3}{4} \times 23$ in. (73 × 58·4 cm.) sight

Head and shoulders, fronting spectator, his head is turned and he looks three-quarters to the left. The King has short black hair, parted in the centre and a short black moustache, he wears a white uniform with narrow green gold-embroidered buttoned-up collar; a broad gold ribbon with green border is across his breast from his right shoulder, he wears a row of medals on his left breast; the background is a plain pale grey-green.

One tablet on the frame states that the portrait was given in 1891, on a second one is: 'Chulalongkorn 1/King of Siam/1887. Given by the King of Siam in 1891.

266 [235]

Victor Emmanuel III (1869–1947), 1891

Victor Emmanuel, King of Italy, was the only son and successor to King Humberto I who was assassinated in 1900. He abdicated in 1946

Edoardo (Odoardo) Gelli (1852–1933)

Canvas 81 × 56½ in. (205·7 × 133·3 cm.)

Three-quarter length, standing, slightly to the left, in uniform, wearing the ribbon of the Garter and other decorations and holding his plumed peaked cap. Signed and dated: 'E. Gelli 1891/Firenze'. The 'E' and 'G' are in monogram.

Presented by the King to the 3rd Marquess of Salisbury in commemoration of his visit to Hatfield, when Duke of Naples, July 25–26, 1891.

267

Unknown Lady of *c.*1640

Painter unknown

Panel. 10⅝ × 8⅝ in. (27 × 21·9 cm.)

Head and shoulders to the right, looking at spectator; brown hair with corkscrew curls, brown eyes, blue dress, brown drapery.

Painted in a style traditionally ascribed to Theodore Roussel.

268 [79] ill. 166, p. 290

Martin Harpertzoon Tromp (?) (1597–1653), 1642

Painter unknown

Canvas 94 × 56 in. (238 × 142·2 cm.)

Whole-length, standing, fronting and looking at the spectator his head is turned slightly to the right; he has brown hair, wears a buff coat with a broad square-cut white collar and a red sash crosses his breast from over his right shoulder. The painting is inscribed on the right, level with his head: 'AEt SVAE 44/1642'.

It is in the 1845 manuscript catalogue, No. 55 on the Grand Stairs. In both this and the 1891 catalogue Cuyp is named as the artist. This was Lot 389, purchased by the 2nd Marquess of Salisbury, at the sale at Pryor's Bank, Fulham, the residence of Thomas Baylis, May 3, 1841 and following days. An article on the sale appeared in *The Gentleman's Magazine*, January 1842, pp. 20–23, with the following about this portrait:'"A fine portrait of Admiral Tromp, whole length, *created a Baron* by Charles 1." Mr Baylis, we understand, purchased this picture under another name, and it was disguised by a wig, which has been cleaned off. It has been identified with the famous Von Tromp, who was born in 1597, with which date an inscription upon it "ÆT SVÆ 44, 1642", corresponds: and it is remarkable that it was in the latter year that he was knighted (not "created a Baron") by Charles the First in England.'

The portrait is not sufficiently similar to any established portrait of Tromp to be declared with certainty to represent him, but the features are not too far unlike to rule out the possibility.

269 [77]

Unknown Lady, *c.*1660

Painter unknown

Canvas 29½ × 24 in. (74·9 × 61 cm.) oval

A head and shoulders portrait; the sitter is turned slightly to the left looking at the spectator. She has auburn hair, and dark slaty eyes and wears

pearl earrings and a necklace, and a low-cut white satin dress with pearl centred buttons down the front.

This may be the portrait of 'My Lady Carlisle cop. £1. 10. 0' in the inventory of the personal effects of Diana, Lady Cranborne, made on June 2, 1675, after her death. A portrait of Lady Carlisle is mentioned in the Salisbury House inventory of 1685. She would be Anne (Howard), wife of Charles Howard, 1st Earl of Carlisle (new creation). She married in 1646 and died in 1703. She was a first cousin of Charles, Lord Cranborne. It is unlikely to represent one of the portraits of the two daughters of Lady Cranborne, also included in the 1675 inventory as they would have been younger than the lady portrayed, c.1660.

The portrait was No. 20, unnamed, in the 1845 catalogue as by Lely and similarly catalogued in 1891. A label on the back is inscribed in an eighteenth (?) century hand: 'painted by H. Stone'.

270 [104] ill. 167, p. 291

Unknown Lady, c.1660–65

Painter unknown, Pierre Mignard (1612–1695) school

Canvas 27½ × 20 in. (69·8 × 50·8 cm.) sight

Head and shoulders, her body almost in profile to right, her head three-quarters to right, looking at spectator. She holds a mirror in her right hand, and the end of a ringlet between the thumb and forefinger of her left hand. Her hair is in long ringlets, she has brown eyes, and wears a blue dress and grey and mauve drapery. There are painted spandrels in the corners. The picture is inscribed low on the right, in yellow letters 'Eleanor Gwynn/ by Vanderbank'.

This is not a portrait of Nell Gwynn, nor does it represent Mary Davis which is the name given to it in the 1891 catalogue. From the date and the lady's age it might represent Lady Margaret

(Manners) wife of the 3rd Earl of Salisbury but no portrait of her is recorded in any Hatfield lists. It might be the 'Picture of a French Lady' listed as in the Parlour in the Hatfield 1679/80 Inventory. In *Family Papers, Accounts 131/3* the following record appears in 1673 in Mr Churchill's payments (Lady Day to Christmas):' . . . a French Lady's picture 7 guineas'.

The portrait is not traceable in the 1823 inventory or 1845 catalogue.

271 [94]

Unknown Lady, c.1670/5

Painter unknown

Canvas 48⅜ × 36⅝ in. (122·9 × 93 cm.) sight

Three-quarter length to right, looking at the spectator her left hand to her breast, her right extended low to the right; her hair is fair and dressed in corkscrew ringlets falling on either side of her head; she has dark slate coloured eyes; she wears a pearl necklace, and a blue-grey dress with white fichu. Sky and park are seen to the right, foliage to the left.

This portrait cannot be traced before 1845, when it and a painting at Cranborne which was burnt in 1945, were catalogued, Nos 43 and 122, as Nell Gwynn. This lady's features do not resemble those of Nell Gwynn in established portraits of her.

272 [116]

Barbara Villiers, Duchess of Cleveland (1640–1709)

Studio of Sir Peter Lely (1618–1680)

Canvas 48 × 39 in. (122 × 99 cm.)

Three-quarter length to the left looking at the spectator, plucking a flower from a small tree growing in a large stone urn. She has brown hair

and a cinnamon coloured satin dress and a pearl necklace. Inscribed: 'Arabella Villiers/Dss of Cleveland/By Lely'.

This belonged to Diana, Lady Cranborne, and is in the inventory of her goods and chattels made on June 2, 1675, shortly after her death. It is recorded in various lists of portraits at Hatfield from 1679/80 onwards. A similar portrait belongs to the Duke of Grafton, at Euston.

273 [100] ill. 168, p. 291

Thomas Sydenham, M.D. (1624–1689)

The famous physician. In the will of the 4th Earl of Salisbury (d. 1694) which was drawn up in 1689 Sydenham was bequeathed £200

Ebenezer(?) Sadler (fl. c.1670–c.1713)

Canvas 29 × 24 in. (73·7 × 61 cm.)

Head and shoulders slightly to the right, the sitter, who is middle-aged, looks at the spectator; his hair is medium brown, his eyes brown; he wears fairly broad plain bands, and a brown gown over a brown coat unbuttoned at the top.

George Vertue made a note in 1739 or 1740 (Walpole Society Vertue, Vol. IV, pp. 160 and 177) that Dr Sydenham's portrait at Hatfield was by Sadler who received his art training at Sydenham's expense, that Sydenham was very intimate with the Earl of Salisbury, and that Sadler became 'Steward or principal domestic to this Earl'. The artist was presumably Ebenezer Sadler who was Steward at Hatfield from 1689 or thereabouts until at least 1713.

A portrait of Dr Sydenham is in Musgrave's 1769 list of portraits at Hatfield as 'Dr Sydenham Aet 57 same as the print'; (there is no engraving exactly like it). In the 1823 catalogue the artist is named as Kneller. It was omitted from the 1845 catalogue. The 1891 catalogue gives the artist as Mary Beale.

274 [92] ill. 169, p. 291

Unknown Lady as a Magdalene, 1694

Sir Godfrey Kneller (1646 or 9–1723)

Canvas 49 × 40 in. (124·5 × 101·6 cm.)

Three-quarter length, seated three-quarters to the left, her head turned and looking to the right; she has light brown hair and wears a brown dress with blue drapery. Her hands are clasped and she has an open book before her on the left. The portrait is inscribed in capitals in the lower right corner: 'Elizabeth/Lady Latimer/Painted by Kneller'.

The portrait hung in the Drawing Room when Musgrave's list was made in 1769. It is entered as 'Lady Latimer as a Magdalen' and was called her from them until recently. In the 1823 inventory it was listed in the King James Room and given to Kneller. It was No. 126 in the 1845 catalogue. It cannot represent Elizabeth (Bennet), Lady Latimer, the eldest sister of the 4th Countess of Salisbury as she died in 1680, a similar portrait at Althorp is signed and dated 1694 by Kneller. It was there called Lady Howard of Escrick whose husband, the 3rd Baron, died in 1694. It is of too young a lady to represent her in 1694. Her husband was the nephew of the 2nd Countess of Salisbury.

275 [110]

Unknown Lady, called Mrs Wrey or Wray (fl. 1694)

See No. 276

Attributed to Sir Godfrey Kneller (1646 or 9–1723)

Canvas 50 × 40 in. (127 × 101·6 cm.)

Three-quarter length, seated to the right, her head is turned slightly to the left and she is looking at the spectator, resting her right arm on a

stone pedestal to the left; she has dark hair, dark hazel eyes and wears a loose decolleté brown dress; a landscape is seen to the right. The painting is inscribed in capitals in the lower left corner: 'MRS WRAY/BY KNELLER'.

There is a possibility that this is a portrait of Grace (Bennet), Mrs Bennet, a sister of the 4th Countess of Salisbury. A lacquered frame was purchased for a 'half-length' (i.e. 50 × 40 in.) portrait of her in 1723 (Family Papers. Bills 524) and a portrait is listed in Musgrave's Hatfield list of 1769 when it was in the Drawing Room next to a portrait of her sister the 4th Countess of Salisbury. The date and age of the sitter fit this identification.

276 [111] ill. 170, p. 290

Mrs Wrey or Wray (fl. 1694), 1694

Sir Godfrey Kneller (1646 or 9–1723)

Canvas 50 × 40 in. (127 × 101·6 cm.)

Three-quarter length, seated slightly to the right her head turned and looking full three-quarters to the left. She has light brown hair; she wears a loose low-cut chemise with olive-green drapery with mauve lining over her left shoulder. The painting is signed and dated in the lower left hand corner: 'G. Kneller fecit/1694'.

In the Hatfield Accounts (Box U 80) is the following receipt which must refer to this portrait 'ye 26 July 1694. Received from the Right honorable the Earle of Salisbury five and twenty pound stg and 2 for a burnisht fream for Mrs Wrey her picture in ful by me. G. Kneller. July 26 1694 Recd. then ten shillings for ye case for ye said picture. I say recd. by me. Edw. Byng'. There is no mention of it in the lists of Hatfield pictures until the 1823 inventory, where it and the oval copy (No. 277) are listed in the Winter Dining Room. It is No. 119 in the 1845 catalogue.

277 [111a]

Mrs Wrey or Wray (fl. 1694), 1694

Studio copy after Sir Godfrey Kneller (1646 or 9–1723)

Canvas 28½ × 23 in. (72·4 × 58·4 cm.) oval

Similar to No. 276 but head and shoulders only.

This portrait is first recorded in the 1823 inventory as an oval portrait of Mrs Wrey by Dobson in the Winter Dining Room. It is No. 8 in the 1845 catalogue listed as by Kneller.

Nos 277, 278 and 279 are three ovals, framed alike. Little is known for certain about the sitters. The portraits were painted shortly after the death of the 4th Earl and must have been acquired by his widow. This suggests that they were her friends or superior employees, perhaps governesses to her son.

278 [112] ill. 171, p. 292

Called **Mrs Pow (or Pauw?)**, 1696

Sir Godfrey Kneller (1646 or 9–1723)

Canvas 29½ × 24½ in. (75 × 62·2 cm.) oval

Head and shoulders to the left, she has turned her head to the right, and she looks down in that direction. She has very fair hair with a tress over her right shoulder which she touches with her left hand; she has hazel eyes; she wears a loose low-cut blue dress. The painting is signed and dated to the right: 'Godfrey Kneller/fe 1696'.

This and No. 279 were probably the two unnamed ovals listed in the Winter Dining Room in the Hatfield inventory of 1823. It is not traceable in earlier Hatfield lists. In the 1845 catalogue No. 15, it is listed as by Kneller, 1696, but given no name. The first mention of the portrait under the name of Mrs Pow is in the 1871 inventory, p. 155, when it hung in Lady Salisbury's Morning Room. In notes at the National Portrait Gallery

made by L. G. Holland, prior to his 1891 catalogue he stated that the name, Mrs Pow, was on a label at the back. It is no longer there.

279 [113] ill. 172, p. 292

Mrs Lee (fl. 1696), 1696

In the Salisbury House inventory of 1692 a lodging room belonging to Mrs Lee is mentioned

Sir Godfrey Kneller (1646 or 9–1723)

Canvas 29¾ × 24¾ in. (75·6 × 62·8 cm.) oval

Head and shoulders to the right, looking at the spectator. She wears a loose low-cut green dress with blue drapery over her left shoulder. Written on the back is: 'Mrs Lee/Kneller fecit/1696'.

This is unnamed in the 1823 inventory and not recorded earlier; it is No. 1 in the 1845 catalogue. See also Nos 277 and 278.

280 [119]

Margaret (Cocks), Countess of Hardwicke (d. 1761)

Margaret Cocks whose mother was sister of John 1st Lord Somers, married first John Lygon and secondly in 1719, Philip Yorke, 1st Earl of Hardwicke

Attributed to Sir Godfrey Kneller (1646 or 9–1723)

Canvas 49¾ × 40 in. (126·4 × 101·6 cm.)

Three-quarter length, standing leaning against a balustrade to the right, her head turned to the left looking down. She has dark brown hair and hazel eyes and is wearing a white dress and blue drapery, with a wispy black veil over the back of her head. Sky and trees are seen to the right.

This portrait was presented to the 3rd Marquess of Salisbury before 1891 by Charles Butler of Warren Wood, Herts. He had bought it at the sale of the Earl of Hardwicke's collection at

Wimpole on June 30, 1888, lot 47. It was catalogued at the sale as 'Lady Salisbury' by Kneller. Why it was called Lady Salisbury is not known.

A similar portrait in the collection of Sir John Carew Pole, Bart., at Antony, Cornwall, is inscribed as the wife of Lord Chancellor Hardwicke and is a pair with a portrait of him. It was probably painted shortly after the death of her first husband, John Lygon. The features correspond with hers in a Kneller of 1713 belonging to Lord Hardwicke.

281

Sir John Saunders Sebright, Bart. (before 1737–1796), 1789

Lieut-General Sir John Sebright succeeded his brother as baronet in 1737 soon after the death of his father that year. He had a seat Beechwood, near Dunstable, in Hertfordshire and was a Member of Parliament from 1763 to 1780

H. Sebright (fl. 1789)

Canvas 14¾ × 11⅜ in. (37·5 × 28·9 cm.) sight

Head and half shoulders to the left, looking at the spectator, wearing scarlet military uniform with black facings, gold lace and gilt buttons, open showing a cream coloured waistcoat.

The canvas is inscribed on the back: 'Sir John S. Sebright Bt/H. Sebright Pinxt 1789'.

This is not mentioned in the 1891 catalogue or in any earlier Hatfield lists, but has been in the collection for many years.

H. Sebright was presumably an amateur artist. He did not exhibit in London. His relationship to the sitter is not known.

282 [142]

George Brudenell Montagu, Duke of Montagu, K.G. (1712–1790), 1789/90

George Brudenell Montagu was the son of the 3rd

Earl of Cardigan. He married Lady Mary Montagu, daughter of the Duke of Montagu (d. 1749). He was created Duke of Montagu in 1776, K.G., 1752. He was Governor of Windsor Castle from 1752 until his death

Sir William Beechey (1753–1839)

Canvas 30 × 25 in. (76·2 × 63·5 cm.)

Head and shoulders to the left, looking at the spectator. He has aged features. The sitter wears a powdered wig and blue and red Windsor uniform with the Garter star on his left breast. The Round Tower of Windsor Castle is seen above trees on the left.

The original was exhibited at the Royal Academy in 1790, Montagu having sat in 1789. A stipple engraving of it by J. Collyer was published in 1793. In the engraving the background is plain. Three studio copies are recorded in Beechey's account book as made in 1791 at 15 guineas each; the original cost 10 guineas but Beechey's charges were raised before the copies were made. The original is presumed to be the version belonging to the Duke of Buccleuch. The copies were made for Mr Oddie, Lord Aylesbury and Lord Cardigan.

The first known record of the portrait at Hatfield is in the 1891 catalogue.

283 [146]

John Whitemore (1698–1801), 1800

Richard Livesay (d. 1823?)

Panel 11½ × 9¾ in. (29·2 × 24·8 cm.)

Head in profile to the left, his grey-black hair reaches to his shoulders. He wears a brown coat.

On the back is written in ink: 'John Whitemore was born in Bedfordshire January 7, 1698. He lived at a farm Carington, Hillfoot. This portrait of him, was painted at Hatfield, Jan. 1800 by R. Livesay'.

Livesay includes Whitemore in his Hatfield

Review, No. 295. The first record found of the painting is in the 1891 catalogue.

284

Thomas Villiers, 2nd Earl of Clarendon (1753–1824), 1824

Robert Trewick Bone (1790–1840)

Panel 13½ × 11½ in. (34·3 × 29·2 cm.)

A head and shoulders portrait, the sitter is in profile to the left, has powdered hair tied in a queue and wears a black coat and buff waistcoat. The back of the panel is inscribed: 'Earl of Clarendon/1824/Robert Trewick Bone fecit/15 Berners St.'

This is not included in the 1845 or 1891 catalogues. Its provenance and date of acquisition are not known. An engraving of it in stipple was published by R. T. Bone in 1825.

285 [159] ill. 173, p. 293

Arthur Wellesley, 1st Duke of Wellington (1769–1852), 1835

Sir David Wilkie (1785–1841)

Canvas 94 × 58 in. (238·8 × 147·3 cm.)

A whole-length portrait, the Duke is standing to the right looking at the spectator. He rests both hands on his sword-hilt and holds his cocked hat; he wears a blue coat and black cape, and white (or cream?) trousers. The jewel of the Order of the Golden Fleece is suspended around his neck, and he wears the Waterloo medal. There is a column to the left.

In the 2nd Marquess's correspondence at Hatfield is a letter from Sir David Wilkie dated July 22, 1835, stating : 'the portrait of the Duke of Wellington had just come down from the exhibition of the Royal Academy and is now ready to be delivered to your Lordship'; and: '. . . perhaps your Lordship will consider about

the frame it will require when put up, as that it had in the exhibition is only temporary'.

The Duke first sat to Wilkie at Stratfield Saye in October and November 1832 and September 1833 for the portrait standing by his charger which was commissioned for the Merchant Taylor's Company. The Hatfield portrait was exhibited at the Royal Academy in 1835, No. 112, as of the Duke in the dress he wore on active service. It was also exhibited at the British Institution in 1842, No. 13. It is No. 91 in the 1845 Hatfield catalogue.

The Hatfield portrait which was commissioned by the 2nd Marquess of Salisbury was first seen by Frances, 2nd Marchioness, on March 2, 1835 at Wilkie's house. She wrote in her diary for that day: 'went to see the picture Wilkie is doing for us of the Duke of Wellington. It is finely colored but I have seen likenesses of him that have pleased me better'. When she saw it at the Royal Academy, May 19, 1835, she wrote: 'went to the Exhibition with the Duke, Mlle d'Este and Lord Ellenborough . . . I am afraid I cannot change the opinion I formed the first moment I saw Wilkie's picture of him, that it is a decided failure in likeness. He thought so himself, and that it was too large about the body. The colouring, though, is good and it is far superior to the two other portraits of him – that by Pickersgill is like a drunken undertaker, and that by Morton made of wood. To these two criticisms Lord Aberdeen adds a third, that Wilkie's is like a Spanish beggarman.' See *The Gascoyne Heiress*, by Carola Oman, 1968, pp. 155 and 165–6.

The sittings for the Merchant Taylor's Company's portrait are recorded in *The Life of Sir David Wilkie* by Allan Cunningham, 1843, Vol. iii, pp. 63, and 71. A number of Wilkie's portraits of the Duke, and sketches for them are recorded in *The Iconography of the First Duke of Wellington* by Lord Gerald Wellesley and John Steegmann, 1935, pp. 50–1. The Hatfield portrait is reproduced on plate 30.

286 [160]

Arthur Wellesley, 1st Duke of Wellington (1769–1852)

See No. 285

Henry Weigall the Younger (1829–1925)

Canvas 49 × 39 in. (124·5 × 99·1 cm.)

Three-quarter length; the Duke is standing turned to the left, looking at the spectator and wearing a blue coat and white waistcoat, with the jewel of the Order of the Golden Fleece, and the ribbon and star of the Order of the Garter.

The portrait is referred to in a letter at Hatfield, in the 2nd Marquess's correspondence, from the 2nd Duke of Wellington, March 1, 1864: 'the picture is painted by Weigall, to whom my father sat for the last picture that was painted of him. Mr Weigall painted two, and this is the 'replique'; the other was exhibited in the International Exhibition and I believe belongs to Mrs Jones of Panglass, and that it was painted for her. My only objection to it is that it is not the kind of likeness which I think ought to be in the house. This criticism does not hold good for friends. My picture is dirt cheap – my bargain was mud cheap I grant'. It thus appears that this was bought by the 2nd Marquess of Salisbury from the 2nd Duke of Wellington in 1864.

Sittings were given to Weigall in the autumn of 1851. Weigall exhibited portraits of Wellington at the Royal Academy in 1852 No. 919, 1853 No. 912 and 1854 No. 381. The original is believed to be a whole-length which belonged for a period to Priscilla, Countess of Westmorland, Wellington's favourite niece. Weigall married her daughter, Lady Rose Fane, and the portrait later came back into his possession. It belongs now to the present Duke of Wellington.

A portrait of the Duke of Wellington by Weigall was in Christies' sale of July 19, 1862, lot 79, the owner's name was not published. It

was bought in. This might well have been bought by the 2nd Duke of Wellington after the sale and be this portrait.

Literature: The Iconography of the First Duke of Wellington by Lord Gerald Wellesley and John Steegmann, 1935, p. 50.

287 [173]

Admiral Henry John Chetwynd Talbot, 18th Earl of Shrewsbury and 3rd of Talbot (1803–1868)

The son of the 2nd Earl of Talbot, he succeeded his father in 1849 and succeeded a kinsman as 18th Earl of Shrewsbury in 1856. He was a first cousin once removed of the 2nd Marquess of Salisbury. He was Member of Parliament for Hereford, 1830–1, and elsewhere later

John St John Long (1797–1834)

Canvas 49 × 39 in. (125 × 99·1 cm.)

A three-quarter length portrait; the sitter has dark brown curly hair; he is standing wearing a captain's naval uniform with a red band round the edge of his cuff which was first worn in 1830. He wears three decorations – that of companion of the Order of the Bath and the orders of St Louis of France and St Anne of Russia. A ship's mast and rigging are seen in the background. Captain Talbot received the orders depicted soon after a naval action in which he took part in 1827. He was admitted to the Greek order of the Redeemer in 1833. All this points to the portrait being painted about the time Captain Talbot was M.P. for Hereford, 1830–1.

The portrait is first recorded at Hatfield House in the 1891 catalogue.

288

Eight sketches by Sir Edwin Landseer (1802–1873)

All pen and ink or ink wash with a little coloured wash on paper

If they were all made at about the same time this must have been near 1850 as Lord Jocelyn (c & d) died in 1854. They were removed recently from an album at Hatfield House that had belonged to Lady Jocelyn the maternal grandmother of the 5th Marchioness of Salisbury. The names now on the backs of the backing boards were noted from the album.

a Lady Louisa Jane (Russell), Duchess of Abercorn (d. 1905)

Lady Abercorn was the second daughter of the 6th Duke of Bedford. She married the 2nd Marquess of Abercorn in 1832. He was created a Duke in 1868

8¾ × 6¾ in. (22·2 × 17·1 cm.) sight

Whole-length, in profile to the left, dark hair, pale mauve dress: 'Duchess of Abercorn' on a typed label at back.

b Perhaps Lady Agnes Georgina Elizabeth (Hay), Countess of Fife (d. 1869)

Daughter of the 17th Earl of Erroll, she married in 1846. Her husband succeeded as 5th Earl of Fife in 1857

6⅞ × 4¼ in. (17·5 × 10·8 cm.) sight

Whole length, head view, in evening dress. Labelled as Duchess of Fife but is of too early a date for her.

c Robert Jocelyn, Viscount Jocelyn (1816–1854)

Eldest son of the 3rd Earl of Roden. He died before his father

5¾ × 4⅛ in. (14·6 × 10·5 cm.) sight

To the waist in profile to the left. His name is inscribed in pencil at the back.

d Robert Jocelyn, Viscount Jocelyn (1816–1854)

8½ × 7 in. (21·6 × 17·8 cm.) sight

Head only, three-quarters to the right, looking to the right of the spectator, vignetted. Written on paper on the backing board is: 'Viscount Jocelyn by Sir Edwin Landseer drawn at Balmoral'.

e Recumbent Lion with paws on Landseer, ill. 174, p. 294

4⅜ × 6⅞ in. (11·2 × 17·5 cm.) sight

Landseer is lying face downwards. Inscribed at top: 'My last night's nightmare EL'. E.L. is in monogram in a circle.

f Unknown Man

6⅞ × 4¼ in. (17·5 × 10·8 cm.) sight

Half-length, head view, his head in profile to left. He is bearded.

g Unknown Man

8 × 6¾ in. (20·3 × 17·1 cm.) sight

Whole length, seated in profile to left, pink wash on face.

h Two dogs

7 × 8½ in. (17·8 × 21·6 cm.) sight

One standing with legs outstretched, the other sitting in front.

289

Unknown Elderly Man, 1868

C. J. Basébe (fl. 1835–91)

Watercolour on paper 7¾ × 6⅛ in. (19·7 × 15·6 cm.) sight – in oval mount

Three-quarter length, seated, turned to the left, looking at the spectator, a book in his hand; grey hair and side-whiskers, pale blue eyes. Sea and buildings can be seen in the distance to the left, vignetted. Signed and dated: 'C. J. Basébe/1868'.

Neither No. 289 nor No. 290, which are a pair, were included in the 1891 catalogue. They are believed to represent relatives of the 3rd Marchioness and may be portraits of members of her mother's family, Drewe.

290

Unknown Middle aged Lady, 1868

C. J. Basébe (fl. 1835–91)

Watercolour 7¾ × 6⅜ in. (19·7 × 16·2 cm.) sight – in oval mount

Half-length, seated turned to the right; her left hand to her cheek, a white bonnet-like head-dress medium brown hair, black dress, a desk to the right, vignetted. Signed and dated: 'C. J. Basébe/1868'. This and No. 289 are a pair.

Several members of the family of Basébe exhibited miniatures in London in the middle of the nineteenth century and later. The artist is presumably C. Basébe who exhibited at the Royal Academy and the Suffolk Street Gallery between 1835 and 1871.

291 [233]

Benjamin Disraeli, Earl of Beaconsfield (1804–1881)

The Conservative Statesman and Novelist

Copy after Heinrich von Angeli (1840–1925)

Canvas 27 × 22 in. (68·6 × 55·9 cm.)

Head and shoulders, slightly to the left, looking down to the left, his hair is black and he wears a black coat.

The original which is the same size is in the Royal Collection at Windsor Castle.

292 [199] ill. 175, p. 294

Landscape view of Hatfield House, *c.*1740

Painter unknown 175, p. 294

Canvas 31 × 47½ in. (78·7 × 120·6 cm.)

Hatfield House is seen in the middle distance from the south-east. There are a few persons on horseback between the house and the spectator and in the foreground there is a group of three, one standing and two sitting, on the hillside.

From the costumes and wigs of the small figures in the landscape this painting can be dated as near 1740. The first known record of it is in the 1845 manuscript catalogue, No. 187: 'Landscape view of Hatfield House painted some years ago', in the Steward's Room. No artist was named. A payment of £5. 7. 6 was made in 1699 to Mr Thomas Sadler, Junior, for drawing Hatfield House (Family Paper, Accounts 75/7), but there is no later reference to this.

293 ill. 176, p. 295

Hatfield House, South Front, *c.*1785

Attributed to William Tomkins (*c.*1730–1792) or Charles Tomkins (*c.*1750–post 1798)

Canvas 25½ × 48 in. (64·8 × 121·9 cm.)

The view is from slightly to the east of south taken in the afternoon sunshine in the summer. Three horses are grazing in the middle right foreground, a group of five adults and two children stand a little way off towards the left. Hatfield Church is seen further back in the middle of the left half of the painting. From the costumes and wigs the painting may be dated as of near 1785.

This and No. 294 are likely to be two of three views of Hatfield House, etc, by Tomkins which were framed by Beckwith and are mentioned in his account of March 1790, p. 9.

294 ill. 177, p. 295

Hatfield House, North Front, *c.*1785

Attributed to William Tomkins (*c.*1730–1792) or Charles Tomkins (*c.*1750–post 1798)

Canvas 25½ × 48 in. (64·8 × 121·9 cm.)

The view is taken from a little to the west of north. From the shadows and foliage it must have been taken in the early morning in the summer. A few people are seen a little way off from the spectator but not near the house, in the left half of the painting.

The painting is a pair with No. 292 *q.v.*

295 [145] ill. 178, p. 296

The Grand Review of Troops at Hatfield by King George III on June 13, 1800

Richard Livesay (d. 1823?)

Canvas 78 × 120¾ in. (198·1 × 304·8 cm.)

The troops are drawn up in many lines; the cavalry, nearer the spectator, are moving from left to right; the infantry move from right to left covering the middle distance from end to end of the canvas except for an open space in the centre in which is the royal carriage and an assembly of spectators; these are all too far off for any persons to be identified. Hatfield House is seen from the south-east some distance beyond the troops to the left. On rising ground in the foreground are a small number of spectators including, near the left, the back view of a man (the artist?) with a woman and child, and towards the right an old man, the centenarian John Whitemore, and a few others; a cavalryman close by is urging them to keep back.

This work is signed and dated in black near the lower left corner: 'Rd Livesay, 1802'.

This is not in the 1823 Hatfield inventory but is in Robinson's 1833 list. In the 1845 manuscript

catalogue it is given as hanging on the stairs in the East Wing.

An engraving in colour of this painting, by J. C. Stadler, was published, January 8, 1802, by Richard Livesay who is described on the print as 'Drawing Master to the Royal Academy, Portsmouth', and as living in Hanover Street, Portsea, Hants. The engraving is entitled: 'Review of the Volunteer Cavalry and Infantry with the Militia of the County of Herts on June 13, 1800', 'from A Picture painted for His Lordship', i.e. the Marquess of Salisbury to whom the print was dedicated. Preserved at Hatfield (Family Paper, Bills 608) is Richard Livesay's receipt dated March 4, 1802, for four etchings of the Hatfield Review, but no record of payment for the painting.

296 ill. 179, p. 296

The Grand Review of Troops at Hatfield by King George III on June 13, 1800

Richard Livesay (d. 1823?)

Watercolour on paper 19 × 30 in. (48·3 × 76·2 cm.)

This drawing is similar to the painting No. 295 but extended a little to the spectator's right.

In a folio volume of notes by Mr Gunton on Hatfield House and Garden is a note that a watercolour drawing of the 1800 Review at Hatfield House, being the original from which Stadler engraved his aquatint, was bought by Lady Salisbury from Mr Speaight in 1916.

297 ill. 180, p. 297

Scene during the Grand Review of Troops at Hatfield on June 13, 1800, c.1802

Richard Livesay (d. 1823?)

Watercolour on paper 13½ × 24¾ in. (34·3 × 65·4 cm.)

The scene is in Hatfield Park, east-south-east of Hatfield House, which is seen in the distance a little from the left side. A long double line of infantry, seen from the rear stretches across the foreground and down the hillside to the right. They appear to be presenting arms to the King advancing up the hill from the right followed by his retinue, all on horseback. Beyond, towards the right is a long double line of cavalry stretched towards the horizon. There are other troops, and in the foreground, on the right, a few spectators stand under a tree.

This and No. 298 are not recorded in the 1891 catalogue but must be the two coloured drawings in gilt frames 'Review in Hatfield Park' listed in the 1868 inventory as being in the West attic.

298 ill. 181, p. 297

Scene during the Grand Review of Troops at Hatfield on June 13, 1800, c.1802

Richard Livesay (d. 1823?)

Watercolour 13½ × 25¾ in. (34·3 × 65·4 cm.)

This is a view taken from the front of a double line of infantry. They appear to be presenting arms to the King who with his retinue rides past them. The nearest troops are on the right, the line of troops disappears among trees just to the left of the centre.

See also No. 297.

299 ill. 182, p. 298

Coursing at Hatfield Park, 1805

John F. Sartorius (1775?–1831?)

Canvas 24 × 33¼ in. (61 × 84·5 cm.)

Hatfield House is in the centre background, seen from the south-east. Two greyhounds are in pursuit of a hare running to the left in the middle distance. Several men and one lady on horseback

are in the foreground and to the right are four greyhounds held on leashes. The Marquess and Marchioness of Salisbury in the uniform of the Hatfield Hunt are said to be among those seen on horseback but no features are distinct enough to make them recognizable.

This painting was bought at Sotheby's sale of November 24, 1965, lot 179, among 'Other Properties'. It was catalogued as by John N. Sartorius and given the title 'Coursing at Hatfield Park, with the Marquess and Marchioness of Salisbury in the uniform of the old Hatfield Hunt'. It must, however, be the painting exhibited by John F. Sartorius at the Royal Academy in 1806, No. 296. It was then catalogued as: 'Coursing at Hatfield-Park, with portraits of horses belonging to the Marchioness of Salisbury'.

The Hatfield Hunt colours were sky blue with black collar and cuffs and silver buttons.

300 ill. 183, p. 298

The Old Palace, Hatfield, 1812

J. Buckler (1770–1851)

Watercolour on paper $14\frac{1}{2} \times 19\frac{1}{2}$ in. (36·8 × 49·6 cm.)

A view of the West Front. Signed low on the right: 'J. Buckler, 1812'. On the mount is written: 'Remains of the Bishop of Ely's Palace at Hatfield, Hertfordshire'.

301

Six watercolour drawings of Hatfield House, exterior and interior, 1835–46

All by the same unknown artist

a Hatfield House, The Gallery

Paper $6\frac{7}{8} \times 9\frac{3}{8}$ in. (17·5 × 23·8 cm.)

Drawn from behind the two columns at the West end; at the other end is a lady seated at an oval table covered with a white cloth; there are three men in the room. The drawing is inscribed in the lower left corner – 'field', the beginning of the word has been trimmed off. Inscribed below on the mount: 'Gallery, Hatfield House, 1835'.

b Hatfield House, West Wing ill. 184, p. 299

Paper $7 \times 10\frac{1}{2}$ in. (17·8 × 26·7 cm.)

View from the East side of the wing. Inscribed below, on the mount: 'Hatfield House West Wing after the fire, Nov. 27th 1839'. This and the next drawing show the West wing as left after the fire of 1835 and before it was rebuilt.

c Hatfield House, West Wing

Paper $7 \times 10\frac{1}{2}$ in. (17·8 × 25·4 cm.)

View of the West Wing from the West side. Inscribed below, on the mount: 'West wing of Hatfield House after the fire Nov. 27th 1839'.

d Hatfield House, Yew Room

Paper $7\frac{1}{2} \times 10\frac{7}{8}$ in. (19 × 27·6 cm.)

The fireplace is on the right with an oak table in front of it; on the left is an open door; there are six portraits on the walls.

Inscribed below, on the mount: 'Yew Room, Hatfield House, 1843'.

e Hatfield House, Summer Dining Room

Paper $7\frac{5}{8} \times 10\frac{3}{4}$ in. (19·4 × 27·3 cm.)

A view from opposite the fireplace on each side of which are hung three portraits. In the left half of the drawing a table, with three chairs round it, is laid for a meal.

Inscribed below on the mount 'Hatfield House. Summer Dining Room, 1844'.

f Hatfield House, North Front

Paper $7\frac{3}{8} \times 11\frac{3}{4}$ in. (18·7 × 29·8 cm.)

A view of the North Front; a carriage drawn by four horses is arriving, there are three persons on horseback and one who has dismounted, all in the forecourt. Inscribed below, on the mount: 'Hatfield House, North Front, 1844'.

The six drawings and two following were purchased from a dealer a few years ago. Their previous history is not known. They are well drawn and are presumably the work of one of the friends of the 2nd Marquess and his first wife, who was evidently a frequent visitior to Hatfield House. The Marchioness gathered the work of her friends into several albums which are still at Hatfield. Much of this work is of high quality. Most of the drawings are views of houses or of fine scenery in this country and other parts of Europe.

302

Two watercolours depicting Queen Victoria's visit to Hatfield House on October 25, 1846

Both by the same unknown artist as the previous six drawings

a The Supper

Paper $10\frac{3}{8} \times 10\frac{7}{8}$ in. (26·2 × 27·6 cm.)

The interior of the Marble Hall viewed from the West end. A long table covered with white cloths along the foreground and one on each side are loaded with food, included is a model of a church with a tower, carved in sugar(?); at the far end is a large round table at which people are seated, too small to be identified; other guests are entering from the door at the far end on the left; some have reached the long table and are being served by members of the staff on the other side of the tables. Lights are concealed in large balloons hung from the ceiling, in the panels of which are the heads of the Caesars which were there before the present paintings.

Inscribed in pencil on the mount below the drawing is: 'Marble Hall Hatfield House. Queen Victoria at Supper, Oct 23, 1846'.

b Queen Victoria and Guests in the Gallery, ill. 185, p. 300

Paper $10\frac{1}{8} \times 12\frac{1}{4}$ in. (25·4 × 31·2 cm.)

A view taken from the West end of the Gallery with the curtained windows on the right. The Queen in white and wearing the blue ribbon of the Order of the Garter is near the foreground on the right. Lord Salisbury (the 2nd Marquess) is near her, as if about to dance with her. Many guests are depicted in the room some of whom in the foreground are probably identifiable; the Duke of Wellington appears to be near the centre with his back to the spectator and his head turned to the left; there are several other Knights of the Garter wearing their blue ribbons.

Inscribed on the mount below the drawing is: 'Gallery, Hatfield House Ball for Queen Victoria Oct 23rd 1846'.

These two drawings were purchased with the previous six drawings.

303 ill. 186, p. 300

A Garden Party at Hatfield House, c.1899

A. Faulkner (fl. 1899)

Pencil $16 \times 11\frac{1}{2}$ in. (40·6 × 29 cm.)

The 3rd Marquess of Salisbury and others with the South East corner of Hatfield House, and Hatfield Church Tower, seen in the background.

Those whose portraits are drawn are, from left to right: the Duke of York (King George V), Lady Gwendolen Cecil, the Duchess of York (Queen Mary), the Prince of Wales (King Edward VII), Lady Cranborne (4th Marchioness of Salisbury), the Marquess of Salisbury, the Hon. Robert Cecil (5th Marquess of Salisbury), the Countess Torby, and the Marchioness of London-

derry. Signed low on the right: 'A. Faulkner'. Inscribed on the mount: 'Original drawing reproduced in "Lady's Pictorial".'

The Garden Party to celebrate Queen Victoria's 80th birthday was held on June 10, 1899. A report of it including a list of many of the guests was published in *The Times* on June 12. The drawing by A. Faulkner was reproduced on the front page of the *Lady's Pictorial* of June 17, and an account of the party was printed on page 871 of that issue. Owing to her having caught a severe chill Lady Salisbury was unable to receive the guests. Lady Gwendolen Cecil took her place, relieved for a while by Lady Cranborne.

304 ill. 187, p. 301

The Casino, Aldborough, 1809

Perry Nursey (fl. 1799–1809)

Canvas $35\frac{1}{2} \times 63\frac{1}{2}$ in. ($90\cdot2 \times 161\cdot3$ cm.) sight

The house with a lawn is in the foreground on which are two cannon facing seawards to the right. The church is further back to the left, on the right on lower ground are some red-tiled houses, the sea can be seen above their roofs.

There is a contemporary engraving by R. Brook of this painting.

The Casino was built by the First Marquess of Salisbury in or just before 1803/4. There are at Hatfield House records of payments for work done on it in 1803/4 and in 'Bills 627' is one dated 1809 from Perry Nursey for £33. 18. 0 for a painting of the Casino.

305 ill. 188, p. 301

Childwall Hall

John Nash (1752–1835)

Pen and sepia wash on paper $18\frac{1}{4} \times 26\frac{1}{2}$ in. ($46\cdot4 \times 67\cdot3$ cm.) sight

There are ruins among the trees on both sides of the house.

306

Childwall Hall in the early nineteenth century

Artist unknown

Watercolour on paper $13\frac{3}{4} \times 19\frac{3}{4}$ in. ($34\cdot9 \times 50\cdot2$ cm.) sight

The house is of pale brown stone, the beginning of an avenue is seen to the right, a gardener is sweeping with a besom in the foreground on the left, a grass lawn reaches right up to the house.

307 ill. 189, p. 302

The North Porch at Cranborne Manor, 1932

Sir Winston Churchill (1874–1965)

Canvas $23\frac{1}{4} \times 19\frac{1}{2}$ in. ($59 \times 49\cdot5$ cm.) sight

The porch is of grey stone, a green-leafed tree on the right. This was signed by him at a later date in the lower left corner: 'W.S.C.'.

This was painted when Sir Winston stayed at Cranborne Manor on a visit to Lord and Lady Salisbury, then Lord and Lady Cranborne, in 1932, and was his gift.

This and another view of the North Porch, now at Chartwell, are reproduced in *Churchill, his Paintings*, by David Coombs, 1967. This is No. 226, p. 165.

308 [217]

View of the Citadel of Charleroi, near Namur, besieged in 1667

Adam Frans Van der Meulen (1632–1690)

Canvas 40×54 in. (39×53 cm.) sight

A large fort is on a low hill towards the right in

the middle distance, a number of barrack-like buildings are on its left on a lower level and across a wide river, linked by a bridge. A few horses are in the foreground two of which are laden. Just beyond them on the right is a group of cavalry, a messenger on foot is delivering a note to their commander, a few more cavalrymen are approaching up a valley from the left. The saddle bag of the horse nearest the spectator towards the right bears a somewhat illegible monogram which may be that of the artist.

The painting is similar to, but by no means identical with, a larger painting by Van der Meulen at Versailles, No. 254 in the Versailles Museum catalogue; *Compositions Historiques* by André Pérate and Gaston Brière, 1931. The Versailles painting is entitled 'Vue de la citadelle de Charleroi près de Namur assiégée en 1667'. There are two copies in an upright form also at Versailles.

The original is reproduced in *Französiche Malerei des XVII Jahrhunderts* by Werner Weisbach, 1932, plate 33.

The Hatfield painting was catalogued in 1891 as depicting Louis XIV and his staff in the foreground. The figures are on too small a scale to be identifiable. Voltaire in *La Siecle de Louis XIV* wrote: 'Il [Louis] entre dans Charleroi comme dans Paris (juin 1667).' The artist painted several battle pieces for Louis XIV which are now at Versailles.

309

View of a House and Park (Hillsborough House (?))

John Downman (?) (1750–1824)

Watercolour 14¼ × 20¾ in. (36·2 × 52·7 cm.)

A corner of an eighteenth-century house is seen on the left, the rest of the painting is of a nearly level garden and park in which a few persons are strolling, the most prominent being an officer in a scarlet uniform with buff facings (the colours of the Hertfordshire militia) with a lady. The picture is signed in the lower right corner: 'JD delin'.

From the costumes the painting can be dated as being of about the mid-1780's.

The drawing is not recorded in the 1891 catalogue or any previous catalogue or list.

3 1 0 [183] ill. 190, p. 302

Veduta de Genoa, 1791

John Thomas Serres (1759–1825)

Canvas 25¼ × 36½ in. (64·1 × 92·7 cm.)

On the right are a jetty and three light-houses, one on the end of the jetty, one on a rock just behind and one on a cliff on the extreme right, there are several sailing ships and boats. The water is very calm giving clear steady reflections.

Signed on the stern of the ship on the right: 'I.T. SERRES' and dated on the starboard side: 'ROMA 1791'.

The first record found of this painting is in the Hatfield House 1845 catalogue, No. 171, when it hung in the Billiard Room. It was omitted from the 1891 catalogue.

3 1 1 [224] ill. 191, p. 303

Dieppe Harbour, 1876

Antoine Vollon (1833–1900)

Canvas 43½ × 59½ in. (110·5 × 151 cm.)

In the foreground on the quay are (from left to right) Lords Edward, William, Robert and Hugh Cecil, sons of the 3rd Marquess of Salisbury. Signed near the lower left corner, 'A. Vollon, 1876'.

Osbert Sitwell in his *Noble Essences or Courteous Revelations*, 1950, pp. 192–3, relates the following story that Sickert told him about how this painting was acquired: 'One day, however, he

[the 3rd Marquess of Salisbury] allowed himself to be taken to see the work of a quasi-Impressionist painter, who lived at Dieppe in circumstances of great poverty. Lord Salisbury had felt sorry for the artist, and had determined to help him. And so, on being shown a picture of the river at Dieppe, he had generously said, "I will buy that river-scene for five-hundred pounds if you will paint in a boat containing my family and myself."

'Enchanted at the idea of a sum that was at least ten times as large as any he had ever asked, and even though, perhaps, a little startled by the stipulation that his new patron had imposed, the painter had eagerly agreed, and had interjected upon the nebulous water a fishing-vessel containing the members of this distinguished English family . . . This story, in its turn, produced a pleasant sequel, for remembering it, I repeated it to Lady Cranborne[1] some years later, and asked her if the picture still hung at Hatfield. . . . Its existence had been forgotten, but her mother-in-law, Lady Salisbury, looked for it, and, sure enough, it was found, as described, put away in the attics there.[2]'

312

Hawes

Wilson Steer (1860–1942)

Watercolours on paper $9\frac{1}{8} \times 14\frac{1}{2}$ in. (23·2 × 36·8 cm.) sight

A house is seen to the left, a clump of trees to the right, a slight grassy dip between them. The drawing is signed in the lower right corner: 'G.W. Steer', at the back is the label of Charles Jackson, a dealer of Manchester. On this is the artist's name and the title, 'Hawes'.

[1] Now Marchioness of Salisbury.
[2] I had forgotten – if Sickert told me – the name of the artist. But Lady Salisbury informed me that the picture is signed: 'A. Vollon'.

This was purchased at Christie's sale, March 20, 1970, lot 219.

313

A Church Doorway, San Remo

Knighton Hammond (1876–1900)

Ink and watercolour 18 × 13 in. (45·7 × 33 cm.) sight

Outside a church doorway. Several persons are standing and sitting on the paving. Signed low on the left.

314

Yachts, Maldon, 1920

Wilson Steer (1860–1942)

Canvas $19\frac{1}{2} \times 29\frac{1}{2}$ in. (49·3 × 75 cm.)

A harbour scene with four sailing ships with sails furled moored on the far side of a quay. Signed and dated.

On the back is a label of the Adams Gallery, London. On this is typed: 'Yachts, Maldon 1920 Ex coll. R.F. Goldschmidt, Albert Mackinson'.

This was bought at Christie's sale of March 10, 1967, lot 94, among miscellaneous properties. It was reproduced in the sale catalogue in which it was stated to have been in the collections of Charles A. Jackson, R. F. Goldschmidt, Albert Mackinson, O. Hughes Jones and the Lefèvre Gallery.

Literature: D. S. MacColl, *Philip Wilson Steer*, 1945, p. 218.

315

Ten drawings by Sir Albert Richardson (1880–1964)

All watercolour on paper

a St Flow

$5\frac{3}{8} \times 8\frac{3}{4}$ in. (13·7 × 22·2 cm.) sight

Signed near right bottom corner: 'A.E.R. and inscribed towards the left: 'St Flow from my window, Friday morning at 7, Sept 7 '38'.

b Chichester

$9\frac{7}{8} \times 11\frac{7}{8}$ in. (25 × 30·2 cm.) sight

A view of the Cathedral over the roof tops of houses. Inscribed low on left 'Chichester. Nov. 1951'.

c Interior of a Cathedral

$12\frac{1}{4} \times 8\frac{7}{8}$ in. (31·1 × 22·5 cm.)

A side-chapel and a pulpit to the right. Signed and dated low on the right once in red and once in pencil: 'AER 1952'.

d Ham House

$10\frac{1}{2} \times 14\frac{1}{4}$ in. (26·7 × 36·2 cm.)

View from under the portico with a large number of sightseers at the entrance. Inscribed low on the right: 'AER Ham House July 1953'.

e York

$9\frac{1}{2} \times 7\frac{1}{2}$ in. (24·1 × 19 cm.)

A street scene with a church in the background. Inscribed low on the right: '25 Dec 58, York, AER'.

f Laon Cathedral, Interior

$10\frac{3}{8} \times 13\frac{1}{4}$ in. (26·3 × 33·7 cm.) sight

A view across the nave from a transept. Inscribed low on right: 'Laon AER. 1961'.

g Burgos Cathedral, Interior

$8\frac{5}{8} \times 6\frac{7}{8}$ in. (21·9 × 17·4 cm.) sight

A view of part of the nave. Dated low on left, 1963, and inscribed at the back: 'To the Countess [sic] of Salisbury, Burgos Cathedral after a love of Spain by A. E. Richardson Christmas 1963'.

h Ancenis

$5\frac{1}{4} \times 8\frac{1}{2}$ in. (13·3 × 21·6 cm.)

View of some houses and trees. Inscribed low on left: 'Ancenis, France, from the Cafe. AER 10 Sept'.

i Ludlow Castle

$5\frac{3}{8} \times 9$ in. (13·7 × 22·9 cm.)

View from a wooded hillside. Inscribed low on the right: 'Ludlow AER'.

j A Mansion or Palace

$6 \times 10\frac{5}{8}$ in. (15·2 × 27 cm.)

Exterior view with a number of sightseers. Not inscribed.

316 [226]

Landscape with Cattle

Willem Romeyn (1624–1693)

Panel $12\frac{1}{2} \times 13\frac{1}{2}$ in. (31·7 × 34·3 cm.) sight

Three cows in the foreground in the right half of the painting; a cowherd sits on the grass with his back to the spectator a little way off in the centre; a donkey stands head to his left and to the left of this are two trees, with little foliage, and a few goats.

The first certain record of this painting at Hatfield is in the 1823 inventory in which it is listed among pictures in the Breakfast Parlour as: 'Landscape and Cattle, very pleasing, small ... Romain'. In Robinson's list, 1833, it appears as: 'Landscape and Cattle ... Salvator Rosa'. In the 1845, No. 165 and 1891 catalogues the artist is given as Romeyn. It is typical of his work.

317

Landscape with Ruins

Painter unknown

Canvas 13½ × 17 in. (34·3 × 43·2 cm.)

An ancient stone building in ruins takes up the left two thirds of the painting. On stonework in the foreground is a carving in relief of a sea nymph reclining on a dolphin(?)

This and No. 318 must be the 'Group of Ruins touched with very great spirit (small)' and companion listed in the Breakfast Parlour in the 1823 Hatfield inventory. In the 1845 manuscript catalogue they are numbered 202 and 203 and given as by Andrew Both. They were then in the Housekeeper's Room. They were omitted from the 1891 catalogue. No certain reference to them is to be found earlier than 1823 and they may be of the late Eighteenth Century unless one or other is 'Landskip resembling Ruines of Stoneworke', and 'landskip representing ruines of stoneworke' in the Hatfield and Salisbury House inventories of 1679/80 and 1685 respectively.

318

Landscape with Ruins

Painter unknown

Canvas 13½ × 17 in. (34·3 × 43·2 cm.)

A ruin of an ancient stone fortification takes up two thirds of the painting with landscape on the right in which are other buildings; a man and woman are in a hollow in the foreground.

See also No. 317

319 [216]

A Mountain Pass in Switzerland

J. G. Vollerdt (1703–1769)

Canvas 39 × 54 in. (99 × 137·2 cm.)

The scene is wintry. A coach drawn by six horses is crossing a wooden bridge in the foreground. A nineteenth-century label is inscribed: 'A Winter Scene/painted by/Nicholas Moliner'.

The earliest known record of this at Hatfield is in the 1845 catalogue, No. 176. It is listed there as a winter scene in Switzerland by Nicholas Molinaer.

320

Landscape with a carved fountain

Painter unknown

Canvas 50 × 58¼ in. (127 × 148 cm.) sight

Two tall trees and a brown rock cliff reach to the top of the painting on the right; below the cliff is a carved fountain, nearby are a lady in a pale blue dress, a man in a red coat, and three dogs. On the left is a white horse in profile to the right, behind which is a man on a brown horse; there is a boat on a lake in the middle distance. The foliage and sky suggest a summer evening, the costumes are of near 1660.

This and the following landscape do not appear to be in any Hatfield catalogue. Included in the inventory of Diana, Lady Cranborne's chattels made on June 2, 1675 after her death (Estate Papers Box A.14) was 'one Lanskipp with Fontes 10.0' which might be this. The artist is not named.

321

Landscape with a ruined arch

Painter unknown

Canvas 55 × 54½ in. (139·7 × 138·4 cm.) sight

A river leads off from the foreground to the middle distance on the left. A ruined high arch nearly fills the left half of the painting; under it a lady in a yellow dress with pink drapery rides

side-saddle on a brown horse which is walking away to the left; a man follows, with his left hand on the horse's rump, another man and a woman are in the foreground in the middle of the painting. There is a circular stone tower on the far side of the river to the right, it has a square projecting building on the front of which is an entablature on which is carved 'REX' over a crown over crossed swords over a date which appears to be 1640.

This is by the same hand as No. 320.

322 [203]

Large Flemish Landscape with many trees and a broken bough foreground

Painter unknown

Canvas 57¼ × 89 in. (145·4 × 226 cm.)

There are rocks in the foreground and a cliff in the middle distance to the right, a river or lake from the foreground fades into the distance in the right half; there are a seated figure and a dog on a flat rock just to the left of centre and in the left foreground are a man on a brown horse, a woman standing with her back to the spectator, and a dog. A large broken bough is in the foreground on the spectator's right. Except on the right trees form the background.

This is in the 1845 catalogues, No. 191, with exactly the same title. No artist is named in it or in the 1891 catalogue. It appears to be by the same as Nos 320 and 321.

323-32

Ten landscapes traditionally attributed to Ebenezer Sadler (fl. 1670–1713)

For a note on Ebenezer Sadler see No. 273

323 [181]

Canvas 38½ × 33½ in. (87·8 × 85·1 cm.) sight

A small lake with rapids flowing down from it near the lower right corner: in the foreground is a seated figure with back to the spectator.

This and No. 324 are presumably Nos 213 and 214 in the 1845 manuscript catalogue, described as: 'Landscape, Mountain scenery by E. Sadler. They are not identifiable among a number of landscapes in the 1823 inventory.

324 [181a]

Canvas 36½ × 41¾ in. (92·7 × 103·5 cm.) sight

A small lake with green and rocky hills in the near background; in the centre foreground are three figures on the near side of the lake, another man leans against a rock on the left. See also No. 323.

325 [206] ill. 192, p. 303

Canvas 52½ × 41 in. (133·3 × 104·1 cm.)

In the foreground are three small figures, two men and a woman near the broken stump of a tree, a river runs across a little distance behind them; a mountain is seen further off, rising out of the plain, in a break in the tall trees on either side.

The first mention of an artist's name for the five landscapes Nos 325 – 329 is in the 1845 manuscript catalogue, Nos 195-9, in which they are listed in the Steward's Room: 'Five landscapes, Compositions in the manner of Poussin by E. Sadler, butler to the 5th Earl of Salisbury'. In the 1823 inventory an upright landscape is listed in the Coffee Room and four upright landscapes in the Billiard Room but no artist is named for them. Landscapes were not described sufficiently in earlier inventories to identify them.

326 [207]

Canvas 51½ × 37¾ in. (130·8 × 95·9 cm.)

In the foreground a river flows from the right over a waterfall towards the spectator; a soldier wearing a helmet and breastplate stands in the right lower corner with his back to the spectators; a mountain rises out of the plain in the distance; there are trees on either side, the river bank rises steeply on the left.

On the back is a label inscribed: 'Landscape composition painted by Sadler'.

See also No. 325.

327 [208] ill. 193, p. 303

Canvas $53\frac{1}{2} \times 40\frac{1}{4}$ in. (135.3×102.2 cm.)

Three men, one standing, two sitting, are in the foreground close to the bank of a river which crosses from the left towards the spectator and to the right; near the left side, a man propels a boat with a pole. On the far side of the river the ground rises steeply to the right; there are stone buildings in the centre near the river with mountainous scenery behind. The lower part of a tall tree is seen in the foreground on the left.

See also No. 325.

328 [209]

Canvas $53 \times 40\frac{1}{4}$ in. (134.6×102.2 cm.)

A shepherd and his dog stand on the high bank of a river on the left with a tree growing from a rock on the extreme left; the river flows from the distance on the left over some rapids in the foreground to the lower right corner; on the far side of the river is rugged country, misty in the distance.

On the back is a label inscribed: 'Landscape composition painted by Sadler'.

See also No. 325.

329 [210]

Canvas $38 \times 47\frac{1}{2}$ in. (96.5×120.6 cm.) sight

A grassy flat-topped mound with buildings behind and rocky hills in the background; there is a low waterfall on the left, the water flows out towards the spectator; there are two figures on the mound, one standing and one seated.

See also No. 325.

330

Canvas $43\frac{1}{2} \times 38\frac{3}{4}$ in. (87.6×98.4 cm.) sight

A waterfall between high rocks falls towards the spectator from a lake in the middle distance; a man, bare to the waist reclines on a rock near the centre foreground, the sky is stormy. Inscribed in capitals in the lower right corner: 'Painted by Sadler'.

331

Canvas 50×33 in. (128×83.9 cm.) sight

A man with a fishing net leans over the bank of a river in the left foreground; there are high banks on either side and a stone fort (?) in the middle distance by a lake from which the river flows.

332

Canvas $53\frac{1}{4} \times 22\frac{3}{4}$ in. (134.6×57.8 cm.) sight

A man in the lower left foreground is seated on the bank of a river or small lake fishing with a rod and line, there is an overhanging cliff on the right and a less high rock on the left.

333 [204]

Flemish Landscape with Figures

Painter unknown

Canvas $35\frac{1}{2} \times 55$ in. (90.2×140 cm.)

A man in brown costume with a black hat is on a white horse in profile to the left, with three dogs

in the foreground. Other figures are further away. There are ruins on the left.

In the 1845 manuscript catalogue it is No. 194, and in the 1891 catalogue it is given the same title. In neither case is the artist named. In 1845 it was in the Steward's Room.

This had a companion piece 'Flemish Landscape with figures', No. 193 in the 1845 catalogue and No. 204 in the 1891 catalogue. The companion piece cannot be traced and may have perished in the fire at Cranborne.

334 [197] ill. 194, p. 304

A Seaport with Figures

Style of Johann Lingelbach (1623–1674)

Panel (the boards are joined horizontally) 30 × 37$\frac{3}{8}$ in. (76·2 × 94·1 cm.) sight

Several men and one or two women are standing on the quay-side in the foreground; they include a turbaned Indian(?) near the centre. A ship is moored close behind them, another ship with sails set is a little way out to sea on the right. From the costumes the painting appears to be of the 1660's.

This painting is built in over the fireplace in the Cromwell Room. It is not identifiable in the 1823 or earlier inventories. In the 1845 manuscript catalogue, No. 181, it is recorded in its present position but the room was called the Queen's Room.

335

Haymaking

Paul Falconer Poole (1807–1879)

Hardboard 10 × 12 in. (25·4 × 30·5 cm.)

A girl with a hay-rake in the centre foreground. A little girl to the left and between them a baby lying with head towards the spectator; further

back to the right three men are raking the hay.

Impressed on the back of the hardboard is the supplier's name and address: 'Roberson & Co. 51 Long Acre'. On a printed paper (cut from a catalogue?) on the back, is: 'Paul Falconer Poole, R.A. 1807–1879 Haymaking'.

336

A Two-arched Bridge

Painter unknown

Watercolour 10$\frac{1}{2}$ × 14$\frac{7}{8}$ in. (26·7 × 37·8 cm.) sight

A two-arched bridge sloping up to the left over a rocky river bed, a man fishes from the near bank, old houses and trees on the far side, a lady on a white horse to the right.

This and No. 337 are by the same hand.

337

A Tudor Cottage

Painter unknown

Watercolour 14$\frac{1}{2}$ × 14$\frac{7}{8}$ in. (36·8 × 37·7 cm.)

The cottage is in the centre on the far side of a road, which slopes up from the centre foreground to the left. Three persons are in the road.

By the same hand as No. 336.

338 [211]

Judith

Painter unknown

Canvas 30$\frac{1}{4}$ × 24$\frac{3}{4}$ in. (76·8 × 62·9 cm.)

A half-length figure turned to the left looking at the spectator, she has hazel eyes and long brown straight hair parted in the centre, she wears a soft black head-dress over the back of her head,

a loose white chemise and brown drapery; her left arm is across her breast, she rests her right forearm along possibly the arm of a chair and appears to hold something in her right hand. The background is dark brown. There are no inscriptions visible on the front or back.

The painting appears to be of the second half of the seventeenth century. In it some high lights which do not connect with the painting as now seen may be the remains of some alterations that have been nearly cleaned away, but not recently.

The painting was entered as 'Judith – a copy from Raphael' in the 1845 catalogue when it was in the Housekeeper's Room. This is the earliest known reference to this painting.

339 [190] ill. 195, p. 304

The Annunciation

Caspar Smitz (d. 1707)

Canvas $46\frac{1}{2} \times 37\frac{1}{2}$ in. ($118 \cdot 1 \times 95 \cdot 2$ cm.)

The Virgin is on the left kneeling on her right knee at a lectern in front of Gabriel who holds a palm on a slightly higher plane to the right; there is a dove above in a break in the clouds. The painting is signed on a footstool 'C. Smitz'. The Virgin has light brown hair and wears a mauve dress with blue drapery. The hairstyle suggests a date soon after 1660.

A possible seventeenth-century reference to this painting is in the Salisbury House Inventory of April 3, 1685. 'In the Great Chamber above Staires' is the entry '2 pictures of ye Salutation of the Angell and ye Blessed Virgin in a Guilded frame'. No artist is named. In the 1845 manuscript catalogue under No. 221 it is given as The Annunciation by G. Smitz.

340 [187] ill. 196, p. 304

The Virgin and Child

Copy by Jacob Huysmans (1633(?)–1696) after Sir Anthony van Dyck (1599–1641)

Canvas $41\frac{1}{2} \times 35$ in. ($105 \cdot 4 \times 88 \cdot 9$ cm.)

A three-quarter length painting of the Virgin, turned to the left but looking high over the spectator's head. She is clothed in red with blue drapery which also falls over a stone pedestal on the left; with both hands she holds the Christ child who stands on the draped pedestal, some white drapery is caught up in her left hand. There is a stone column in the background to the left, the sky is seen to the right. On the back of the canvas 'Tomkins/at El of Salisbury/Hatfield.

In the Hatfield Family Papers (C.F. and E.P's Bills 175 file), is a bill dated July 7th, 1663, which includes: 'For a Virgin Mary after Van dick of Houzman's painting with a carved gilt frame £6:–'. This is endorsed in the hand of Lady (Diana) Cranborne: 'Mr Tomson's bills the picter drayer that my son Salsbury has undertaken'. This must have been written after her son succeeded to the title in 1668. This, like No. 343 remained in her possession and was listed in the inventory June 2, 1675, made of her goods and chattels after her death. (Family Papers, Box A/14): The 'Blessed Virgin and Christ in her lapp £15.0.0'. It next appears in the Hatfield 1679 inventory, 'Picture of the B. Virgin and our Saviour in her arms', in 'the next great withdrawing room'. In the 1823 inventory it is listed in the Breakfast Parlour thus: 'The Virgin and our Saviour the Colouring much resembling that of Rubens, the Expression in the Countenance of the Virgin truly sublime, the Draperies and background excellent . . . Vandyk'. It is No. 173 in the 1845 manuscript catalogue.

Mr Tomson from whom this was bought must be Richard Tompson, the printseller who according to George Vertue was a buyer of pictures (Walpole Society, Vertue, Vol. V, pp. 55–6). Tomkins, whose name is on the back, restored many Hatfield pictures shortly before 1782

(Pennant, *Journey from Chester*, 1782).

A variant of this painting was in the P. Vitez Collection, Brussels.

341 [215] ill. 197. p. 305

The Adoration of the Magi

Attributed to Jan Asseylin (1610–post 1652)

Panel 11⅞ × 15 in. (30·2 × 38·1 cm.) to which a piece ⅝ in. (1·7 cm.) wide was added along the top

Whole-length figures, the Holy Family are seated on the right turned to the left, Joseph on the extreme right, the unclothed infant Jesus is on his Mother's knee. The three Magi are on the left, the foremost has already sunk on his knees. They bear gifts in their hands. Behind them to the left are retainers, two horses and a camel.

Probably the painting; 'The Wise Men's Offering (small) listed in the Breakfast Parlour in the Hatfield 1823 inventory. In the 1845, it was in the Billiard Room and was catalogued, No. 153, as by J. Asseylin. In the 1891 catalogue it was described as being on copper and stated to be by J. Van Herpe (1432–1486). It cannot be a work of so early a date.

342 [214] ill. 198, p. 305

The Last Supper

Attributed to Willem van Herp I (1614–1677)

Copper, 11¾ × 14¾ in. (29·8 × 37·5 cm.)

'The Last Supper (small) – Jordaens', was listed in the Breakfast Parlour in the Hatfield 1823 inventory. In the 1845 catalogue, No. 158, it was listed in the Billiard Room and again given to Jordaens. In 1891 this and No. 215 were stated to be by Jan van Herpe (1432–1486), presumably in error for Willem van Herp I.

343 [188] ill. 199, p. 305

The Crucifixion

Jacob Huysmans (1633(?)–1696) after Sir Anthony van Dyck (1599–1641)

Canvas 49¾ × 39¼ in. (126·4 × 99·7 cm.)

Christ crucified with three winged cherubs holding chalices to catch the blood from His hands and feet, and a fourth cherub on the left, clouds float round them, Jerusalem is silhouetted low on the right. On the back of the picture is a label 'The Crucifixion painted by Lucca Giordano'.

This, like No. 340, was bought by Lady (Diana) Cranborne and is recorded on the same bill dated July 7, 1663 (see No. 340) 'For a Crucifix after Vandick of Huymans painting with a carved and gilt frame £10: –'.

It is in the June 2, 1675 inventory of Lady Cranborne's goods after her death: 'One our Saviour on the cross after Vandike £10'.

A 'Picture of Christ upon the Cross in a guilded frame' was listed as in the Wardrobe in the Hatfield 1679 inventory. In the 1823 inventory this was listed in the Breakfast Parlour as 'The Crucifixion – a splendid Piece of Colouring certainly equal in that Respect to the best Efforts of the Venetian School; the Anatomy is well marked, and the back Ground exhibits a Proof of the consumate Knowledge of the Masters in grand Effect; Vandyk'. In the 1845 manuscript catalogue, under No. 219, it is given as by Luca Giordano.

This copy must have derived from the Crucifixion with the angels catching the Blood of Christ in golden goblets which Bellori records was painted by Van Dyck for the Earl of Northberland.

'Per lo Conte di Northumberland depense it Crocifisso con cinque Angeli che in tazze d'oro raccolgono il sangue dalle pinghe, e sotto la croce vi dispose la Vergine San Giovanni, e

Madalena'. See *Le Vite de Pittori Scultori et Architetti Moderni*, by Gio. Pietro Bellori, Rome, 1672, p. 261.

A version close to but not exactly similar to the Hatfield painting is in the gallery at Toulouse and another was bequeathed to the National Art Collections Fund in 1937 by Mrs Alway and was presented to the Museum and Art Gallery, Newport, Monmouthshire.

344 [191] ill. 200, p. 305

Angel at the Tomb and the three Maries

Caspar Smitz (d. 1707)

Canvas $48\frac{3}{4} \times 39\frac{1}{2}$ in. (123·8 × 100·3 cm.)

The three Maries are climbing the hillside from the right and are awed by an Angel in white on the left, seated on a carved stone tomb on the hillside looking down on them and pointing straight up with his right hand. The dresses of the Maries from left to right are blue-grey, purple-red and pale yellow. The painting is signed about six inches up and twelve inches from the left 'C. Smitz'.

This is not identifiable in the 1823 inventory. It is No. 220 in the 1845 MS catalogue 'The three Maries at the Tomb by G. Smitz'.

345 [194]

An Angel holding a Lily, 1873

Copy by Raffaels Luccesi (fl. 1873) after Carlo Dolci (1616–1686)

Canvas $27\frac{1}{4} \times 21$ in. (69·2 × 53·3 cm.) sight, in an oval mount

Head and shoulders only of a winged angel nearly in profile to the left looking down at a lily held near his breast in his right hand. The painting is inscribed in a corner under the mount 'Raffaello Lucchesi/copio 1873'.

346 [195]

Female Saint holding a cup

Copy by Raffaels Luccesi (fl. 1873) after Carlo Dolci (1616–1686)

Canvas $28\frac{3}{4} \times 22\frac{1}{4}$ in. (73 × 56·5 cm.)

Half-length of a woman saint (?) full three-quarters to the right, looking up, her hands across her breast, holding a silver covered cup in her right hand; there is a halo round her dark hair; she wears maroon and black drapery. The background is grey. The painting is inscribed 'Raffaello Lucchesi/Copio'.

In the 1891 catalogue this was described as an angel holding a cup of spices.

347 [177]

Head of a Magdalene

Elizabetta Sirani (1638–1665)

Panel $20\frac{1}{4} \times 16\frac{3}{4}$ in. (51·4 × 42·5 cm.)

Head and half-shoulders turned full three-quarters to the left, looking up; her hands are across her breast. She has brown hair and brown eyes. A label at the back is inscribed in ink: 'Head of a Magdalen painted by E. Sirrani'.

The painting has the appearance of having been cut from a larger work.

This was entered in the 1823 inventory as being in the Breakfast Parlour: 'Head of a Magdalen, in prayer, clearly colored, on pannel'. It is No. 162 in the 1845 manuscript catalogue, where it is stated to be by E. Sirani.

348 [182]

A Magdalene Kneeling in a Cave

Caspar Smitz (d. 1707)

Canvas $20\frac{1}{4} \times 27\frac{3}{8}$ in. (51·4 × 69·5 cm.)

Whole-length, kneeling in a cave nearly in profile to the left; she wears a pink dress with dark drapery from her waist down. She looks down at a closed box on a rock to the left.

This was No. 164 in the 1845 Hatfield manuscript catalogue, described as 'Magdalen in a Cavern Scene' by Caspar Smitz. No identifiable earlier record of it has been found.

Caspar Smitz painted many Magdalenes and became known as Magdalene Smitz.

349

A Magdalene before a Crucifix

Caspar Smitz (d. 1707)

Canvas 19 × 14¼ in. (48·3 × 36·2 cm.) sight

Whole-length figure of the Magdalen kneeling nearly in profile to the left in a cave the opening of which is behind her to the right. Before her is a small crucifix. She has auburn hair and wears dark green drapery over a white chemise.

Nos 349–352 are not in the 1891 catalogue. In the 1823 inventory listed in the Billiard Room are: 'Four small pictures – Magdalens'. No earlier references to them have been found. In the 1845 manuscript catalogue are 'four pieces with Magdalens in different positions by Caspar Smitz'. They are numbered 215–218 but are not separately described.

350 ill. 201, p. 306

A Magdalene with a Crucifix and a Skull

Caspar Smitz (d. 1707)

Canvas 19½ × 14¾ in. (49·5 × 37·5 cm.) sight

Whole-length seated fronting the spectator, her head turned to the left looking up; a crucifix is clutched in her left arm, a skull is below it on a rock close by her. There is a greenish glint in her fair hair; she wears a blue low-cut dress exposing her right breast.

See also No. 349.

351

A Magdalene near a Book and Skull

Caspar Smitz (d. 1707)

Canvas 20½ × 14 in. (52 × 35·6 cm.) sight

Whole-length seated fronting the spectator leaning on a rock to the right her head turned and looking up to the right. She wears a low-cut blue dress with brown skirt; an open book and a skull are on the rock close to her on the right.

See also No. 349.

352

Magdalene wearing a Chaplet of Roses

Caspar Smitz (d. 1707)

Canvas 21 × 15¼ in. (53·3 × 38·6 cm.)

A whole-length, seated to the right with her head in profile to the left, resting her right arm on a broad sculptured stone pedestal on which is a sheet of paper at which she is looking, her hands are clasped together. She has a chaplet of roses on her light brown hair; she wears pale brown and pale blue drapery, leaving her left breast bare. A shepherdess's spud leans against the rock on the left.

On the back of the stretcher is a label inscribed in ink: 'Magdalen/painted by Caspar Smitz'.

See also No. 349.

353 [229] ill. 202, p. 306

Bacchanalian Procession of Silenus

Attributed to Willem van Herp (1614–1677)

Copper 11¼ × 14¾ in. (28·6 × 37·5 cm.)

Nude Silenus is seated on a cloth on a braying ass

seen in profile to the left; he is supported on either side by Satyrs. There are other figures and children on both sides with trees behind.

The first known record of this painting is in the 1823 inventory where it is listed in the Breakfast Parlour: 'Silenus borne upon an Ass, attended by a Group of Bacchanals – Jourdaens'. In 1891 it was stated to be by Jan van Herpe. This was presumably in error for Willem van Herp, an attribution which appears to be right.

354 [213]

Cleopatra

Stated to be by an artist in Rome

Canvas $30\frac{1}{2} \times 24\frac{1}{2}$ in. (77·5 × 62 cm.)

Depicted at half-length turned to the left, looking at the spectator; with both hands she holds before her to the left a shallow gold dish, about the size of a saucer, in which is some fluid. She has brown eyes, medium brown long loose hair with a jewelled gold ornamental head-band; she wears a white chemise and cinnamon coloured drapery partially concealing a black jewelled strap over her left shoulder. The background is dark brown. The canvas is on a fairly new stretcher on the back of which is a label evidently removed from the old stretcher. Inscribed in ink on the label is: 'Cleopatra dissolving the Pearl/ painted by/ an artist in Rome'.

The earliest certain record of this is in the 1823 catalogue in which it is given in the Drawing Room as: 'A Female holding a Cup, probably intended for Cleopatra'. In the 1845 catalogue, No. 208, it is entered as: Cleopatra dissolving a pearl'. In neither case is any artist named. If it can be as early as 1611 it might be the painting listed in early Hatfield inventories as woman holding a cup: In 1611 in the 'Lobbie between the Great Chamber and the Gallery', in 1612 (Box D.1), July, 1612 (Box B.5) in 1629, 1638 and 1646 in the Gallery.

355

Interior with Dutch Boors Brawling

Egbert van der Poel (?) (1621–1694)

Panel $23\frac{1}{2} \times 32\frac{1}{2}$ in. (59·7 × 82·5 cm.) – the pieces of wood are joined horizontally

Several figures in a barn-like interior; a man sitting on the floor on the left and brandishing a knife or dagger is being attacked by another man whom a man and a woman try to hold back. There are three other figures. The left portion is strongly lighted, the right is in semi-darkness.

The painting was No. 152 in the 1845 manuscript catalogue and given to Jan Steen. It was later attributed to 'Polenburgh'. It is not in the 1891 catalogue.

356 [212]

Interior, with a Cart of Vegetables, 1646

Egbert van der Poel (1621–1694)

Panel (the boards are joined horizontally) $15\frac{3}{4} \times 28\frac{3}{4}$ in. (40 × 73 cm.)

In a cavern-like interior two men are loading or unloading a cart, one in the cart, the other standing towards the right at its rear end; a boy rides a white goat in the centre of the left of the painting, which is lighted from the left.

The painting has been stated to be dated 1646 but it appears to be of a somewhat later date in the century.

This has the same title in the 1845 catalogue, No. 201, and 1891 catalogue. In 1845 when it hung in the Housekeeper's room, the painter's name is given with no initial or forename. In 1891 it was given as Egbert van der Poel.

357 [227] ill. 203, p. 307

Interior of a Philosopher's Study

Thomas Wyck (*c.*1616–1677)

Panel 15¾ × 13½ in. (40 × 34·3 cm.) sight

The philosopher sits with his back to a leaded window with two lights on the left. In this high ceilinged room are scattered manuscripts and books and a large globe on a stand.

The first known Hatfield record of this is in the 1823 inventory in which it is listed in the Break-fast Parlour: 'An Interior with a Philosopher in Study, very excellent – J. Wycke'. In 1845, No. 154, it was in the Billiard Room.

Thomas Wyck painted many pictures in the same vein soon after 1660 and was in London at the time of the Great Fire of London which he painted. He died in Haarlem.

358 [228] ill. 204, p. 307

Philosopher Punishing an Intruder

Thomas Wyck (*c.*1616–1677)

Panel 15¾ × 13½ in. (40 × 34·3 cm.)

A high ceilinged interior with a window on the left. On the right a boy on his knees pleads to a bearded man in a gown with an open book in his left-hand, who threatens him with a stick.

The first known record at Hatfield is in the 1823 inventory where it is listed in the Breakfast Parlour: 'Interior with Schoolmaster correcting his Pupil – J. Wycke'. In 1845, No. 160, it was called: 'Philosopher punishing an Intruder'.

359 [231] ill. 205 p. 307

Sleeping Girl and Duenna

Sir Peter Lely (1618–1680)

Canvas 40¾ × 39 in. (103·5 × 99 cm.)

A girl, three-quarter length, seated to the left rests her head nearly in profile, on her right hand, and her right arm on a draped pedestal to the left, her eyes are closed, her dark hair is un-brushed; she wears a brown dress and loose blue drapery exposing her left breast. To the right of centre an elderly woman approaches in semi-darkness close behind her bearing a paper in her left hand.

The earliest known record of this at Hatfield is in the 1823 inventory where it is listed in the Breakfast Parlour; 'A Sleeping Female and her Attendant – M. A. Caravagiow'. It was also given to Caravaggio in 1845, No. 166, and in the 1891 catalogue. It was, however, identified by Mr Oliver Millar as a Lely of near 1650 and ex-hibited as by Sir Peter Lely at the Tercentenary of the Battle of Worcester exhibition held at Worcester in 1951, Cat. No. 40.

360

Finished preparatory drawing for a Wall Painting in the Salisbury Chapel in Hatfield Parish Church

G (or J) Taldini (fl. 1875–1878)

Sepia wash and white chalk on paper 22 × 54½ in. (55·9 × 133·3 cm.) sight

The drawing represents Christ in the centre with the foolish virgins on one side and the wise virgins on the other side.

361

Finished preparatory drawing for a ceiling panel in the Marble Hall at Hatfield House

G (or J) Taldini (fl. 1875–1878)

Sepia wash and white chalk on paper 42¼ × 36¼ in. (107·6 × 92·4 cm.) sight

In the centre of the painting are a satyr and cupids and nearby are two shepherds and two shepherd-esses, in a rugged landscape. The drawing is signed in the lower right corner 'G (or J.) Taldini'.

The final work is one of ten paintings on the ceiling of the Marble Hall, being that at the Eastern end on the South side. These paintings replaced paintings of the Caesars.

362

A Lyric Fantasy

Augustus John (1878–1961)

Charcoal on paper laid down on linen 92 × 180 in. (234 × 453 cm.)

There are eleven figures about life size, in a landscape. They are, from left to right: two young women dancing together, a boy beating a drum, a nude young woman sitting on the ground her legs drawn up in profile to the left, a young woman bare down to the waist holding a baby, a young woman playing a lute, a boy clutching her, two more boys, the one on the right looks up at a young woman, who is, the last figure on the right.

The cartoon was drawn c.1911 as a preparatory study for the painting of approximately the same size in the collection of the late Hugo Pitman, Esq. The painting which differs considerably from the cartoon is reproduced in *Augustus John*, 1944, by Sir John Rothenstein, Plate 83.

The cartoon was lot 109 in Christie's sale, June 21, 1963, Part II of their sales of Drawings and Paintings from Augustus John's studio.

363 [201]

Large Flower Piece with Children

Jean-Baptiste Monnoyer (1636–1699)

Canvas 60¾ × 43⅜ in. (154·3 × 111·1 cm.)

A large vase of flowers in front of which are cherubs, with various fruits including half a pomegranate in the foreground which the left-hand cherub touches. The middle cherub touches a flower, the right-hand cherub is looking up to the left.

A number of flower paintings were bought for small prices from M. Savage and Co. in 1702, the most expensive were: '3 large flower pieces framed for chimney £3. 3. 0' (Family Papers, Bills 395). In 1713 14 large flower pictures were bought at 10s. each from Ann Tyndall and Mr Savage (Family Papers, Bills 540). In neither case were the artists named; two flower pieces were cleaned by Mr Chauncey between 1718 and 1724 but no artist is named in his bill.

364

A Silver Vase of Flowers on a Windowsill

Jean-Baptiste Monnoyer (1636–1699)

Canvas 53¾ × 60½ in. (136·5 × 153·7 cm.)

This and No. 365 are the 'two large flower pieces' given as by 'Baptiste' listed in the 1823 inventory in the Billiard Room. They were Nos 205 and 206 in the 1845 manuscript catalogue when they were not hung. They were omitted from the 1891 catalogue.

See also No. 363.

365 ill. 206, p. 308

Flowers in a copper or pewter vase on windowsill with a monkey chained to the left side of the window

Jean-Baptiste Monnoyer (1636–1699)

Canvas 53½ × 60½ in. (136 × 153 cm.)

The remains of a signature ('JB' in monogram) are to be found in the lower right corner; some of the paint and canvas at this point has rotted away.

See also Nos 363 and 364.

366 [223]

Grapes in a Vase, 1876

Antoine Vollon (1833–1900)

Panel $10\frac{5}{8} \times 8\frac{1}{2}$ in. (27 × 21·6 cm.)

An ornamental ceramic vase shaped like a sauce-boat on a foot, overflowing with foliage. Signed in lower right corner, 'A. Vollon'. Inscribed at the back: 'A Madame La Marquise de Salisbury, hommage respectueux, Vollon, 26 Octobre 1876'.

367

A Hunt in Progress, c.1720

An unknown primitive painter

Panel (joined horizontally) $29\frac{1}{2} \times 63$ in. (72·4 × 160 cm.) sight

A huntsman blowing his horn on horseback in profile to the right is in the centre of the painting, two men on horseback in profile to the right are following him, about twenty dogs are running towards the right; there are woods in the background to the left and fields and hills to the right. It can be dated from the costumes as being of near 1720.

The painting was bought about the year 1935.

368–375

Eight portraits of Horses by John Boultbee (c.1745–c.1812)

368

Horse held by a groom on the right

Canvas $23\frac{3}{4} \times 29$ in. (60·3 × 73·4 cm.) sight

The brown horse is in profile to the right with a groom standing on the right and a dog; the groom is dressed in a blue coat with silver-coloured epaulets, collar and cuffs, a black hat edged with silver, and buff breeches.

369

Horse held by a groom on the left

Canvas 24×29 in. (61 × 73·7 cm.) sight

The brown horse is in profile to the left, the groom stands on the left dressed in the same coloured clothes as the groom in No. 368.

370

A groom feeding a horse

Canvas $23\frac{3}{4} \times 29\frac{1}{4}$ in. (60·3 × 74·3 cm.) sight

A saddleless chestnut horse stands in profile to the right, the groom is on the right about to feed the horse from a circular tray; and a bridle hangs from his left wrist; there is a house on a hill to the left and a tree to the right.

371

A Horse, saddled, and tied to a tree

Canvas $23\frac{1}{8} \times 29\frac{1}{8}$ in. (58·7 × 74 cm.) sight

A medium brown horse in profile to the left, saddled and tied by its rein to a fixing on a tree to the left, a dog is sitting on the left.

372

Horse saddled and tied to a pailing

Canvas $23\frac{1}{8} \times 29\frac{1}{8}$ in. (58·7 × 74 cm.) sight

A light brown horse in profile to the right, saddled and tied by its rein to the upright post of a railing; part of a building and bushes are seen to the left, and trees to the right.

373 ill. 207, p. 308

A horse and three dogs, 1784

Canvas 24 × 29⅛ in. (61 × 74 cm.) sight

A dark horse in profile to the left tied by his rein to a hook on a stone building, the corner of which is seen on the left; there are three dogs on the left, two are standing, the smallest is sitting; there are trees on the right. The artist has signed and dated the painting in the mid-foreground: 'J. Boultbee Pinx 1784'.

374

A horse, 1790

Canvas 27 × 35 in. (68·6 × 88·9 cm.) sight

A dark horse in profile to the left, not saddled, tied by its rein to a rail on the left; bushes and the corner of a stone building are seen on the left. The painting is signed and dated midway between the rear horses and the horse of the canvas: 'J. Boultbee pinx '90'.

375

A horse

Canvas 15¾ × 20¼ in. (40 × 51·4 cm.) sight

A dark brown horse with clipped ears in profile to the left, it has no reins or saddle, there is a tree on the left near the foreground and a wood behind it.

376

A horse and groom

F. Rowell (fl. near 1800)

Canvas 40 × 48 in. (101·6 × 121·9 cm.) sight

The bay horse with three white fetlocks is in profile to the left, the groom, on the left holding him by a leading rein is fronting the spectator. He wears a black cap and is dressed in brown with scarlet collar and cuffs. The painting is signed in the lower left corner: 'F. Rowell'. It appears to be of the late 18th century. No other work apart from No. 377 by this artist has been found.

377

A horse and groom

F. Rowell (fl. near 1800)

Canvas 39½ × 48½ in. (100·3 × 123·2 cm.) sight

A chestnut horse standing in profile to the left is held by a leading rein by a groom on the left fronting the spectator who wears a black cap, blue coat and red waistcoat.

The painting pairs with No. 376 *q.v.*

378 ill. 208, p. 309

A horse, 1806

Ben Marshall (1767–1835)

Canvas 32⅞ × 38⅞ in. (83·5 × 99·7 cm.) sight

A medium brown horse in profile to the left, a small black and white dog stands in profile to the left in the foreground towards the left. There is a hollow oak on the left and a lake (?) in the distance on the right; the background is misty. The painting is signed and dated in the lower left corner: 'B. Marshall px 1806'.

379

A horse, 'Prince', 1874

A. Bishop (fl. 1874)

Canvas 18 × 23¼ in. (45·7 × 59 cm.) sight

A near black horse in profile to the left in a loose box, a grill to the left; his name, 'Prince', is on a

plaque above him on the wall behind. Signed and dated in the lower left corner: 'A. Bishop/1874'.

SCULPTURE

380 [165]

James Brownlow William Gascoyne-Cecil, 2nd Marquess of Salisbury, K.G. (1791–1868), 1864

See No. 170

George Halse (fl. 1855–1894)

Marble, height 25 in. (63·5 cm.) on a circular marble socle height 5 in. (12·7 cm.)

The Marquess is partially bald, his eyeballs are not incised; he has a small moustache; whiskers frame his face. He has drapery over his shoulder revealing the ribbon of the Order of the Garter and the Star on the breast of his vest. The marble is incised at the back: 'G. HALSE, Sc. 1864'. This is presumably, No. 165 in the 1891 catalogue there stated unaccountably to be by William Theed, 1854.

Exhibited at the Royal Academy in 1865, No. 945.

No. 380a, a plaster cast, similar to No. 380.

381 ill. 209, p. 309

Lord Arthur George Villiers Gascoyne-Cecil (1823–1825)
Arthur George Villiers was the second son of the 2nd Marquess of Salisbury

Sir Francis Chantrey (?) (1781–1841)

Marble, height 13¾ in. (34·9 cm.) with circular base height 3¼ in. (8·3 cm.)

Head and shoulders, with drapery round the lower part of the bust leaving his left shoulder bare. The eyeballs are not incised.

The bust stands on a white marble cube on which is incised: 'CHANTREY'. There is no mention of this bust in Chantrey's meticulously kept account book in the possession of the Royal Academy.

This was not included in the 1891 catalogue.

382 [169] ill. 210, p. 309

Robert Arthur Talbot Gascoyne-Cecil, 3rd Marquess of Salisbury, K.G. (1830–1903), 1875

See No. 181

William Theed (1804–1891)

Marble, height 29½ in. (74·9 cm.) including circular marble socle height 5¼ in. (13·3 cm.)

Head and shoulders; his eyeballs are incised, he wears a fur-collared cloak over a coat, waistcoat, shirt and bow tie and a fur collared gown over his left shoulder with drapery over his right shoulder which comes across the bottom of the front of the bust.

Incised at the back is: 'W. Theed Sc/1875'. This is presumably, No. 169, in the 1891 catalogue, there entered as of 1864 by William Theed, Junior.

383

Robert Arthur Talbot Gascoyne-Cecil, 3rd Marquess of Salisbury, K.G. (1830–1903), 1888

See No. 181

Albert Bruce Joy (1842–1924)

Plaster coloured bronze, height 10½ in. (26·7 cm,), square base height 2¼ in. (5·7 cm.)

The head and shoulders, the head turned slightly to the left, wearing a loose gown over court dress. Incised at the back: 'A Bruce Joy Sc/1888'.

There are letters at Hatfield House from the sculptor early in 1886 asking Lord Cranborne (later the 4th Marquess) to view a bust in clay

on which he had been working for some time from photographs. There is no indication that Lord Cranborne viewed it or that Lord Salisbury gave any sittings. A bronze cast was made and this obtained an award at the Paris Salon of 1896. A copy in marble was acquired by the Corporation of the City of London. The bronze remained in the sculptor's possession until 1921 when it was acquired by the 4th Marquess and presented by him to Eton College.

When this small bust was acquired has not been discovered. It was presumably cast from a small copy made by the sculptor two years after he had made the life-scale bust. He had in his studio in 1921, according to a printed catalogue in the Hatfield files, a model in marmorine of the bust.

384

Robert Arthur Talbot Gascoyne-Cecil, 3rd Marquess of Salisbury, K.G. (1830–1903)

See No. 181

Sir George Frampton (1860–1928)

Bronze, height including the base which is cast in one piece with the bust, $13\frac{3}{4}$ in. (34·9 cm.)

Head and shoulders, wearing his gown as Chancellor of Oxford University over his coat and waistcoat. The bust is incised at the back: 'Geo Frampton/1903'.

The date of acquisition is uncertain.

385

Robert Arthur Talbot Gascoyne-Cecil, 3rd Marquess of Salisbury, K.G. (1830–1903)

See No. 181

Sir George Frampton (1860–1928)

Bronze, life scale

Whole-length seated in an Elizabethan chair wearing the robes of Chancellor of the University of Oxford and the collar of the Order of the Garter. He holds a scroll in his left hand.

The following inscription is incised on the plinth under his coat of arms which is carved in relief: 'Robert Arthur Talbot, Marquess of Salisbury' KG, GCVO. Three times Prime Minister of Great Britain and Ireland 1820–1903. Erected to his memory by His Hertfordshire Friends and Neighbours in recognition of a great life devoted to the welfare of his Country'.

The statue was unveiled at the gates of Hatfield Park on October 20, 1906, by the Earl of Clarendon, Lord Lieutenant of the County of Hertford, and presented to the 4th Marquess by him on behalf of the subscribers. It was originally on a plinth of Portland stone. The position of the statue was slightly altered and a new plinth made in 1912.

The plaster model from which the bronze was cast was acquired for Hertford County Hall in 1908.

It is no longer there and is believed to have been destroyed.

386

Robert Arthur Talbot Gascoyne-Cecil, 3rd Marquess of Salisbury, K.G. (1830–1903), 1906

See No. 181

Sir George Frampton (1860–1928)

Plaster coloured bronze, height 28 in. (71·1 cm.)

Cast of the sculptor's sketch for the life-scale statue of 1906 at the gates of Hatfield Park. Some changes were made in the life-scale statue, for instance in the model the Chancellor's gown does not cover Lord Salisbury's left knee, but in the statue it does.

Incised in the plaster on the left side of the base is: 'GEO FRAMPTON, RA./1906'.

This cast was presented by the sculptor to the 4th Marquess of Salisbury in 1922.

387

Robert Arthur Talbot Gascoyne-Cecil, 3rd Marquess of Salisbury, K.G. (1830–1903)

See No. 181

Sir William Goscombe John (1860–1952)

Bronze effigy, life scale

Similar to the effigy by Sir William Goscombe John on his monument in Westminster Abbey. The original which was conceived in 1904 was presented to the Abbey in 1909 by the 4th Marquess. The effigy at Hatfield was cast in 1912, and was exhibited at the Royal Academy and placed on the monument in Hatfield Church that year. The monument was not completed until 1913.

The sculptor offered the plaster model for the Westminster Abbey effigy to Lord Salisbury in 1943. This he accepted and gave to the Hertford County Council for the County Hall. It is no longer there and believed to have been destroyed.

388

Robert Arthur James Gascoyne-Cecil, 5th Marquess of Salisbury, K.G. (b. 1893)

See No. 214

David Wynne (b. 1926)

Bronze, height $11\frac{7}{8}$ in. (30·2 cm.)

Head only. Lord Salisbury sat for this in 1966 or 1967.
Another bronze cast is at Christ Church, Oxford.

389 ill. 211, p. 310

Robert Arther James Gascoyne-Cecil, 5th Marquess of Salisbury, K.G. (b. 1893), 1967.

See No. 214

Lorne McKean (b. 1939)

Bronze, height $15\frac{1}{2}$ in. (39·4 cm.), on marble base height $2\frac{1}{2}$ in. (6·3 cm.)

Head and half shoulders. A gift from Lord Cranborne to his parents on the occasion of their golden wedding, 1965.

390

George III (1738–1820), 1801

See No. 256

Miss Catherine Andras (*c.*1775–post 1823)

Wax relief, height about 4 in. (10·2 cm.) on circular white plaque – diameter 7 in. (17·8 cm.)

Head and shoulders in profile to the left; the King wears his K.G. ribbon over his coat, emerging from drapery. On a paper at the back is written in ink: 'Model of His Majesty/by Catherine Andras/87 Pall Mall, Modeller in wax to Her Majesty/ April 10th 1801'.

A wax bust of George III in a circular frame is recorded in the Elm Room in the 1871 inventory, p. 67.

391

Queen Victoria, 1883

Sir Joseph Edgar Boehm (1834–1890)

Bronze, height $13\frac{3}{8}$ in. (34 cm.) including square shaped socle height $2\frac{5}{8}$ in. (6·7 cm.)

Head and shoulders, her head is turned three-quarters to the left; she wears a close fitting head dress, pearl-drop earrings, a pearl necklace in a double row, the ribbon and star of the Order of the Garter over her dress, an oval jewelled relief of herself and Prince Consort in profile is suspended from a bow tied on her left shoulder. The

bust is incised at the back: 'J. E. Boehm/1883'.

392

Arthur Wellesley, 1st Duke of Wellington
(1769–1852)

James Kendall

Painted plaster, height 16½ in. (41·9 cm.)

Head and half shoulders, wearing an open cloak over a high collared coat, waistcoat and neck-cloth. The bust terminates in an oblong base with no socle. Incised at the back is the following: 'Walmer Castle/Oct 1852' and – below this: 'Jas Kendall'. The inscription is partially obliterated by coats of biscuit-coloured paint.

James Kendall was for many years the Duke of Wellington's personal servant. The bust was published (with the family's leave) by Mitchell, Royal Library, 33 Old Bond Street. The sub-scription book is at Stratfield Saye. Prince Albert and the 2nd Duke of Wellington head the list, closely followed by Lord Salisbury.

393

Arthur Wellesley, 1st Duke of Wellington
(1760–1852)

Sculptor unknown

Colossal bust

The bust is black. It is believed to be plaster. It is high up in the Marble Hall and in so dark a position that further details cannot be given.

394

Benjamin Disraeli, Earl of Beaconsfield
(1804–1881), 1880
See No. 291.

Victor Prince von Hoenlohe-Langenburg, Count Gleichen (1833–1891)

Terra-cotta height 18 in. (45·7 cm.) including circular socle height 2¼ in. (6·3 cm.)

Head and shoulders fronting spectator, his eye-balls are incised. He wears a coat, a wing collar to his shirt and a bow-tie. Incised at the back is: 'G/1880'.

395

Unknown Man, c.1860

Sporer (or S. Porer)

Bone (?) 5 × 3⅞ in. (12·7 × 9·8 cm.) sight – oval

Sculptured in high relief; head and shoulders in profile to the left, the sitter has long hair but is bald on the top of his hed, he wears a 'Gladstone' collar and a coat. Incised under the truncated arm is: 'SPORER fecit'.

The costume suggests a date near 1860.

396

Unknown Lady, c.1860

Sporer (or S. Porer)

Bone (?) 4⅞ × 3¾ in. (12·4 × 9·5 cm.) sight – oval

Sculptured in high relief; head and shoulders in profile to the left wearing a decorated bonnet over tightly drawn back hair. Incised on the truncation under her arm is: 'SPF'.

This and No. 395 are a pair.

397

A Baby Boy

Sculptor unknown

Bronze, height 19⅜ in. (49·2 cm.)

A whole-length figure of a baby boy of two years old or less, standing in front of a tree stump which is behind his right leg up to the height of

his thigh, his head is turned and tilted slightly to the right; he looks at his left hand which is raised to eye level, his right hand is at hip level.

Neither the provenance nor the date of acquisition of this piece is known.

The cast appears to be of the eighteenth century. The composition was a popular one; stylistically it corresponds with the work of François Duguesnoy (1597–1643) or one of his immediate followers.

398

Luigi

John Tweed (1869–1933)

Bronze, height 41¾ in. (106 cm.)

A standing whole-length figure of a young man, nude.

This was given to Lord Salisbury by the sculptor's daughters after his death. Exhibited at Knoedler, 1933.

MINIATURES

Note on the Miniatures

It is the fate of most miniatures to lose their identities. Those at Hatfield are no exception and some of the identifications are not certainties. The first known list of the miniatures is of 1868. At that time there were 47 and over half were not given names. It will probably never be possible to identify more than an odd one or two of those without names unless payments to artists are discovered. There are no remarkable likenesses in features between any unnamed miniatures and life scale identified paintings. It is only rarely that identifications made by near facial resemblance are to be depended on.

The difficulty of even suggesting identifications of the Hatfield miniatures is accentuated by there being a mixture of the miniatures in-herited by the Gascoigne heiress, (the first wife of the 2nd Marquess) and those which were previously at Hatfield. No separate list of either collection has been found.

Many of the miniatures have inscriptions on the backing papers written in the same hand which appears to be of the mid-nineteenth century. In these inscriptions the artist is named and a date given for some miniatures which are not signed or dated. A few of these can be shown to be inaccurate from date of costume and hair-style but some can hardly have been invented and the writer must have had access to earlier information not now known to us. The writer was evidently not well acquainted with the history of the family for he made mistakes such as always writing Granville for Glanville.

A few miniatures have numbers on their backs to identify them from a separate list which unfortunately is not now known.

Almost all the miniatures have been removed from their original frames. Most are now in plain narrow nineteenth-century frames. There is in the Hatfield archives a bill of 1802 from Brookes & Co. of 22 Coventry Street for frames for 11 miniatures. In this there is also mention of taking one large miniature out of its original frame and re-setting.

The 1868 list unfortunately does not name the artists. As so many were and are unidentified it is rarely possible to be sure which is which on that list. A plan of how they were arranged in a large case is attached to the list. The miniatures were drawn very roughly to scale oval or round as the case may be. This helps towards knowing what some were called then.

The miniatures as a whole are of good quality. About five-sixths of them are by artists who worked in the eighteenth century and over half were painted in the second half of the eighteenth century when skilled miniaturists were living in this country in greater numbers than at any other period.

399 [4] ill. 212, p. 310

Called **Charles Cecil, Viscount Cranborne** (1619–1660), 1646

See No. 129

Samuel Cooper (1609–1672)

Card $1\frac{7}{8} \times 1\frac{1}{4}$ in. (4·8 × 3·2 cm.) oval

Head and shoulders to the right; the eyes looking at the spectator. He has long auburn hair and dark blue eyes. He wears armour, a linen collar and a black quilted scull cap (for use under a helmet). The background is bright blue. The miniature is signed and dated 'S.C. 1646' in gold low on the right. It has unfortunately suffered much in restoration.

This may be No. 20 in the 1868 list, entered as: 'male head (old Portrait)'. It is called Lord Cranborne in the 1891 catalogue.

Lord Cranborne was made a K.B. in 1625 but there is no sign of the ribbon or jewel of the Order of the Bath in this miniature or in the painting of him (No. 129).

400 ill. 213, p. 310

Charles I (1600–1649), **in the last year of his life**, 1648/9

Painter unknown

Oil on metal $2 \times 1\frac{3}{4}$ in. (5·3 × 4·6 cm.) oval

Head and shoulders to the left, looking slightly to the spectator's right. The King has long brown hair and blue eyes. He wears a moustache and a thick beard and a black cloak open in front, revealing the blue ribbon of the Garter, and a lace-edged collar. Part of the Garter star is visible on his cloak. The background is blue.

In this miniature the King is depicted with an even more bushy beard than is seen in the paintings by Edward Bower at the time of his trial.

There is no doubt that Charles I is represented here after his barber had been dismissed in February 1648.

401 [30]

William III (1650–1702), *c.*1690

Stated to be by Bernard Lens (1631–1708)

Enamel on metal $1\frac{1}{4} \times 1$ in. (3·2 × 2·7 cm.) oval

Head and half shoulders to the left, looking at the spectator. The King wears a dark wig; the top of his coronation robes is seen. The background is brown.

Inscribed in ink on the backing paper are the words: 'William the 3rd. By Lens'.

This is a copy of the head of Kneller's portrait of *c.*1690 of which Hatfield No. 115 is a version.

402

Unknown Man, *c.*1695–1700

Painter unknown

Oil on metal $3 \times 2\frac{1}{2}$ in. (7·8 × 6 cm.)

Head and shoulders in profile and the head three-quarters to the left, his blue eyes look at the spectator. He wears a long dark grey wig, a white neckcloth and armour. The background is blue. The miniature has a metal-backed frame which is not inscribed.

The wig suggests a date of about 1695–1700. This miniature and No. 403 are a pair and so presumably represent a husband and wife. The only likely Cecils are Robert (1667(?)–1715/6) and his wife or one of his four sisters with her husband.

403

Unknown Lady, *c.* 1695–1700

Painter unknown

Oil on metal 3 × 2⅞ in. (7·5 × 6 cm.)

Head and shoulders fronting the spectator, her head slightly to the left, she looks at the spectator; she had brown hair and blue eyes. The sitter wears a white chemise and lemon coloured drapery hangs over her right shoulder. There are no inscriptions.

The hair style suggests a date of about 1695–1700. The sitter appears to be about 20 years of age. This miniature pairs with No. 402.

404 ill. 214, p. 310

The Hon. Robert Cecil (1667 or later–1715/6), 1698

See No. 136

Jacques Antoine Arlaud (1668–1746)

Card 3½ × 2¾ in. (8·5 × 7 cm.) oval

Head and shoulders, slightly to the left his head is three-quarters to the right, he looks at the spectator; his wig is large, long and black and his eyes brown; he wears a lace cravat and armour. The miniature is inscribed on the back: 'Jacobus/Antonius/Arlaud/Genevensis/pingebat ad vivum/Parisiis/mense Octobris/Anno 1698'. Horace Walpole has written on a paper on the back of the frame: 'Robert Cecil/second son/of/James, third Earl of Salisbury,/ and Father/of/ Charles Bishop of Bangor/ and of Margaret/ wife of Sʳ Robert Brown'.

The miniature is not in Horace Walpole's *Description of Strawberry Hill*, 1784, but was Lot 155 on the 18th day of the Strawberry Hill Sale, 1842, when it was bought by Rodd, a dealer. It was lent to the Miniature Exhibition at South Kensington in 1865 (Catalogue No. 492) by the Hon. William Ashley. He sold it at Christie's on May 15, 1884, Lot 20. It then passed to W. W. Aston who lent it to the Burlington Fine Art Club's Miniature Exhibition of 1889 (Catalogue No. 11, p. 1).

The miniature was bought by the Marquess of Salisbury at Sotheby's Sale of January 15, 1968 Lot 30.

405 [6]

Unknown Lady, c.1700

Lawrence Crosse (1654 or before – 1724)

Card (?) 3 × 2¾ in. (7·6 × 6·1 cm.) oval

Head and shoulders, fronting the spectator; her head is slightly to the left, but she looks at the spectator. She has dark brown hair and brown eyes and wears a blue dress. The miniature is signed L.C. in monogram low on the left.

Inscribed in ink on the paper backing is: '"Countes of Sallisbery L7011 Ɛ Crosse" as written on the back of the miniature which is by Lewis Cross 1724'.

The reason for the exact dating is not known. The costume and hair style suggest a date near 1700. If this represents a Countess of Salisbury, she is more likely to be Frances (d. 1713), wife of the 4th Earl. The miniature was called Anne, Countess of Salisbury (wife of the 5th Earl) in the 1891 catalogue. It was probably No. 14 in the 1868 list, called her.

406

Unknown Lady, c.1720

Painter unknown

Enamel on metal 2⅞ × 1½ in. (4·5 × 3·6 cm.)

Head and shoulders fronting the spectator, her head is slightly to the left, she looks at the spectator, She has brown hair and brown eyes; she wears yellow and red flowers in her hair and a white dress. It is not inscribed on the back.

The sitter appears to be about 20–25 years of age and the work datable about 1720.

407 [25]

Lady Anne (Tufton), Countess of Salisbury (?) (1693–1757), c.1727–28

See No. 157

Probably Christian Frederick Zincke (1683/4–1767)

Enamel on metal 1¾ × 1⅜ in. (4·5 × 3·5 cm.) oval

Head and shoulders slightly to the left, the sitter has turned her head three-quarters to the right but she looks at the spectator; her hair and eyes are brown; she wears a blue dress and mauve drapery. The background is grey.

Inscribed in ink on the backing paper are the words: 'Lady Anne Tufton, wife to the 5th Earl of Salisbury by Zincke'.

This and No. 408 are a pair and are presumably mother and son, painted about the same time, c.1727–28.

408 [12] ill. 215, p. 311

James Cecil, 6th Earl of Salisbury (1713–1780), c.1727–28

See No. 162

Christian Frederick Zincke (1683/4–1767)

Enamel on metal 1¾ × 1½ in. (4·3 × 3·7 cm.) oval

Head and shoulders to the left, looking at the spectator. The youthful sitter has light brown hair falling behind to chin level, and brown eyes; he wears an open blue coat; his shirt has a frilled front. The background is grey brown.

Engraved on the back of the frame are the letters 'J. C.' in monogram, below a Viscount's coronet. Below the monogram is engraved: 'No. 5'.

Inscribed in ink on the paper stuck on the back of the miniature is: 'Evidently this is the companion enamel to the Lady Tufton. Can it

be John the 5th Earl? A fine Zincke'.

This must be the 6th Earl, aged 14 or 15, when Viscount Cranborne just before the death of his father in 1728. No. 407, a companion portrait, presumably represents his mother Lady Anne (Tufton), the 5th Countess.

409 [19]

Unknown Man, c.1730

Bernard Lens (1682–1740)

Ivory 2⅛ × 1¾ in. (5·5 × 4·4 cm.) oval

Head and shoulders to the right, the eyes looking slightly to the spectator's right. The eyes are hazel and the sitter wears a long grey wig, and pale brown coat. The background is a cloudy sky.

Inscribed in ink on the backing paper are the words: 'By B. Lens, 1740' and on the back of the ivory the number 'No. 1'.

This and No. 244 are similar, presumably Lens copied the life-scale portrait. He made many copies. No. 244 is said to represent a member of the Glanville family. The costume and wig suggest a date near 1730.

This and No. 410 are a pair, they probably represent the 5th Earl of Salisbury and his wife.

410 [18]

Unknown Lady, c.1730

Bernard Lens (1682–1740)

Ivory 2 × 1⅝ in. (5·1 × 4·2 cm.) oval

Head and shoulders fronting the spectator, the lady's head is turned a little to the left but she looks at the spectator, her hair is brown and her eyes pale green; she wears a green dress, with an ermine drape over her left shoulder.

Inscribed in ink on the backing paper are the words: 'By B. Lens, 1740' and on the back of the ivory: 'No. 2'.

This pairs with No. 409. It probably represents Anne, Countess of Salisbury (1693–1757), wife of the 5th Earl.

411 [11]

William Glanville (?), 1740

Bernard Lens (1682–1740)

Card 1⅝ × 1⅜ in. (4 × 3·7 cm.) oval

Head and shoulders to the right, looking at the spectator, He has hazel eyes and wears a grey wig, blue coat and a gold coloured waistcoat. The background is grey-green.

An inscription in ink on the backing paper reads: 'Will Granville Esqʳ. By B. Lens 1740'.

The costume and wig are of c.1740.

412 [14]

Bridget (Raymond), Mrs Evelyn-Glanville, c.1740–45

Second wife of William Evelyn-Glanville I (b. 1686) and grandmother of Sarah Evelyn-Glanville who married Charles Price

Nathaniel Hone (1718–1784)

Ivory 1½ × 1¼ in. (3·4 × 3·1 cm.) oval

Head and shoulders, slightly to the left, her head turned and looking three-quarters to the right. She has brown hair, and hazel eyes and wears a white dress. The miniature is signed in monogram 'NH', low on the left.

Inscribed in ink on the backing paper: 'Mrs Granville'.

The costume and hair style suggest a date c.1740–45. No. 413 is a copy of this work with slightly less of the figure.

413 [38]

Bridget (Raymond), Mrs Evelyn-Glanville, c.1740–45

See No. 412

Nathaniel Hone (1718–1784)

Ivory 1⅛ × 1 in. (3 × 2·5 cm.) oval

This miniature is similar to No. 409, but a little less of the figure is shown. It is not signed.

Inscribed in ink on the backing paper are the words: 'Bridget Granville – Grandmother to William Gascoyne. By N-Hone'.

414 [3a]

Unknown Man, c.1745–55

Jean (André) Rouquet (1701–1758)

Enamel on metal 1⅝ × 1⅜ in. (4·2 × 3·5 cm.) oval

Head and shoulders turned slightly to the left, looking at the spectator. The sitter has dark brown hair and dark eyes and wears a buff coat and light blue waistcoat. The background is grey blue. It is signed to the right: 'R'. 'No. 3' is inscribed in black on the white enamelled back.

A pair with No. 415.

415 [3b]

Unknown Lady, c.1745–55

Jean (André) Rouquet (1701–1758)

Enamel on metal 1⅝ × 1⅜ in. (4·2 × 3·5 cm.)

Head and shoulders fronting and looking at the spectator but the sitter's head is slightly to the left; she has fair hair, and blue eyes and wears a white bonnet and brown dress with broad lace edged fichu (?). The background is grey blue. 'No. 4' is inscribed in black on the white enamelled back; a paper on the back is inscribed in ink 'By Chs. Boit'.

This miniature and No. 414 are a pair by the

same artist and the inference is that they are husband and wife.

The costume and hair-styles are *c*.1745–55 and the sitters' ages appear to be *c*.30–35.

416 [41]

Unknown Man with a Globe, *c*.1750–60

Painter unknown

Enamel on metal $\frac{1}{2} \times \frac{7}{16}$ in. (1·5 × 1·2 cm.) oval

Head and shoulders to the left, looking down at the globe on the left, his right hand raised to his forehead; he has light golden hair.

417 [40]

Unknown Lady, *c*.1750–60

Painter unknown

Enamel on metal $\frac{1}{2} \times \frac{7}{16}$ in. (1·5 × 1·2 cm.) oval

Head and shoulders are to the right, looking at the spectator. The lady has black hair; and she wears a blue dress; a bonnet or bandeau round her head is indicated.

As this and No. 416 are the same tiny size and of the same date it is presumed that they are of husband and wife. This miniature appears to represent the same lady as No. 418 in similar pose and head dress.

418

Unknown Lady, *c*.1750–60

Attributed to John Plott (1732–1803)

Ivory $1\frac{5}{8} \times 1\frac{1}{4}$ in. (3·8 × 3·1 cm.)

Head and shoulders full three-quarters to the right, looking at the spectator. The lady has black hair and hazel eyes; she wears a white drape on her head and a white dress embroidered in pale colours. The background is grey.

Inscribed in ink on the backing paper: 'By J. Plott'.

The lady appears to be about 30 years of age and the work is datable at about 1760.

419 [32]

William Evelyn-Glanville I (?), of St Clere, Kent, 1760

Father of Sarah who married Chase Price and grandfather of Sarah Price who married Bamber Gascoyne

Samuel Cotes (1734–1818)

Ivory $1\frac{3}{8} \times 1\frac{1}{8}$ in. (3·5 × 3 cm.) oval

Head and shoulders to the right, looking slightly to the spectator's right; his wig is grey and his eyes hazel; he wears a mauve coat. The background is grey. The miniature is signed low on the right: 'S.C./1760'.

Inscribed in ink on the backing paper are the words 'Evelyn Granville. Grandfather to Will Gascoyne. By S. Cotes. 1760'.

The sitter appears to be about 60 years of age.

420 [29]

Probably **William Evelyn-Glanville II,** 1760

The brother of Sarah who married Chase Price and and was mother of Sarah Price (No. 143) who married Bamber Gascoyne

Samuel Cotes (1734–1818)

Ivory $1\frac{1}{2} \times 1\frac{1}{4}$ in. (3·8 × 3·4 cm.) oval

Head and shoulders to the right looking at the spectator. The sitter has thinning auburn hair and hazel eyes, and wears a mauve coat. The background is light grey. The miniature is signed low on the right 'S.C./1760'.

Inscribed in ink on the backing paper are the words: 'Will. Son of Will. Granville Esq. By S. Cotes 1760'.

The sitter appears to be aged about 30.

421 [15]

Elderly Unknown Lady, c.1760–65

Painter unknown

Ivory 1½ × 1¼ in. (3·7 × 3 cm.) oval

Head and shoulders to the right. The lady's eyes are blue; she wears a white bonnet over grey hair, and a black lace shawl (?) over a white dress. She appears to be aged about 75–80. The costume and hair style suggest a date near 1760.

Inscribed in ink on the backing paper are the words: 'a copy from a picture of the Cromwell period. Artist not known'.

If a Cecil, the sitter might be Anne, Countess of Salisbury (1693–1757) very late in life. (See No. 156). If the lady was a member of the Glanville family she might be Bridget, 2nd wife of William Evelyn-Glanville. It was catalogued in 1891 as a lady of the Cromwellian period.

422 [8] ill. 216, p. 311

Unknown Lady, 1761

Samuel Finney (1718/19–1798)

Ivory 1⅛ × 1 in. (3·1 × 2·6 cm.) oval

Head and shoulders to the right, looking at the spectator. The lady has brown hair and hazel eyes; her hair adornment, neck ribbon and ribbon round the top of her dress are all blue. The background is pale green-grey. The work is not signed, but on the backing paper is inscribed: 'By S. Finney. 1761'.

There is no reason to question the attribution to S. Finney, a little known miniature painter. Nos 423 to 424 also attributed to him, should be members of one family, a mother and her son aged c.8 and daughter aged c.5.

423 [16]

Unknown Girl, 1761

Samuel Finney (1718/19–1798)

Ivory 1⅛ × 1 in. (2·9 × 2·4 cm.) oval

Head and shoulders to the left, the sitter looks at the spectator, her hair is brown, and her eyes hazel; she wears a white dress and a blue hair adornment. She must be about 4 to 6 years of age.

Inscribed in ink on the backing paper are the words: 'By S. Finney, 1761'.

See also No. 422.

424

Unknown Boy, 1761

Samuel Finney (1718/19–1798)

Ivory 1⅛ × 1 in. (2·9 × 2·4 cm.)

Head and shoulders to the right, looking at the spectator. The boy aged about 8, has brown hair and hazel eyes; he wears a blue coat. The background is grey.

The backing paper is inscribed: 'By S. Finney, 1761'.

See also No. 422.

425 [36]

Unknown Lady, 1763

Nathaniel Hone (1718–1784)

Ivory 1½ × 1⅛ in. (3·7 × 3 cm.) oval

Head and shoulders to the left, the lady's head is almost in profile to the left, and she looks slightly down in that direction; her hair is brown; she wears a pale blue gown edged with ermine. The background is grey. The miniature is signed in monogram and dated: 'NH/1763', low on the left.

Inscribed in ink on the backing paper are the words: 'Countess Rothes, wife to Raymond Evelyn Esqr. By N-Hone 1763'.

The miniature represents an adult lady and so is unlikely to be rightly named the Countess of Rothes (1750–1810) who married in 1766 George Raymond Evelyn. If a Glanville, the sitter could be Susannah (Borrett) wife of William Evelyn-Glanville II.

426 [39]

Called **The *Hon. Mary Tryon** (d. 1799), 1763

Mary Tryon was a Maid of Honour to Queen Charlotte from 1761 to the time of her death. She was a sister of Lieutenant General William Tryon, last English Governor of New York

John Smart (1741–1811)

Ivory 1¼ × 1⅛ in. (3·2 × 2·8 cm.) oval

Head and shoulders are to the right, looking at the spectator. She has brown hair and brown eyes; she wears a white neck-frill, and a white dress both of which are threaded with a narrow blue ribbon. The miniature is signed and dated: 'J.S./1763'.

An inscription in ink on the backing paper reads: 'The Hon^ble Mis Tryon, Maid of Honor to Queen Charlotte signed J.S. 1763. Smart'.

Mary Tryon's brother married a relation of the 1st Marquess of Downshire through whose influence he was appointed Lieutenant-Governor of North Carolina in 1764. It thus appears likely that the miniature came into the collection through Lord Downshire's daughter, the 1st Marchioness of Salisbury.

*Maids of Honour were accorded the honorary rank of Baron's daughters.

427 [31]

Unknown Man, 1765

Nathaniel Hone (1718–1784)

Enamel on metal 1½ × 1⅛ in. (3·6 × 3·1 cm). oval

Head and shoulders full three-quarters to the right looking at the spectator. The sitter had dark brown hair and hazel eyes and wears a blue coat. The background is brownish green. The miniature is signed in monogram and dated low on the right 'N-H/1765'.

The sitter appears to be aged about 35.

428

Called **Mrs Lee**, c.1765–70

Attributed to Richard Crosse (1742–1810)

Ivory 1¼ × 1 in. (3·2 × 2·7 cm.) oval

Head and shoulders are nearly in profile to the right; her hair is medium brown and her eyes blue; she wears an oyster-coloured head drape and dress. The background is pale green-grey. Engraved on the metal backing is the monogram: 'C.M.L.'. The hair-style is of c.1765–70.

429 [17]

Unknown Lady, c.1765–70

Attributed to John Smart (1741–1811)

Ivory 1¼ × 1⅛ in. (3·4 × 2·9 cm.) oval

Head and shoulders in profile to the left. Her hair and eyes are brown; she wears an oyster coloured dress and head-dress. The background is green-grey.

Inscribed in ink on the backing paper is: 'By J. Smart'.

The sitter's hair style is of c.1765–70. From her age she may be Mrs Sarah Price. the mother of Sarah, Mrs Bamber Gascoyne (No. 251), but there are many other possibilities. It has been suggested that she was a Miss Lee.

430

Unknown Lady, *c.*1765–70

Painter unknown

Ivory $1\frac{5}{8} \times 1\frac{1}{4}$ in. (3·8 × 3·2 cm.) oval

Head and shoulders to the left, looking at the spectator; her somewhat dark brown hair is dressed high in the style of *c.*1765–70; her eyes are blue; she wears a pink dress and pearl necklace. The background is a pale varying blue.

'No. 13' is written on the backing paper.

431 [23]

Called **Lady Emily Mary (Hill), Marchioness of Salisbury** (1750–1835), *c.*1765–70

See No. 168

Painter unknown

Ivory $1\frac{1}{4} \times 1$ in. (3·5 × 2·7 cm.) oval

Head and shoulders almost in profile to the left. The sitter's hair is brown and her eye hazel; she wears a blue dress. The background is hazel.

Inscribed in ink on the backing paper is: '"Emily wife of —" By Boyer 1783'. Stuck below this is another paper on which is written in a somewhat illegible hand what appears to be 'Emily Mary B—out'.

The miniature might represent the 1st Marchioness at about the age of 20. No artist is known of the name of Boyer; the name which is on one of the labels at the back; the hair style is too early for 1783, being of *c.*1765–70, and thus too early to suggest that Boyer is a corruption of Bowyer (Robert Bowyer, born 1757 or 8).

432 [7] ill. 217, p. 311

Unknown Young Man, 1766

Samuel Cotes (1734–1818)

Ivory diameter $1\frac{5}{8}$ in. (4·8 cm.) circular

Head and shoulders to the right, looking at the spectator; he has dark brown hair and hazel eyes and wears a light brown coat. Foliage is seen to the left. The miniature is signed and dated on the right: 'S. Cotes/1766'.

Inscribed in ink on the paper backing is: 'Edmond Burk Qy. By "S. Cotes" 1766' and a paper stuck on the backing paper is inscribed 'Marquess of Salisbury ser 186'.

The miniature was No. 29 in the 1868 list when it was not given a name. It was catalogued in 1891 as a portrait of Edmund Burke (1729–1797) by S. Cocks, 1766. This identification cannot be substantiated. The sitter appears to be a young man of near 20 years old; it has been suggested that he is George Raymond Evelyn-Glanville who married in 1766 Jane Elizabeth Leslie, Countess of Rothes. The features fairly closely resemble those of the 1st Marquess of Salisbury, see No. 165.

433

Unknown Lady, 1767

James Scouler (?) (1740–1812)

Ivory $1\frac{1}{4} \times 1$ in. (3·1 × 2·7 cm.)

Head and shoulders fronting the spectator. The Lady's head is slightly to the right; she looks at the spectator; she has brown hair and hazel eyes; she wears a very long plait looped on her left shoulder and a blue gown edged with ermine over a lemon-coloured dress. The miniature is signed low on the left: 'J.S./1767'.

Inscribed in ink on the backing paper: Signed "J.S. 1767" John Smart or James Scouler'.

434 [42]

Unknown Man, *c.*1770–75

Painter unknown

Ivory (?) $\frac{3}{4} \times \frac{7}{8}$ in. (1·8 × 1·5 cm.) oval

Head and shoulders to the left, looking at the spectator; his hair is powdered and his eyes blue; he wears a pale blue coat. He is fairly young. The hair-style and costume are of about 1770–5.

435 [24] ill. 218, p. 311

James Cecil, 7th Earl and 1st Marquess of Salisbury (1748–1823), 1775

See No. 165

Samuel Cotes (1734–1818)

Ivory $1\frac{1}{2} \times 1\frac{1}{8}$ in. (3·5 × 2·9 cm.) oval

Head and shoulders to the right, looking at the spectator. The hair is a powdered wig or his own hair curled over his ear; his eyes are hazel; he wears a scarlet coat. The background is grey-green. The miniature is signed and dated low on the right 'S.C./1775'. The miniature has a metal backing on which is engraved the letter 'C' surmounted by a Viscount's coronet above the date '1775', Below this is scratched the number 'No. 16'.

This work was catalogued in 1891 as the 6th Earl but the sitter is a young man and his age in 1775 fits the 1st Marquess, who was Viscount Cranborne at that date. He succeeded as 7th Earl of Salisbury in 1780.

436

Called **Lady Emily Mary (Hill), Marchioness of Salisbury** (1750–1835), 1778 (?)

See No. 168

Attributed to James Nixon (1741(?)–1812)

Ivory 3 × $2\frac{1}{2}$ in. (7·6 × 6·2 cm.) oval

Head and shoulders to the right, looking at the spectator; she has powdered hair and hazel eyes;

she wears a lemon coloured dress with white fichu. The background is a cloudy sky.

Inscribed in ink on the backing paper are the words: 'By James Nixon ARA 1778'.

437 [37]

Unknown Lady, c.1780–85

Painter uncertain

Ivory $1\frac{1}{4} \times 1\frac{1}{8}$ in. (3·3 × 2·9 cm.) oval

Head and shoulders are to the right, nearly in profile; the lady's hair is powdered, only the edge of her low-cut dress is seen.

Inscribed in ink on the backing paper: 'Frances wife of Admiral Boscawen. By Maria Cosway(?)'.

The miniature represents a lady under 40, with her hair dressed in the style of c.1780–5. This rules out Mrs Boscawen who married in 1742. In the 1891 catalogue it is stated to be by Maria Cosway and the date to be 1760, which is too early for the hair-style. There is affinity to the work of Richard Crosse and it could be one of the miniatures for which Lady Salisbury paid him in 1784, see No. 440.

438 [2]

Unknown Lady, c.1780–85

Painter unknown

Silhouette in black on ivory $1\frac{1}{8} \times \frac{5}{8}$ in. (2·8 × 1·8 cm.) octagonal

Head and half shoulders in profile to the left, aged probably about 30. This appears to have been No. 8 in the 1868 list, called a 'Female Head'.

439 [1]

James Cecil, 7th Earl and 1st Marquess of Salisbury (1748–1823), c.1785

See No. 165

Silhouettist unknown

Silhouette in black on gold ground on the back of a convex glass 2½ × 2 in. (6·4 × 5·2 cm.) oval
Head and half shoulders of a young man in profile to the left. He wears a wig with queue and a frill to his shirt front. Inscribed on a paper at the back is: 'Lst Marquess of Salisbury/by Field'. The costume and hair-style are of *c*.1785. This appears to have been No. 7 in the 1868 list, called the First Marquess.

The silhouette appears to be too early to be by John Field (1771–1845)

440 [26]

Unknown Lady, *c*.1780–90

Attributed to Richard Crosse (1742–1810)

Enamel on metal 2½ × 2 in. (6·3 × 5 cm.) oval

Head and shoulders slightly to the left, her head is full three-quarters to the right, she looks slightly down; her hair is auburn and over it she wears cinnamon coloured drapery; her dress is pink with blue drapery. The background is blue-grey.

Inscribed in ink on the backing paper are the words: 'An enamel by Rich^d Crosse 1790'.

Richard Crosse, a deaf and dumb artist, kept a ledger which, edited by Basil S. Long, is printed in the Walpole Society Volume xvii, 1929, pp. 67–94. No payment he recorded in 1790 or in the years immediately following can be connected with the miniature or No. 428. On March 12, 1784, however, Crosse received £16. 16s. from Lady Salisbury for two miniatures. He did not mention whether they were of her or of other persons.

441 [23] ill. 219, p. 311

Lady Emily Mary (Hill), Marchioness of Salisbury (1750–1835), 1790

See No. 168

George Engleheart (1750/2–1829)

Ivory 2¼ × 1⅞ in. (5·6 × 4·7 cm.) oval

Head and shoulders to the right, looking at the spectator. The sitter has powdered hair and pale blue eyes; she wears a near-white dress. The background is a cloudy sky.

Inscribed in ink on the backing paper are the words: 'Emily Mary 1st Marchioness of Salisbury'.

In *George Engleheart* by G. C. Williamson and H. L. D. Engleheart 1902, there is a list of Engleheart's sitters, extracted from his Fee Book; Lady Salisbury's name appears under the year 1790 on page 113. The Hatfield House miniature is reproduced in reverse opposite page 80.

442 [21]

Elderly Unknown Lady, *c*.1785–95.

Painter uncertain

Ivory 3 × 2⅜ in. (7·3 × 5·8 cm.) oval

Head and shoulders, the lady fronts the spectator, but her head is turned and she looks full three-quarters to the right. She wears a white bonnet over powdered hair, a white fichu and black lace dress. The background shows a cloudy sky.

Inscribed in ink on the backing paper are the words: '"The Dowager", considered to be painted by Cosway'.

The sitter's age appears to be about 60 and the date about 1785–95. The miniature was reproduced in an article on the Hatfield House Collection by J. Bolt in the *Connoisseur*, December 1903, Vol. vii, p. 226, as the first Marchioness of Salisbury by Maria Cosway. It does not, however, represent the first Marchioness (born 1750).

443

Lady Emily Mary (Hill), Marchioness of Salisbury (1750–1835), 1790

See No. 168

Copy after Robert Bowyer (1757 or 8–1834)

Ivory 3¾ × 3 in. (9·5 × 7·5 cm.) oval

The sitter is portrayed to the waist, her body is in profile to the left her head three-quarters to the left, she looks at the spectator. Her hair is powdered (style about 1785–90), her eyes blue; she wears a white dress. The background is pale blue. The miniature is inscribed to the right of her shoulder 'Cosway 1790'.

This is nearly similar to an engraving in stipple by Caroline Watson inscribed as after a miniature of the Marchioness of Salisbury by R. Bowyer. The engraving, however, is extended below the waist and in it a dog's head is seen nestling close to her waist, snout upwards; Lady Salisbury rests her right hand on the dog's head.

The engraving was published January 12, 1790, and was dedicated to the Princess Royal. Robert Bowyer is described as 'miniature painter to his Majesty'. He succeeded Meyer in this office in 1789.

444

Called **Lady Emily Mary (Hill), Marchioness of Salisbury** (1750–1835), c.1790–1800

See No. 168

Artist unknown

Ivory 2¾ × 2¼ in. (7·1 × 5·6 cm.) oval

Head and shoulders fronting the spectator, her head is turned and she looks three-quarters to the right. The sitter has powdered hair and wears round it a yellow bandeau studded with pearls; she has a white dress with a narrow yellow drape

from her right shoulder. The background is of a cloudy sky.

Engraved on the metal backing are the words: '1st Marchioness of Salisbury E.M.B.C. Cecil, given me by Mama 1815'. 'E.M.B.C. Cecil' has not been identified. It appears that there must be an error in the inscription.

The hair-style is of about 1790–1800.

445 [28] ill. 220, p. 311

James Cecil, 7th Earl and 1st Marquess of Salisbury (1748–1823), c.1795–1800

See No. 165

Attributed to Adam Buck (1759–1833)

Card or paper 2¾ × 2¼ in. (7·1 × 5·8 cm.) oval

Head and shoulders in profile to the left; the hair is powdered, the sitter wears a black coat over which is the blue ribbon of the Garter.

Engraved on the back of the metal frame are the words: '1st Marquess of Salisbury'.

The wig and costume suggest a date 1795–1800.

The miniature is very similar to miniature No. 446 and is probably the original. It was catalogued in 1891 as by Cosway.

446 [22]

James Cecil, 7th Earl and 1st Marquess of Salisbury (1748–1823), c.1795–1800

See No. 165

Attributed to Adam Buck (1759–1833)

Ivory 2⅞ × 2⅛ in. (7 × 5·5 cm.) oval

Head and shoulders in profile to the left. His hair is powdered in a queue, his eyes are hazel; he wears a black coat with a velvet collar over which is the ribbon of the Garter. There is a vertical

crack in the ivory just to the left of the face.

Inscribed in ink on the backing paper are the words: 'James, 1st Marquess of Salisbury Obt 1823. By Adam Buck'.

The costume and hair-style suggest a date near 1795–1800. This and miniature No. 445 are nearly similar. No. 445 appears to be the original.

447

James Cecil, 7th Earl and 1st Marquess of Salisbury (1748–1823)

See No. 165

Painter unknown

Silhouette, painted on paper 3 × 2⅜ in. (7·6 × 6 cm.)

Head and shoulders in profile to the left aged 50 or thereabouts. The black is touched in with silver. There is an inscription on the back stating that the silhouette was given by the Marquess to Sarah Tillman.

448 [43]

Unknown Man, c.1795

Painter unknown

Ivory (?) 1¼ × 1 in. (3 × 2·7 cm.) oval

Head and shoulders to the left, looking at the spectator; he has short brown hair and brown eyes; he wears a scarlet coat with a blue collar and gold lace button-hole. The background is brown.

Inscribed in ink on the backing paper is: 'George Raymond Esq. son to Will Granville Evelyn Esq'.

The sitter is about 35 years of age, his costume is of about 1795. The miniature was called George Evelyn-Glanville (d. 1770) in the 1891 catalogue. If a Glanville is represented he could be William Evelyn-Glanville III.

449 [20]

Called **James Cecil, 7th Earl and 1st Marquess of Salisbury** (1748–1823), c.1800

See No. 165

Attributed to Richard Cosway (1742?–1821)

Ivory 2¾ × 2¼ in. (7·2 × 5·7 cm.) oval
Head and shoulders fronting the spectator, his head is turned and he looks three-quarters to the right. The hair is powdered and the sitter wears a blue uniform with an upright scarlet collar and silver lace buttonholes. The background shows a light cloudy sky. Inscribed in ink on the backing paper are the words: 'Painted by Henry Edridge, ARA, 1821'.

The sitter's age appears to be about 45–50 and the costume and hair-style suggest a date near 1800.

Henry Edridge made a whole length drawing of the 2nd Marquess, with his white staff and key as Lord Chamberlain of the Household, in 1803. This was engraved by A. Cardon in 1805.

450 [13] ill. 221, p. 312

Unknown Lady, c.1800–1805

Louise Chacaré de Beaurepaire (fl. 1787–1833)

Ivory diameter 2¾ in. (7 cm.) circular

The sitter is depicted to the waist to the left, looking at the spectator, she has medium brown hair and blue eyes; and wears a white dress, she has a black ribbon round her hair; the top of a lemon coloured long glove is visible. The background is pale blue. The miniature is signed along the right edge: 'de Beaurepaire'. The costume and hair-style are of about 1800–1805; the costume appears to be of a foreign (French?) style.

Madame (or Mademoiselle) de Beaurepaire, a pupil of Augustin, exhibited miniatures at the Royal Academy in 1804, and from 1816 to 1822,

from addresses in London. She also worked in Bath in that period.

451

Called **Mary, Queen of Scots** (1562–1587), copy made in 1807 (?)

Painter unknown

Ivory $2\frac{1}{8} \times 1\frac{3}{4}$ in. (5·4 × 4·2 cm.) oval

Head and shoulders slightly to the left; she looks at the spectator; she has auburn hair, and brown eyes. She wears a cinnamon coloured head-dress and top to a red dress. The background is grey. This is a free copy of the 'Carleton' portrait called Mary Queen of Scots at Chatsworth.

Engraved on the metal backing is: 'Mary Queen of Scots' and on the card backing to the ivory: 'Mary Queen of Scots 1807'.

452 ill. 222, p. 312

Unknown Young Military Officer, 1809

Richard Cosway (1740–1821)

Ivory $2\frac{3}{4} \times 2\frac{3}{8}$ in. (7 × 5·7 cm.) octagonal

Head and shoulders slightly to the right, looking at the spectator. The sitter's hair is brown; he wears a scarlet coat with gold lace edging and gilt buttons, and a black neck cloth. The background is a blue sky with fleecy clouds.

Inscribed in ink on a label on the back is: 'R^dus Cosway RA & FSA, Pictor Primarius Serenissimi Principi Pinxit 1809', and on another paper: 'Restored by H. Arrowsmith, Lawn House, Blackwall'.

There is a likelihood that this represents a progenitor of the 4th Marchioness of Salisbury.

453

Frances Mary (Gascoyne), Marchioness of Salisbury (1802–1839), c.1814

c.1814

See No. 172

Andrew Robertson (1777–1845)

Ivory $3\frac{3}{8} \times 2\frac{5}{8}$ in. (8·6 × 6·5 cm.) oval

Head and shoulders. to the left, looking at the spectator. She has darkish hair and brown eyes; she wears a coral necklace and a white dress. The background is a cloudy sky with a suggestion of trees to the right.

Engraved on the metal backing is: 'Frances Mary Gascoyne 2nd Marchioness of Salisbury by A. Robertson'.

The sitter would seem to be about 12 years of age. It has been said that she had not fully recovered from scarlet fever when the miniature was painted.

454

Pope Pius VII (1742–1823)

Pope from 1800 to 1823

After Vincenzo Camuccini (1773–1844)

Ivory diameter 3 in. (7·5 cm.) circular

Head and shoulders full three-quarters to the right, looking down. The Pope's hair is black; he he wears an ermine-edged red robe. The background is grey.

The original, a seated three-quarter length, was engraved in live by Giovanni Ballista, Rome, 1816. The miniature is close to a circular engraving of the head and shoulders by Giovanni Folo, 1819. On another engraving the portrait is stated to be in the Belvedere Gallery Rome.

455

An Army Officer, *c.*1820–30

Painter unknown

Ivory 2⅞ × 2⅜ in. (7·3 × 6 cm.) oval

Head and shoulders to the left, looking at the spectator. He is slightly balding, his hair is dark brown and his eyes brown. The sitter wears side whiskers, a black uniform with upright collar and gold epaulettes. The background is light brown.

A vertical crack in the ivory runs through the left side of the iris of his right eye. From the uniform the miniature may be dated as of *c.*1820–30.

There is a likelihood that this represents a progenitor of the 4th Marchioness of Salisbury.

456 ill. 223, p. 312

Frances Mary (Gascoyne), Marchioness of Salisbury (1802–1839), *c.*1825–30

See No. 172

Thomas Hargreaves (1775–1846)

Ivory 4 × 3 in. (10 × 7·5 cm.) oblong

Head and shoulders to the right, looking at the spectator. Lady Salisbury has black hair and brown eyes; she wears a black plumed head-dress and mauve dress. The background is brown with sky to the right.

Engraved on the metal backing is: 'Frances Mary 2nd Marchioness of Salisbury by T. Hargreaves'.

457 [34]

Lady Mary Catherine (Sackville-West), Marchioness of Salisbury (1824–1900), 1826

See No. 174

Copy by the Hon. Mrs Sackville-West after Anthony Stewart (1773–1846)

Ivory diameter 2½ in. (6·4 cm.) circular

Head and shoulders aged *c.*2–3, fronting the spectator, her right hand raised chin height, her hair is fair, short, and curly; she wears a coral necklace and bracelet, white dress and blue, mottled.

Inscribed on a paper at the back is: 'The Lady Mary C. West B. 1824. m. 1847 James 2nd M. of Salisbury. original painted by Anthony Stewart 1826, now in the possession of the Duchess of Bedford. copied in 1854 by the Hon^ble M^rs Sackville West'. The last named was presumably the sitter's sister-in-law Fanny Charlotte (Dickson), the wife of the Hon. Mortimer Sackville-West, whom she married in 1847.

458

Robert Arthur James Gascoyne–Cecil, 5th Marquess of Salisbury (b.1893)

See No. 214

Painter unknown

Ivory 2¾ × 2¼ in. (7 × 5·7 cm.) oval?
Head and shoulders slightly to the left, looking at the spectator. Lord Salisbury's hair is fair and his eyes pale blue. He is depicted when a youth, dressed as a page wearing a blue coat and lace-ended jabot. The background is pale blue.

Lord Salisbury was page to his grandfather, the 3rd Marquess at the coronation of King Edward VII and at functions as Chancellor of Oxford University. He was also page to his father at the coronation of King George V.

INVENTORIES, LISTS AND CATALOGUES

All the known inventories, lists and catalogues of the possessions of the Earls and Marquesses of Salisbury, in which pictures are mentioned are arranged chronologically in the following list. The wording and spelling of their titles has not been followed.

1597 May 27. Inventory of the household stuff at Enfield. Part II Box D.41

1606 September. Inventory of the household stuff at Enfield. Part I Box D.41

1611 September 30. Inventory of Hatfield House Box A.1

1612(?) Inventory of Hatfield House. Almost a copy of that of 1611 but more pictures are listed Box D.1

1612 July 31. Inventory of Hatfield House Box B.5

1614 September 23. Inventory of Cranborne Manor. Called 'an inventory of stuffe delivered to Mr Jackson 23 September 1614 by me John Blandford' Box C.17

1620 October 26. Inventory of Hatfield House 2 copies. One is signed by John Reynolds and Marmaduke Cha[vner] Box A.3
 The other copy is unsigned Box A.2

1621 August 20. Inventory of Hatfield House 2 copies Box A.4 and Box A.5

1629 June 9. Inventory of Hatfield House by James Hodgkinson and others Box A.6

1629 June 11. Inventory of Quickswood by Abner Stansby. 3 pictures are mentioned Box C.35

1629 Dated June 11 outside and June 20 inside. Inventory of Salisbury House by John Glase Box C.8

1638 September 23. Inventory of the goods in the keeping of James Hodgkinson at Hatfield House (with a few additions to 1641) Box A.7

1639 August 26. Inventory of Cranborne Manor (2 copies), with notes of stuff lost by plunder by Prince Maurice's troops and General Goring's, May 24, 1651 Box C.27

1639/40 Inventory of Salisbury House by John Adams Box C.9

1645/6 March 9. Inventory of Salisbury House Box A.9a

1645/6 March 9. Inventory of Salisbury House by Robert Lord Box C.4

1646/7 March 9. Inventory of Salisbury House by John Adams. This varies slightly from that in Box C.4 but the pictures are the same Box C.5

1646 July 25. Inventory of Hatfield House by James Hodgkinson Box A.8
 Another copy signed by Robert Lord. Stated to have further notes to 1665 Box A.9

1647 June 3. Inventory of Salisbury House. A few entries added up to 1663 Box C.6

1647 June 28. Inventory of Hatfield House by John Adams Box D.2

1651 May 24. Inventory of Cranborne Manor (2 copies) Box C.22 and Box C.27

1651 December 12. Inventory of Quickswood (2 copies) Box C.33 and Box C.37

1664 Inventory of Hatfield House and Quickswood Box A.13

1675 June 2. Inventory of the goods of the late Diana Lady Cranborne Box A.14

1679/80 March 3 or 24. Inventory of Hatfield House Box A.10

1680 December 28. Inventory of the (late?) Countess of Kinnoull's goods at Salisbury House by Ebenezer Sadler. This includes one portrait and a painted screen Box C.7, Part 2

1683/4 February 2. Inventory and account of goods at Hatfield except household stuff and furniture belonging to the late Earl Box A.12

1684 An account of the household stuff and furniture by John Fisher and E. Sadler. Includes Hatfield, Quickswood and Salisbury House. Only the number of paintings in each room is given Box D.3

1684/5 Inventory of Hatfield, Quickswood and Salisbury House, London, claimed by the Earl of Salisbury under the will of his father. Exhibited at the Court of Chancery, July 1, 1685. Two pictures are named, otherwise only the number of pictures in each room is given Box A.11

1685 Inventory of goods at Salisbury House by E. Sadler. Signed at the end by Mrs Dorothy Packe and others April 11, 1685 Box C.7, Part 1

1686/7 Dated February 1 outside and January 1 inside. Inventory of goods at Salisbury House by Samuel Adams. On the outside is: 'taken for the use of the Earl of Northampton' Box C.3

1688 January 18. Inventory of Salisbury House (let to the Earl of Rutland) 2 copies Box C.1 and Box C.2

1692 August 30. Inventory of Salisbury House

Box C.12

1702 Inventory of Hatfield House by Mrs Lucy Bowyer and Mrs Anne Adams. Three pictures are named otherwise only the number of pictures in each room is given Shelf 1 Bay 6

1710 Inventory of goods in York Buildings. Eight landscapes (not described) are listed and one other painting Box D.35

1711 Inventory of the Mansion House at Quickswood. Signed by E. Sadler and the Earl of Salisbury. Three pictures (not named) are recorded

Box C.38

1823 Inventory of Hatfield House by Kimpton and Son, Hertford. The first list in which artists' names are often given Shelf 1 Bay 6

1824 June 28–31. Inventory of the effects of the late B. Gascoigne, Esq. Shelf 1 Bay 6

1833 March. Inventory of Hatfield House

Shelf 1 Bay 6

1836 Inventory of the goods belonging to the Marquess of Salisbury at Childwall Hall

Shelf 1 Bay 6

1845 December 16. Paintings at Hatfield House (made by H. R. Bolton?) (2 copies) Shelf 1 Bay 6

1848 Inventory of Hatfield House Shelf 1 Bay 6

1851 Catalogue with drawings of the paintings at Hatfield House. An ambitious work, only just begun (by H. R. Bolton?) Shelf 1 Bay 6

1865 Printed *Catalogue of the Paintings at Hatfield House*. Only 35 copies printed, for private circulation. This is described as 'revised' by the Marchioness of Salisbury. It is almost word for word a copy of the 1845 manuscript catalogue, with the same plans of the positions of the paintings on the walls

1868 May. Inventory and valuation of the personal effects of the 2nd Marquess of Salisbury by Alexander McKenzie and James D. Metcalf

Shelf 1 Bay 6

1868 July. Inventory of Hatfield House, a copy of the May 1868 inventory Shelf 1 Bay 6

1871 December. Inventory of Hatfield House taken by E. Newbury, G. Andrews and J. Strike

Shelf 1 Bay 6

1891 Printed *Catalogue of the Paintings at Hatfield House and Arlington Street*, by Lawrence Gifford Holland

1903 Inventory and valuation of the personal effects of the late Marquess of Salisbury, by Harding and Sons Shelf 1 Bay 6

LISTS OF HATFIELD HOUSE PICTURES MADE INDEPENDENTLY

There are a number of lists of some of the pictures at Hatfield House made by visitors for their own use or for inclusion in various publications. In some cases these have furnished valuable evidence concerning sitters and artists. The following should be mentioned:

1734 A short list was made by George Vertue the engraver and antiquary on a visit in 1734. Printed in Walpole Society. Vertue, Vol. XXX, 1900, p. 12

1761 Horace Walpole. A list of a few of the portraits he saw on a visit in 1761. Printed in Walpole Society, Vol. XVI, 1928, p.35.

1769 A list of portraits at Hatfield House, June 28, 1769 made by Sir William Musgrave for his large collection of lists of portraits in the larger private houses. A few annotations and additions were made at a later date, the last in date being Romney's portrait of the 1st Marquess of Salisbury. This is by far the fullest list before the 1823 inventory. This has not been printed. It is among the Musgrave manuscripts in the British Museum. Add. MS. 6391, ff. 79–80.

1777 Another list made by Sir William Musgrave. This list, of 1777 is shorter than that of 1769 and does not contain anything not in the 1769 list. British Museum, Add. MS. 5726. E.1, ff. 9–14.

1782 A list printed in Thomas Pennants' *Journey from Chester to London*, 1782, pp. 403–11.

c.1804 A list made by George Perfect Harding in one of his four 8 volume notebooks containing lists of portraits in public and private collections written in or close to 1804. He marked in the lists those of which he had made small watercolour copies.

1808 A list printed in Brayley's *Beauties of England, Hertfordshire*, 1808, pp. 277–9.

1819 A list printed in J. P. Neale's *Views of Seats*, 1819, Vol. II.

1833 A list printed in *History of Hatfield House* by P. F. Robinson, 1833, p. 28.

PAYMENTS TO RESTORERS

There are records of restoring and varnishing paintings in the collection from the first half of the seventeenth century onwards. Rarely, with the notable exception of Mr Chauncey's bill, are individual paintings named. It must be of some interest to see at what intervals large parts of the collection received treatment and to know the names of the

restorers, so the major records of payment are listed chronologically here. There is no certainty that this is a complete list of the major restorations.

1652 The picture drawers bill for renewing the pictures in Salisbury House: renewing 30 pictures £4, renewing and stoping the picture of Adam and Eve £1.5.0; renewing and stoping the picture of Judge Bacon 7/–: making clean pictures of alabaster.

1666 Mr Stillingfleete for cleaning, mending and new painting all the pictures at Salisbury House, £31.16.0 (Family Papers, Accounts 130/7).

1710 For cleaning and varnishing 30 pictures £1.10.0 (Bill 437).

1724 Mr Chauncey's bill, listing by name 71 pictures including 25 portraits which he restored from 1718–24. He states his charge for each one and the amounts and dates of payments on account. The total was £166.19.6. (Family and Estate Papers, Bills 521).

c.1780 Thomas Pennant, in his *Journey from Chester*, 1782, p. 411, stated: 'the pictures have been repaired by Mr Tomkins'.

1820 An anonymous estimate amounting to £82 for restoring pictures survives. Only two are named.

1843 There is at Anthony House a letter from H. R. Bolton to W. H. Pole-Carew, dated March 14, 1843, written at Hatfield House, stating: I am now cleaning and restoring the entire collection of the Marquess of Salisbury which consists of about 200 pictures, but which I shall have finished by June.' He does not say when he started but mentioned that he was at The Grove, Watford, from the previous August till Christmas.

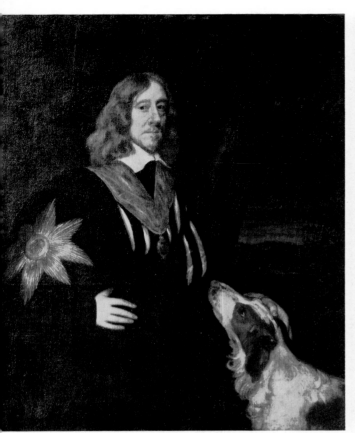

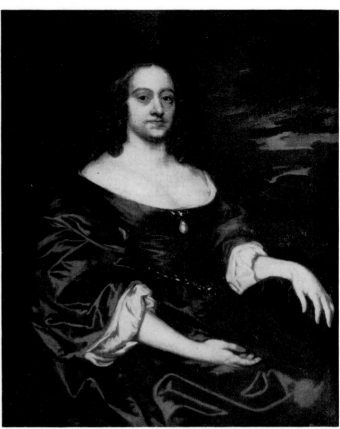

top left) Ill. 100. **William Cecil, 2nd Earl of Salisbury, K.G.,** 1654, by Sir Peter Lely (Cat. No. 124, p. 167)

top right) Ill. 101. **Catherine (Howard), Countess of Salisbury,** 1654, by Sir Peter Lely (Cat. No. 125, p. 167)

above) Ill. 102. **Algernon Percy, 10th Earl of Northumberland, K.G.,** his wife **Lady Anne (Cecil)** and one of their daughters, c.1634/5, Studio of Sir Anthony van Dyck (Cat. No. 126, p. 168)

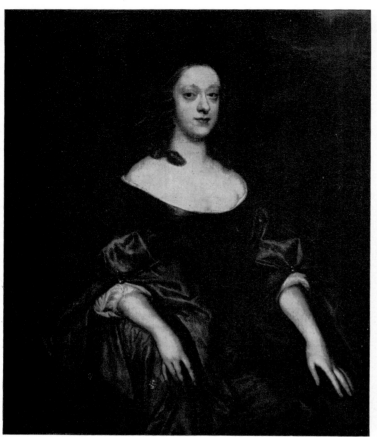

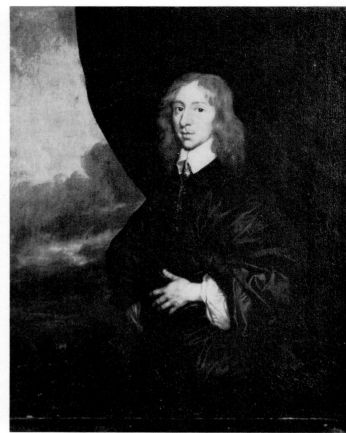

(above left) Ill. 103. **Mary Cecil, Lady Sandys,** 1655,
by Sir Peter Lely (Cat. No. 127, p. 168)
(above right) Ill. 104. **Charles Cecil, Viscount Cranborne,**
c.1645/55, by Sir Peter Lely (Cat. No. 128, p. 169)
(right) Ill. 105. **Diana (Maxwell), Viscountess Cranborne,**
by Sir Peter Lely (Cat. No. 130, p. 170)

(opposite) Ill. 106. Called **Catherine (Cecil), Countess of
Kinnoull** and her son **Lord Dupplin,** by Caspar Smitz
(Cat. No. 132, p. 170)

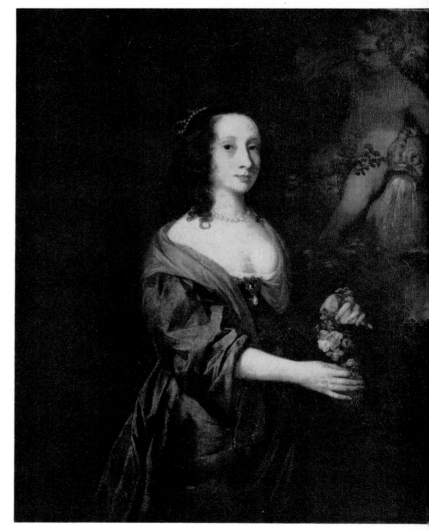

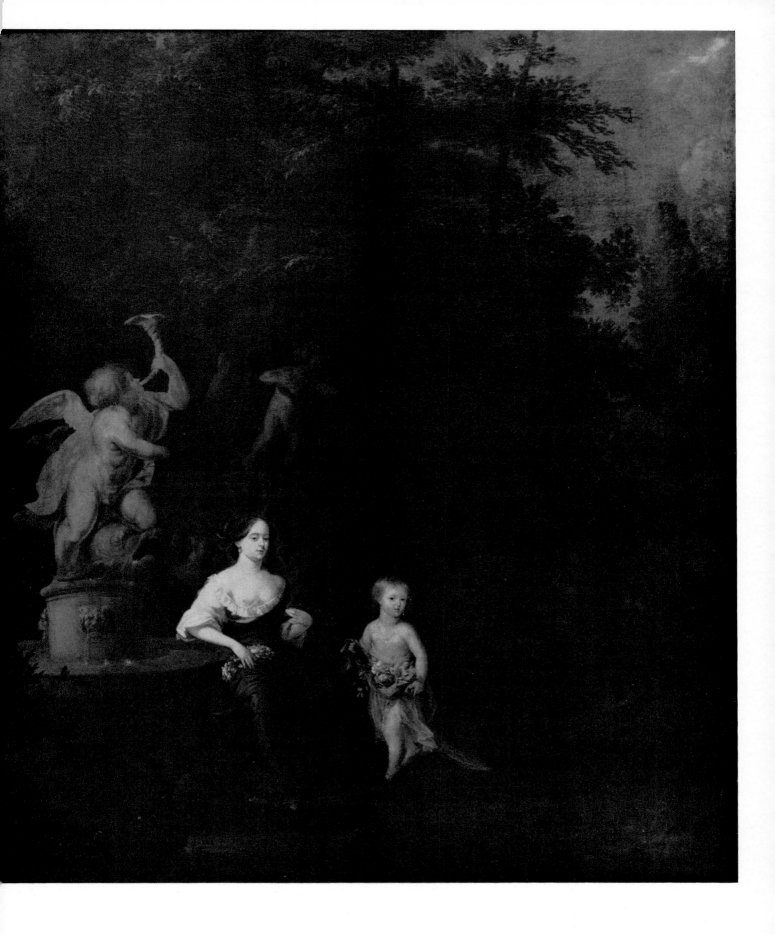

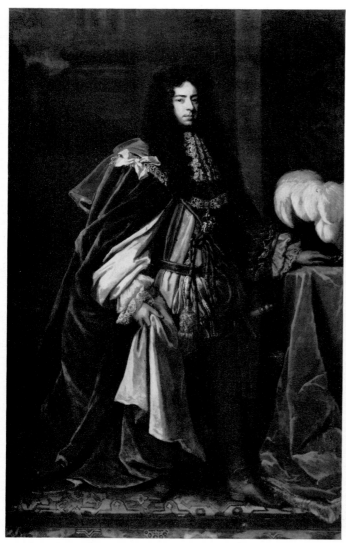

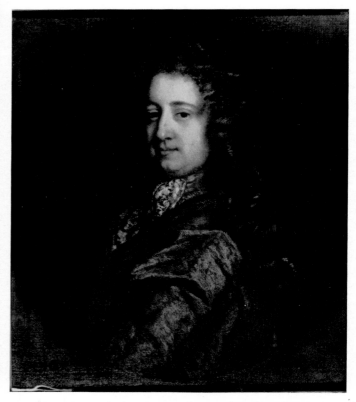

(left) Ill. 107. **James Cecil, 3rd Earl of Salisbury, K. G.,** 1680 or 1681, by Sir Godfrey Kneller (Cat. No. 133, p. 171)
(below) Ill. 108. Called the **Hon. Robert Cecil,** by Charles Beale the Younger (Cat. No. 137, p. 172)
(bottom left) Ill. 109. Called the **Hon. William Cecil,** by William Wissing (Cat. No. 139, p. 173)
(bottom right) Ill. 110. Called **Lady Frances (Cecil), wife of Sir William Halford (or Holford),** attributed to William Wissing (Cat. No. 142, p. 174)

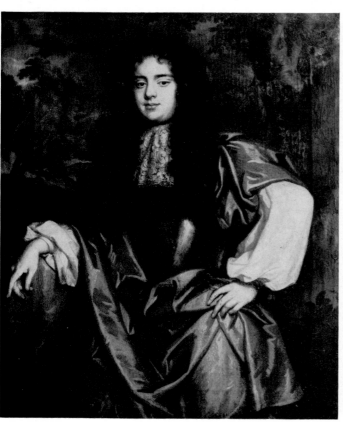

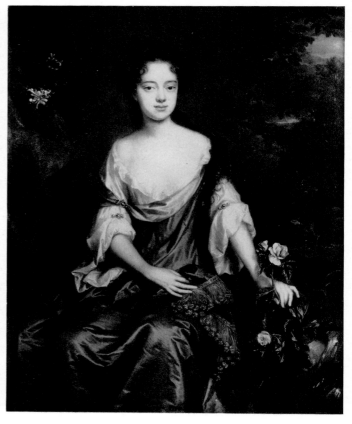

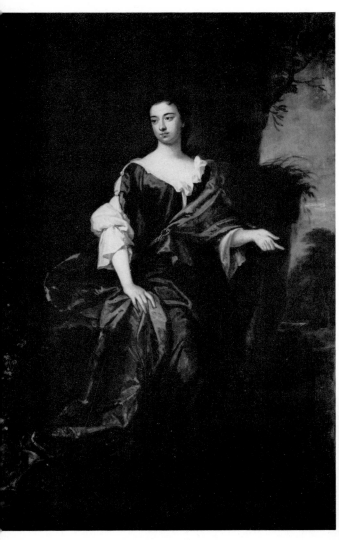

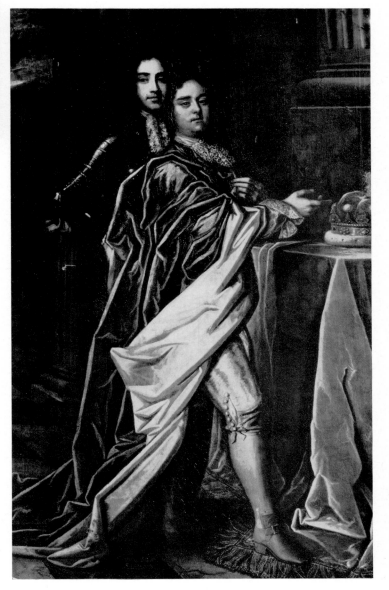

(above) Ill. 111. **Lady Margaret (Cecil), Countess of Ranelagh,**
by Sir Godfrey Kneller (Cat. No. 144, p. 174)
(right) Ill. 112. **James Cecil, 4th Earl of Salisbury,** 1687 or shortly
before over an earlier portrait of **James, Duke of Monmouth,**
by William Wissing (Cat. No. 145, p. 174)

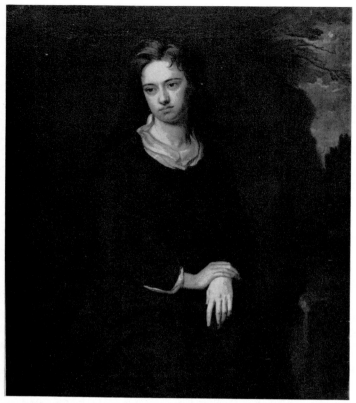

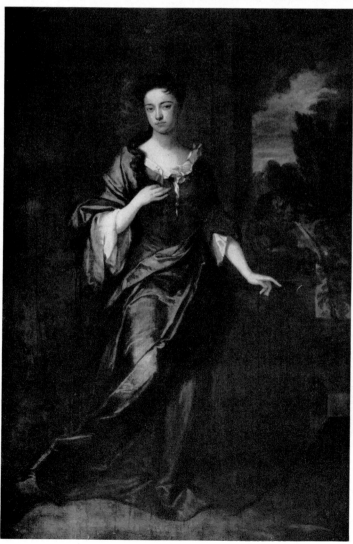

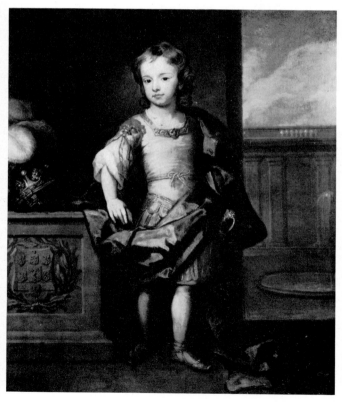

(above left) Ill. 113. **Frances (Bennet), Countess of Salisbury,** 1695, by Sir Godfrey Kneller (Cat. No. 148, p. 176)
(left) Ill. 114. **Frances (Bennet), Countess of Salisbury(?),** c.1686, by William Wissing(?) (Cat. No. 149, p. 176)
(above right) Ill. 115. **James Cecil, 5th Earl of Salisbury,** 1695, by Sir Godfrey Kneller (Cat. No. 150, p. 176)

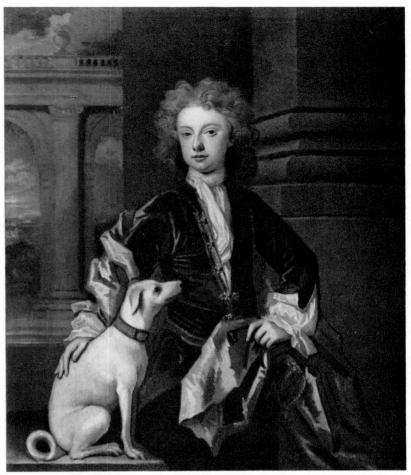

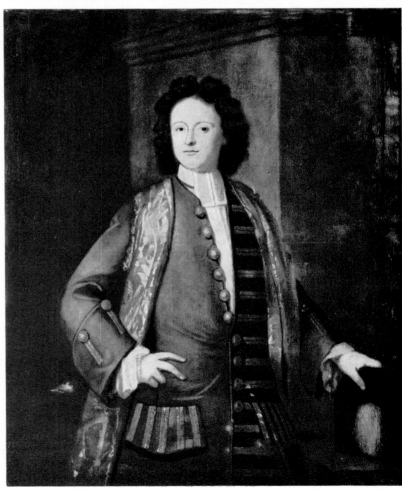

(above right) Ill. 116. **James Cecil, 5th Earl of Salisbury,** *c.*1703,
attributed to Charles Jervas (Cat. No. 152, p. 177)

(right) Ill. 117. **James Cecil, 5th Earl of Salisbury,** 1705–7, by
William Sonmans (Cat. No. 153, p. 177)

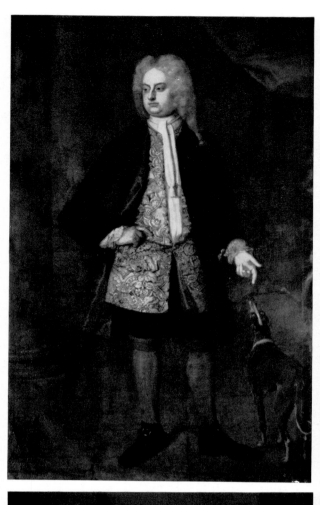

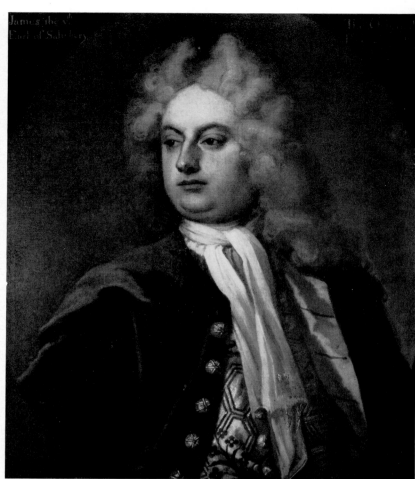

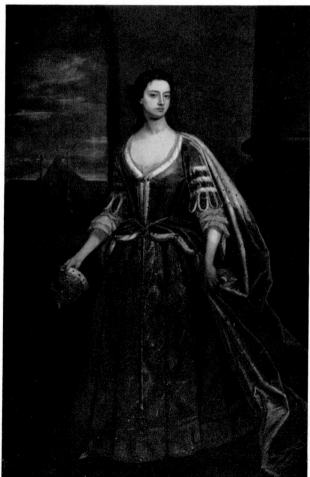

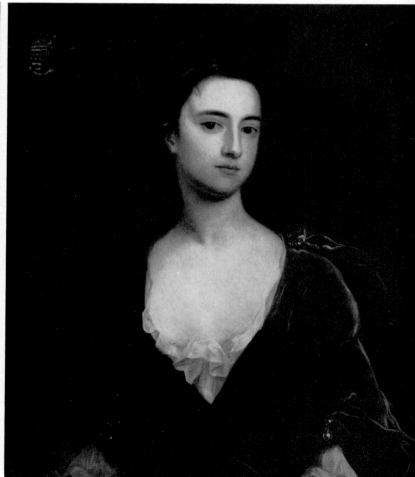

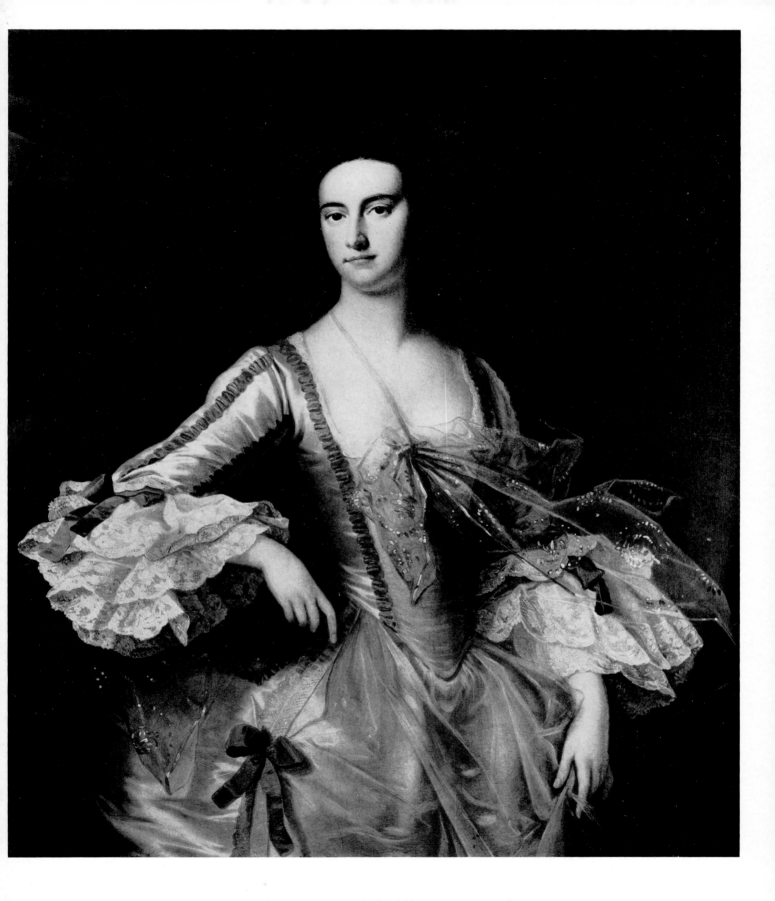

(opposite above left) Ill. 118. **James Cecil, 5th Earl of Salisbury,** by Michael Dahl (Cat. No. 154, p. 178)
(opposite above right) Ill. 119. **James Cecil, 5th Earl of Salisbury,** by Michael Dahl (Cat. No. 155, p. 178)
(opposite below left) Ill. 120. **Lady Anne (Tufton), Countess of Salisbury,** by Charles Jervas (?) (Cat. No. 156, p. 178)
(opposite below right) Ill. 121. **Lady Anne (Tufton), Countess of Salisbury,** by Charles Jervas (?) (Cat. No. 157, p. 179)

(above) Ill. 122. **A daughter of the 5th Earl** (?), c.1740, by Thomas Hudson (Cat. No. 160, p. 180)

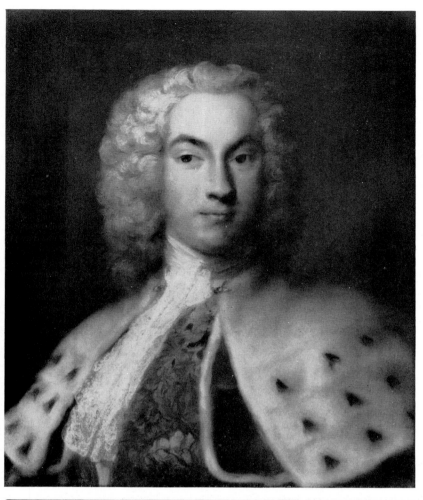

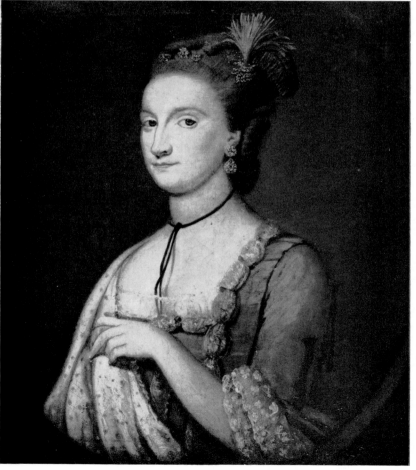

(above left) Ill. 123. **James Cecil, 6th Earl of Salisbury,** 1733, by Rosalba Carriera (Cat. No. 161, p. 180)
(left) Ill. 124. **Elizabeth (Keet), Countess of Salisbury** (?), 1774, by Benjamin van der Gucht (Cat. No. 163, p. 181)

(opposite above left) Ill. 125. **James Cecil, 7th Earl and 1st Marquess of Salisbury, K.G.,** 1781–83 or a little later, by George Romney (Cat. No. 165, p. 181)
(opposite above right) Ill. 126. **James Cecil, 7th Earl and 1st Marquess of Salisbury, K.G.,** 1803, by Sir William Beechey (Cat. No. 167, p. 182)
(opposite below left) Ill. 127. **James Brownlow William Gascoyne-Cecil, 2nd Marquess of Salisbury, K.G.,** 1844, by John Lucas (Cat. No. 171, p. 184)
(opposite below right) Ill. 128. **Frances Mary (Gascoyne), Marchioness of Salisbury,** 1828 or 9, by Sir Thomas Lawrence (Cat. No. 172, p. 184)

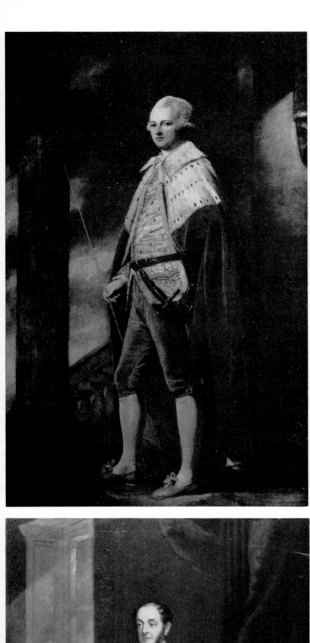

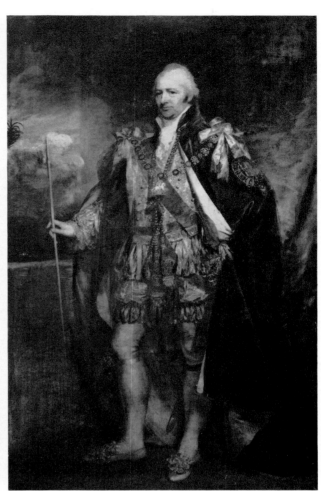

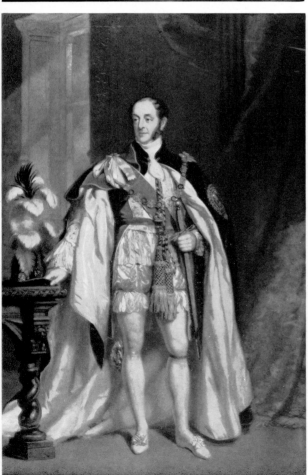

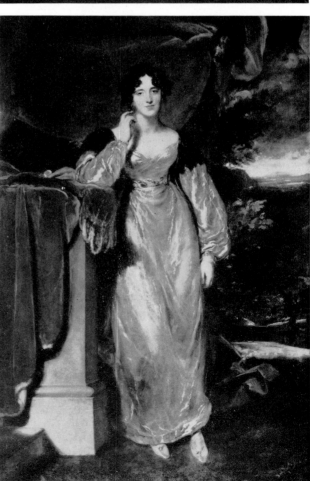

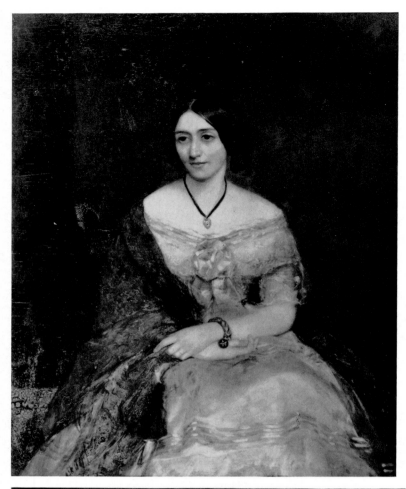

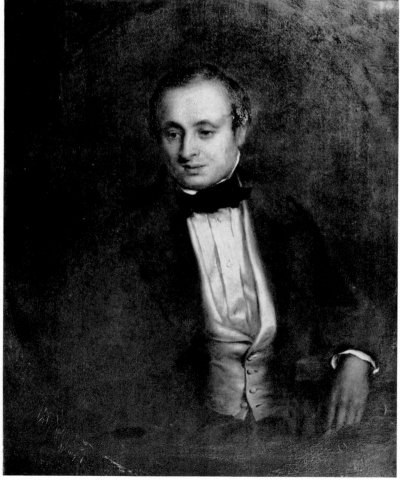

Ill. 129. **Lady Mary Catherine (Sackville-West), Marchioness of Salisbury and later Countess of Derby,** 1850, by James Rannie Swinton (Cat. No. 174, p. 185)

Ill. 130. **James Emilius William Evelyn Gascoyne-Cecil, Viscount Cranborne,** 1850, by Reuben Sayers (Cat. No. 180, p. 186)

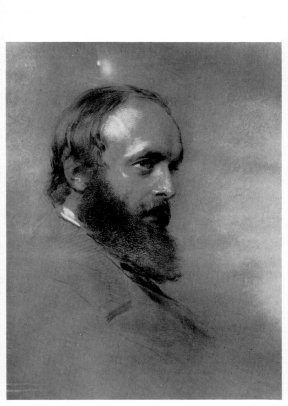

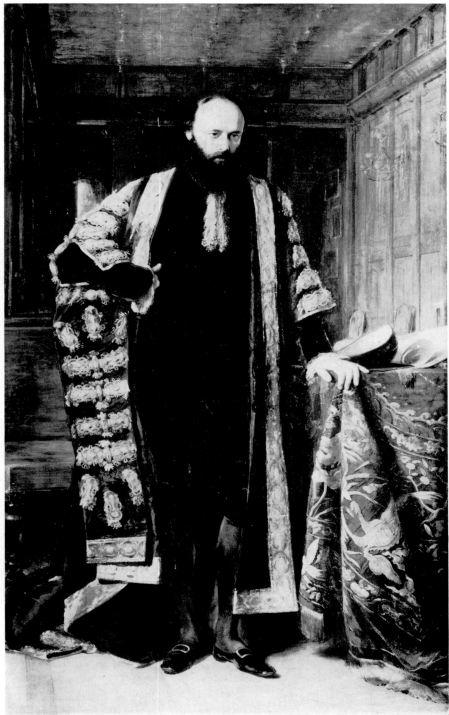

(above left) Ill. 131. **Robert Arthur Talbot Gascoyne-Cecil, 3rd Marquess of Salisbury, K.G.,** 1861, by George Richmond (Cat. No. 181, p. 186)
(right) Ill. 132. **Robert Arthur Talbot Gascoyne-Cecil, 3rd Marquess of Salisbury, K.G.,** 1870/2, by George Richmond (Cat. No. 182, p. 187)

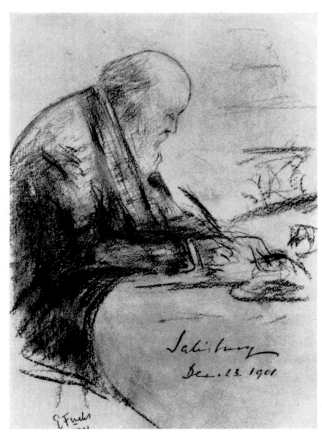

(left) Ill. 133. **Robert Arthur Talbot Gascoyne–Cecil, 3rd Marquess of Salisbury, K.G.,** 1901, by E. Fuchs (Cat. No. 188, p. 188)
(below) Ill. 134. **Salisbury Sisyphus,** 1887, by Sir John Tenniel (Cat. No. 1890, p. 189)

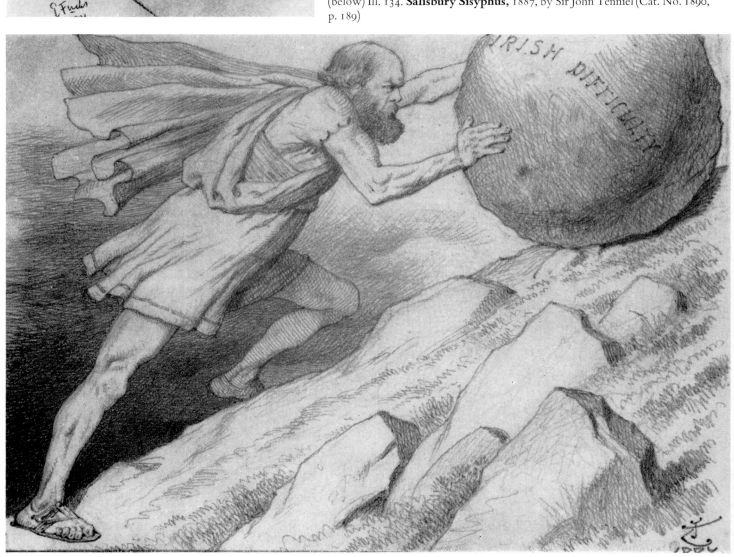

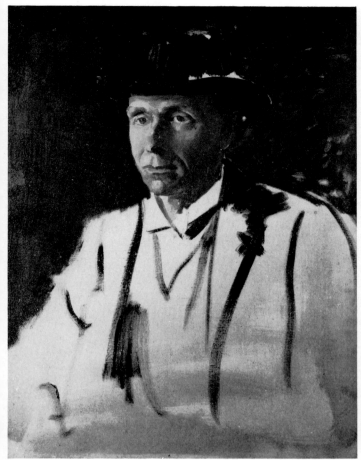

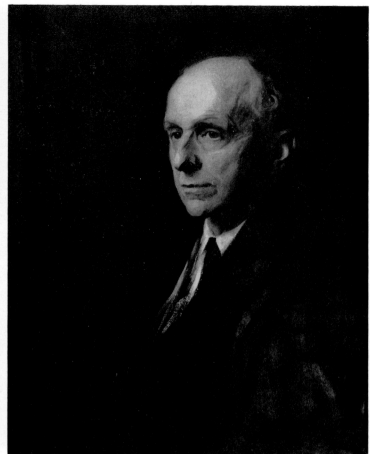

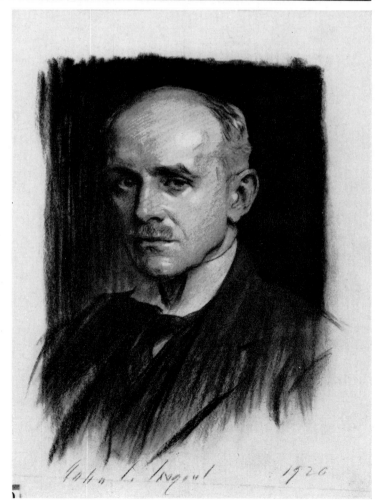

(above left) Ill. 135. **Lord Edgar Algernon Robert Gascoyne-Cecil, Viscount Cecil of Chelwood,** 1919, by Augustus John (Cat. No. 196, p. 190)

(above right) Ill. 136. **Lord Edgar Algernon Robert Gascoyne-Cecil, Viscount Cecil of Chelwood** (Cat. No. 197, p. 191)

(right) Ill. 137. **Lord Hugh Richard Heathcote Gascoyne-Cecil, Baron Quickswood,** 1920, by John Singer Sargent (Cat. No. 198, p. 191)

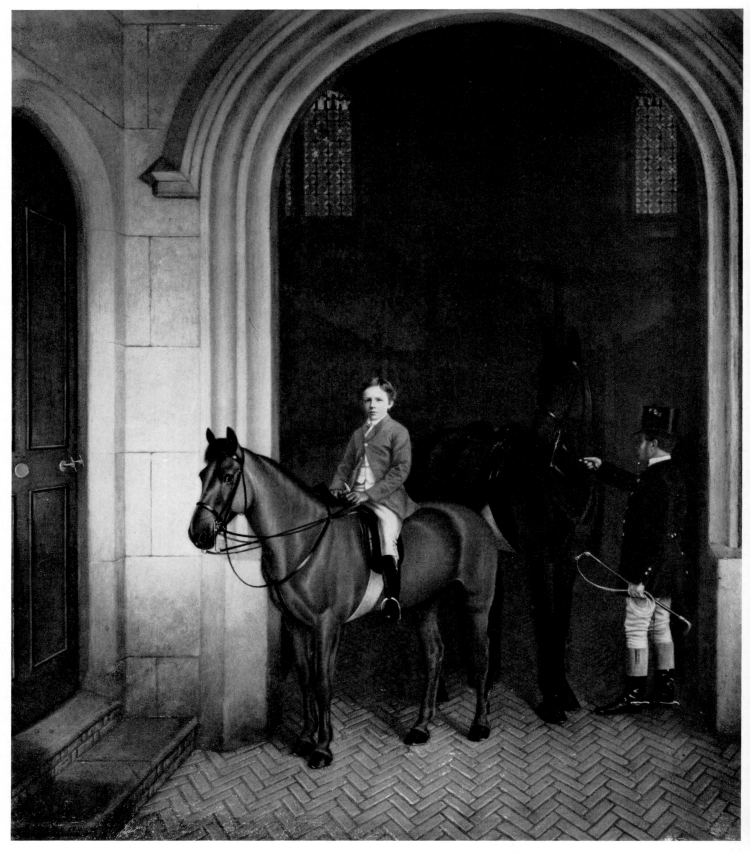

Ill. 138. **James Edward Hubert Gascoyne-Cecil, 4th Marquess of Salisbury, K.G.,** 1874, by A. Bishop (Cat. No. 203, p. 192)

(opposite above left) Ill. 139. **James Edward Hubert Gascoyne-Cecil, 4th Marquess of Salisbury, K.G.,** 1917, by Glyn Warren Philpot (Cat. No. 206, p. 193)
(opposite above right) Ill. 140. **Cecils in Conclave, 1913,** by Sir Max Beerbohm (Cat. No. 209, p. 194)
(opposite below) Ill. 141. **James Edward Hubert Gascoyne-Cecil, 4th Marquess of Salisbury, K.G.,** and his three Brothers, 1928, by Frederick Hawksworth Sinclair Shepherd (Cat. No. 210, p. 194)

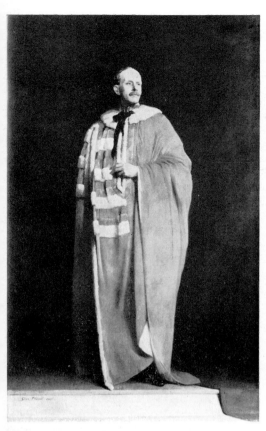

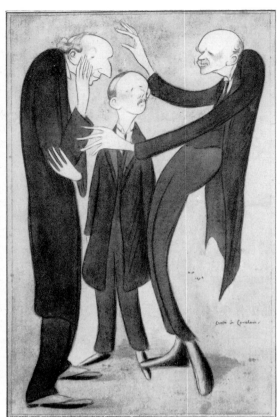

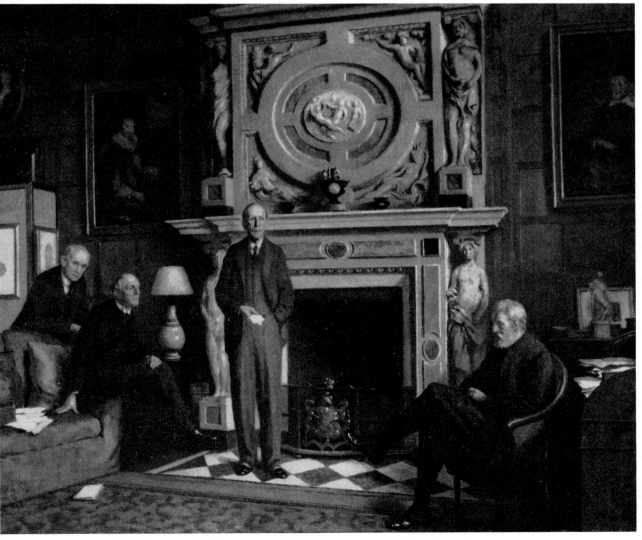

(below left) Ill. 142. **Lady Cicely Alice (Gore), Marchioness of Salisbury** and her younger son, **Lord Edward Christian David Gascoyne-Cecil,** 1908, by Sir James Jebusa Shannon (Cat. No. 211, p. 194)
(below right) Ill. 143. **Robert Arthur James Gascoyne-Cecil, 5th Marquess of Salisbury, K.G.,** 1914–19, by Sir William Orpen (Cat. No. 214, p. 195)

(opposite above) Ill. 144. **The 5th Marquess of Salisbury** with his brother, **Lord David Cecil,** and his two sisters, **Beatrice Edith Mildred, Lady Harlech** and **Mary Alice, Duchess of Devonshire,** 1951, by Edward Irvine Halliday (Cat. No. 219, p. 196)
(opposite below left) Ill. 145. **Elizabeth Vere Cavendish, Marchioness of Salisbury,** 1917, by Ambrose McEvoy (Cat. No. 221, p. 197)
(opposite below right) Ill. 146. **Robert Edward Peter Cecil Gascoyne-Cecil, Viscount Cranborne,** 1943, by William Dring (Cat. No. 228, p. 198)

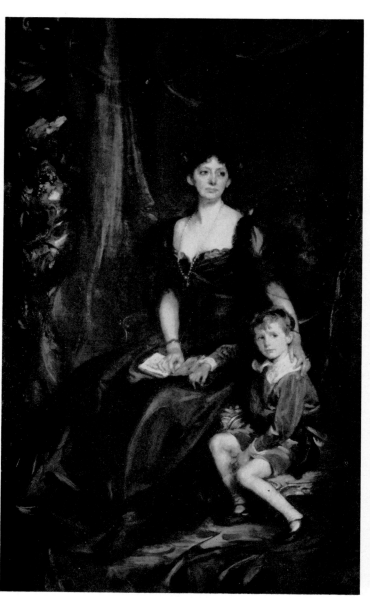

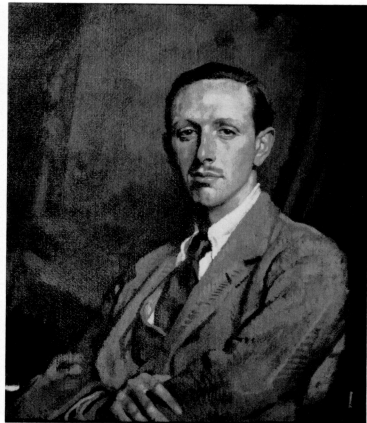

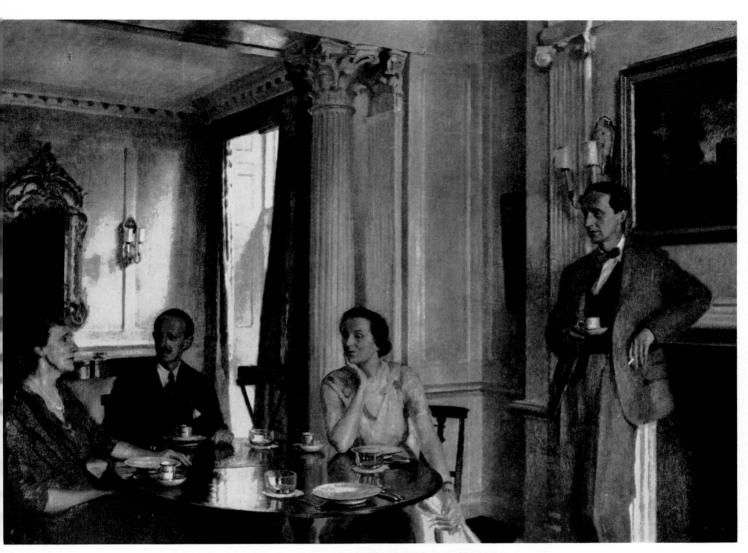

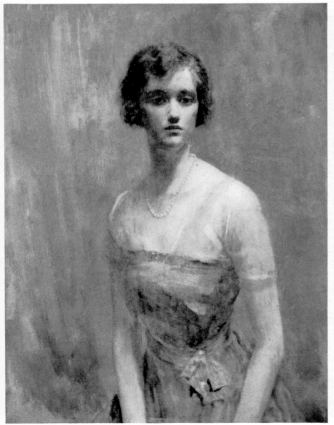

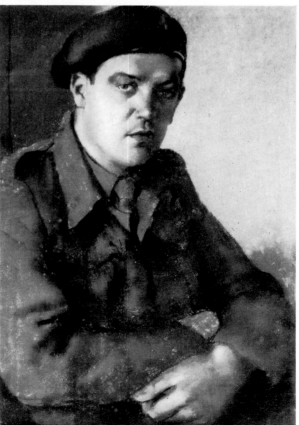

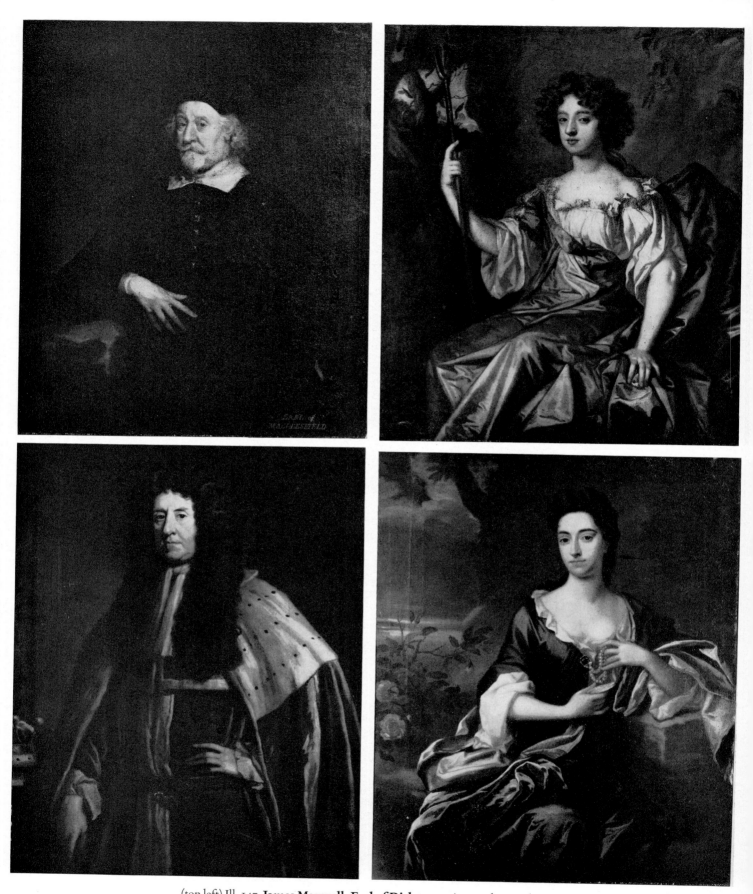

(top left) Ill. 147. **James Maxwell, Earl of Dirleton,** painter unknown (Cat. No. 229, p. 198)
(top right) Ill. 148. Called **Lady Elizabeth (Boyle), Countess of Thanet,** attributed to William Wissing
(Cat. No. 231, p. 199)
(above left) Ill. 149. **Thomas Tufton, 6th Earl of Thanet,** attributed to John Closterman (Cat. No. 232, p. 200)
(above right) Ill. 150. **Lady Catherine (Cavendish), Countess of Thanet,** *c.*1690–95, attributed to John Closterman
(Cat. No. 233, p. 200)

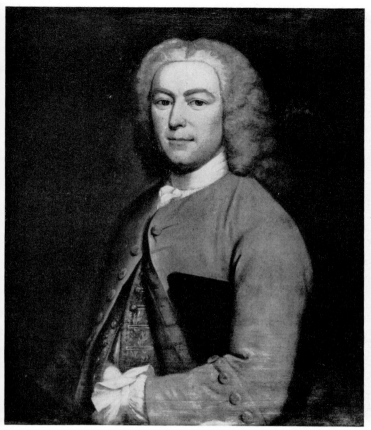

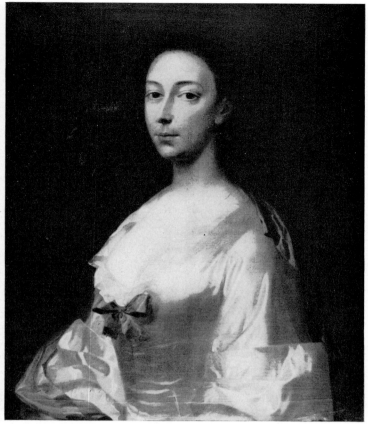

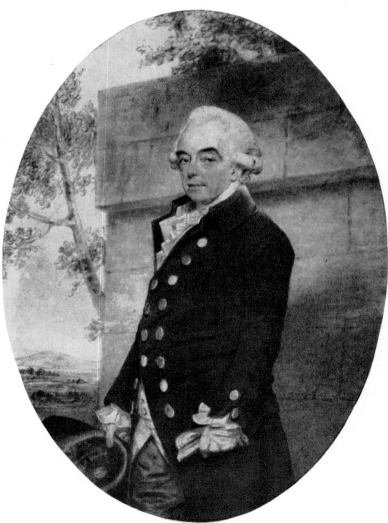

(above left) Ill. 151. **Sir Robert Brown, Bart.,** attributed to Jonathan Richardson (Cat. No. 234, p. 200)

(above right) Ill. 152. **Margaret (Cecil), Lady Brown,** attributed to Jonathan Richardson (Cat. No. 235, p. 201)

(right) Ill. 153. **Wills Hill, 1st Marquess of Downshire,** 1786, by John Downman (Cat. No. 238, p. 202)

(right) Ill. 154. **Arthur James Balfour, 1st Earl of Balfour of Whittinghame, K.G.,** by Sir Winston Churchill (Cat. No. 242, p. 203)
(below) Ill. 155. **Dr John Bamber, F.R.S.,** 1739, by William Verelst (Cat. No. 245, p. 203)

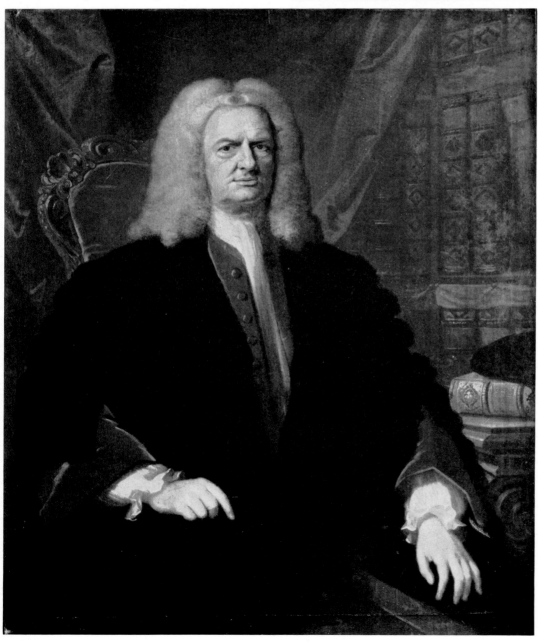

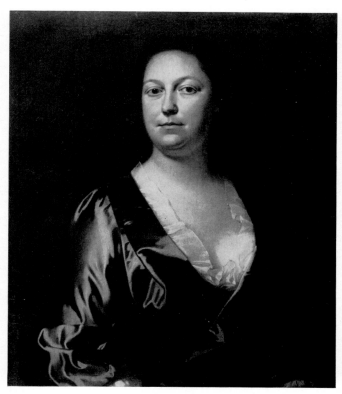

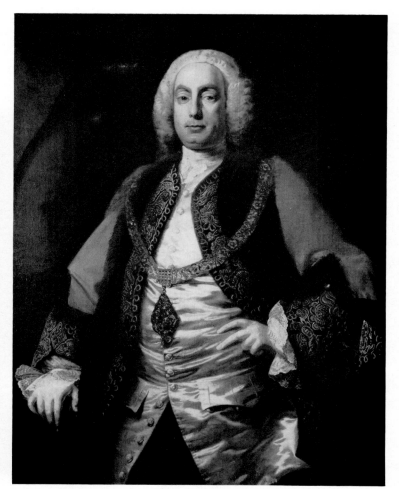

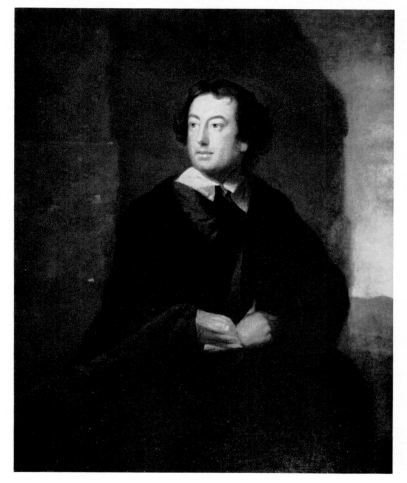

(above left) Ill. 156. **Margaret (Bamber), Mrs Gascoyne** (?),
by William Verelst (Cat. No. 246, p. 204)
(above right) Ill. 157. **Sir Crisp Gascoyne,** 1753, by William
Keable (Cat. No. 248, p. 205)
(right) Ill. 158. **Chase Price (?),** by Sir Joshua Reynolds (Cat. No.
249, p. 205)

(left) Ill. 159. **Bamber Gascoyne I,** by J. Sayer
(Cat. No. 250A, p. 206)
(below) Ill. 160. **Bamber Gascoyne II,** 1820, by
Richard Dighton (Cat. No. 250B, p. 206)

(opposite above left) Ill. 161. **Sarah Bridget Frances
(Price), Mrs Bamber Gascoyne,** 1770, by Sir Joshua
Reynolds (Cat. No. 251, p. 206)
(opposite above right) Ill. 162. **Sarah Bridget Frances
(Price), Mrs Bamber Gascoyne (?),** 1769, by Francis
Cotes (Cat. No. 252, p. 207)
(opposite below left) Ill. 163. **George III,** 1800, by Sir
William Beechey (Cat. No. 258, p. 208)
(opposite below right) Ill. 164. **Charles XII,** Studio of
David von Krafft (Cat. No. 261, p. 209)

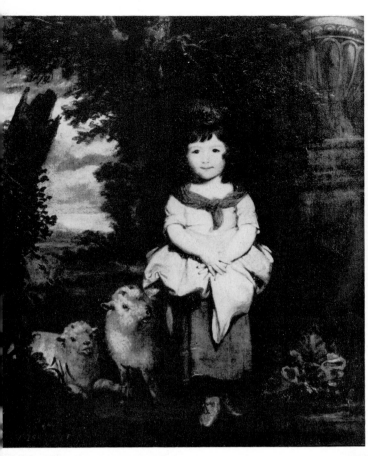

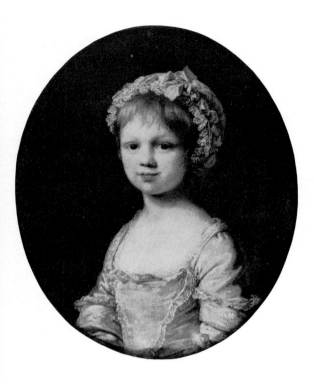

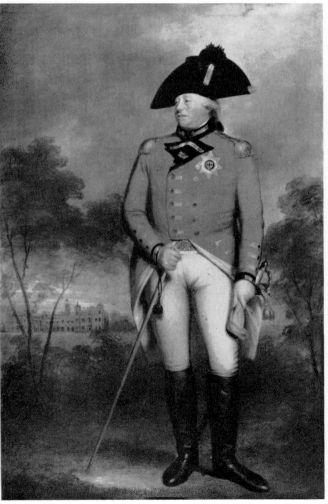

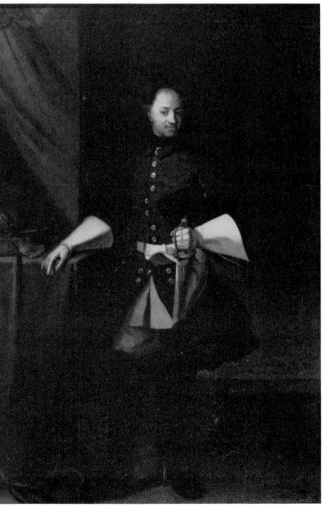

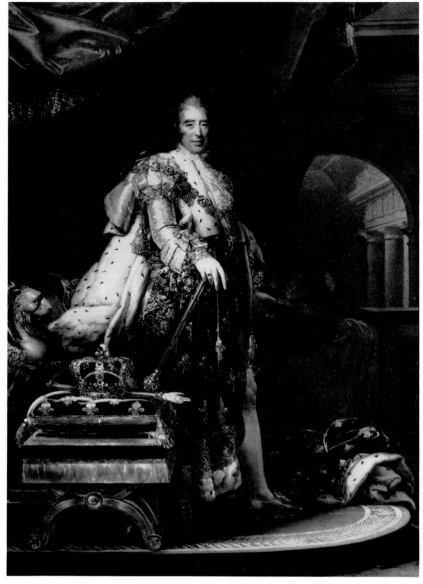

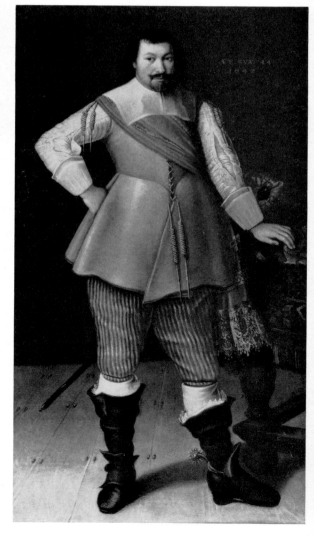

(above) Ill. 165. **Charles X,** by François, Baron Gérard (Cat. No. 263, p. 210)
(right) Ill. 166. **Martin Harpertzoon Tromp**(?), 1642, painter unknown
(Cat. No. 268, p. 211)

(opposite above left) Ill. 167. **Unknown Lady,** c.1660–65, painter unknown,
Pierre Mignard School (Cat. No. 270, p. 212)
(opposite above right) Ill. 168. **Thomas Sydenham, M.D.,** by Ebenezer(?)
Sadler (Cat. No. 273, p. 213)
(opposite below left) Ill. 169. **Unknown Lady as a Magdalene,** 1694, by
Sir Godfrey Kneller (Cat. No. 274, p. 213)
(opposite below right) Ill. 170. **Mrs Wrey or Wray,** 1694, by Sir Godfrey
Kneller (Cat. No. 276, p. 214)

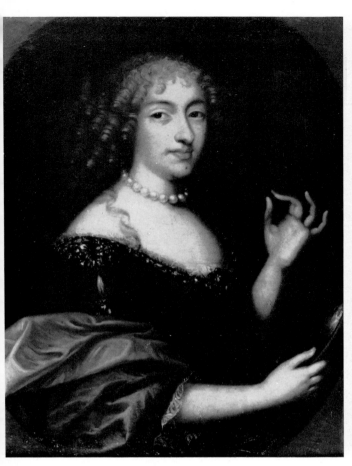
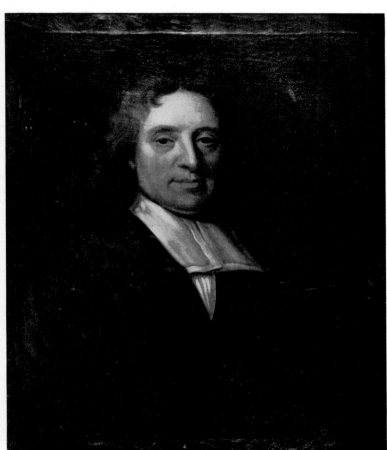
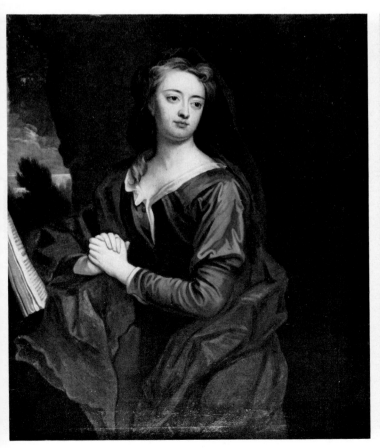
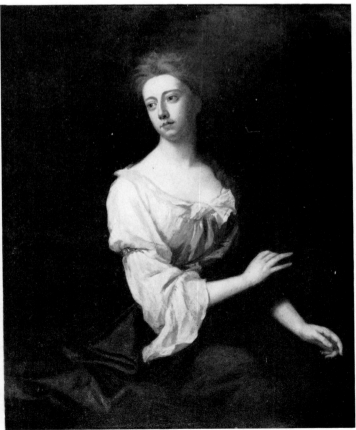

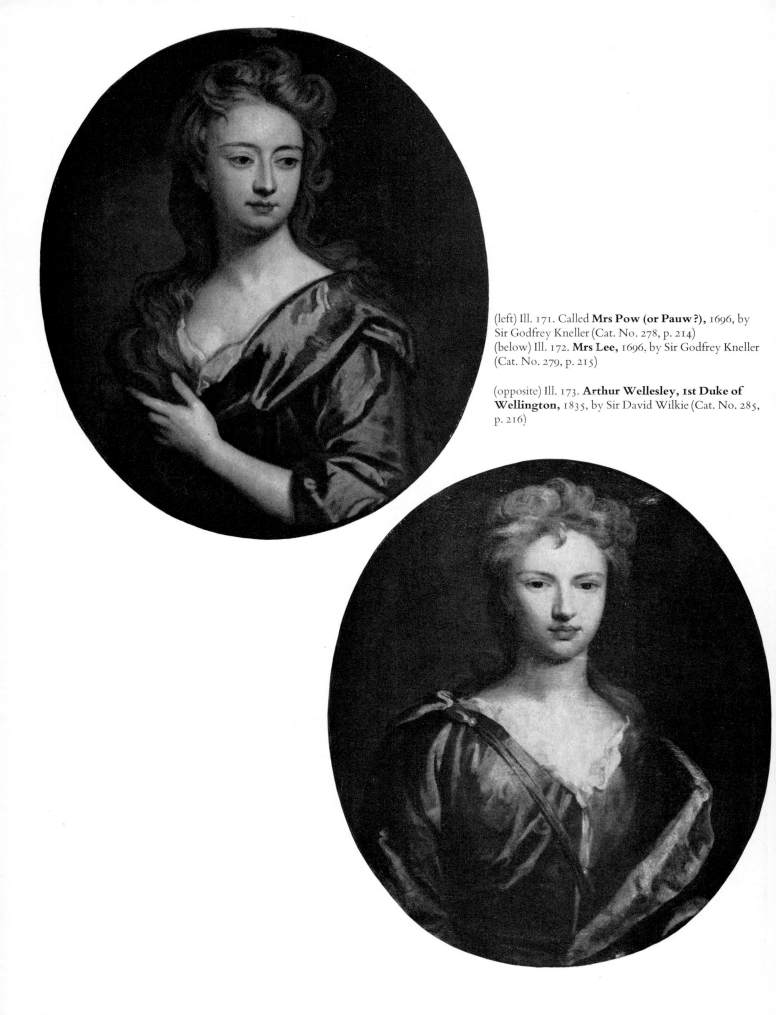

(left) Ill. 171. Called **Mrs Pow (or Pauw?),** 1696, by Sir Godfrey Kneller (Cat. No. 278, p. 214)
(below) Ill. 172. **Mrs Lee,** 1696, by Sir Godfrey Kneller (Cat. No. 279, p. 215)

(opposite) Ill. 173. **Arthur Wellesley, 1st Duke of Wellington,** 1835, by Sir David Wilkie (Cat. No. 285, p. 216)

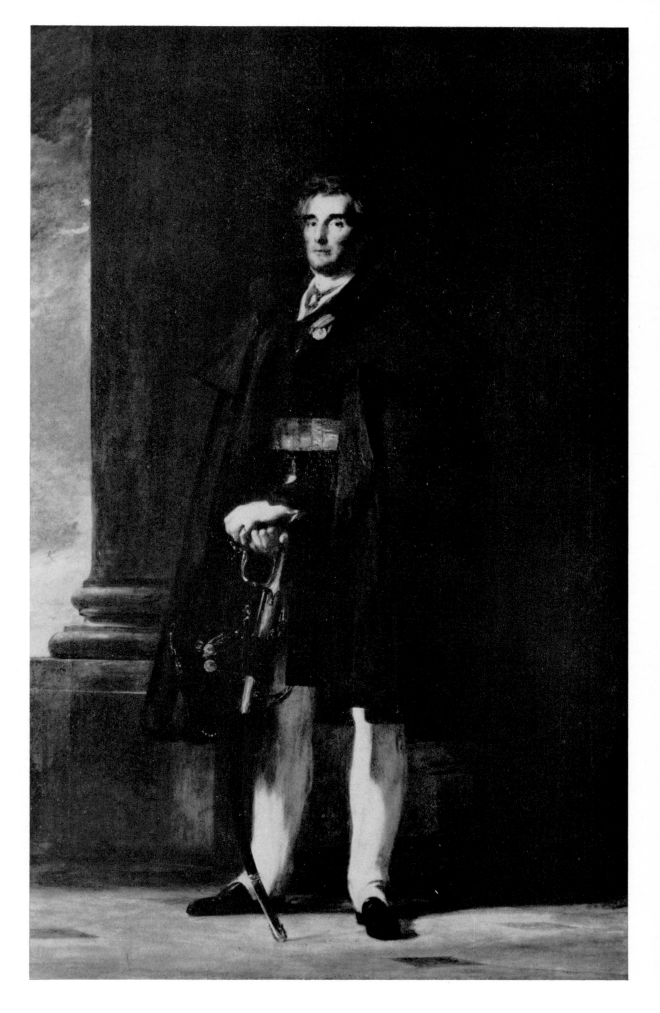

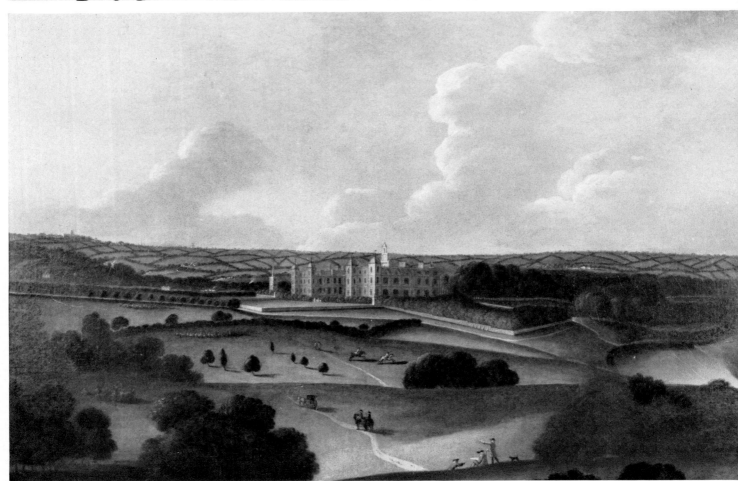

(above) Ill. 174. **Recumbent Lion with paws on Landseer,** *c.*1850, by Sir Edwin Landseer (Cat. No. 174e, p. 219)
(below) Ill. 175. **Landscape view of Hatfield House,** *c.*1740, painter unknown (Cat. No. 292, p. 220)

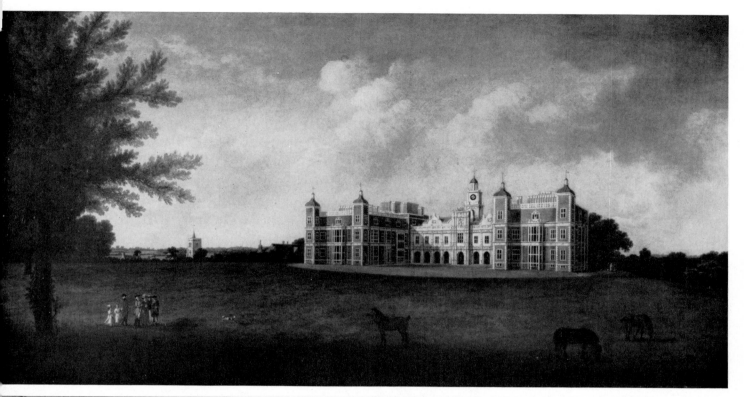

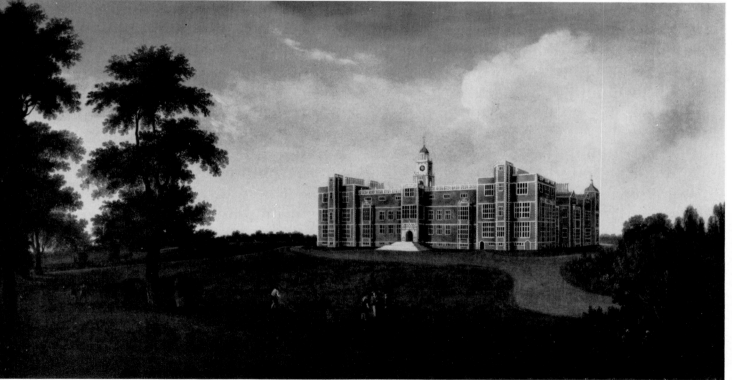

(above) Ill. 176. **Hatfield House, South Front,** *c.*1785, attributed to William Tomkins or Charles Tomkins (Cat. No. 293, p. 220)
(below) Ill. 177. **Hatfield House, North Front,** *c.*1785, attributed to William Tomkins or Charles Tomkins (Cat. No. 294, p. 220)

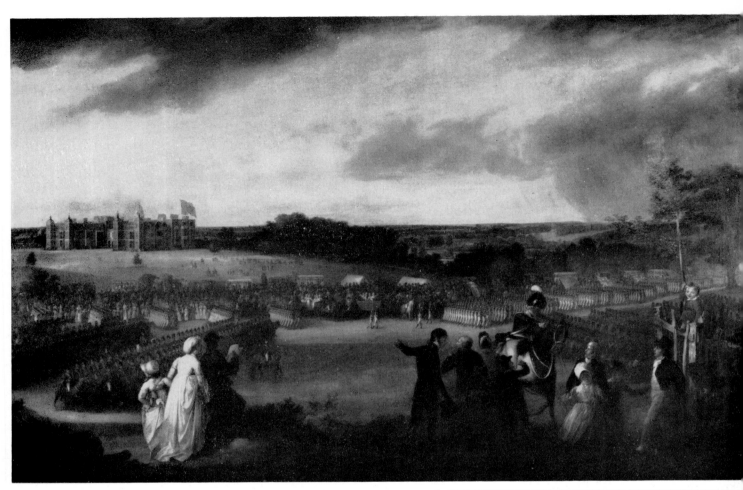

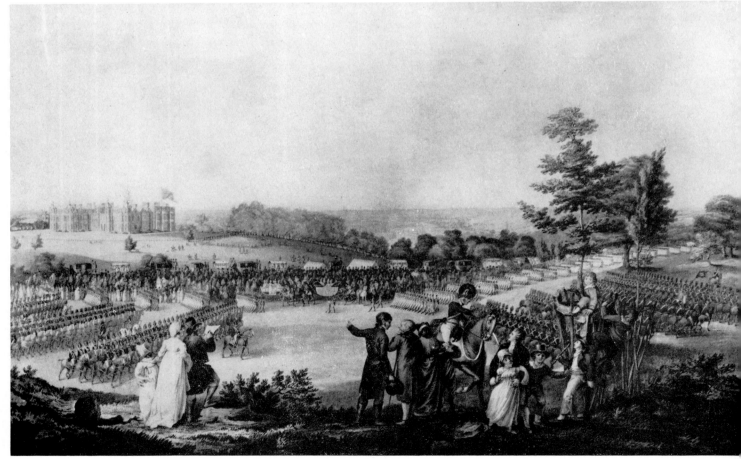

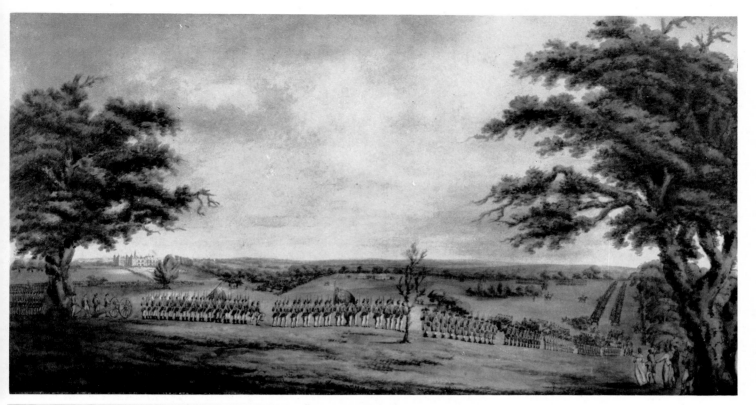

(opposite above) Ill. 178. **The Grand Review of Troops at Hatfield by King George III on June 13, 1800,**
1802 by Richard Livesay (Cat. No. 295, p. 220)
(opposite below) Ill. 179. **The Grand Review of Troops at Hatfield by King George III on June 13, 1800,**
*c.*1802, by Richard Livesay (Cat. No. 296, p. 221)

(above)Ill. 180. **Scene during the Grand Review of Troops at Hatfield on June 13, 1800,** *c.*1802, by Richard Livesay
(Cat. No. 297, p. 221)
(below) Ill. 181. **Scene during the Grand Review of Troops at Hatfield on June 13, 1800,** *c.*1802, by Richard Livesay
(Cat. No. 298, p. 221)

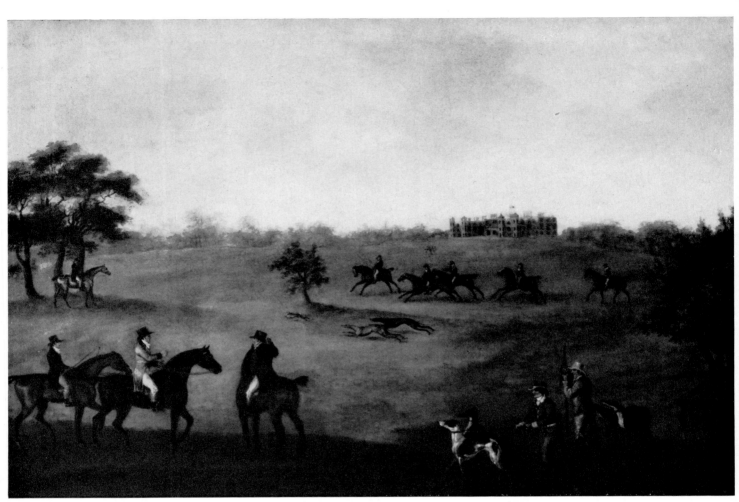

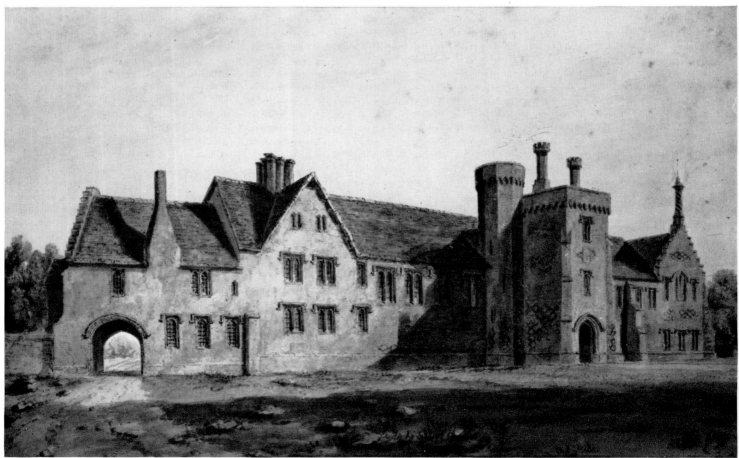

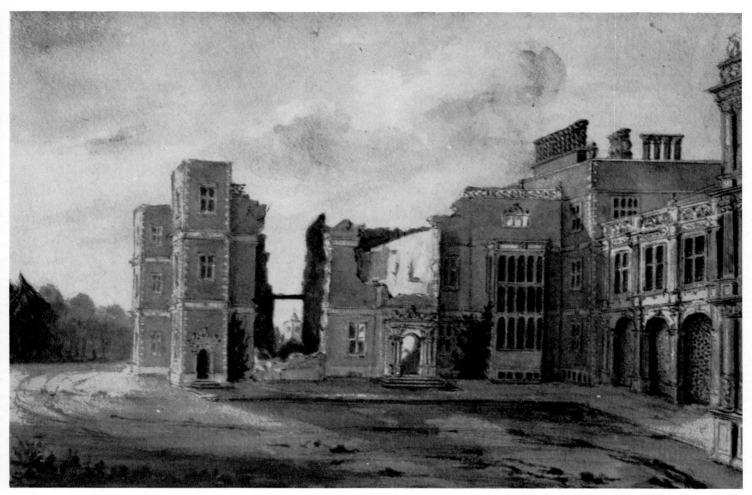

(opposite above) Ill. 182. **Coursing at Hatfield Park,** 1805, by John F. Sartorius (Cat. No. 299, p. 221)
(opposite below) Ill. 183. **The Old Palace, Hatfield,** 1812, by J. Buckler (Cat. No. 300, p. 222)

(above) Ill. 184. **Hatfield House, West Wing,** 1835–46, painter unknown (Cat. No. 301b, p. 222)

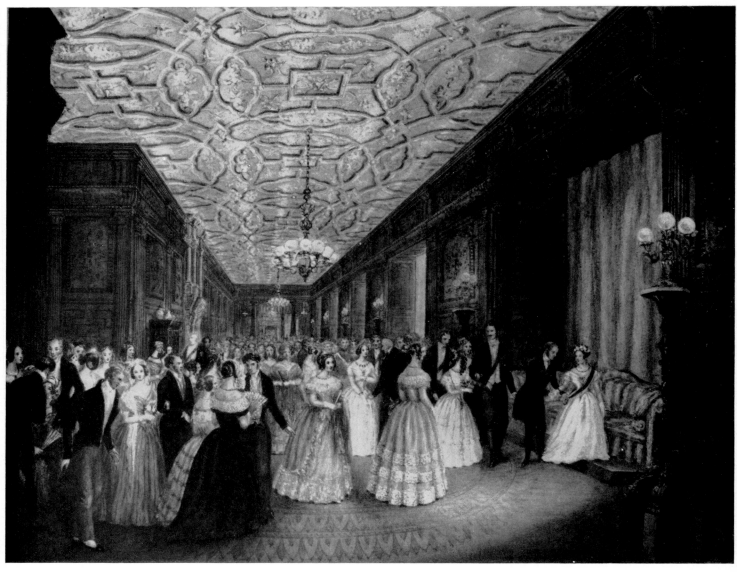

(above) Ill. 185. **Queen Victoria and Guests in the Gallery,** 1846, artist unknown
(Cat. No. 302b, p. 223)
(right) Ill. 186. **A Garden Party at Hatfield House,** *c.*1899, by A. Faulkner
(Cat. No. 303, p. 223)

(opposite above) Ill. 187. **The Casino, Aldborough,** 1809, by Perry Nursey
(Cat. No. 304, p. 224)
(opposite below) Ill. 188. **Childwall Hall,** by John Nash (Cat. No. 305, p. 224)

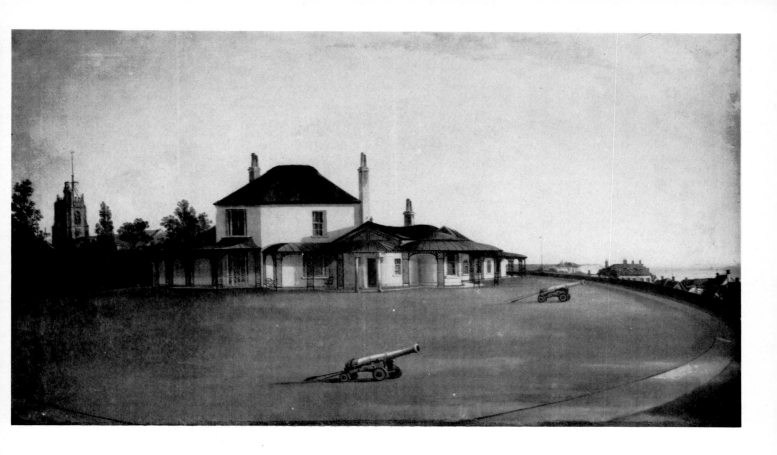

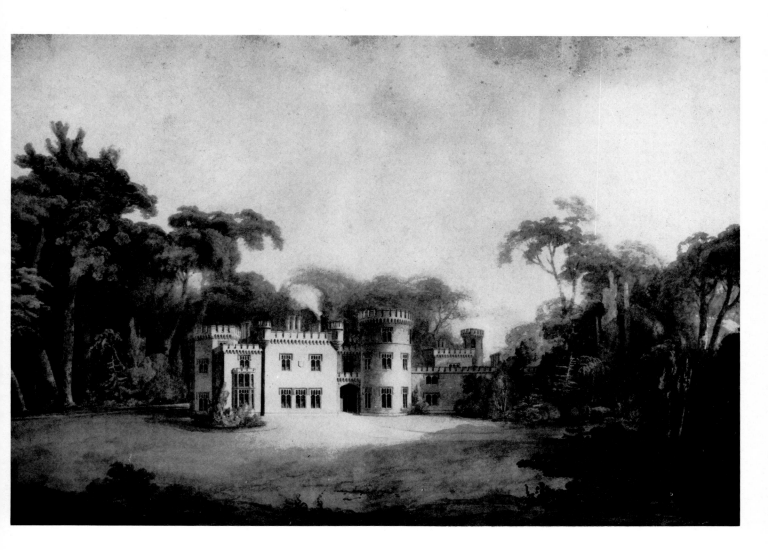

(right) Ill. 189. **The North Porch at Cranborne Manor,** 1932, by Sir Winston Churchill (Cat. No. 307, p. 224)
(below) Ill. 190. **Veduta de Genoa,** 1791, by John Thomas Serres (Cat. No. 310, p. 225)

(opposite above) Ill. 191. **Dieppe Harbour,** 1876, by Antoine Vollon (Cat. No. 211, p. 225)
(opposite below left) Ill. 192. **Landscape,** attributed to Ebenezer Sadler (Cat. No. 325, p. 229)
(opposite below right) Ill. 193. **Landscape,** attributed to Ebenezer Sadler (Cat. No. 327, p. 230)

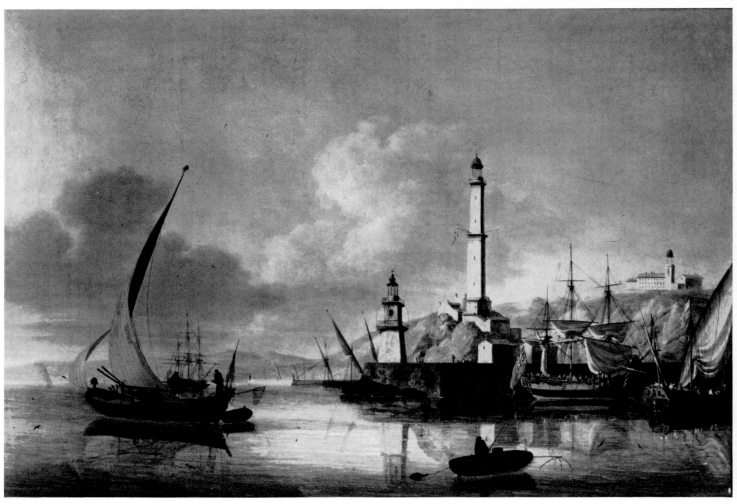

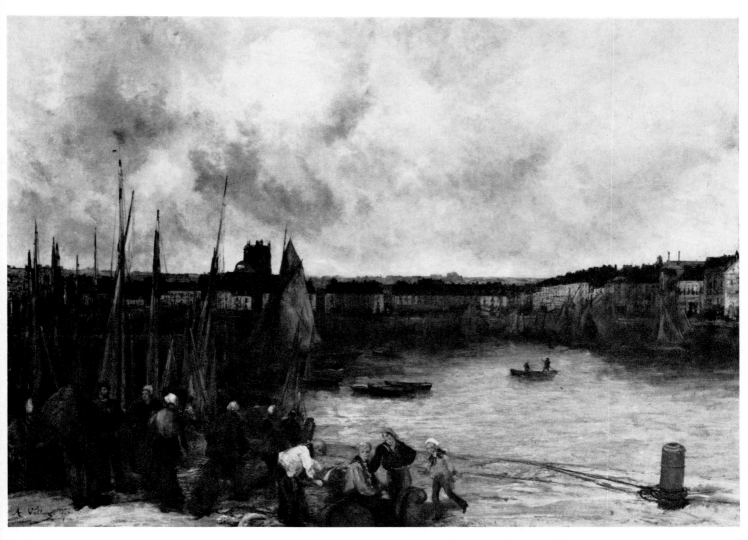

(above left) Ill. 194. **A Seaport with Figures,**
Style of Johann Lingelbach (Cat. No. 334,
p. 231)
(left) Ill. 195. **The Annunciation,** by Caspar
Smitz (Cat. No. 339, p. 232)
(above) Ill. 196. **The Virgin and Child,** Copy
by Jacob Huysmans after Sir Anthony van
Dyck (Cat. No. 340, p. 232)

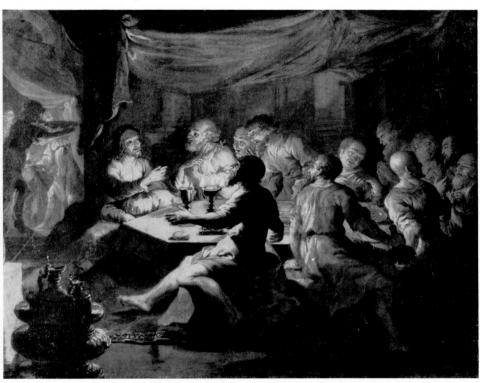

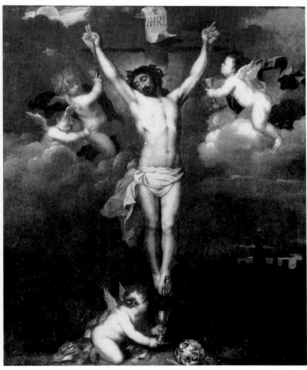

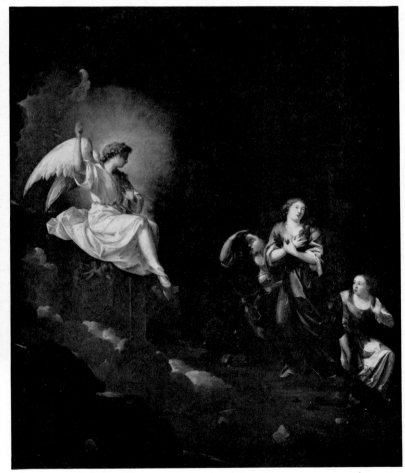

(top left) Ill. 197. **The Adoration of the Magi,**
attributed to Jan Asseylin (Cat. No. 341, p. 233)
(top right) Ill. 198. **The Last Supper,**
attributed to Willem van Herp I (Cat. No. 342,
p. 233)
(above) Ill. 199. **The Crucifixion,** by Jacob
Huysmans after Sir Anthony van Dyck
(Cat. No. 343, p. 233)
(right) Ill. 200. **Angel at the Tomb and the
three Maries,** by Caspar Smitz (Cat. No. 344,
p. 234)

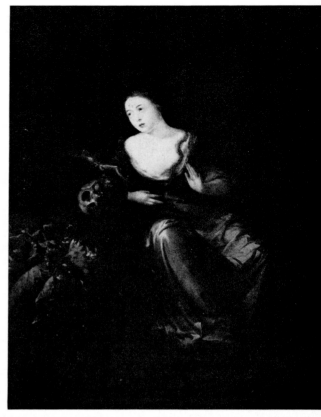

(right) Ill. 201. **A Magdalene with a Crucifix and a Skull,** by Caspar Smitz (Cat. No. 350, p. 235)
(below) Ill. 202. **Bacchanalian Procession of Silenus,** attributed to Willem van Herp (Cat. No. 353, p. 235)

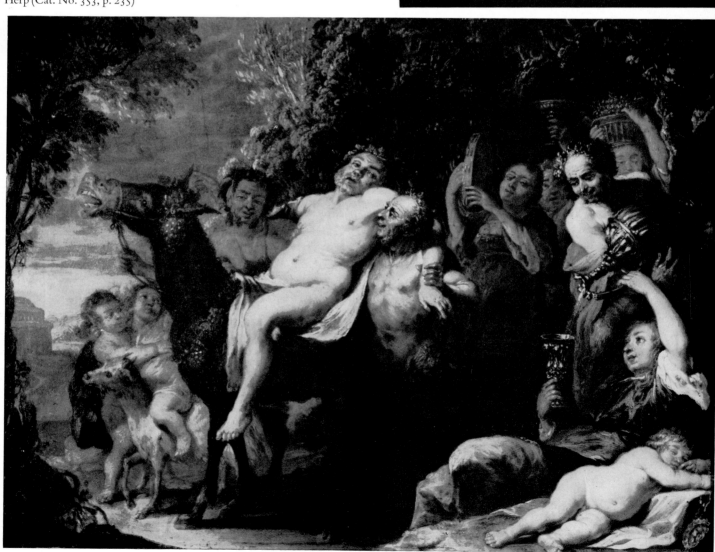

(above left) Ill. 203. **Interior of a Philosopher's Study,** by Thomas Wyck (Cat. No. 357, p. 236)
(above right) Ill. 204. **Philosopher Punishing an Intruder,** by Thomas Wyck (Cat. No. 358, p. 237)
(right) Ill. 205. **Sleeping Girl and Duenna,** by Sir Peter Lely (Cat. No. 359, p. 237)

(right) Ill. 206. **Flowers in a copper or pewter vase on a windowsill with a monkey chained to the left side of the window,** by Jean-Baptiste Monnoyer (Cat. No. 365, p. 238)

(below right) Ill. 207 **A horse and three dogs,** 1784, by John Boultbee (Cat. No. 373, p. 240)

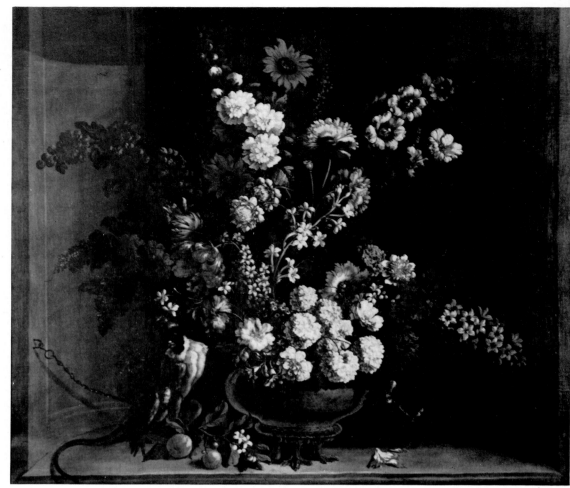

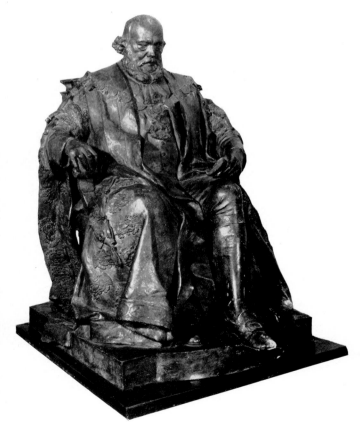

(top) Ill. 208. **A horse,** 1800, by Ben Marshall (Cat. No. 378, p. 240)
(above left) Ill. 209. **Lord Arthur George Villiers Gascoyne–Cecil,** by Sir Francis Chantrey (?) (Cat. No. 381, p. 241)
(above right) Ill. 210. **Robert Arthur Talbot Gascoyne–Cecil, 3rd Marquess of Salisbury, K.G.,**
1875, by William Theed (Cat. No. 382, p. 241)

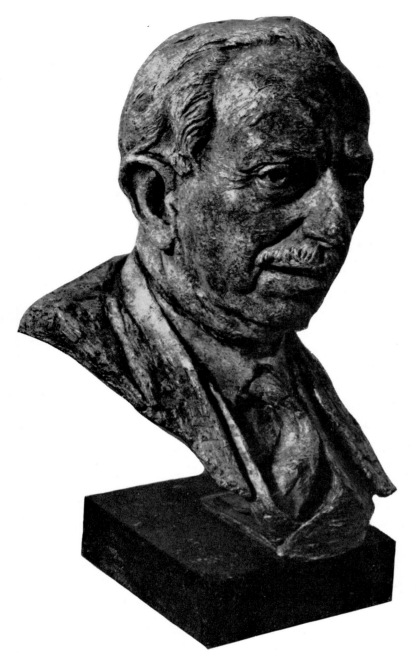

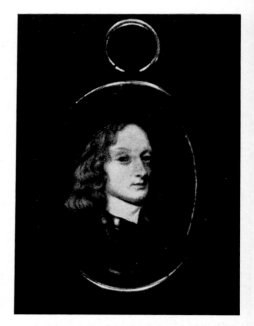

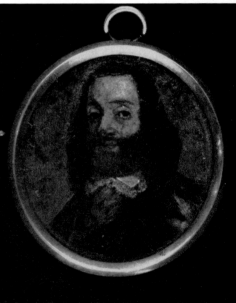

(above) Ill. 211. **Robert Arthur James Gascoyne-Cecil, 5th Marquess of Salisbury, K.G.,** 1967, by Lorne McKean (Cat. No. 389, p. 243)
(top right) Ill. 212 Called **Charles Cecil, Viscount Cranborne,** 1646, by Samuel Cooper (Cat. No. 399, p. 246)
(right) Ill. 213. **Charles I, in the last year of his life,** 1648/9, painter unknown (Cat. No. 400, p. 246)
(below) Ill. 214. **The Hon. Robert Cecil,** 1698, by Jacques Antoine Arlaud (Cat. No. 404, p. 247)

(opposite top left) Ill. 215. **James Cecil, 6th Earl of Salisbury,** c.1727–28, by Christian Frederick Zincke (Cat. No. 408, p. 248)
(opposite top right) Ill. 216. **Unknown Lady,** 1761, by Samuel Finney (Cat. No. 422, p. 251)
(opposite centre left) Ill. 217. **Unknown Young Man,** 1766, by Samuel Cotes (Cat. No. 432, p. 253)
(opposite centre right) Ill. 218. **James Cecil, 7th Earl and 1st Marquess of Salisbury,** 1775, by Samuel Cotes (Cat. No. 435, p. 254)
(opposite below left) Ill. 219. **Lady Emily Mary (Hill), 1st Marchioness of Salisbury,** 1790, by George Engleheart (Cat. No. 441, p. 255)
(opposite below right) Ill. 220. **James Cecil, 7th Earl and 1st Marquess of Salisbury,** c.1795–1800, attributed to Adam Buck (Cat. No. 445, p. 256)

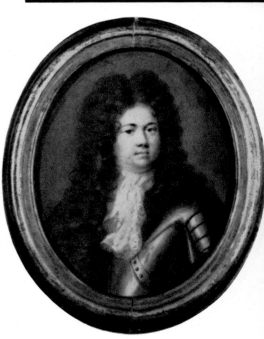

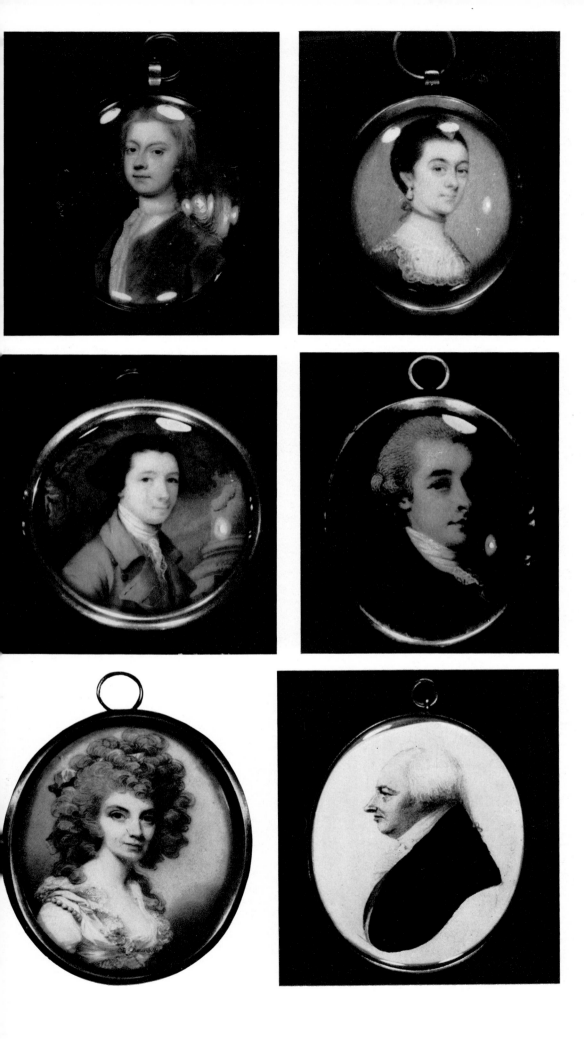

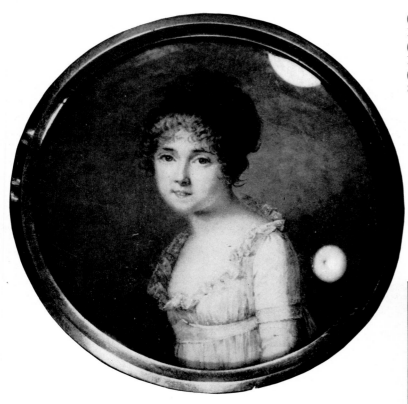

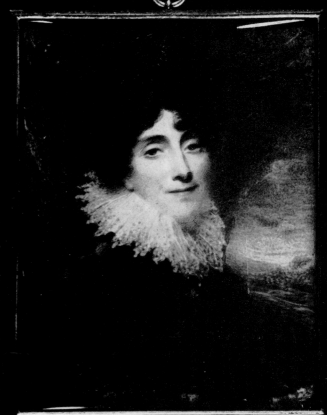

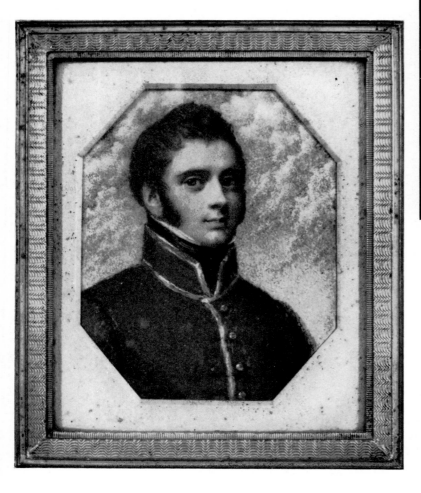

(left) Ill. 221. **Unknown Lady,** *c.*1800–1805, by Louise Chacaré de Beaurepaire (Cat. No. 450, p. 257)

(below left) Ill. 222. **Unknown Young Military Officer,** 1809, by Richard Cosway (Cat. No. 452, p. 258)

(below) Ill. 223. **Frances Mary (Gascoyne), Marchioness of Salisbury,** *c.*1825–30, by Thomas Hargreaves (Cat. No. 456, p. 259)

Indexes

INDEX OF PORTRAITS

The numbers are those of the catalogue entries and illustrations, not those of the pages

INDEX TO ARTISTS

The numbers are those of the catalogue entries and illustrations, not those of the pages